Facial Choreographies

Facial Choreographies

Performing the Face in Popular Dance

SHERRIL DODDS

OXFORD
UNIVERSITY PRESS

Oxford University Press is a department of the University of Oxford. It furthers
the University's objective of excellence in research, scholarship, and education
by publishing worldwide. Oxford is a registered trade mark of Oxford University
Press in the UK and certain other countries.

Published in the United States of America by Oxford University Press
198 Madison Avenue, New York, NY 10016, United States of America.

© Oxford University Press 2024

All rights reserved. No part of this publication may be reproduced, stored in
a retrieval system, or transmitted, in any form or by any means, without the
prior permission in writing of Oxford University Press, or as expressly permitted
by law, by license, or under terms agreed with the appropriate reproduction
rights organization. Inquiries concerning reproduction outside the scope of the
above should be sent to the Rights Department, Oxford University Press, at the
address above.

You must not circulate this work in any other form
and you must impose this same condition on any acquirer.

Library of Congress Cataloging-in-Publication Data
Names: Dodds, Sherril, 1967– author.
Title: Facial choreographies : performing the face in popular dance / Sherril Dodds.
Description: New York, NY : Oxford University Press, [2024] |
Includes bibliographical references and index.
Identifiers: LCCN 2023033911 (print) | LCCN 2023033912 (ebook) |
ISBN 9780197620366 (hardback) | ISBN 9780197620373 (paperback) |
ISBN 9780197620397 (epub)
Subjects: LCSH: Facial expression in dance. | Choreography. |
Facial expression. | Dance.
Classification: LCC GV1782.5 D63 2024 (print) | LCC GV1782.5 (ebook) |
DDC 792.8/2—dc23/eng/20230919
LC record available at https://lccn.loc.gov/2023033911
LC ebook record available at https://lccn.loc.gov/2023033912

DOI: 10.1093/oso/9780197620366.001.0001

Paperback printed by Marquis Book Printing, Canada
Hardback printed by Bridgeport National Bindery, Inc., United States of America

For my youngest son,
Dylan Dodds

Contents

Acknowledgments	ix
1. About Face	1
The Face in Performance	3
Performing the Habitual Face	10
The Work of Facial Choreography	18
2. SMILE	27
Michael Jackson and the Pedagogy of a Smile	29
The Tenacity of the Minstrel Smile	36
Maddie Ziegler and the Billion-Dollar Smile	42
Smiling Toward Happiness	48
3. LOOK	54
(En)Visioning the World	57
Performances of Looking in Hip Hop	60
Feeling the Gaze in Battles	69
Check Out the B-Girls	77
4. FROWN	83
Michael Jackson and the Intention to Be Bad	85
Frowning and Facial Signifyin(g)	92
Mythologies of Mean Mugging in Breaking	94
Mugsy, Bugsy, and Keeping It Real	101
5. CRY	111
The Surrogate Face of a Reluctant Celebrity	115
Sia and Big Girls Cry	122
Maddie Ziegler and Her Affective Cry	128
A Cry of Outrage	131
6. SCREAM	137
Re-Facing Michael Jackson	140
Defacement, Freakery, and Race	144
A Choreographic Scream	151
Michael Jackson: The Commodity and the Cut	157

7. LAUGH 163
 The Viral Face of Maddie Ziegler 166
 Maddie, Eddie, and a Wookie 174
 Laughter and Derision in Hip Hop Battles 179
 Tickling the Cypher Crowd 186

8. Face the Facts 191

Notes 199
References 219
Index 237

Acknowledgments

I love this part of completing a book as I pause to reflect on the many people who have supported and guided my research journey. Books are written in and through community, and I cannot thank the following people enough for helping me reach this point.

I am grateful to Dean Robert Stroker and Boyer College of Music and Dance; parts of the fieldwork were funded through a Vice Provost for the Arts Grant and I was also awarded a reduced teaching load in 2021–2022 to complete the writing of this book. I was a recipient of a Presidential Humanities and Arts funding award from Temple University, which similarly contributed to the fieldwork components of the research. I am deeply appreciative of my generous colleagues in the dance department and its brilliant PhD students who have helped to develop my thinking around the dancing face. I was fortunate to work with a meticulous group of transcribers for my ethnographic interviews: Elisa Davis, Julie Johnson, Whitney Weinstein, Don Martin, Min Yi Chen, and Susan Le. I was also supported by three outstanding graduate research assistants, Elizabeth Bergman and Colin Murray, and Pritika Agarwal, who initially volunteered to assist me out of the goodness of her wonderful heart when she first arrived at Temple University.

As a fellow professor and scholar, I know that we are frequently short on time and energy yet several incredibly generous colleagues in the field read draft chapters and offered detailed feedback: Harmony Bench, Tommy DeFrantz, Rachel Fensham, and Rebecca Rossen. In addition, many other knowledgeable scholars took time to talk through ideas, offer guidance, or lead me to new resources: Susan Leigh Foster, Brandon Shaw, Alex Harlig, Jasmine Johnson, Anusha Kedhar, Michael Sakamoto, Shana Goldin-Perschbacher, Paul Rardin, Lawrence Indik, Mark Franko, Uttara Coorlawala, Marion Kant, Clare Croft, Pallabi Chakravorty, and Jo Read (who was my first hip hop instructor and gave me the courage to go to classes in Philadelphia). Members of the TransX research group, Susan C. Cook, Rachel Cowgill, Marta Robertson, and Andrea Harris, have given both intellectual guidance and moral support, which I absolutely treasure. And

I would also like to thank the insightful comments offered by the anonymous reviewers who read the initial book proposal.

This is not the first time I have thanked Norm Hirschy, my editor from Oxford University Press, for his care and expertise in this role, but it bears saying again that his commitment to dance studies as a field of scholarship has produced a sizeable and robust corpus of academic literature that showcases some of the most innovative work in the field. Thank you, Norm, for trusting that dance can speak critically about the world.

Although this book addresses several case studies, the research into hip hop dance battles and culture formed the most substantial area of work. I arrived in Philadelphia in the summer of 2011, and the warmth and openness that I have experienced from its hip hop community has been quite overwhelming. With all my heart, I thank the dancers who generously gave up their time to be interviewed, as well as those who held space for me as a novice b-girl and offered kind words and gestures of support. Specifically, I want to acknowledge Vince Johnson and Urban Movement Arts as a community studio that honors the care we should take in learning about Black dance practices; Hip Hop Fundamentals (Mark Wong and Steven Lunger), Macca Malik, and Benyaamin Barnes-McGee (Box Won) for your willingness to collaborate with me on research projects; Jay Jao (Rukkus) for your infectious enthusiasm, knowledge of the culture, and persistent encouragement; Autumn Dziegrenuk (A-Tek) for talking to me endlessly about breaking and baking; and to Tiffany Holmes (Dichotomy) for our joyous training sessions and intense conversations. Finally, it is with huge appreciation that I turn to my two breaking mentors: thank you Mark Wong (Metal) for assuming I would want to learn how to break and for driving me with your passion and dedication to the form; and thank you Jerry Valme for your high expectations, compassionate teaching, and for never letting me wriggle out of anything when it comes to learning moves!

Behind the scenes, a small tight-knit unit offers me the unconditional support I need to do my work. Thank you to my sons, Billy and Dylan Dodds, and to my partner, James Powell, who finds me running out to hip hop battles at all hours and patiently listens to me complain about my bumps, bruises, and aching bones. Thank you again JP.

1
About Face

> If it moves, it can dance. So you got lots of muscles, if I'm not mistaken, in your face. Dance! Dance in your face.
>
> —Professor Lock[1]

Without doubt, dancers and audiences are attentive to the expressive capacity of the face. As the opening quotation shows, hip hop dancer Professor Lock encourages performers to employ facial expression as a dance in and of itself. Indeed, I recall the deluge of facial expressions issued by Professor Lock and other dancers at hip hop battles, parties, and jams I have attended in Philadelphia over the past ten years: the lockers who exude wide open-mouthed smiles and flash their tongues in a cheeky moment of play; the poppers whose steely expressions and facial grimaces capture the tensing of their muscles as they hit in time to the beat; and the poker-faced b-boys and b-girls who stare down their opponents in an intimidating dance of one-upmanship at the beginning of a round (Dodds 2016).

Notably, other observers have also paid attention to the expressivity of the face in dance. Dance critic Wendy Perron (2002, 6) details the facial idiosyncrasies of celebrated American concert dance performers, such as the "sad but brave visage" of ballerina Gelsey Kirkland, the "sensual and glamorous face" of modern dancer Katherine Dunham, and the "hint of agitation" evident in the face of postmodern choreographer Lucinda Childs. Turning to India, dance scholar Uttara Coorlawala (2010) describes the classical form of Koodiyattam, in which the performer, with an elaborately decorated face, sits and narrates through expressive hand and eye gestures. Recounting a performance of *Ramayana*, Coorlawala (2010, 126) notes how "the eyelids would quiver in synchrony with the percussive rhythms of the accompanying orchestra," and "at different times the eyebrows and lips also 'danced' in this rhythmic way."

In the area of popular dance, several scholars observe how the face works almost excessively to portray ideas about the dance and the people engaged

in its performance: in female striptease, dancers pout, purse, and lick the lips as part of their seductive repertoire (Liepe-Levinson 2002); in competition tango, a serene countenance or clenched jaw reveals the physical and emotional sensations of this intimate partner dance (McMains 2019); and in studio dance competitions, young participants enact melodramatic facial expressions (Guarino 2014). It appears that the face in popular dance performance creates a visual spectacle above and beyond modes of expression typically employed in habitual life. I see this in a range of popular dancing faces: the saucy glances, knowing winks, and looks of outrage that I witnessed on the neo-burlesque stage (Dodds 2011, 2014); the perpetually clenched smiles of the young competition dancers who feature on the reality television show *Dance Moms*; and the agitated frowning, biting and snarling actions that characterize the music video performances of Michael Jackson at the height of his career.[2]

Yet despite this acknowledgment that the face offers an important contribution to dance performance, the dancing face has not been fully examined within the field of dance studies. This oversight seems odd given that within a Western paradigm at least, the face occupies such social and physiological significance in everyday life (Coates 2012; Perrett 2010). We look to the face as a unique identifier that differentiates one person from another, and we read facial expression to comprehend what and how people feel. In this book I pursue the pressing research questions of what the face does in dance and what it might mean. I start from the position that a "dancing face" forms a vital component of dance performance, and it can be set in motion or fixed in stillness according to different traditions. I focus specifically on the face within popular dance performance as it permits the face to be one of excess, spectacle, and exaggeration, as well as disclosure or deception. Indeed, popular dance often calls upon facial expressions and actions that are commonplace in quotidian life, such as a smile, frown, or glance, but then remain stuck upon the face, overstated through a corporeal hyperbole, or presented in such rapid succession that they are rendered peculiar to or outside the norms of everyday social interaction. As different facial modalities are aligned with specific dance genres and styles, the dancing face is not simply random or erratic, but is purposeful, rehearsed, and choreographic. The design of the dancing face is intentional and practiced across diverse movement idioms, thus it conveys ideas, values, and meanings embedded within the social and aesthetic fabric to which it belongs. Furthermore, if the face can reveal meanings, it can also comment upon and resist them depending

upon its compositional attitude. This is where my fascination lies: facial choreography that can provoke and critique.

To explore the organization of the face across various popular dance forms and to mine its interpretive possibilities, in this introduction I set out my preliminary thinking about the face, before moving on to outline the focus and scope of the research. I have titled the introduction "About Face" as an intentional double play: I both consider what various disciplines can tell us "about the face" and I take the idiomatic expression "about-face" to position some of my ideas in opposition to prior assumptions. In the first section, I turn to performance scholarship, examining the face across various art practices, and then speculating as to why the face has failed to receive serious scholarly attention within dance studies. Here I assert that although some dance forms foster a relatively disengaged face, others positively call attention to the visage, and therefore provide a rich area of insight. It is this latter group that forms the focus of this study. The absence of existing scholarship on the face in dance studies leads me to develop an interdisciplinary methodology, predominantly rooted in cultural theory, which supports my attention to dancing faces situated within the domain of popular cultural production. In the second section, I explore the prominence of the face in daily life, and the breadth of scholarship that addresses its expressions, representations, functions, sensations, and interactions. I identify five critical strands across this literature that offer frameworks through which to analyze the face, yet I also note the limitations of many of these approaches and where I hope to make interventions in response. In the final section, I return to the subject of popular dance performance where I emphasize the complexity of the choreographic as purposefully devised movement to suggest that the dancing face can stage a mode of critical work that the face in everyday life has less opportunity to exploit. Here, I introduce the three case studies for my facial analysis: global celebrity Michael Jackson, the dancing child star Maddie Ziegler, and my local community of hip hop dancers.

The Face in Performance

In much the same way that dance employs a range of facial compositions and attitudes according to the codes and conventions of diverse aesthetic paradigms, the expressivity and behavior of the face also adapts to specific theatrical and musical traditions (Auslander 2006; Schechner 1988). For

instance, in some dramatic forms, such as Japanese Noh theater, Greek theater, and the Italian Commedia dell'arte, the quotidian face is masked or disguised, allowing the performer to express emotions through the body or take on other identities. Within the Euro-American realist or naturalist theater tradition, the actor's face forms a dramatic rendering of the character's interior psyche.[3] And in the Western music idiom, performance scholar Phillip Auslander (2006) compares the facial contortions of opera singer Luciano Pavarotti and the facial attitudes of heavy rock guitarists to show how they are less a direct expression of individual personality, and instead are idealized performance values shaped by the artist, audience, and aesthetic genre.

In particular, the face on screen has attracted significant scholarly interest. As film scholar Noa Steimatsky (2017, 1) observes, "the human face is already, itself, a moving image," and the screen media can radically transform how faces are seen and thereby understood. Steimatsky (2017) conceives the cinematic face as a *dispositif*, in the sense that it reveals a specific disposition constituted through the filmic apparatus, modes of seeing, its performance attitude, and modalities of understanding. Consequently, the face is not simply a framed object but a "critical lens" that embodies a theoretical point of view (Steimatsky 2017, 3). While I examine both live faces and screen faces within this book, I show how the choreographic possibilities of the face in popular performance can also adopt a critical attitude toward the very countenance it occupies and resist the social and aesthetic boundaries that seek to delimit its potential.

In reference to the cinematic image, several scholars have examined the relationship between the close-up shot and the face. Steimatsky (2017) asserts that the face was discovered anew through the birth of cinema, and film writer Béla Balázs made the historical observation that the magnified facial close-up on the film screen created new forms of perception (Davis 2004). Dance scholar Erin Brannigan describes close-up movement of the face as "*decentralized micro-choreographies*" (2011, 44, emphasis in original), which returns to Professor Lock's idea that the mobility of the face can be viewed as a dance in and of itself. Indeed, several screen choreographies exist that consist entirely of a facial dance, and I examine one such example (the pop music video for "Big Girls Cry" featuring Maddie Ziegler) later in the book.[4] That said, as I will shortly argue, the analysis of the face needs to be considered in relationship to the entire dancing body.

To return to the cinematic screen, another conception of the face views it in terms of a mask. Although an idea already exists that the face itself masks an interior self, the film screen behaves as a celluloid mask, producing a spatio-temporal distance between actors' faces and cinema spectators (Coates 2012). In his essay "Garbo's Face," literary scholar Roland Barthes (1973, 62) captures this disjunction between presence and absence in his analysis of film star Greta Garbo: on the one hand, he conceives her face on screen as an "absolute state of the flesh" in recognition of its mortal corporeality, but on the other as a divine and ephemeral "archetype of the human face" that cannot be accessed.

Whereas the cinema screen produces distance between performer and spectator, the television screen engenders proximity. Unlike the remote celebrity of film stars, the talking head of the television screen represents a quotidian and mundane image, with its glut of familiar faces that are scripted through the narratives of the small screen (Davis 2004). Communications scholar Paul Frosh (2009, 92) suggests that the headshot represents the most common image on television: the direct address between the presenter and home viewer produces an intimacy that "helps train us in the subliminal art of face-reading." Although the devices spectators use to engage with screens have extended beyond movie theaters and domestic television sets to personal computers, tablets, and smart phones, the face continues to occupy a central position across these platforms as the close-up image captures both its affective capacity as an expressive medium and its communicational function as a site of speech.

Given the degree to which the face operates across dance, theater, music, and screen performances, I am mindful of the limited attention awarded to the face within the field of dance studies. I therefore turn to dance scholarship and criticism to examine how it has dealt with the face in performance. I do not aim to provide a comprehensive cross-cultural history of the dancing face, but rather to show how the face has been perceived by specialist dance commentators.

The origins of ballet in the Renaissance court dancing of Europe lay important historical grounding regarding social values relating to the head and face, which can be traced through to the bodily aesthetics of ballet. Historian Georges Vigarello (1989) describes how the courtly nobility of the sixteenth century privileged a straight back and upright head as an indicator of morality and civility, and the body could be trained to achieve this desired vertical

posture through the noble activities of fencing, riding, and dancing. The values of an erect head and vertical plane formed the aesthetic foundations of Renaissance court dancing (Foster 1986), and an externalized presentation of an upright body that "faces" and rotates out toward the spectator continued with the development of ballet (Rameau 1728; Stokes 1983; Volinsky 1983). Notably, the face played an important role in this evolution. Although the detail of its composition and intention is not fully fleshed out, French dancer and ballet master Jean-Georges Noverre espoused the expressive character of the face in eighteenth-century ballet-pantomime (Nye 2009), and Italian ballet teacher and author Carlo Blassis (1888, 531) emphasized the importance of the face in nineteenth-century technique manuals: "All our gestures are purely automatal, and signify nothing if the face is dumb in expression." The idea that the face invites opportunity for dancers to express complex ideas and emotions in ballet continues with twentieth-century performance. Perron (2002, 6) exemplifies this in her nuanced analysis of ballet dancers as she speaks of "wide-eyed" Angel Corella, who "looks pumped"; Damian Woetzel, who displays a "sly poker face"; and Darci Kistler with "lips parted as though ready to swoon for the sheer love of dancing."

Yet this emphasis on facial expressivity recedes with the advent of twentieth-century modern dance. The external and erect presentation of the head and face that characterized ballet was firmly challenged through modern dance and its critique of the hierarchical organization of the body. Ballet advocate Lincoln Kirstein describes how modern dance responded to gravitational pull over the aerial ideal, and that its focus dwells "on and in central somatic areas of the body, rather than extension of peripheries" (1983, 240). Thus the head and face carried less import than the entire body, which became a universal expression of ideas that interested the innovators of modern dance. I also note here the impact of nineteenth-century French acting coach François Delsarte on early modern dance. Delsarte's codified system drew a correlation between certain psychological traits and emotional states in relation to specific facial expressions and bodily gestures, thus projecting that each movement signified a particular meaning (Ruyter 1996). American Delsartism, which was developed by early modern dancer Genevieve Stebbins and attracted the interest of other pioneers such as Isadora Duncan, Ruth St. Denis, and Ted Shawn, not only demonstrates a connection between acting and dance, but also supports the universalism that characterized twentieth-century modernism (Ruyter 1996). In reference to Stebbins, literature scholar Carrie J. Preston (2011) explains that the idea

of a facial expression depicting an individual self was replaced by the mask-like quality of a universal type. Along similar lines, Perron (2002, 6) details the desire of modern dance choreographer Martha Graham to universalize human experience: "Graham's artistic aim was the stylization of human emotion. Her face, with angles and planes framing her all-knowing eyes, seemed to embody modernism."

Whereas modern dance centers on universal modes of representation, attention to the face as an expressive individual entity disappears even more with the development of postmodern dance in the 1960s, and its critique of authorship. In considering the work of dance artist Trisha Brown, dance scholar Jeroen Fabius (2015) explains that postmodern dance assumed a calm and neutral demeanor, therefore the facial gaze and orientation were considered impersonal or dehumanized; and in reference to Yvonne Rainer's seminal postmodern dance *Trio A*, dance scholar Sally Banes (1987, 64) describes how a sense of the personal recedes into a "withdrawn face." Thus dance scholars and critics perceive a major shift from the expressive face developed in eighteenth- and nineteenth-century ballet to the so-called neutral or disengaged face of postmodern dance. I would question these generic expressions to some extent, as I suspect that individual performances of specific works demonstrate far greater diversity of facial expression than perhaps suggested. Nevertheless, these periodizing and generic understandings of the face go some way to explaining why the face has been largely ignored in dance studies. The initial development of the field was dominated by Euro-American scholarship (Giersdorf 2009), and its teaching and research centered on the canon of modern and postmodern dance (Franko 2014). Consequently, as its focus was directed to the integrated body-self as the epitome of style, scholars showed little concern over a face that refused to draw attention to itself. It is here, however, that I intervene with an about-face maneuver. While some scholars argue that the face disappears into a full-bodied expressiveness within the field of "contemporary dance" (Brannigan 2011; Davies 2007; Lepecki 2007), this position overlooks the deployment of the face in other dance genres, which fully engage with the performer's countenance and mine its choreographic potential.

Indian classical dance offers a rich case study, in which dancers are schooled in elaborate facial movements that express specific aesthetic meanings (Bharata-Muni [1951] 1967; Bose 1970). The term *rasa* describes the aesthetic moods or emotional states expressed through facial and gestural actions, and these comprise the *abhinaya* or storytelling component

of the dance (Chatterjee and Ling 2012; Devi [1972] 1990). Indeed, facial features are considered minor limbs, known as *upāngas*, and gestures of the face are named *mukhaja* (Vatsyayan 1967). Various glossaries and training manuals provide detailed instructions regarding the direction or positioning of the head, neck, eyes, eyebrows, nose, mouth, lips, teeth, tongue, and chin to convey specific characterization and emotion (Bharata-Muni [1951] 1967; Bose 1970). The eyes express the eight *rasa*, and in a technique such as Kathakali, dancers train over many years to perform the *Nritta Drishti* or "dance of the eyes."[5] In her study of Kathak, dance scholar Pallabi Chakravorty (2008) notes that unlike the objectifying Western gaze, which assumes a distance between the observer and observed, in Kathak dance, seeing embraces gazing, knowing, *and* touching, such that it creates an awakening of *rasa* within the spectator. Hence the visual produces a reciprocal sense of touch between dancer and observer. Although facial expression was already important to the classical Indian forms, dance scholar Janet O'Shea (2007) notes that bharata natyam dancers moved from a naturalistic to theatrical style of expression in the twentieth century as the dance entered proscenium-style concert venues. These large-scale theaters meant that dancers "amplified the facial expressions of the abhinaya... with the aim of rendering the expressions legible" (O'Shea 2007, 27). Evidently, ways of performing and conceiving the face are culturally and historically variable, an idea that I return to throughout the book.

In directing attention to the face, I similarly note the ubiquity of mask performances that appear widely across the African continent (Belting 2017; Glass 2007; Welsh 2004).[6] In some instances the face is painted and in others the face is covered with an actual mask, but in both cases the facial disguise serves to conceal the identity of the performer (Okafor 1991; Welsh 2004).[7] When a performer puts on a mask, they undergo a process of transformation as it awards them with supernatural qualities that summon a spirit or deity, and their movement reflects the specific character of the mask (Glass 2007; Okafor 1991). For instance, the West African Yoruba mask tradition of Gelede presents an aesthetic ritual that pays respect to women in anticipation that the entire community might benefit from their power.[8] Although the masquerade is performed entirely by men, the costumes, masks, and movement can be female, and the dance component brings *ase*, a vital power or life force, into being (Drewal and Drewal 1983). Ideas of masking extend to dances of the African diaspora, and dance scholar Thomas DeFrantz applies this idea to describe the "aesthetic of the cool" exhibited in hip hop dance.[9]

Drawing on a heritage of African aesthetics, he delineates how a cool and composed countenance, which he refers to as an "inscrutable facial mask," redirects attention to the heat, energy, and vitality of the body in motion (DeFrantz 2004, 72).

Although the Indian classical forms and African masking are two obvious examples of dance practices that explicitly call attention to the face, I also think of the distinctive countenance in the Japanese form of Butoh and in the Haka dances of the Māori people of New Zealand. It strikes me as ironic that within Western culture the face emanates such value and power, yet within the idioms of Euro-American modern and postmodern dance, its expressive capacity has almost disappeared. This embodied tactic perhaps serves to distance the face of Western concert dance from the overt signaling of the face within non-Western genres, such as the examples I describe above. It indicates an exercise in whitening in which the universal visage of modern dance and the withdrawn face of postmodern dance project a racial separation from "Other" dance styles that consciously work with the face.[10] This racialization of the face might then explain why dance studies scholarship has been slow to examine the dancing face as its own colonialist investments placed white European forms at the center of its teaching and research (Dodds 2019a).

The same strategic distancing occurs in relation to popular dance. As I discuss earlier in the introduction, the face in popular dance tends to explore a broad expressive capacity and, not surprisingly, it frequently originates from communities of color and has historically been positioned as low culture in relation to the high of Western concert dance (Dodds 2011). Yet although these categories of high versus popular culture, or Western versus non-Western dance are operational terms, I do not intend to further reify them though my study of the face. The facial expressions that I examine in this book might appear across many dance genres as well as in everyday life. My interest here, however, is how they are deployed in each instance and to what effect. That I focus on an area termed "popular dance" reflects both my personal interests and research expertise. Thus, as I continue to apply this term, I try to resist locking certain expressions into specific dance idioms. I hope that the ways in which I speak about the dancing face might provide templates for examining the dancing face across other genres and styles. Indeed, some of my discussion centers on how habitual faces intersect with and depart from dancing faces that feature in an area I conceive as "popular presentational dance" through intentional choreographic strategies.

While dancing in social contexts for recreational purposes might typically engage faces more akin to those of everyday life, in popular dance that emphasizes a presentational component, the face works to its full potential across a spectrum of expressions. Here I refer to popular dance performances, situated on stage and screen or in vernacular contexts, that assume the presence of a spectator, whether that constitutes a separate audience or fellow dancers who watch. For instance, vernacular dance competitions, pop music videos, Broadway musicals, Las Vegas dance spectacles, cruise ship entertainment, hip hop battles, and reality television shows spring to mind as popular performance sites in which the face might exceed the kinds of expressions that characterize life in the common public sphere. Indeed, in comparison to the relatively still and understated facial expressions that have typified modern and postmodern dance, the face becomes positively hyperbolic and hypermobile in presentational popular dance. I therefore look specifically at popular performance to examine the actions, meanings, and sensations of the face, and how it eclipses the norms of the face in everyday life.

Performing the Habitual Face

Composed of bone, muscle, skin, and hair, the face occupies the frontal region of the head, and we come to recognize it through its eyes, brow, mouth, cheeks, ears, nose, and chin. Together, the head and face constitute a specialized area of the body that contains and protects the brain, hailed within Western thinking as the central system of sensory, intellectual, and nervous activity, and they house major organs connected to visual, auditory, gustatory, and olfactory senses (Brophy 1946). The face accommodates twenty-two muscles on either side, which are attached to the skin, and when activated they render an extremely mobile surface (McNeill 1998). Indeed, the facial area seems to contain the very means of our existence as we breathe, consume, and communicate through the face.

Within the hierarchy of the body, the head holds import as a signifier of dominance and leadership. Following the classical thinking of Plato, Western philosophy has aligned the head with nobility and reason (Coates 2012; Magli 1989), hence metaphorical references to the head of the table, the household or the state delineate a position of authority and power. Regarding the face specifically, it engenders the humanist belief in the primacy of a unique self. At face value, we cling to a conception of the face as characteristic

of a singular identity with its own set of signature features (McNeill 1998). Such is the prominence of the face, it has been imagined as an index to the self (Kesner 2007), a surrogate for the entire body (Belting 2017), a mirror to the soul (Davis 2004), or even a conduit to essential character traits (Magli 1989).[11] Yet the face has also been conceived as a stage (Belting 2017) or mask (Steimatsky 2017) to suggest that it performs a social version of the self rather than revealing an unfiltered display of interior thoughts and emotions. Such a perspective highlights the somewhat fuzzy line that exists between the performance of the everyday face and the face in popular dance performance.

In contrast to the face as a reflection of the individual, in other instances it delineates a powerful and immutable icon that stands for a collective body. For instance, meanings become attached to the public visage of state leaders to represent the national face of a people: Adolf Hitler as the evil face of fascism and Donald Trump as the face of an unhinged neoliberalism. Equally terrifying are the crude facial signifiers employed to index, misread, and discriminate against a broad body of people in service of a narrow political agenda. Across several Republican administrations in the United States, for example, one only has to think of the hoop earrings and gaudy make-up of the "Black welfare queen," the dark skin and bearded face that stands in for the "Jihadi militant," and the sweaty countenance and black moustache of the "bad hombre," to see how facial tropes support a social and political discourse that targets some of the most vulnerable people in the nation as a threat to American sovereignty.[12]

Irrespective of whether faces come to represent individual or collective bodies, within Western society the face is constantly put on display. Belting (2017, 29) refers to a "facial society" to describe the excessive commodification of the face through the media, advertising, and politics, which do not showcase an idiosyncratic "natural face" but a generic "blank facial formula." This cultural saturation of the face has been further heightened with the development of the smart phone and its facility for "selfie" portraits. Selfies quickly dominated the social media networks, such as the apt-named Facebook, that gained rapid popularity in the early twenty-first century. Yet the import of the face extends beyond its excessive representation into an entire arena of labor described as "facework" (Domenici and Littlejohn 2006). Facework concerns the effective communication practices required to "build, maintain, protect, or threaten personal dignity, honor, and respect" that people deploy across their personal relationships and professional interactions (Domenici and Littlejohn 2006, 7).

Given the primacy and presence of the face across the public and private sphere, its familiarity suggests that it cannot be taken for granted. We barely think twice about the faces that surround us. Yet in another about-face turn, I argue that the face must be taken seriously and interrogated to understand the work it performs in the world. As indicated above, the face carries social values that invariably shape human interactions, hence my desire to know how faces act and are acted upon. Faces carry potent social meanings, and through thinking about the face in everyday life, it offers potential frameworks for examining the face in popular dance. I therefore look to a body of scholarship on the face, across the natural sciences, psychology, sociology, anthropology, philosophy, disability studies, Black studies, and feminist, postcolonial and queer theory, and Black studies theory to delineate five perspectives that each conveys the face through a specific intellectual lens. Notably, some of this literature expands beyond the face to include studies of emotion and affect. I take this necessary detour not only because of the critical debates that center on how faces express emotion or carry affective resonances, but also because the popular dancing face often stages heightened emotional qualities or provides intensely affective encounters. In conducting this literature review, although I continue to reference the five faces through the book, my intention is not to employ them as a systematic theoretical framework; rather, I show how they have shaped different understandings of the quotidian face in ways that might support or undermine my study of the dancing face.

I describe the first visage as a *physiological face*, which is rooted in the work of natural scientist Charles Darwin, who published his seminal study, *The Expression of the Emotions in Man and Animals*, in 1872.[13] His work encompasses cross-cultural research on emotional expression in mammals, from which he asserts that facial responses are biologically determined and universal, but that they evolve as nerve pathways to habitualize certain movements (Mair 1975).[14] Although Darwin's work reveals methodological limitations and social biases, the impact of his thinking should not be underestimated as the idea of universal facial expressions, which reflect innate emotional states, has impacted more recent research.[15] A major line of influence can be found in the work of psychologist Paul Ekman and his associated team of researchers who have published extensively on the face since the early 1970s (Ekman 1980, 2006, [1972] 2013; Ekman and Friesen [1975] 2003; Ekman, Friesen, and Ellsworth 1972; Ekman and Rosenberg 1997). Ekman (1998a) claims that humans share six common emotions (anger,

disgust, sadness, happiness, fear, and surprise), which can be read directly through facial expression.[16]

Despite his extensive output, Ekman's research has been met with critique.[17] It assumes a "basic emotions paradigm" in which emotions are crudely conceived as hard-wired reflexes and the face as an authentic measure of these interior states (Leys 2011, 439). His list of six universal expressions fails to account for additional emotions, such as love or jealousy, and the Euro-American terminology used does not necessarily translate cross-culturally, nor recognize emotions unknown to the English-language lexicon (Neu 1987). Furthermore, multiple scholars have insisted that reading faces as isolated expressions fails to acknowledge the many ways in which they can be perceived and interpreted according to the specific contexts in which they occur (Daly 1988; Mair 1975; Niedenthal et al. 2010).[18]

Although situated as a separate strand of research from facial expression, the concept of affect bears close proximity to ideas of feeling and emotion and can work through the composition of the face. Within the field of psychology, feelings are defined as subjective and interior psychophysiological sensations within the realm of the natural; and, contrary to the Darwinian position, emotions are visible and identifiable feelings that are learned behaviors (Besnier 1990; Lutz 1986). Affect then describes the intensities or sensations that emerge through encounters between bodies, objects, and practices (De Laet 2017; Seigworth and Gregg 2010). Although affect theory covers a range of scholarship, one strand conveys it in terms of innate physiological drives (Seigworth and Gregg 2010). Following Darwin and Ekman, psychologist Sylvan Tomkins conceives affect in close relation to the concept of feeling: muscular and glandular reactions that emerge through the face and are dispersed through the body, and then sensed as socially appropriate or otherwise (Lutz 1985, 1986).[19] Yet unlike feeling, which is personal or biographical, affects are posited as nonconscious, prelinguistic, and trans-subjective states (Leys 2011). Social psychologist Margaret Wetherell (2015) comments on how affect theory overlooks a socially constituted dimension of affective experience, arguing that humans are sentient subjects steeped in reflexive social practices that place them in dialogue with others about their world experience.[20]

Overall, universalist, naturalist, and physiological conceptions of the face have overlooked, or at least underestimated, the role of the social in its expressive capacity. As a point of departure from this work, I move on to the second strand of literature, which I conceive in terms of a *sociocultural*

face. This area of research is largely indebted to the work of sociologists and anthropologists who are attentive to the role of the social in the organization of facial expression. In 1959, sociologist Erving Goffman published his seminal study *The Presentation of Self in Everyday Life*, which focuses on the "face-to-face interaction" that takes place between individuals, which he conceives as "performances." Using this theatrical metaphor, Goffman describes how we might "lose face" (1959, 62) when we fail to provide an authentic presentation of the self, or how we allow our "expressive mask" (1959, 121) to drop when out of public view.

Scholars from anthropology have likewise offered important insight into the role of the social in facial expression. In a direct challenge to Darwinian thinking, the social constructionist school of thought examines emotions as learned responses that are context specific (Neu 1987).[21] Scholars working from this position are critical of the way that the biological perspective places emotion within a dualistic value system, in which cognition and reason are placed in opposition to passion and irrationality: this dangerously absolves a person of responsibility regarding so-called emotional acts (Besnier 1990; Lutz and White 1986). Furthermore, anthropologist Catherine Lutz (1986) cautions that the Euro-American conception of emotion constructs normative power relations in which women, children, and racial Others are perceived as natural, chaotic, and impulsive, in contrast to rational white, male thought.[22] Notably, several anthropologists have identified significant cross-cultural variance in emotional expression, both in terms of how they are conceived and articulated (Besnier 1990; Lutz 1985; Myers 1988).[23] Anthropologist Ray Birdwhistell's work also deserves consideration, specifically his 1970 text, *Kinesics and Context: Essays on Body Motion Communication*. Birdwhistell developed the concept of "kinesics" to examine how kinemes, discrete units of movement, express culturally specific meanings, including the action of the smile and the nod of the head.[24] While I welcome his attention to the cross-cultural specificity of facial expression, his interest in units and structures of meaning privilege isolated expressions (Daly 1988), and his focus on the minutiae of anatomical organization loses the larger sense of bodily action (Farnell 1999).[25]

Although the field of philosophy has awarded the face surprisingly little attention, the following two conceptions of the face come directly from philosophical texts. The third approach I consider derives from Emmanuel Levinas, which I term an *ethical face*. A face-to-face encounter forms the central tenet of Levinas's thinking in his book *Totality and Infinity: An Essay on*

Exteriority ([1961] 1969), in which he argues that subjectivity is dependent on knowing something exterior to the totality of the self. For Levinas, totality can only be surpassed through a phenomenological encounter with an "other" that opens up a world of infinity through all that is exterior to us.[26] He describes how this confrontation with the face of an other disturbs the sense of self: it dismantles the totalizing position of the ego through being "faced" with another world view. The encounter is therefore an ethical one as the subject must take the "not I" into account. Yet rather than conceiving this as a hostile encounter, Levinas [1961] 1969, 197) describes a "welcome of the face" as a position of generosity as the subject becomes open to infinity and learning.[27] Although Levinas provides some provocative thinking about the face and social interaction, his conception of the face-to-face encounter falls into a universalist perspective.

The fourth conception of a face that I examine, which I describe as a *semiotic face*, emerges partly in response to Levinas. Here I look to the work of philosopher Gilles Deleuze and psychoanalyst Félix Guattari whose chapter "Year Zero: Faciality" features in their coauthored book *A Thousand Plateaus: Capitalism and Schizophrenia* (1987).[28] In thinking about the face, Deleuze and Guattari stage a poststructuralist intervention against the humanist subject (Davis 2004; Loh 2009). They conceive the face as a semiotic system that consists of a white wall of *significance*, marked by signs and their omissions, and a black hole of subjectification, which suggests a consciousness or passion that can never be accessed: "A broad face with white cheeks, a chalk face with eyes cut in for a black hole... The face is not an envelope exterior to the person who speaks, thinks or feels" (Deleuze and Guattari 1987, 167). Hence the face does not represent an individual self, but a delimited zone that only enables expressions that conform to prescribed signification. For Deleuze and Guattari (1987, 168), the face is rendered meaningful through an "*abstract machine of faciality (visagéité),*" which offers multiple permutations of expression. The abstract machine concerns semiotic systems already in place (Rushton 2002), therefore the face is coded according to social systems of knowledge and power (Loh 2009).

The social logic of the abstract machine is semiotically coded in accordance with a Western epistemology. Deleuze and Guattari (1987, 176) conceive the face as gendered and racialized in its semiotic legibility as that of a "White man."[29] They assert that faciality rejects faces that do not conform and operate normatively in relation to a binary of acceptable and deviant faces. Thus faciality is despotic and imperialist, a machine that disciplines the body

in ways that do not facilitate difference or polyvocality. Theology scholar Gavin Wittje (2015) avers that Deleuze and Guattari's concept of faciality offers a critique of Levinas in terms of the latter's failure to directly confront the social politics of the face. Yet unlike Levinas, Deleuze and Guattari do not consider the face within specific face-to-face encounters, which philosophy scholar Warwick Mules (2010) describes as precritical in that there is no moment in which the self becomes aware. Similarly, cultural theorist Therese Davis (2004, 30) gestures to the absence of any agency in what she perceives as the two-faced operation of faciality: although it functions like a face, with the individuality this presupposes, in actuality the body constitutes an "undifferentiated mass that gets worked on by the cultural/social machine of faciality."

The final strand of literature I consider speaks to an *identifiable face*. I use this term not to suggest that stable identity markers of race, gender, sexuality, dis/ability, and age are legible through the face, but to indicate how the face is nevertheless indexed to social constructions of identity that assume a recognizable face, which can also be open to interpretation and misreading. To an extent, this can be placed in conversation with the work of Deleuze and Guattari (1987), who semiotically furnish the face through codes that delimit it as normative or deviant. In terms of the racialization of the face, I briefly note psychiatrist Frantz Fanon, whose book *Black Skins, White Masks* ([1952] 2008) offers a groundbreaking critique of mid-twentieth century racism. As I am mindful of American studies scholar Nicole Fleetwood's (2011) caution over the oft-cited iteration of the Fanonian moment, suffice it to say that Fanon's attention to an "epidermal racial schema" ([1952] 2008, 92) indicates how the face is racialized according to a hierarchy of Black and white.[30] For the purposes of this book, I draw heavily on the field of Black studies to consider how ideals of whiteness fail to make purchase on faces of color and how Black aesthetics and sensibilities provide alternative epistemologies for knowing, reading, and embodying facial expression and sensation (Brown 2008; Carpenter 2014; DeFrantz 2004; Dixon Gottschild 2003; Fleetwood 2011; hooks 2015; Moten 2003; Pough et al. 2007).

The work of feminist and postcolonial scholar Sara Ahmed also offers an important framework for addressing how the face articulates identity, as well as bridging the relationship between emotion and affect. In *The Cultural Politics of Emotion* (2015), which was first published in 2004, Ahmed explores how emotions shape and produce relations of power between certain bodies.[31] She conceives emotions as socially constituted discourses and

analyzes a range of texts about women, racial minorities, and queer bodies to analyze how emotions are invoked and put into circulation.[32] Ahmed demonstrates how emotions, such as hate, fear, disgust, and love, occur through contact with objects and people and make "impressions" on us, and become sticky with affect.[33] Although Ahmed ([2004] 2015) is not concerned with the face specifically, I appreciate her consideration of the political and affective work of emotions, as she details how they can fix us relationally to forms of subordination, such as the family, heterosexuality, and nation.[34] In her later book, *The Promise of Happiness* (2010), the face receives considerably more attention in her analysis of the affective work of happiness in relation to tropes such as the feminist killjoy, the angry Black woman, and the melancholy migrant.

In addition to scholarship on race and gender, queer theory and disability studies offer robust perspectives to think about the face. Although not always addressing the face directly, their critiques of normativity help to reveal how the face works ideologically to support heteropatriarchal, capitalist, and ableist power structures. Dance and American studies scholar Clare Croft (2017, 2) argues that "queer *does* (rather than *is*)" to show how queerness works as a form of activism and therefore "queer dance" offers a critical space to imagine other ways of being. Along similar lines, English scholar Tobin Siebers (2013) asserts that able-bodiedness sets norms, yet in doing so creates exclusionary positions that occupy a site of privileged epistemological critique. He uses the concept of "complex embodiment" to explain how disability then provides theoretical knowledge that exposes the organizational structures of an ableist society. Returning to the face specifically, neuroscientist Jonathan Cole (1998) highlights the value placed on an animated face as conditions that affect or restrict facial movement, such as Parkinson's disease, Bell's palsy, or Moebius syndrome, appear to render the individual less of a person.

As I have demonstrated, the expressions and interactions of the face in everyday life bears the weight of a considerable body of scholarship, and this informs how I think about the face in popular dance. As a cultural theorist, I do not subscribe to the idea of a *physiological face* rooted in biological essentialism, although I will come to show how such ideas continue to inform popular understandings of the dancing face. Instead I am invested in the work of a *sociocultural face* shaped by its environment. Therefore I remain committed to the idea that the face and its interactions can only be understood within its discrete social contexts, and that the degree to which the

subject can mask, perform, or control its expressions is potentially variable. In terms of philosophical perspectives, both the *ethical* and *semiotic face* offer some assistance in my examination of the dancing face. Levinas's attention to the encounter between faces makes sense for popular presentational dance as it is conceived with co-participation or spectator and performer in mind; and Deleuze and Guattari encourage me to look at how the face signifies according to social structures and norms, and therefore consider how the dancing face arrives on stage or in a club already socialized and saturated with existing social meanings. The *identifiable face* then enables me to think about how identity constructions are read through the look and expression of a face.

The Work of Facial Choreography

The beginning of the introduction asserts that the composition of the face in dance is neither random nor coincidental, but that it observes the conventions of specific dance styles and genres. This leads to the concept of a "dancing face." Yet given that the face in everyday life also "performs" through its public presentation and communicative facework (Belting 2017; Domenici and Littlejohn 2006; Goffman 1959), how do the expressions and actions of the face in popular dance performance work differently, if at all? Indeed, I have already noted that the face in popular dance deploys some of the same expressions that occupy habitual life. The facial compositions discussed in the book are commonplace and, as isolated expressions, are relatively easy to reproduce. That said, I argue for a discernible distinction between the performance of the everyday face and the face in popular dance performance, which lies in the notion of the choreographic. As a culturally defined space in which bodies are not required to behave according to the rules of everyday life, the face in popular dance performance can exceed the expressions of a habitual face. Coupled with a dancing body, the face stands out. In all my case study examples, the dancing countenance is composed, manipulated, and deployed in ways that transgress social norms. As the book will reveal, the face in popular presentational dance performs a mode of excess: it is hyperbolic and hypermobile, and even when holding a fixed expression it works its musculature almost to a point of exhaustion. Consequently, I conceive the practiced, intentional, and somewhat experimental design of the dancing face as "facial choreography." In this way, the popular dancing

face is distinctive. I appreciate, however, that the concept of "choreography" carries some complicated baggage.

The term "choreography" was invented by Raoul Auguste Feuillet in early eighteenth-century France to describe "the writing down of dances," and he developed a notation system to ensure a vocabulary of dance movements could be translated to the page (Foster 2005, 87). While a parallel can be drawn between this conception of choreography and the intricate facial choreography of classical Indian dance explicated in treatises and manuals (Bharata-Muni [1951] 1967), no such written score exists for the facial compositions examined in this book. This understanding of choreographic writing overlooks oral methods of transmitting the "values, aesthetics, and actual movement traditions" of dance (Jackson 2001–2002, 44). Notably, the passing on of dance through oral means characterizes Africanist dance practices, and I have already highlighted how popular dance owes much of its repertoire to Black vernacular traditions, which are typically improvisational forms rather than set compositions. The term "choreography" has evolved as a Europeanist concept that describes the theatrical dance-making processes of singular artists (Kraut 2015), which then places value on a white compositional tradition. Consequently, popular dance scholars have critiqued this ethnocentric model. Naomi Bragin (2014) conceives the privileging of concert dance creation as a form of "choreocentricity," which mistakenly assumes community-created dance practices or those that deploy improvisation methods, both of which pertain to popular social dance, demonstrate a lack of training, structure, and organization. Jonathan David Jackson (2001–2002, 44) also insists that the improvisational practices of Black vernacular dance are absolutely choreographic as they demand the "creative structuring, or the choreographing, of human movement in the moment of ritual performance."

Despite this troubled understanding of the term "choreography," I retain it as a central epistemological concept to the creation of dance. The notion of "facial choreography" asserts that the dancing face is purposeful, creative, and communicative. Unlike much of the critical literature discussed in the previous section, which bases its analysis on still images of faces (Daly 1988; Mair 1975), the book attends to the visage in motion. Consequently, I am less interested in the face as a snapshot visual signifier, in the sense of an isolated and fixed expression that can be read, than as a choreographic modality, which concerns a polysemous and diachronic face that dances. The dancing face is not only considered as a visual register of meaning, but attention also

turns to the labor and experience of pulling those expressions in recognition of the sensorial capacities of the face. The various chapters show how facial composition is learned both through formal methods of instruction and informal observation of dancing conventions, and how dancers embody and conform to the strictures of particular facial choreographies, but at other times re-choreograph their faces as a critical unworking of what a dancing face might represent. The book therefore historicizes facial expressions and their modifications within genealogies that pertain both to performance traditions and social conventions. In doing so, it highlights specific epistemic breaks that produce codified facial expressions within popular dance traditions which are then maintained or critiqued through the case studies examples. Although these ideas carry across to many of the dancing faces that feature in presentational popular dance, this study centers on three faces of particular note, to allow an in-depth examination of what these faces do and what they might mean: musical entertainer, virtuosic dancer, and global celebrity Michael Jackson, whose face has occupied a site of fervent controversy; dancer Maddie Ziegler, child star of the American reality television series *Dance Moms* and the de facto face of Australian pop star Sia; and a community of hip hop dancers primarily based in the Northeast region of the United States.

I selected these specific faces as they are choreographically rich and collectively deploy a broad expressive range. Yet they also provide a diversity that leads to compelling lines of inquiry. First, these faces range from youth to adult: they include the childhood performances of Ziegler and Jackson; Ziegler's early adolescent performances with Sia; and the faces of Jackson and the hip hop dancers in early to full adulthood. This attention to different life stages poses the questions of how dancing faces learn to compose themselves, how faces mature socially in their expressive capacity, and what kinds of choices can be made as faces grow in age.

Secondly, these dancing faces range from relatively anonymous to internationally renowned. The majority of hip hop dancers in my study are recognized, at most, within their local or regional dance community, but otherwise remain largely unknown.[35] In contrast, the emotive face of Ziegler is familiar to the US television audience that watches *Dance Moms* and it has gained increasing international visibility though her music video and live performance work with Sia, as well as through her social media presence and branding for corporate advertising campaigns. In turn, the superstar status of Michael Jackson ensures he is arguably one of the most famous, yet

contentious, faces on the planet.[36] The relationship between the dancing face and degree of recognition leads me to ask: What are the differences between celebrity faces and anonymous faces, and what are the potentials and limitations of each?

Thirdly, these dancing faces are diverse across lines of gender, sexuality, race, and class, and I ask how these faces both maintain and trouble the borders of identity. The facial articulations and motions produced by these dancers range from improvised expression in accordance with the conventions of each dance style through to set facial composition designed by an external choreographic voice. Therefore I explore what the work of fixed choreography does to produce expressions of identity, and how alternative choreographies or freestyle improvisation re-think or disrupt identity to reveal the political potential of the face.

And finally, these facial choreographies exist across screen representations and live vernacular sites. I focus on the screendance faces of Jackson and Ziegler to examine how they are composed, shot, and edited to become semiotically meaningful representations across the genres of popular music video and reality television. While these screen images exert control over the design of the face, they become fixed in place to be read by different audiences at different times. I then counter this with an ethnographic study of the live faces of hip hop battles to show how dancers can make split-second choices to engineer specific facial expressions according to the demands of the performance moment; yet due to the unpredictability of live dance, they sometimes make errors or lose focus, and succumb to facial expressions outside their physical control.[37]

Bringing the dancing faces of Jackson, Ziegler, and a community of hip hop dancers together allows me to identify common facial expressions that have become tropes within popular presentational dance. Yet in curating this diverse combination, each facial choreography needs to be examined within its specific social, historical, and political performance contexts to understand its meanings and affects. To highlight these points of commonality and distinction, three of the chapters discuss the same facial expression across two different case study examples.

Given the overlap between everyday facial composition and the face in popular dance, the chapters are structured according to commonplace facial expressions: SMILE, LOOK, FROWN, CRY, SCREAM, and LAUGH. I intentionally present these chapter titles in upper-case font to illustrate the performative and hyperbolic character of these expressions within popular

presentational dance. Despite using lay terms to describe facial expression, I show the uncertainty and instability of what they reveal and pay particular attention to their mobility and labor. Indeed, "smile," "look," "frown," "cry," "scream," and "laugh" are not simply fixed expressions. As parts of speech, I conceive these as "action-expressions," verbs rather than nouns: they are doing words, full of motion, actively working even in times of stillness. In claiming this facial labor as an action-expression it signals the choreographic character of the face as an agential and creative entity rather than a passive and reactive conduit. Occasionally, I reference facial musculature to explain movement, but predominantly employ a qualitative and descriptive language unapologetically replete with meaning to reveal my interpretations of the facial choreography I observe.

Beyond describing what the dancing face does, how do I arrive at what the dancing face means? In keeping with cultural, sociological, and anthropological understandings of facial expression, the dancing face requires analysis that is attentive to its holistic contexts of production and reception. For this reason, I resist the temptation for this to be a study from the neck up. Here, dance scholar Brenda Dixon's Gottschild's (2003) seminal critique of the reductive way in which the Black dancing body has been conceived as a set of racialized parts that denies a whole and complex being provides an important caution. That said, I foreground the face as an often overlooked but integral part of dance performance and therefore award it attention as a socially privileged body part that labors to create choreographic meaning. Yet the face cannot be understood in isolation. Rather it needs to be examined in relationship to the entire dancing body and the context in which it dances. Although the face sometimes works expressively in tandem with the body, at other times it seeks to counter or contradict it. The chapters set out to discover what each action-expression does under specific dancing conditions.

The SMILE chapter excavates a genealogy of the smile in performance, from late nineteenth-century minstrelsy and the early twentieth-century chorus line, to show how pedagogies of a racialized and gendered smile persist through the screen performances of Michael Jackson and Maddie Ziegler. The chapter analyzes the construction of Jackson's smile within his early career performances through the racial and racist structures of the popular music industry, which schooled Jackson in the art of polished facial expressions (Malone 1988). It then explores how the dance studio trains Ziegler to smile as a form of service culture (LaFrance 2011), as an ideology of positivity (Ehrenreich 2009), and as an orientation toward objects

of happiness (Ahmed 2010), all of which are tied to the values of competition dance and its ethos of winning. Both cases demonstrate how the popular demands a "glossy and tenacious smile" that labors to fix identities in place, but the capacity of the smile to mask feelings and experiences ensures that it can never be trusted.

The LOOK chapter asserts that the act of looking is not simply a neurological register of sensory perception, but a culturally specific framework of (en)visioning the world. It turns to hip hop dance battles to examine how dancers actively look both to assess an opponent's moves and to engage in a performance of looking that signals their battle attitude. It then narrows its focus to female hip hop dancers of color through the lens of a "superfacial politics" (Cushman 2005, 390) to consider how they are subject to a hegemonic gaze within the battle context. It draws on b-girl Rokafella's call to "Check us out!" in conversation with Black studies and hip hop feminist scholarship (Brown 2008; DeFrantz 2004; Fleetwood 2011; hooks 2015; Johnson 2014; Pough et al. 2007) to show how two b-girls, Sunny and Macca, craft a "defiant look" within the creative space of the cypher. This look stages an embodied refusal to internalize misogynistic and colonialist structures of looking projected upon their bodies and their resistance stands in plain sight.

The FROWN chapter opens with the idea that the frown performs a refusal to smile, and instead signals displeasure or disagreement. With the release of Michael Jackson's second solo album *Thriller* in 1982, he radically re-choreographed his performance expression from a benign smile to a brooding frown. The first part of the chapter analyzes three of his music videos, from *Thriller* and the follow-up album *Bad* (1987), in which he explores screen characters that are marked as streetwise and dangerous. Through Henry Louis Gates Jr.'s (1988) concept of "Signifyin(g)," it argues that Jackson's frown cannot be reduced to a mask of intimidation, but as a choreographic play that calls attention to African American popular music traditions and questions racist social frameworks that seek to position Black masculinity within a primitivist representation. The second part of the chapter examines the use of the frown in hip hop battles, specifically within the style of breaking. Although the frown can be used as a form of aggression, I attend to both its actual and mythologized history to explain how and why b-boys and b-girls invoke and critique the deployment of a frown. Employing ideas of "mean mugging" (Schloss 2009, 85), the inaccurate links between breaking and gang violence (Aprahamian 2019), and the intertextual deployment of a cartoon character in the frowning b-boy persona, the chapter

excavates historical layers of meaning placed upon the frown. The idea of a "provocative frown" asserts that the frown might work choreographically to signal discontent and stimulate aggression, but this sits in tension with its capacity to question and reformulate the histories and values of popular dance practice.

The CRY chapter traces Ziegler's departure from the hyperbolic displays of crying on *Dance Moms* that reproduce the trope of the weepy female to her emotive performance in Sia's music video "Big Girls Cry" (2014). Notorious for refusing to show her face in public, Sia has adopted Ziegler as a surrogate face, and this video takes crying as its subject matter but does not employ this action-expression in a literal sense. Instead, it comprises a single close-up of Ziegler performing an arty facial choreography that both moves and alarms in turn. Young female spectators and various music critics speak of the affective capacity of her performance, and feminist scholarship (Ahmed [2004] 2015; Braidotti 2015; Stras 2010) assists in showing how the facial choreography critiques the expectations placed on girls and women in public life regarding standards of beauty, the reduction of their emotional expression to that of cry-babies, and the expectation that this should be kept in check as adult women. Evidently, Ziegler's performance provokes a deep sense of empathy in its female viewers. Yet this video also produces an ethical discomfort. Literature on celebrity and whiteness (Redmond 2007; York 2018) helps to raise concern over the way that Sia replaces her own face with that of a beautiful celebrity child, which ensures that her economic and racial privilege is maintained. In turn, Ziegler's facial performance allows her to transition from the little girl on *Dance Moms* to a young adolescent mingling in the edgy arena of the adult popular music industry. The idea of a "manipulative cry" shows how this facial choreography produces affective connections between Sia, Ziegler, and their fans, but that it stages a questionable performance of a young girl to ensure that celebrity and whiteness remain supreme.

The SCREAM chapter examines Michael Jackson's 1995 music video titled "Scream." In the lead-up to its release, Jackson's life became the subject of serious public scandal and intense media scrutiny. In 1993, he was accused of sexually molesting a young boy and speculation that his face had been radically altered through cosmetic surgery intensified. "Scream," which was a musical duet with his sibling Janet, staged Jackson's raging response to his treatment by the popular media. Yet the release of the documentary film *Leaving Neverland* in 2019, which centers on further allegations of sexual abuse, prompted me to take pause and "re-face" Jackson with these

revelations in mind. The idea that Jackson is "re-faced" many times over also comes through his changing visage, which was perceived by the news media as a monstrous affront to his natural self. Anthropologist Michael Taussig's (1999) concept of "defacement" provides a lens to examine how the discourse around his face both acknowledges the social construction of race but appeals to a biological heritage to make sense of his facial freakery. To understand Jackson's musical and choreographic scream I turn to the work of Fred Moten (2003), who conceives the scream as an originating trauma in Black subjectivity that is both recited but can also be given a radical breakdown through Black artistic expression. While Jackson's "potent scream" labors to shatter an equilibrium, it bears the question of whether its efficacy can be maintained.

The final chapter, titled LAUGH, explores how the base measure of positivity gauges the extent to which laughter deviates from its premise of a feelgood interpersonal experience (Nikopoulos 2017). It begins with an analysis of two parodic performances of Maddie Ziegler in the Sia music video "Chandelier," the first on the late-night television chat show *Jimmy Kimmel Live!* and the second, a mash-up of *Star Wars* and "Chandelier," on the video-sharing platform YouTube. In both cases, none of the performers laugh; rather they manipulate their faces to draw attention to the "corporeal signature" (Liu 2013) of Ziegler's viral dancing face and generate laughter in their audiences. While the first takes an uncritical stance on the original to pursue the commercial interests of a "convergence culture" (Jenkins 2006), the second offers a radical interpretation of the original which pushes back against the hold of the mainstream media. The chapter then moves on to look at the immediacy of laughter within hip hop battles in which dancers deploy quick improvised responses to deride or laugh with their opponents and produce laughter as they tickle the cypher crowd. Although it begins by discussing a range of hip hop battles, it comes to focus on breaking. While breaking has often been misconstrued as an aggressive dance practice, the chapter shows how b-boys and b-girls laugh in the face of their opponents through a full-bodied corporeal clowning that creates "communities of laughter." In all these examples, irrespective of their intended goals regarding humor, I develop the idea of a "cathartic laugh" as each offers some degree of release.

In bringing the book to a close, the concluding chapter, "Face the Facts," looks at the state-mandated masking of the face through the global COVID-19 pandemic and the implications of this for popular dance. It specifically

addresses the ubiquity of dance on the social media platform TikTok and how the face plays a spectacular role in TikTok performance. Overall, I hope this book reveals the breadth and depth of facial choreography in popular presentational dance. Across a range of popular dance styles, facial choreography engenders opportunity for startling creativity, the articulation of identity, a cathartic expression of feelings and attitudes, and a critical capacity to undercut previously held assumptions. Through its vibrant action-expressions, tensions come into play regarding what the dancing face might appear to represent and what it then does. Its mesmerizing facial choreography tauntingly slips between visual, sensory, and kinetic registers and, as I will come to show, nothing can be taken at face value.

2
SMILE

> A smile is a social act with consequences.
> —LaFrance (2011, p. x)

In 1984, twenty-six-year-old Michael Jackson was at the height of his fame when he entered intense negotiations over a five-million-dollar deal to feature in a Pepsi television commercial (Taraborrelli 2010). The Pepsi executives were keen to showcase his star face, while Jackson insisted the shoot focus on other iconography, such as his signature penny loafers or diamond-encrusted glove.[1] In postproduction, the fraught discussions continued as Jackson was not only unhappy with the length of time that his face was exposed, but also expressed displeasure that he was caught smiling in shot, stating "I never smile when I dance" (Taraborrelli 2010, 293). Although Jackson smiled persistently in his early career performances and the shots remained of him smiling in the final cut of the Pepsi commercial, the release of his critically acclaimed album *Thriller* (1982) two years earlier marks the spectacular demise of his smile.[2] Why was the smile was so troubling for Jackson?

Maddie Ziegler was eight when she first appeared on the reality television show *Dance Moms* (2011) and, even at that young age, she was known for the expressivity of her face. The show revolves around a competition dance studio in which the young dancers are encouraged to pull dramatic and emotive "facials," which often feature an ebullient smile.[3] Ziegler's smile is typically the most brilliant and this maintains itself as she frequently wins first place in solo and team performances. As Gianna Martello, one of the dance instructors, observes, "She's the best role model a teen can ask for—she's such a hard worker, gives 150 percent to everything she does, and always keeps a smile on her face" (cited in Ziegler 2017, 75). What is the purpose of this persistent smile?

Within the realm of popular presentational performance, the spectacle of a celebrity countenance remains etched upon the public imagination.

Specifically, the pleasing insistence of the smile labors to create and maintain an idealized facial image that solicits audience engagement and commercial success. In this chapter, I focus on the facial choreography of the smile through the visage of international superstar Michael Jackson and child celebrity Maddie Ziegler. Notably, both were trained in the art of smiling as child performers, and although Jackson experienced a global fame way beyond the predominantly North American, European, and Australian reach of Ziegler, both have exercised significant control through their celebrity faces and their winning smiles. Before considering each artist in turn, I pause to consider the action of a smile. As psychologist Marianne LaFrance (2011) suggests in the opening quotation to this chapter, the smile functions as a social interaction that shapes relations between people, and therefore occurs far more frequently in public than in private. Yet despite its familiarity, the smile has proved slippery as a subject of inquiry.

To return to the late nineteenth century and the notion of a *physiological face,* Darwin ([1872] 1989) proposed that the smile constitutes a neuromuscular expression of happiness. This understanding of the smile has persisted as psychology scholar Dacher Keltner (2009) describes it as an evolutionary phenomenon designed to produce well-being; it creates feelings of contentment, reduces stress, and its positive energy spreads to others. Yet given that people also smile in adverse situations, the smile cannot be reduced to a positive state of being (Birdwhistell 1970). Notably, a contemporary of Darwin, anatomist G. B. A. Duchenne de Boulogne, examined the smile through applying electrodes to activate the musculature of the face (Keltner 2009; LaFrance 2011). From these experiments Duchenne identified two distinct smiles. The first, described as a spontaneous or genuine smile (also named a Duchenne smile), not only works the zygomaticus major, the muscles which pull up the corners of the mouth, but also engages the orbicularis oculi, the muscles at the corner of the eye; in contrast, the second smile, known as a fake or social smile (a non–Duchenne smile) only uses the zygomaticus major (Keltner 2009; LaFrance 2011). From this comes the popular belief that we only truly smile with our eyes. Furthermore, whereas genuine smiles are said to express positive emotions, fake smiles mask negative ones (Keltner 2009).

Several scholars alert us to the limitations of examining the smile as a neuromuscular response. LaFrance (2011) suggests that there are many types of smiles configured across the tripartite axis of the mouth, cheeks, and eyes, and which are further diversified depending on its intensity and duration.[4] Whereas some smiles are conscious and intentional, others are unconscious

and spontaneous, and despite its frequency and recognition, the smile is an ambiguous expression. Even scholars most closely aligned to evolutionist and universalist beliefs about the smile acknowledge the "display rules" that prescribe how we should manage the face in given social situations (Rosenberg 1997). The idea of a *sociocultural face* would suggest that smiling is a learned and culturally variable behavior (Bielski 2011; Zimmer 2011), and how it is received and interpreted is key to understanding its meaning (Birdwhistell 1970). Dance scholar Ann Daly (1988) suggests that a smile needs to be read in its individual, interactional, institutional, and cultural context, and for those scholars invested in full-bodied explorations of human movement, Birdwhistell (1970) reminds us that the smile is not an abstracted and isolated expression but encompasses the entire body.

I therefore turn to the full-bodied expressions of the smiling face through the performances of Jackson and Ziegler. I examine both as child performers, and Jackson as he moves into young adulthood, to show how they were trained through the pedagogy of a "glossy and tenacious smile." To do so, I trace the history of the smile through popular performance from the mid-nineteenth and early twentieth centuries, specifically the construction of the smile in blackface minstrelsy and in the kickline chorus girl, to show how it has been choreographed into a persistent and enduring action-expression that delimits social and cultural expectations of race, gender, and sexuality.

Michael Jackson and the Pedagogy of a Smile

Michael Jackson was born in 1958 in Gary, Indiana. Under the strict influence of his father, Joseph Jackson, as a young boy Michael and his four older brothers, Jackie, Tito, Jermaine, and Marlon, were ushered into a musical career as a singing and dancing group called the Jackson 5 (Whiteley 2005).[5] They initially played local clubs in Gary, and as they became more accomplished performers, began to tour the "chitlin circuit" (Taraborrelli 2010; Whiteley 2005).[6] Although Motown created the mythology that singer Diana Ross discovered the sibling group, the Jackson 5 successfully auditioned for the record label in July 1968 (Taraborrelli 2010). In October 1969 the Jackson 5 made its television debut, and in December 1969 the group appeared on the long-running popular entertainment program *The Ed Sullivan Show* (Taraborrelli 2010).[7] As part of this iconic performance, the group showcased their hit single "I Want You Back."[8]

Set against a bright backdrop of red and yellow geometric shapes, the Jackson 5 launch into a rousing song and dance routine. In response to the lively instrumental opening, with its jangly guitars and pumping brass section, Marlon, Jackie, and Michael spin in a canon formation, sidestep with angular jazz arms, and fall into an exuberant Charleston step as Tito and Jermaine stand either side playing their guitars, bobbing in rhythm, and falling in line with a few of the steps. Breaking into a dazzling solo spin, topped off with a sharp click of the fingers, Jackson then grooves over to the microphone. Although the image cuts to a long shot in which he is partly obscured by an out-of-focus drum kit, the camera slowly zooms in while Jackson sings the first line. The visual privileging of the eleven-year-old Jackson, dressed in a purple felt hat, electric blue waistcoat, and heavily patterned shirt, emphasizes him as the standout member of the group. This continues with regular close-ups, which introduce the television audience to Jackson's flawless young face and stunning smile that continues to be highlighted throughout the number (see Figure 2.1).

In the first of these close-ups, as Jackson sings, "When I had you to myself, I didn't want you around," a huge smile spreads across his face showing off his white teeth, and his vibrant eyes look out to the audience. The image then cuts to a long shot of the entire group, with Jackson placed slightly in front of his four brothers. As Jackson continues with the verse, the brothers step in time to the music and come in with back-up vocals at the end of the phrase. The image swiftly returns to a close-up of Jackson as he implores, "Oh baby give me one more chance," issuing the same bright smile. The scene then cuts to another long shot of the brothers, who execute a unison sidestep, tapping the working foot twice, and they too echo Jackson's smile as they come in with "To Show You That I love You." The camera returns to Jackson alone and, although he cannot maintain the smile while he enunciates the words "Won't you," as he delivers, "please let me," his engaging smile returns and persists as his brothers sing "back in your heart." Throughout the number, Jackson and his brothers continue to smile and sing and dance as the camera cuts across a range of shots, and even when the lyrics or vocal flourishes prohibit a full smile, the eyes remain joyous, the mouth positive, and the body energized. The collective bodies of the Jackson 5 labor to produce a holistic and enduring smile.

At the end of the number, the five brothers congregate around Ed Sullivan, slightly out of breath, but continue to smile and wave cheerily or blow kisses to the audience. If we are to take it at face value, their smiles ostensibly index

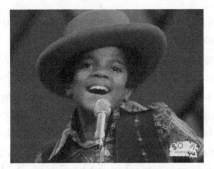

Figure 2.1 Michael Jackson smiling as he sings "I Want You Back" on the Ed Sullivan Show in 1969.

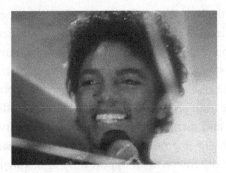

Figure 2.2 Michael Jackson smiling on the music video for "Rock With You" (1979).

the excitement the Jackson 5 experienced as they appeared on live television, the pleasures of performing their lively routine, and their gratitude for the huge round of applause they received. Yet there are several discomforting dimensions to this clip that suggest the smile may not be a genuine indicator of contentment and joy. Certainly, evidence suggests that Jackson experienced an unhappy childhood, as he was physically abused by his father and forced into a relentless work schedule as a child performer; therefore it is difficult to ascertain the conviction of his smile in this instance (Clay 2011; Hamera 2017; Whiteley 2005; Yuan 1996). Although Jackson dutifully motioned his face into a smile, it occasionally appears forced on the eleven-year-old boy. A couple of times during the performance Jackson's eyes glance down awkwardly, and he looks ill at ease as the corners of his mouth drop slightly so that his smile fades in and out. While I will show how his smile

became more polished in later screen performances, at this young age he was still learning how to enact the façade of a genuine smile. And in an uncomfortable scene toward the end of the clip, Sullivan, as the white male authority figure, instructs the boys to take a bow. As they do so, he holds Marlon by the back of the neck and, while Marlon returns to standing with a smile plastered on his face, Sullivan appears like a ventriloquist in control of this young African American boy. This nascent performance holds in tension moments when the smile may be genuine, thus articulating its sensorial pleasure through the face, and moments when the brothers force it into being, therefore repressing other feelings that might potentially distract from the positive meanings that the smile conveys.

Irrespective of how genuine or comfortable the brothers were with these perpetual smiles, the Jackson 5 were clearly schooled in a performance pedagogy that demanded a bright smiling persona, and to understand the necessity and significance of the smile in the early part of Jackson's career, I attend to the racialized structures of the popular music industry. Music scholar Tamara Roberts (2011) asserts that since its inception, popular music and its marketing have been organized along racial lines according to vocal style, instrumentation, and formal composition. In the early twentieth century, African American music producers and record labels strategically adopted these positions of difference as an opportunity to distinguish their expressive practices from a dominant white mainstream. Yet for African American popular music artists to ensure success at this time, they needed to succumb to one of two concessions: to undergo a "sonic and visual 'whitening'" or to "adhere more closely to stereotyped black images" (Roberts 2011, 23).

By the late 1960s, when the Jackson 5 signed to Motown, although the label was dedicated to African American artists, its founder Berry Gordy had sought to create a sound and look that would appeal to a white American youth through cross-racial marketing strategies (Hamera 2017; Malone 1988; Whiteley 2005). Dance scholar Judith Hamera (2017) likens Gordy's methods to the Detroit assembly lines where the record label was based to illustrate the consistent and manufactured music and image of Motown artists.[9] Popular music scholar Sheila Whiteley (2005, 38) characterizes this succession of singers by their "up-beat close harmony pop" and "well staged performances," and Jackson (2009) himself recalls how Motown schooled the brothers in etiquette, grammar, and grooming. This strict code of behavior concerning the management of the body relied upon an earlier iteration of Black male performance rooted in 1940s tap dance.

The "class act tradition" was a style of tap characterized by "elegant dress, aural precision, a detached coolness in performance, and flawless execution" (Valis Hill 2010, 162). The direct lineage between the sophisticated presentation of class act tap dance and the slick performances of Motown music artists came through the figure of Charles "Cholly" Atkins, one half of the renowned class act duo Coles and Atkins (Malone 1988). Although the class acts flourished throughout the 1940s, dance scholar Jacqui Malone (1988) notes that by the 1950s Coles and Atkins often featured on the same bill as rock 'n' roll groups. Observing that these groups lacked a refined show business style, Atkins evolved into a performance coach who trained the novice rock 'n' roll groups in stage etiquette and African American vernacular dance. In the mid-1960s Atkins was hired by the Motown Artists Development Wing, a unit of Motown tasked with training its new Black artists (Malone 1988). To align with the Motown aesthetic, the corporeal disciplining of African American performers included a re-choreographing of facial expression. Former modeling coach Maxine Powell, who was also strategically recruited for the Motown Artists Development Wing, "insisted that singers be mindful that unacceptable onstage deportment included grimacing [and] closing your eyes" (Malone 1988, 15). Atkins's performance pedagogy rooted in the precise elegance of the class act tradition clearly conformed to a politics of respectability that would appeal to white audiences, which surrendered to an evolutionist narrative that assumed Black bodies required civilizing. Yet it also enabled Black artists to access economic mobility, which explains why Motown was able to create its production line of talented singers and musicians. Although the Jackson 5 were not trained by Atkins directly, the group observed his coaching and modeled its stage performances on those Motown artists who were (Atkins and Malone 2001). The Motown values of good deportment, performance etiquette, and polished facial expressions were evident in the Jackson 5's performance on *The Ed Sullivan Show* and evidently the smile dominated.

Given that Motown sought to appeal to white American audiences, the smile presented one of the only expressive options for the Jackson brothers as young African American men. Sociologist Andreana Clay (2011) details how popular culture provides limited opportunities for Black masculinity and asserts that Black male bodies are persistently adultified and hypersexualized. She calls upon feminist scholar Audre Lorde to argue that Black childhood is marked by a bid for survival against an enemy that emerges institutionally in the form of the police, the penal system, the media, the school system

and, I would add, a racialized and racist popular music industry. Clay (2011) concludes that this results in a hypersurveillance and criminalization of Black male bodies, which she identifies in Jackson's performance on *The Ed Sullivan Show*. She describes how Jackson demonstrated a matureness to his performance, through his vocal virtuosity and expressiveness, while his ostentatious costume resembled that of the pimp archetype represented in 1970s Blaxploitation films.[10] Thus from a young age, Jackson entered the prescribed symbolic economy of a Black male sexuality. Jackson's vocal and visual appeal in this early television appearance invoke adult themes through the lyrics, which detail sexual longing for a lost love, his mature vocal performance, and lurid outfit that signals a profession and virility beyond his years. His pleasing and innocent smile suggests he is content with this stereotypical representation, although his benign facial performance keeps him at a safe distance from the reality of Black male sexuality and criminality. Yet the smile is also unsettling: this adult image of Black manhood wrestles uncomfortably with the eleven-year-old body on stage and the flashes of doubt that flicker across his eyes or at the corners of his mouth question the positivity of the smile.

Multicultural studies scholar Sherrow Pinder (2012) similarly attends to the limited representational framework for African American performers in her study of Michael Jackson and Black identity. Pinder observes how Jackson struggled to locate himself within a country which privileges and normalizes whiteness as a neutral identity marker. She describes how blackness is essentialized as a white construction, and one authenticating marker of blackness is the capacity to sing and dance. The naturalized assumption that African Americans are innate entertainers has been well critiqued in dance studies (Das 2019; Desmond 1997; Kraut 2015). Yet as Pinder indicates, this essentialist proposition holds firmly in place as the Jackson brothers are showcased as authentic child entertainers through the white middle-aged authority of presenter Ed Sullivan. As the Jackson 5 cluster around Sullivan at the end of their performance, he calls attention to fellow Motown artist Diana Ross seated in the audience and describes how she discovered the Jackson 5 in Gary, Indiana.[11] His narrative assumes that Ross had chanced upon a fully evolved ensemble of singing and dancing siblings, which invisibilizes the industrial-style production of Motown in professionalizing and whitening the Jackson 5. On the one hand, the Jackson 5 are assimilated into a white aesthetic through their restrained bodily deportment and disciplined facial expressions that align with the white corporeal values of etiquette and

restraint instilled through Motown; yet Michael represents an authentic and adultified Black Other in his vocal maturity, his confident dancing ability, and "the authority in his facial expressions" (Clay 2011, 7). The initial schooling by Motown in the idiom of the contented Black entertainer and the choreography of the polished smile becomes further professionalized as Jackson's career continues.

In 1975, the Jackson 5 left Motown records and signed as The Jacksons to CBS and its subsidiary label Epic Records. Their first single with Epic, "Enjoy Yourself," was released in 1976 and was accompanied by a music video that features Michael, Marlon, and Jackie (who replaced Jermaine) on vocals, Tito on guitar, and Randy on congas. The performance takes place in a small, brightly colored studio with four large mirrors set directly behind the brothers. They wear identical crisp white suits with silver ornamentation on the lapels and gently flared pants, shiny silver shoes with stack heels, and their hair in Afros. As the three vocalists sing, they execute precisely choreographed actions, often in unison and occasionally in solo. Their vernacular moves include intricate stepping patterns with intermittent lower leg flicks to the side; circular arm motions or straight arm points that mark out a distant horizon; dips of the knees, which then swish from side to side; heel digs and struts; a relaxed grooving torso; and dazzling spins by Michael specifically. The brothers smile to the camera, sometimes looking out to the imagined audience, sometimes glancing down. Occasionally they cannot hold the smile as they sing particular lyrics that disassemble it, but it quickly returns and stays strong on held notes, which extend its potential to signify pleasure in the act of performance. Toward the end of the video, the camera cuts to several close-ups of the individual brothers, to catch them each emitting a huge smile that seems to express a contagious pleasure and invites their coperformers and the home audience to luxuriate in an interactive and affective joy.

As with "I Want You Back," the genuine nature of Jackson's smile in "Enjoy Yourself" cannot be confirmed, especially as the Jackson brothers left Motown to go to Epic under fraught circumstances.[12] Nevertheless, their performance dazzles the audience with a glossy and tenacious smile. Their smiles are consummately polished, with no signs whatsoever of doubt or hesitancy, and their professionalism is mirrored in the slick movement and dapper outfits. Hamera (2017, 32) comments on the virtuosity of Jackson as an artist and entertainer and likens this capacity to please an audience with the service industry commitment to deliver "service with a smile."

The narrative of good grooming and stage etiquette, and the explicit corporeal pleasure invested in music and dance, all of which were developed at Motown and then continued at Epic, recall the limited representational framework offered to African American popular music artists, based on the dual restriction of assimilation or segregation. In fact, the Jacksons were racially determined within both discursive spaces as their elegant presentation speaks to the sameness required by a white music mainstream, and their difference is marked through their assumed natural Black pleasure in the embodied practices of singing and dancing. Most disturbingly, the insistence of the smile fixes them within a mask of pleasure that tells audiences they are happy within this confined subject position, a trope that did not originate with Motown, but evolves from an earlier performance practice over which African American artists also exercised little representational control.

The Tenacity of the Minstrel Smile

Blackface minstrelsy has been characterized as the first form of American mass entertainment (Bean, Hatch, and McNamara 1996; Jones 2013; Stearns and Stearns 1994), which seriously took hold with the advent of the Virginia Minstrels in 1843 (Southern 1996), and persisted throughout the nineteenth century as a popular performance spectacle (Johnson 2012).[13] The impact of minstrelsy on the conditions and representations available to African American performers, and the way that American spectatorship constructs and interprets Black artists cannot be overstated.[14] Indeed, several scholars have identified links between the minstrel mask and the work of Michael Jackson (Cannon 2010; Lhamon 1998; Manning 2013; Yuan 1996).[15] My interest here, however, specifically concerns the minstrel smile as an indeterminate facial expression rooted in the blackface tradition that influenced subsequent performance practices by African American artists, including the facial demeanor of the Jackson brothers from their time at Motown.

In the early part of the nineteenth century, classic minstrelsy featured white male performers whose faces presented a grotesque and singular depiction of an African American countenance: popular music scholar Harriet Manning (2013, xi) details the "vulgar mask" of a "white physiognomy having been blackened by boot polish, burnt cork or soot, and eyes and mouths painted with vermillion." As white actors created this universal Black face, it came to represent an essential Black self thus negating the complex and individuated

experiences of African American peoples. Aside from darkening the face as a deleterious parody of blackness, what the minstrel face came to represent and how it operated choreographically offers important insight into the way in which Jackson used his face cosmetically and performatively throughout his career.

Although minstrel performance generically traded in stereotypes of a Black primitivism, virility, or proximity to nature (Danielson 2006; Manning 2013), its facial representations and expressions were deployed to signal other stereotypes and attitudes imposed upon Black lives in the nineteenth century. In 1896, as a critique on minstrelsy, the poet Paul Laurence Dunbar penned *We Wear the Mask* (Cole and Davis 2013, 8), which comments on "the mask that grins and lies . . . with torn and bleeding hearts we smile." Dunbar focuses here on perhaps the most enduring feature of the blackface representation: an exterior smile that conceals a traumatic interior life under white supremacism. Musicologist Anne Danielson (2006, 22) notes how blackface minstrelsy perpetuates the depiction of African Americans as "simple, happy people," and this fixing of the face through a fabricated smile of joy has circulated within the historical tradition of minstrelsy and beyond. Notably, the trope of the "happy darky" was already prevalent in America during this period in its representation of plantation life; the notion of enslaved Black people as being contented, loyal, and grateful to their white masters featured in Southern literature of the early nineteenth century, which portrayed them as "singing, carefree slaves" (MacKethan 2002, 327). The smiling stock character contained within minstrelsy thus played to the idea that African American people were of low intellect and a target of derision (Cockrell 2012; Toll 1996). And from this point, the spectacle of the witless grinning fool becomes attached to Black faces within the white American popular imagination.

Following the Civil War, it became common for African American performers to enter the professional field of minstrelsy, with the first permanent troupe forming in 1867.[16] Yet one of the first and most influential African American minstrel performers from the 1840s was William Henry Lane, who was known by the stage name of Master Juba (Winter 1996). Notably, in his oft-cited travel journal, *American Notes* (1842), English author Charles Dickens writes about a minstrel performance he encounters, which historians have assumed to be Master Juba. Here Dickens details the prominence of facial expression: "He never leaves off making queer faces and is the delight of all the rest, who grin from ear to ear incessantly" (Winter

1996, 228–229). This continues with later African American performers who also employed the smile and other comic expressions to produce mirth in their audiences. For instance, Manning (2013, 69) describes how comedian Billy Kersands "was best loved for his caricature of the grinning, fat-lipped figure central to the minstrel tradition." Hence the bid to smile as well as make audiences laugh perpetuated the deceit that the blackface mask assumed.

Blackface has proved such a persistent and virulent expression in North American culture that several scholars have identified its continued presence into and through the twentieth century, with an alarming resurgence in the early twenty-first century (Cole and Davis 2013; Danielson 2006; Johnson 2012; Manning 2013).

The legacy of the blackface smile and its grasp on the popular music industry is evident from the Jacksons' work with Motown in the late 1960s as child performers and as young adults with Epic. Although Jackson and his brothers did not intend to produce comedic effects through their musical performances, they were clearly trained in the pedagogy of a smile. Ironically, the class act tradition that influenced the slick presentational style of Motown artists had originally sought to reconceive African American entertainment beyond early blackface tropes. Valis Hill (2010, 41) details how class act traditions evolved at the turn of the twentieth century as an "elite group of black performers" who sought to eschew "the minstrel-show stereotypes of the grinning and dancing clowns, the fool and the dandy." Yet although the glossy smile of the class act performer replaces the blackface grin of the simple fool, both labor to appease the white spectator.

Too often the smile performs a lustrous but superficial display that serves to entertain and to reassure that the Black body is neither aggressive nor threatening. This laborious working of the facial musculature demands excessive effort and denial of the complexity of Black lived experience. Thus the action-expression of the slick Motown smile, which continued even after the Jackson brothers departed from the label, indicates the limited representational range that African American artists were permitted to inhabit: they are contented entertainers servicing a white musical ideal.

The tenacity of the smile and its operative power within the popular imagination also remained with Jackson as he moved into a solo career. Dissatisfied with the lack of freedom to explore his own musical ideas within the aesthetic and social confines of the tight family group, in the first of several commercially and artistically successful collaborations with producer Quincy Jones, Jackson released his critically acclaimed solo album *Off the Wall* with

Epic in 1979 (Taraborrelli 2010). His first single from this album was "Don't Stop 'Til You get Enough" (1979) and its music video features Jackson in a smart black tuxedo, white shirt, and bow tie, which again references the class act tradition, singing and dancing against a backdrop of luminous abstract shapes. Although Jackson commences the song with a brief spoken word introduction, whereby his disposition remains serious and introspective, as soon as the main musical opening kicks in with his signature, high-pitched "wooh," his face breaks into a huge smile that continues throughout the video. Early indications of his skill as a star dancer emerge in the video, further magnified as a soloist, away from his brothers, as he executes his now-familiar angular isolations of the arms, legs, and pelvis, his lower body rocks back and forth, his dexterous switches of the feet, low center of gravity, multiple spins, and funk-style groove in time to the exuberant disco music. Notably, the camera frequently cuts to a close-up to show his huge smile of satisfaction and remind us of his affective pleasure of moving and singing as indices of blackness. The spectacle of his smile is pure excess, magnifying Jackson's choreographic demonstration of happiness and success. Yet occasionally during the video, Jackson throws his head back and closes his eyes as if lost in a private sonic and kinetic pleasure. This refusal to meet the gaze of the camera creates a distancing effect so that the audience is momentarily alienated from the security of Jackson's professional smile that openly shares its contentment with the viewer through eye-to-eye contact. His disappearance into a smile that closes down the mutual gaze between performer and spectator might lead the viewer to question whether the smile is a genuine index of his desire to entertain or whether it acts as a mask-like hyperbole that negates Jackson's life experience or conceals his private pleasures.

The distance created by the blackface mask of nineteenth-century minstrelsy and the social and economic standing of the performers who deployed it has been the subject of complex debate. In revisionist accounts, several scholars have reconceived minstrelsy as a white working-class critique. While these scholars recognize its injurious representations of enslaved Black people, they frame white working-class participation as a social commentary on class, race, gender, politics, and work (Lhamon 1998; Lott 1995; Maher 1996; Saxton 1996; Toll 1996). Yet other scholars remind us that this perspective does not attend to the way that African Americans were denied access to their own representation and how the minstrel mask continues to operate as a primary definition of blackness in the popular imagination (Cockrell 2012; Hartman 1997; Jones 2013; Nyong'o 2009). In response to this literature,

Manning (2013) considers the work that the mask does to distance its performers from the representations that it upholds. While white performers used the blackface mask to show racial distinctiveness, African Americans countered this supremacist construct through a process of "semantic reversal" by which they held their own cultural meanings and interpretations of the practice (Manning 2013, 71). In particular, the exaggerated depictions operated as a strategic distancing from a singular representation of blackness and indicated community belonging through the shared experience of humiliation and degradation (Manning 2013).

Historian and literature scholar Saidiya Hartman (1997) makes a similar point in relation to plantation life in which enslaved African Americans were required to entertain the white master and used compliance to mask subversion. Although on the face of it the difference is subtle, Hartman (1997, 8) suggests that "the grins and gesticulations of Sambo indicating the repressive construction of contented subjugation" operate as an active critique of the power relations that suppressed Black life. While the debates are nuanced, it strikes me that the crudeness of blackface, the excessive hyperbole of the smile, and its deterministic representation of a contented Black body within minstrelsy offers serious cause for hesitation. From the singularity of the minstrel grin, through the slick smiles of the class act tradition, and into the production-line facial expressions of Motown that signal a polished entertainer, the relentlessness of a smile under the extreme social and economic hardships experienced by Black bodies suggests that the smile cannot be trusted. This opens the potential for the spectator to be clowned by the smile, fooled by its mask, and left uncertain of its meaning. Furthermore, the politics of the Black Arts Movement in the 1960s had mobilized Black consciousness such that as Jackson moved into adulthood, he would have been all too aware of the burden of representation placed upon Black bodies.

In "Rock With You" (1979), Jackson's second single from *Off the Wall*, and its accompanying music video, the persistent smile remains.[17] Still referencing the glamorous imagery of the disco music and club aesthetic, Jackson wears a tight sequin silver top and matching knee-length boots, with sequin silver and black striped pants. A spotlight flashes from behind, which produces a dazzling glare from Jackson's full-bodied sparkles. For this performance, he sings with a microphone, therefore his dancing remains in place, and he gyrates his hips and torso with the rhythm of the beat, and occasionally gestures with his free hand. The camera regularly closes in on his face

and he emits a stunning glossy smile (see Figure 2.2), with his perfect white teeth in full view. His entire dancing body displays a joy in motion, the energy of which fuels his indefatigable and radiant smile. Again, the viewer can be in little doubt that Jackson is engulfed in the pleasure of his performance as the spectator is hailed through the cuts between his close-up smile and the full shots of his easy bodily groove. During a short instrumental break, the close-up focuses on Jackson's sparkling boots, which step and swivel in a dynamic response to the music, so that his feet also convey the pleasurable joy that emanates from the music. The image then returns to Jackson's beaming face, which holistically represents the consummate and contented Black entertainer. Yet although the smile shines brightest, moments of close-up camera work reveal fleeting facial movements: a modest frown, a jutting jaw, and a slight biting action. The rapid flickers of uncertainty concerning the stability of the smile cause the viewer to question whether it can be completely trusted, and as I will show in later chapters, these rapid facial tics represent an adumbration of Jackson's face to come.

To return to the beginning of this chapter and Jackson's displeasure over the presence of his smile in the rough cut of the Pepsi commercial, as an African American man, he clearly took issue with what the smile represents. Although Jackson was firmly schooled in the pedagogy of a smile through the industrial machinations of Motown, as a young child he struggled to fully invest in it and as a young man there are fleeting moments when he cannot maintain it or a brief wavering that undermines it. By the time he features in the Pepsi commercial, he refutes that he smiles while he dances. I have shown how Jackson was required to perform an *identifiable face* through the action-expression of a smile that fix African American men into a racist social framework that assumes a weak intellect but contented disposition, which can be historically traced to nineteenth-century minstrelsy. Although shifting from a witless grin to a glossy smile in the twentieth century, the tenacity of this brilliant but superficial expression shaped Jackson's early career performances. Yet despite its persistence, the smile renders a dazzling yet impenetrable mask. As much as it attempts to determine Black masculine identity, its fixity proves indeterminate as we can never fully access what lies behind it. As his solo career developed further, Jackson strategically rechoreographed his face by deviating from this smile that served to placate white audiences. His refusal to maintain this *semiotic face* not only exposed his dissatisfaction but revealed the smile for what it represented: a façade of happiness and an outmoded, offensive, and exhausting racial trope. As I will

show in later chapters, Jackson abruptly ditched the smile in his music video performance, which marked a break with this polished and tenacious deceit.

Maddie Ziegler and the Billion-Dollar Smile

While Jackson was trained as a young boy in the pedagogy of a smile in the late 1960s, forty years later, an eight-year-old Maddie Ziegler was also being schooled in the art of smiling in the reality television show *Dance Moms*. First aired in 2011, the show revolves around the Abby Lee Dance Company (ALDC), a dance instruction studio in Pittsburgh, Pennsylvania, and the young girls (and their attendant mothers) who belong to one of its elite dance teams. Each episode follows studio owner Abby Lee Miller, the girls, and their mothers preparing for and participating in a weekly regional or national dance competition, and this is surrounded by much emotionally driven drama that translates into melodramatic crying and screaming.[18] The team comprises Maddie Ziegler and her younger sister Mackenzie, Chloe Lukasiak, Brooke and Paige Hyland, and Nia Frazier, and their respective mothers Melissa Gisoni (formerly Ziegler), Christi Lukasiak, Kelly Hyland, and Holly Hatcher-Frazier. Although much of the series focuses on the young girls, "the dance moms" also feature heavily through petty squabbles with each other and with Miller over the success or otherwise of their daughters. I principally focus on the smiling labor of the girl dancers, although the mothers often comment on the qualities of the dancing face as they watch their children in rehearsal and competition.

In Season 1, a deluge of bright, white smiles come to characterize the girls' performances. In one, an eight-year old Ziegler dances an upbeat tap routine in a cute yellow-sequined dress, and her huge toothy smile is evident throughout.[19] In another, although a few shots of the girls waiting in the wings reveal anxious looks and furrowed brows, as they come on stage for a jazz routine, they immediately hit the audience with big confident smiles, interspersed with pouting lips and coy glances.[20] Ziegler is strategically placed center stage and emits the most vivacious beam among them, although all the girls commit to an insistent smile, while Miller sits in the audience with an anguished face as she begins to spot mistakes in the routine. And even in lyrical dance numbers, which are often more forlorn in mood and subject matter, Ziegler finds moments to let her winning smile shine out (see Figure 2.3). Dressed in a delicate lilac top and skirt, as she runs on stage,

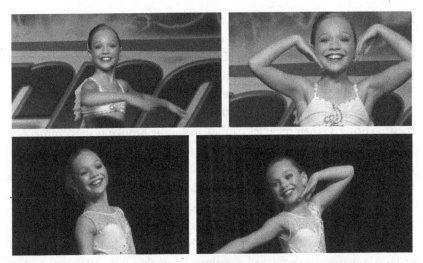

Figure 2.3 Maddie Ziegler showcasing her winning smile on *Dance Moms*.

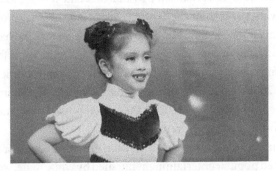

Figure 2.4 Vivi-Anne with her clenched smile on *Dance Moms*.

her mouth opens in delighted surprise straight into a smile; she smiles as she executes a *grand jeté* across the stage; she smiles throughout successive *fouettés* and double pirouettes; and she hits a final dazzling smile as she holds her ending pose.[21] This uplifting facial exclamation is magnified all the more as the camera cuts to her mother's face overcome with emotion as it crumples in tears.

The device of showcasing frozen and amplified smiles immediately before or after shots of dramatically contrasting facial expressions forms a recurring trope of the show. While teenagers Brooke Hyland and her dance partner

Brandon sit in the dressing room with sullen expressions, feeling awkward and self-conscious about their intimate duet, Miller snaps, "What's going on over there? You both look miserable!" In her bullying tone, Miller gestures in front of her face: "You should draw the judges' eyes over to you, that's the choreography!" Their performance follows, and Ziegler opens the dance with a huge smiling pirouette. As the rest of the group becomes animated, they too bring on their relentless smiles, including Brooke as she commences her duet. But again, their collective smile is offset with a cut-away to Miller's poker face describing the dance as "a mess." No matter what occurs behind the scenes, these young girls labor to produce a smile.

To understand the genealogy of Ziegler's competition smile, I return to the late nineteenth and early twentieth century where significant changes occurred in the development of popular theater, particularly as the spectacle of female performance formed a major part of this shift. Historian LeRoy Ashby (2006) describes how this period saw a rapid expansion of the entertainment industry. In addition to the popular forms of minstrelsy and circuses, which were well established by this time, the few decades leading up to and following the turn of the century witnessed the arrival of burlesque, vaudeville, and amusement parks. These popular pastimes moved from marginal entertainments to an amusement industry and were in perfect step with the development of a consumer culture based on commodities and spectacle (Ashby 2006). Collectively conceived as a "billion-dollar smile" (Ashby 2006), this description aptly captures the face of popular entertainment and its capacity for high economic return.

The late nineteenth century saw a division emerge between a low culture, which included popular entertainment pursued by white male, working-class audiences due to its increasing sexual content, and high art, which became the preserve of demure white middle-class tastes (Ashby 2006). Notably, white female performers were instrumental in attracting male audiences, and this can be traced back to theatrical traditions of the mid-nineteenth century. Several productions featured women, such as Adah Isaacs Menken and Lydia Thompson, who appeared in scandalous costumes and engaged in behaviors that challenged the norms of female propriety (Allen 1991; Ashby 2006).[22] This paved the way for burlesque theater, and although it initially attracted middle-class patrons, attacks from the press for its impropriety prompted a decline in this demographic and instead drew the interest of male working-class audiences (Shteir 2005). By the early twentieth century, burlesque was replaced by strip shows and belly dancers (Shteir 2005), and

in a bid to make popular theater respectable, another form of "female sexual exhibitionism" developed through Florenz Ziegfeld and his chorus line of showgirls (Ashby 2006, 115). Female troupes such as the Tiller Girls (Elswit 2014) from England, the dancers of the Moulin Rouge in Paris (Ashby 2006), Ziegfeld Follies in the United States (Shteir 2005), and later the Busby Berkeley chorines of Hollywood cinema (Franko 2002) each presented lines of smiling women duplicated in dress, movement, and facial expression. Although chorus lines of African American women existed (Brown 2008), the infamous chorus lines I list above exclusively featured white women in a vision of identical formation.[23] With their precision dance and uniform appearance, these chorus line women were rendered sexually alluring through tight costumes, exposed legs, heavy make-up that emphasizes Western beauty ideals, and the codified choreography of a "billion-dollar smile." This smile, which English scholar Brenda Foley (2005) describes as a construction of white Western femininity that signifies a benign, pleasing, passive and available being, continued to fuel female entertainment throughout the twentieth century, such as in beauty pageants and female striptease (Foley 2005), Hollywood musicals (Morrison 2014), cheerleading (Adams and Bettis 2003), and female figure skating (Feder 1994).

At the beginning of this chapter, I highlighted a division between genuine and fake smiles, although LaFrance (2011) suggests that smiles that appear to be spontaneous are sometimes the result of practice, and an intentional smile may be genuine. The persistent and systematic smile produced through chorus lines, showgirls, beauty contestants, cheerleaders, ice skaters, and young girls in studio competition dance is rehearsed, conventionalized, and a practice of facial choreography. Indeed, the effort that these female performers must exert in smiling continuously positions it as a form of labor, designed to appear effortless and voluntary. The ALDC elite team is required to smile for long periods during a dance, smile through exhausting and technically demanding movement material, and smile even when costume malfunctions occur or the performance goes wrong. The sensation of holding them becomes a laborious endeavor, and as young dancers they must surely sense the lack of authenticity as they attempt to maintain this cheerful façade. Yet Ziegler exudes such an exuberant smile in her dancing that it is hard to conceive that it might not be spontaneous and genuine, and this could certainly be the case. Her smile perhaps expresses both the sensorial pleasure she experiences when dancing and the confidence she feels regarding her capacity to win; however, we also know that she must put on a

smile when events surrounding the performance are unfavorable. Here, I am less concerned with the authenticity of her smile than with her capacity to perform a smile that appears genuine in a way that the other cast members often fail to achieve. I will return to this comparison between Ziegler and the other dancers in the final section, but first I examine the smile as a form of labor and how successful workers are required to present a polished professional smile.

The relationship between a service economy and the professional smile has not gone unnoticed. LaFrance (2011, 47) details how private corporations and public organization train their employees "to conduct business with a smile."[24] Indeed, the investment in a perfect smile has led to a lucrative business in cosmetic surgery and dentistry, which fuels a consumer obsession with full lips and straight white teeth. To return to dance, the link between facial expression, dance as entertainment, and the service economy are evident when we consider dance as labor. Dance scholar Mark Franko (2002) examines the relationship between movement and labor in dance works of the 1930s and analyzes the Busby Berkeley chorus line using Siegfried Kracauer's concept of the "mass ornament."[25] He suggests that the chorus girl serves a capitalist function in that she cheerfully represents a Taylorized work model through her precision routines and benign smile. Dance scholar Kate Elswit (2014, 64) also turns to the female chorus line, specifically the Tiller Girls within the context of the Weimar Republic, and observes how commentators read the dancers as commodities due to their "uniformity and repeatability."[26]

Although ALDC is not a professional dance company and the young dancers are not provided with remuneration for starring in *Dance Moms*, the children hope to become full-time professional dancers or performers of some variety.[27] Therefore the development of a professional smile indicates that they are prepared to enter an industry that provides entertainment as a cultural service; that they can duplicate facial expressions and movement languages demanded of the profession; that they will be disciplined and benign workers, irrespective of how they might behave off-stage; and their glossy and tenacious smiles model a genealogy of compliant femininity. Given that the chorus lines featured unison formations of smiling women and that the elite team on *Dance Moms* consists almost entirely of young girls, it bears little surprise that smiling constitutes a gendered act.[28] LaFrance (2011) asserts that girls are socialized to smile more than boys, and a higher proportion of women enter service and care-giving industries where smiling is

a necessity and pay rates are lower. In the case of *Dance* Moms, the majority of the girls are white, which connects not only to the racialized construction of the chorus line as a spectacle of whiteness, but also to English scholar Jayna Brown's (2008) assertion that the mechanistic representation of the chorus line concerned the intimate relationship between industry and the white capitalist worker.[29] Thus the smile here is socially and economically aligned with white female labor, willing and cheerful service, and a body that is attuned to disciplined performance work. This reproduces an ableist vision of facial perfection as girls and women issue a bright smile framed by pink lips and glistening teeth.

To achieve a professional smile requires training and effort, and *Dance Moms* showcases multiple examples of this pedagogy and labor. Miller frequently makes comments about the composition of the face in general, such as, "C'mon girls, do something with your face,"[30] and "Get your game faces on!"[31] As Ziegler is both a winning dancer and constantly praised for her facial expression, Miller focuses her criticism on the other girls and their failure to produce a polished smile. For instance, while Chloe is learning a tango-style choreography, Miller shouts "Change your face, smile!";[32] and in an extended critique of Brooke, she states "It's not your dancing, it's your face. You go out there and you have this 'smile' on your face [Miller fixes her teeth in a grimace], and you don't move your head or your eyes. This is not what a mature dancer does."[33] To provide a professional service in the cultural entertainment of dance competition, dancers are required to smile on command. Clearly, significant emotional and physical labor is spent on creating such a smile, and there is sufficient crying, humiliation, and upset off-stage to suggest that the atmosphere is not always conducive to smiling on stage.

An interesting parallel might be drawn with the smile of child film star Shirley Temple within the context of the Great Depression. In a press photograph of her after a meeting with President Franklin Roosevelt, American studies scholar John Kasson (2011, 16) refers to Temple's "practiced smile." Yet he observes that producing a smile is hard work. It might appear effortless and spontaneous but requires forethought and training: "One may blink back a tear or stifle a sob... but the smile must stick, or the feelings it sustains will shatter" (Kasson 2011, 17).[34] Continuing this tradition of the child star, a component of Ziegler's professionalism is her capacity to engender a plausible and affective smile when required. Given that the art of smiling forms a significant component of the studio dance pedagogy and an absolute

necessity within the competition events, this opens the questions of why the girls are required to smile and to what affect.

Smiling Toward Happiness

The relationship between smiling, positivity, and success should not be underestimated. In her book *Smile or Die: How Positive Thinking Fooled America and the World* (2009), author Barbara Ehrenreich examines the link between smiling and an uncritical optimism that has taken hold in the United States and extended to other parts of the world. She identifies an assumption that a smile can produce a positive mood, and describes positivity as an ideology that irrationally assumes optimism is more likely to yield success in life, and that negative thinking leads to failure.[35] Rooted firmly in a capitalist paradigm, the tenet of positive thinking has resulted in a self-help industry that has been employed to tackle matters such as cancer, job loss, and weight gain, and it has entered the fields of religion, business, and academia. Ehrenreich (2009) shows how the smile operates as an index of positive thinking, and the praxis of smiling and success is frequently evidenced within *Dance Moms*.

Although the children, mothers and Miller often engage in dramatic outbursts, such as crying and screaming, Miller insists that the girls curb negative displays of emotion. They are frequently instructed to stop weeping, sulking, or complaining and, whatever upset happens before or after they dance, they are told to smile throughout. These enduring smiles are linked to the expectation that they should be relentlessly optimistic and assume that they are winners. Yet despite this ongoing tutelage, we see different degrees of smiling, different degrees of work ethic, and, within the logic of positive thinking, this leads to different degrees of success. Not surprisingly, Ziegler is positioned within a cycle of smiling, positivity, and winning: she is constantly shown laboring in the studio, she exudes a huge and apparently genuine smile while she dances, and she is typically a first place winner in solo competitions. This is not the case for the other girls, and their failure to smile and be positive becomes an important narrative within the show.

In the first episode of *Dance Moms*, Kelly Hyland learns that her thirteen-year-old daughter Brooke wants to quit dancing for cheerleading and asks her whether it matters that she no longer wins first place. Brooke stares impassively at the camera and states, "not really!" This sets the tone for future

episodes in which close-ups of Brooke's sullen disposition indicate that she is not destined to be a winner, her tendency toward injury becomes associated with her negative and lazy attitude,[36] and even when she is placed at the top of Miller's weekly pyramid,[37] she matter-of-factly reflects, "I don't really care!" Another child who fails to smile willingly or successfully is Vivi-Anne, the young daughter of Cathy Nesbitt-Stein, owner of Candy Apples dance studio.[38] While driving to a competition, Nesbitt-Stein, who epitomizes the ambitious stage mother, instructs Vivi-Anne, "Put a smile on your face" as the camera cuts to Vivi-Anne looking deadly serious.[39] And after Vivi-Anne awkwardly performs her bumble-bee dance, with a half-clenched smile fixed onto her face (see Figure 2.4), Nesbitt-Stein concludes, "You know honey, I'm not pleased with what you did." Vivi-Anne's poor delivery, unconvincing smile, and inability to be positive are summed up when she comments, "My mom wants me to dance even more than I want to."[40]

In contrast to Brooke and Vivi-Anne, although Chloe Lukasiak is desperate for success, her self-doubt constantly leaks out. Chloe is a promising dancer who wins a prestigious scholarship at the Joffrey Ballet summer school; yet within the narrative of *Dance Moms*, her smile lacks confidence and conviction, and she is always placed second to Ziegler. In one episode, Chloe is given the role of "envy" in a dance based loosely on the seven deadly sins.[41] The point is not lost on a distressed Chloe, who confides in her mother, "I'm not jealous of Maddie." In a later episode, when criticizing Chloe for a technical error, Miller vents, "I don't know why your mother says you don't have confidence; you are the cockiest kid I've ever worked with."[42] Chloe then attempts to mark the dance as tears role down her anxious face. Although Chloe switches on a smile when required in performance, and it appears more relaxed than the clenched grimaces of Brooke and Vivi-Anne, it is always smaller and more tentative than Ziegler's. Within the hierarchy of *Dance Moms*, her lesser smile suggests lesser positivity, which makes her a lesser dancer to Ziegler.

In these examples, the authenticity of the smile acts as a gauge for positivity, which is linked to individual success and access to happiness. In her book *The Promise of Happiness* (2010), Sara Ahmed observes the presumption that happiness is good, therefore it exists and is measurable. She proposes that happiness comes through our experiential engagement with the world: happy objects are those that most positively affect us. In orienting ourselves toward happy objects, happiness is that which hopefully follows: hence objects cause happiness in advance of its arrival, and such objects circulate

as "social goods" (Ahmed 2010, 28). In recognizing the social production of happiness, Ahmed (2010) comments that we are oriented to objects that are already deemed tasteful and invested with positive or negative attributes. These ideas concerning an affective attachment to objects of desire resonate with cultural theorist Lauren Berlant's (2011, 2) notion of "cruel optimism." Berlant conveys how we invest in a fantasy of "the good life" yet it cannot be achieved. In Berlant's terms, the promise of capitalism implies that we can achieve this sovereign fantasy, yet we remain in a structure of collective precarity that can never deliver the goods.

Although the experience of dancing itself might conceivably constitute a happy object, it is winning that is most emphasized in *Dance Moms*. While frustration, humiliation, and rivalry exist in the rehearsal studio, on the competition stage a glossy smile dominates and the promise of happiness is oriented toward winning first place position and a trophy or crown. The primacy of winning is iterated in the way the camera orients the viewer toward multiple signifiers of success: motivational quotes, such as "Winning Isn't Everything, It's the Only Thing," are pinned up in the ALDC studios; stacks of trophies are lined up in display cabinets at the studio, or laid out on tables ready to be awarded at the competition events; and Miller drops regular stock phrases, such as "You're only as good as your last performance" or "Second place is the first one to lose." Collectively these trade in a cruel optimism that signal both objects of attraction and the precarity of winning.[43] Yet in almost every episode, we witness shining smiles of success as Ziegler and the other dancers clasp trophies at the competition events. Clearly, these happy objects are already in circulation as desirable social goods within the economy of ALDC and dance competition, but as viewers, we are oriented toward these objects as we see how they affect the girls through the aspiration of winning as a promise of happiness.

Ahmed (2010, 45) notes that "some bodies more than others will bear the promise of happiness," and Ziegler evidently embodies this privileged position as she is always held up as the best at smiling, the hardest worker, and the most successful competitor. Midway through Season 2, however, Ziegler hits a rare wobbly patch. After discovering that Chloe was the top choice for the Joffrey Ballet summer school, a close-up succinctly catches Ziegler's doubtful face as Chloe and her mother receive this positive news.[44] Indeed, Chloe's desire to engage in the serious business of concert dance perhaps explains her lack of investment in a glossy smile, which Ziegler struggles to comprehend.

In the middle of her solo she suddenly rushes off stage, panicked and hyperventilating with distress magnified on her face, as she has forgotten her routine. Two weeks later, Ziegler is now at the bottom of the pyramid because she refused to do a solo the previous week.[45] Fearing she has lost her passion, her mother pushes her daughter to ask Miller if she can perform a solo, but when Ziegler tries this out, Miller is not convinced: "That's not a game face! That's not the Maddie face I know." Thus Ziegler's face is used as a register for assessing her desire to win. In keeping with the dramatic narrative of the show, Miller relents and allows her to compete. In a delicate pink dress, Ziegler performs a lyrical solo, and while there are moments when she expresses a yearning, serious face to match the reflective mood of the piece, this is interspersed with a huge glossy smile that seems to be energized by her renewed love of dancing. A momentary drama occurs when the CD skips and the music judders, but Ziegler continues to dance regardless. Her generous smile extends to the audience who cheer in encouragement, and we see one of the judges smiling back in awe of her professionalism. As she comes to kneeling at the end of the dance, Ziegler emits a final luminous smile, at which point the auditorium erupts in applause and the camera cuts across her family, friends, and audience members smiling back as evidence of her infectious and affective smile. True to form, Chloe's solo ranks third place, and Ziegler beats her with second.

Yet despite the apparent determinacy of the smile, to what extent can it be trusted? In her mission to examine happiness, and its dark counterpart unhappiness, Ahmed (2010) develops the figure of the "feminist killjoy" who refuses to convene around, and sets out to destroy, what is assumed to be an object of happiness. She begins with second-wave feminist Betty Friedan's critique of the "happy housewife" and continues with Marilyn Frye, who exposes the oppressive framework that demands women "smile and be cheerful," otherwise they are read as angry, bitter, and hostile (Frye cited in Ahmed 2010, 66).[46] Ahmed (2010, 69) also invokes feminist activist Shulasmith Firestone, who demanded a "smile boycott" for the women's liberation movement as a bodily reorientation that would rid women of their "pleasing smiles." Taking on the work of a feminist killjoy and knowing that the young girls in *Dance Moms* are trained in the gendered pedagogy of a winning smile, I am less concerned with its erasure than with examining how girls and women in dance might work the smile to critique its compliant attitude and pleasing disposition.

Returning to the earlier part of this chapter, in which I traced a genealogy of smiles from nineteenth-century theatrical performance, a template already exists for women who used the smile to stage critique. Focusing specifically on the burlesque performances of Lydia Thompson and her British Blondes, art historian Maria Buszek (2006) details how Thompson exhibited an "awarishness" in the way she exerted control over and took pleasure in her sexual representation. Buszek (2006, 53) suggests that this knowing performance style is evident in the "even gaze and smirking expression" of the British Blondes depicted in popular postcards of the time. Although artists such as Menken and Thompson produced and solicited smiles through their provocative flouting of feminine propriety in the late nineteenth century, several scholars have also demonstrated the indeterminacy of the compliant feminine smile of the chorus line. In her discussion of the Tiller Girls, Elswit (2014, 82) disputes the argument that they resemble an undifferentiated mass of bodies, instead asserting that they were able to look back with faces that contained an individual aura that called attention "to the specific presence of the live performer."[47] And in his study of the Busby Berkeley chorine, Franko (2002, 32) suggests that her fixed smile masks her emotional disposition, therefore she is potentially distracted and "her mind is elsewhere."

In the case of Ziegler and *Dance Moms*, while all the girls are oriented toward winning, and they smile to show positivity and happiness toward this end, there are clearly moments of resistance: Brooke's sullen face, Viva-Anne's gritted teeth, and Chloe's shadow of a smile all display some degree of refusal to adopt a committed and winning smile. There is one moment, however, when Ziegler herself proves to be a feminist killjoy. Toward the end of the third season, the girls are waiting backstage: Ziegler, sister Mackenzie, and Nia cluster together on one side of the wings, and Chloe, Kendall, Asia, and Peyton are on the other.[48] In the briefest of exchanges, Ziegler gestures a thumbs-up to her teammates opposite, mouths in a stage whisper "C'mon! Face!" while circling her face with her hand, takes a deep breath and quickly plasters on a fake smile, then lets her breath out with a deep sigh and a comical pout, followed by a split-second look of mirth. Although her only opportunity to make this critique is behind the scenes, and we see her moments later on stage dramatically pulling tormented facial expressions, she has cleverly unraveled our assumptions about Ziegler the dancer and her winning smile: in spite of its apparent sincerity, her smile is a performance that can be switched on and off; it is an automated drill that she and her fellow dancers must endure; the gesturing to the face is a worn old trope;

and these facial demands are both silly and superficial. In this moment of mocking performativity, we see Ziegler's "awarishness" of what is at stake in her gendered performance and her refusal to succumb to a compliant smile. Contrary to all that *Dance Moms* tries to tell us about competition dance, Ziegler has troubled the allure of positivity and the promise of happiness engendered in the smile.

In this chapter, I have traced how a glossy and tenacious smile produces an *identifiable face* that has dominated popular performance practice since the mid-nineteenth century. Indeed, instances of this wide bright smile that showcases a perfect line of teeth can be identified across contemporary popular performance, such as stage musicals, cruise ship entertainment, popular music video, cheerleading competition, ice dancing, and gymnastic floor routines. As young child performers, Jackson and Ziegler were trained in the art of smiling respectively through the capitalist apparatus of the music recording industry and studio competition dance instruction. Notably, the case study examples examined were of video or television performances, and we can see how the camera is attracted to and showcases persistent instances of smiling. Through carefully arranged editing, these action-expressions that signify happiness and contentment are affective and infectious as they circulate across coperformers and audiences. Set in relation to the norms of a *semiotic face*, Jackson's smile colludes with limited representations of Black masculinity designed to appease white audiences, and Ziegler's smile equates with a compliant white femininity. While Jackson's smile bears the lineage of blackface minstrelsy and the class act tradition, Ziegler's smile reveals its roots in the ableist white spectacle of the kickline chorus girl. The smiles issued by Jackson and Ziegler eclipse the smiles of everyday life: it is rehearsed, magnified, and sustained. This popular performance smile is choreographic, hyperbolic, and switched on in the moment of dancing, therefore it requires effort, labor, and careful crafting. Although the onstage smile might reveal genuine pleasure and joy, it also masks behind-the-scenes disharmony or moments of hesitancy, flickers of resistance, and a critique of its attempt to fix in place gender, race, and emotional disposition. It may shine bright, but this glosses over the complexity of life experience that lies behind it and engages a cruel optimism concerning the precarity of celebrity success. In the chapters that follow, I show how the dominance and certainty of the smile in popular dance slowly unravels to make way for other facial expressions. Before doing so, however, I move from the mouth to the eyes to consider the work that they perform in popular presentational dance.

3
LOOK

> I read a lot from the eyes of a dancer.
>
> —Nelson (2001, 2)

Second Sundae. All Styles Battle. Tony Teknik (he/his) up against Mad Hatter (they/them). A tiny dark club, flashing disco lights, the crowd tightly packed in a circle formation. Three judges sit, distractedly glancing around. The mix of dancers, supporters, and a few who've wandered in from the street eagerly look back and forth to check who will go out first. Face-to-face, across the dancefloor, the two competitors briefly eye each other up. DJ Royale spins a banger of a track by local Philly DJ Sega, and out comes Tony Teknik with his signature popping style, hitting hard with precise robotic angles. As he edges within a few inches of Mad Hatter's face, they turn, casually walking away, dissing him with a palpable lack of interest.[1] Undeterred, Tony Teknik edges across the floor shadowing Mad Hatter's footsteps back and forth, one moment staring intently at them, the next making eye contact with his people in the crowd and issuing a mischievous smile. Mad Hatter looks down at the floor, idly glances up, paying him little attention overall. Momentarily, Tony Teknik's eyes glaze over as if lost in the sharp rhythmic beats of his muscles, but as his body direction changes, he smiles again, exchanging a knowing look with the crowd. He moves toward Mad Hatter, "tutting" (precise gestural hand motions) around their face. Mad Hatter waggles their finger "No," smiles, and takes a couple of steps away. As his round winds down, Mad Hatter begins to step in time to the track, their body energizes, the faux boredom disappears, and they're off, bouncing around with playful house dance steps, flamboyantly "waacking" their arms around their head, frenetically popping, limbs flying out to the side, all the while staring right back at him with energy, determination, and a defiant attitude. Tony Teknik meets their gaze, staring back, his head and body juddering at one with the music, in a dynamic ocular exchange. This battle is truly electric.

Facial Choreographies. Sherril Dodds, Oxford University Press. © Oxford University Press 2024.
DOI: 10.1093/oso/9780197620366.003.0003

Given the technicality and virtuosity of movement expertise demonstrated in hip hop battles, my focus on one of the smallest parts of the body, the eyes, appears faintly ridiculous. Yet as the opening quotation suggests, in a beautifully poetic essay titled "Before Your Eyes," dancer Lisa Nelson (2001) insists that the eyes reveal a dancer's vitality and they direct her attention as a spectator. In hip hop battles, the concept of looking emerges in multiple ways: dancers look to orient their bodies in motion; they watch their opponents to assess their round; they work the eyes as part of their battle strategy; and they are the bearer of a gaze projected upon them by onlookers in the space.[2] Although these acts of looking often concern a reading of the entire body, I conceive the action-expression of a look and the performance of looking as essential components of facial choreography. In this chapter, I explore how hip hop dancers actively look, how they are the object of an external gaze, and how they creatively look back. As I indicated in the "About Face" chapter, we look directly to the face to make a rapid assessment of race, sex, gender, age, class, and dis/ability, emotional disposition, and ideals such as beauty and intelligence. Therefore, we see a *semiotic face*, coded according to social norms, and we look for an *identifiable face*, hoping to construct a constellation of characteristics that are meaningful to us.

Whereas the previous chapter, SMILE, addresses the celebrity faces of Michael Jackson and Maddie Ziegler, the hip hop dancers featured in this chapter are mostly unknown outside their circle of family, friends, and coworkers.[3] Furthermore, as the previous chapter concerns a textual analysis of screendance performances featuring Jackson and Ziegler, the gaze of the artist and the spectator is shaped by the directorial focus of the camera. In this chapter, I explore the decentralized gaze characteristic of vernacular dance events through an ethnographic methodology. My study primarily centers on Philadelphia, where I am based, and which has produced a vibrant community of hip hop dancers with expertise in a variety of styles. While the city is geared slightly more toward breaking and house dance, a keen population of dancers are skilled in popping, locking, hip hop social dancing, krumping, and waacking. Although my research primarily concentrates on battles in Philadelphia, I have also attended battles in broader Pennsylvania, New Jersey, Maryland, and New York City. Depending on the size and prestige of the battle, these events typically attract dancers from the Northeast coast and occasionally from elsewhere in the United States and beyond.

I have observed over eighty battles since commencing this research in 2011.[4] These are usually relatively small gatherings, ranging from 50 to 150 dancers and spectators, that have been held in a variety of sites such

as nightclubs, community centers, university leisure facilities, an art gallery, a basketball court, a car show, and a shopping mall. At these, the crowd stands in a circle formation, known as a cypher, while a seated panel of three judges watch from one side and gesture to the winner with their hands. I have also attended a few large-scale competitions, such as Silverback Open Championships, a commercially sponsored stadium battle that has taken place either close to or within the city of Philadelphia. This high-profile breaking competition attracted internationally renowned b-boys and b-girls, along with several hundred spectators, and was evaluated by a panel of seven judges who scored each round through an electronic voting system.[5]

I have conducted sixty-five semistructured interviews, and engaged in numerous unstructured interviews at battles, workshops, classes, and practice sessions. I started attending adult hip hop classes in 2010 and continued to take a variety of workshops and classes across a range of styles until 2015, at which point I began to focus specifically on breaking. Although I started late in life, I take this involvement seriously and currently train four times a week. I attend classes and workshops in Philadelphia, participate in regular cypher sessions in the community, I am part of a b-girl crew named Chronic SASS, and have entered several breaking battles as b-girl S-Dot.[6] The technique of breaking therefore dominates this research over other hip hop styles, due to its sizeable presence in Philadelphia and through my ongoing practice within the local breaking community.

Given that this chapter addresses practices of looking, as a reflexive ethnographer I am conscious that I bring my own modes of looking into the research setting and these inevitably shape the ways in which I collect and analyze data. As a white, female, British, middle-aged dance professor, my position informs how I look at and interpret this community of dancers. Considering recent discussions within the hip hop scene regarding the dismantling of white supremacy and call for social justice, I appreciate that I am a guest within a dance culture that hails from the African diaspora.[7] Indeed I am extremely grateful for the generosity and support offered by dancers both in my fieldwork and in my journey as a b-girl. As my position has gradually changed from a complete outsider to someone who dances within the community, my place of understanding has shifted from that of an experienced ethnographer to a novice practitioner. While I would argue that there is never absolute stability in one's position as a researcher, I recognize that how I look and how I am looked at has altered over the course of this research.

I will come to the ethnographic detail of the battles shortly, but first I consider what it is to look and to be looked at.

(En)Visioning the World

Visual culture scholar Janne Seppänen (2006, 3) asserts that we exist within a "visual order" that includes visual representations, structures of looking, and visual literacy. This optical framework therefore shapes perceptions of reality and the meanings it engenders, and practices of looking and being looked at are key components of subject formation (Seppänen 2006). The eyes visibly stand out on the human face, largely because of the sclera, the white surface area that exposes the irises (Perrett 2010). Within a Western paradigm, the eyes also play an important psycho-cultural role. Conceived as a portal to the mind or window to the soul, the eyes are said to reveal a person's interior feelings, desires, and intentions (Cole 1998; McNeill 1998). As a bodily organ, the eyes can register a vast range in light strength, and selectively focus on pertinent detail and filter out extraneous material (Seppänen 2006). Yet looking involves more than a neurological register of sensory perception. As a socially constituted mode of visual recognition and interaction, the concept of the gaze describes culturally specific frameworks of (en)visioning the world.

Within developmental psychology, the direction and attention of the gaze forms an important component of social, emotional, linguistic, and cognitive development (Flom, Lee, and Muir 2007). The direction of a gaze toward a particular focus can signal intentionality and the interactions of the gaze between people can generate strong social bonds (Hood and Macrae 2007). Yet such practices of the gaze are far from universal. For instance, Seppänen (2006) describes how meeting the eyes of another constitutes a social norm within European cultures, whereas for some cultural settings, to look directly into the eyes would be considered inappropriate or offensive. This is further complicated in performance practice whereby performers invite spectators to stare openly for a sustained period and seek to hold this gaze as a sign of their power to captivate. Within Europeanist norms at least, although one is encouraged to make eye contact, staring is considered rude.

To differentiate from the act of looking, dynamics of power are embedded within the concept of the gaze. Both the focus and length of gaze signal the degree of attention given to a person or object, and these two factors also

operate as a mechanism for controlling attention (Hood and Macrae 2007). Indeed, scholars have written at length about how the gaze is organized, how it can be directed, and what it can do. One of the most influential ideas concerning the power of the gaze comes from philosopher Michel Foucault ([1975] 1991). He draws upon the architecture of the panopticon, a central tower with windows placed around that allows an authority figure to look out at surrounding annexes occupied by subjects, such as a prisoners, patients, or school children.[8] Foucault ([1975] 1991) then develops this structure to suggest that subjects not only operate under the power of a social gaze but internalize and act according to that disciplinary regime whether under actual surveillance or not.[9]

While theories of the gaze encompass diverse topics such as global tourism (Urry and Larsen 2011), spiritual experience (Morgan 2005), and the beauty industry (Wegenstein 2012), a significant body of work centers on the operation of the gaze along axes of gender and race. In his sharp-sighted critique of the Western art canon, critic John Berger (1972) asserted that images are not simply neutral representations, but embody a masculine point of view and, shortly after, feminist film scholar Laura Mulvey (1975) issued a stinging assessment of the Hollywood film industry through her conception of the "male gaze."[10] Similarly to gendered modes of looking, scholars working within critical race theory and postcolonial studies have been equally attentive to the operations of a colonial or racialized gaze. Historian Tamara Hunt (2002) describes how a racially situated gaze emerges from the ways colonialists misinterpreted and misconceived indigenous peoples, and which served to maintain a power structure that privileged colonialist interests. Black studies scholar bell hooks (2015) recounts how enslaved Black people were punished for looking, thereby recognizing that the gaze is both powerful and dangerous, and cultural studies scholar Nicole Fleetwood (2011, 16) asserts that the Black body troubles the visual field due to its overdetermination, which erases the lived histories of Black people as "ethical and enfleshed subjects." Consequently, a rich scholarship has evolved that seeks to contest this Eurocentric power model through returning (Everett 2001), reversing (Ntarangwi 2010), redirecting (Robin and Jaffe 1999), or resisting (hooks 2015) the colonial gaze. Sociologist John Urry and urban studies scholar Jonas Larsen describe the gaze as "a performance that orders, shapes and classifies, rather than reflects the world" (2011, 3). The idea that the gaze works performatively proves useful for thinking about dance: that the gaze engenders ideas, that it produces meaning, that it shapes how bodies

move and affects how bodies are seen aligns itself with the practice of choreography. It bears little surprise then that the gaze has also attracted the interest of dance scholars, who reveal different genealogies of the gaze according to specific historical and social contexts of dance performance.

Given that early dance scholarship centered on Western concert dance, a sizeable body of work explores the operation of the gaze on the concert stage. As this artistic field was dominated by female performers, attention turned to the operations of a male gaze across (neo-)classical ballet and (post)modern dance choreography (Adair 1992; Daly 1987; Manning 1997), although a couple of dance scholars also consider the gaze in relation to the male dancer (Burt 1995; Franko 2000). Most notably, the scholarship on concert dance typically assumes a unidirectional and omnipotent gaze, which creates the duality of a spectator who actively "looks" and a dancer who is passively "looked at." This spectator-performer divide stands in contrast to the decentered and shifting looks that take place within vernacular dance settings in which participants dance close to one another in a mutual performance space. In hip hop battles specifically, a tension exists as the dancer in the center of the cypher might attempt to secure an all-encompassing gaze, but this remains vulnerable to the disorderly and mobile glances of their opponent, the crowd, and the judges. Even within the concert dance model, in which the collective gaze of an entire audience is generally directed toward a soloist or smaller body of dancers, the power of the gaze has been called into question.

In a critique of the objectifying and consuming spectatorial gaze assumed in Western concert dance, Ann Cooper Albright (1997) instead offers the idea of "witnessing" as an embodied and interactive response to visual and kinetic sensations in late twentieth-century contemporary dance.[11] Yet this sense of careful noticing and responsiveness does not capture the assertive, dialogic, and sometimes dismissive exchanges of looks that take place in hip hop battles. Notably, some productive thinking on the gaze comes from the perspective of dancers rather than audiences: Susan Foster (1986) conceives the dancer's gaze as a "rhetorical device" to show how a mutual gaze might produce a connection between dancer and spectator, while a refusal to break the theatrical fourth wall creates a barrier between the two (Foster 1986, 64).[12] Jeroen Fabius (2015) meanwhile describes how dance artist Trisha Brown, along with other postmodern dance artists of the 1960s, was assumed to convey an emotionally detached mode of expression, which resulted in a distant or impersonal gaze that refused to acknowledge the spectator. Yet

Fabius argues that this offers the spectator opportunity to take in the entire body of the dancer, and the gaze of the dancer concentrates on signaling bodily orientations and experience. Brenda Dixon Gottschild (2002, 9) writes about the dance circle in Africanist performance practices, and this description most closely aligns with the decentered and mobile gazes within hip hop battles that I mention above:

> Since there is no proscenium staging separating audience from performers, spectators may choose where to focus their attention, and performers may choose where to locate themselves while performing ... No one person is capable of knowing/seeing all that is going on at any particular moment in time.

I draw on this rich body of work to consider practices of looking and the dispersed operations of the gaze in hip hop battles. The direction and intensity of the gaze in hip hop dance is subject to the same gendered and racialized modes of looking that organize the power structures of everyday life. Equally, the gaze can be observed as a choreographic performance in that its mobility, direction, and intent are both an essential component of the dance and serve to produce meaning through the purposeful exchange of looks within performance. Whether dancers glance, glimpse, gape, stare, scan, or peek, the quality of the look is a major component of their facial performance.

Performances of Looking in Hip Hop

In August 2015, at the Flava 360 Anniversary Battle, an excitable tension pings around the room as two respected b-boys in the Philadelphia breaking scene, Knuckles and Are You Randy, stand across the floor from two b-boys, completely unknown to the local crowd, who later reveal themselves to be from Germany.[13] Three judges, Rukkus, Hussain, and Duron, crowd together on a small sofa while the persistent drum beat from DJ Fleg's "Funky Stickem" blasts out from the speakers. The two pairs of b-boys pace around, casually looking at the floor and occasionally glancing up at the opposing side to check in on who might make the first move. The eyes of the crowd flicker across the dancers in anticipation, and the trio of judges sit back, looking ahead, waiting for some action. Attention shifts to a bottle that rolls to the center of the floor, sent by an anonymous member of the crowd, but fails to land in a direction that clearly indicates which side should go up

first. Frustrated by the refusal to throw down a first round, Duron jumps up and dances a couple of bars of percussive toprock before slamming his hand on the floor to signal that it's time to get moving. The two other judges send knowing looks of appreciation to Duron, while the b-boys still refuse to meet the eyes of their mutual opponents in this ongoing standoff. The frustrating deadlock continues and, as Rukkus punches his hand in the air to hit an instrumental beat, he and Duron shift to the edges of their seat as if to signal the need for action. B-boy Randy stares at his opponents, playing a couple of rounds of "rock paper scissors" with his hands in time to the music to attempt to initiate a response. A few more seconds of the standstill persists, at which point Duron starts to creep off the sofa with his fingertips leading the way, looking up to see if his threat to perform a round in the center of the cypher will motivate either crew to go out. It works. One of the German b-boys explodes out onto the floor, and Knuckles and Randy immediately drop their eyes to concentrate intently on the footwork issued by their adversary.

Within hip hop battles, the act of looking is not random, but instead dancers are trained to think about how, where, and why they look:

> When I started dancing in Philly, people would emphasize the fact that you need to interact with the person you're dancing against. You need to look at them and there needs to be some sort of engagement and exchange. (Sunny)[14]

> I definitely have been taught to engage the person in front of you ... For the most part, everything seems directed and channeled to your opponent like, "this move is for you," "this freeze is for you," "this footwork is for you." Like eat that! You know? (Renaissance Ray)[15]

> I got advice as a younger dancer, you need to keep your eyes on them, like point at them. You know, let them know that you are taking this seriously 'cause your intent is very important. The intent is in your eyes. (Steve Believe)[16]

The eyes form an essential part of the technique and choreography of hip hop dance, and the dancers whom I interviewed shared a plethora of ideas about different modes of looking in battle events.

As I describe at the beginning of this section, battles typically begin with both parties reluctant to start the round, and this often includes a

theatrical display of looking, which Renaissance Ray describes as the "stare down."[17] Whereas the intensity of a stare off would generally be considered intimidating and inappropriate in quotidian life, its assertive posture works well within the performance of a battle. Clearly, the second dancer has the advantage as they can carefully observe the material that their opponent throws down to hopefully better it in some way, and several dancers identified what they look out for:

> I don't have a problem with going first, but if I can go second, I love it. I can watch exactly what they're doing, what they're proficient at or what they're not. (Sk8z)[18]

> It's just like looking for something, like maybe a specific drop, that I can play off when I come out to show that I can do what you're doing, and I can do it better. (Macca)[19]

> I see if they did that move in the prior battle already. So if that person is repeating, then I'm like, "You should be having enough moves to not repeat, 'cause that's how the game works." (Dosu)[20]

In addition to scrutinizing the technical complexity or originality of the movement material, dancers also read their opponent's gaze as a measure of their overall confidence:

> If your opponent is looking down the whole round, most of the time it's because they're not comfortable being in that space and they're not comfortable owning that space. (Mai Lê)[21]

> If they are looking down, I can tell they are either nervous, no matter how great of a dancer they are, or maybe eye contact just isn't comfortable for them at all. (Jenesis)[22]

Yet an intent mode of looking might also serve other purposes. At times, it can be less concerned with assessing the opponent, than with helping a dancer to prepare for their round. Here dancers spoke at length about creating an illusion of looking at their opponent as part of the etiquette of a battle, but that instead they withdraw into an interior state that focuses on the self and tries not to acknowledge what happens before them. Metal describes this as a "performance of looking" and elaborates as follows:

I'm doing the thing where I'm looking at them but I'm not looking at them. So I'm kinda like this [demonstrates "fake looking"], so it looks like I'm looking at them, but really I'm trying really hard to ignore what they're doing so I can just go and do my thing.[23]

Similarly, Sunny explains,

In breaking it's pretty common to have people throw burns or make insulting gestures or whatever it may be. So in order to push all that aside and not be distracted, I'm gazing at that person so it looks like I'm watching, but actually I'm not focused at all on what they are doing.

For Ynot, his studied focus on his opponent serves to filter out factors that might divert from his sense of self in the battle moment:

You're on stage, there's lights, there's people, there's weird things. Sometimes I don't feel like myself in those situations. So it's not that I'm trying to be something else: I'm actually just trying to get back to who I am and I'm trying to connect with what that means to me.[24]

It appears that dancers are both looking and not looking: they make rapid assessments of technical competency and confidence of performance; they are filtering out external distractions, insults and burns; and they intentionally disengage the gaze to find a sense of presence or calm during this period of competitive duress. This nuanced consideration of what the eyes signal and what they choose to see reveals looking as a performance that displays the dancer's intent to eye up and overcome their opponents, and mask the need to assuage any fears of inferiority or failure.

A few dancers described intentionally averting their gaze and not looking at their opponent. For instance, Mad Hatter described the need to present original movement material:

You don't know what song the DJ is going to put on so I have to look away from the opponent so that they don't influence me.[25]

Or if competitors bring out an overly aggressive demeanor, Metal states,

Sometimes I'm consciously not looking at them just to be like, "you're an idiot. Stop doing that." ... So I try to ruin the "little theater of the moment"

they're trying to do. If they don't have an audience for it then there is just no theater.

Denying the gaze can both serve to protect the integrity of the dancer and undermine what might be considered unacceptable behavior in the cypher.

Once the opponent has completed their round and the second dancer enters the circle, their eyes are important both in the execution of the dance and in asserting a competitive edge. Given that many of the battles I attend are held in small, crowded venues, the cypher space can be tight. B-girl Rokafella describes how careful observation is essential to managing her body in the cypher:

> I don't want to kick anybody's shoes. I don't want to hit the judges' table or fall off the stage because sometimes it's like an elevated platform . . . Plus, let's say I'm doing a backspin or something. I'm trying to figure out if I just did a spin, I saw you, and I'm rotating, in order for me to finish the freeze and face in your direction, I have to keep a real good eye during all the spins where you were.[26]

As breaking involves multiple rotations on the hands, back, head, shoulders or feet, dancers surveil their environment to avoid becoming disoriented, to check their body in relation to onlookers, and to hit a freeze or complete a round strategically facing either their opponent or the judges, as can be seen in Figure 3.1. Indeed, a heightened sense of observation is built into the technical training from looking at hand placement while learning footwork and basic power, to returning to a forward-facing position so that the eyes are always oriented back to an imaginary opponent.

While some of the other hip hop styles are less disorienting in terms of bodily direction and balance, several dancers stressed the importance of using the eyes to guide attention to specific components of the technique. For instance, Professor Lock comments on how the eyes create a dialogic relationship with other body parts:

> When you're locking, you're looking like, "Boom! Waa!" Doing that, you might look like that [he pointedly looks at each action]. And then, "Point! Roll! Clap! And put your hand out! No? Okay! Boom!" Like, there's a conversation!

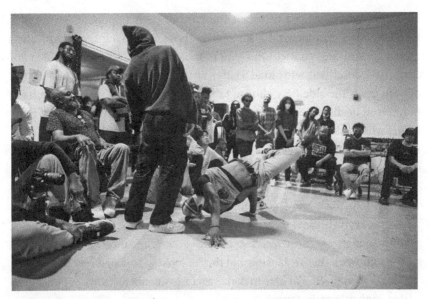

Figure 3.1 B-boy Valme (Jerry Valme) directing his gaze at his opponent as he hits a chair freeze at Armageddon (2022). Photograph by Albert Shin. Used with permission.

Likewise, as Tony Teknik shares, the eyes play a similar role in popping through directing focus toward certain movements:

> Tracing is a big thing with poppers that we do when we're waving and we follow the wave through our body with our eyes or our head.[27]

Yet aside from the technical execution of movement, dancers also think strategically about how they look at their opponent while dancing. Although a few dancers reflected on how they used to, or would still, drop their gaze because they were nervous, intimidated, or did not want to get distracted, many felt that looking directly in the eye of the opponent on their round signals intent to win:

> It's the intimidation factor and letting your opponent know that "I'm with you in this round. I'm not phased by you. I'm here to win this round." You show them that by looking at them in the eye and saying that through your movements. (Mad Hatter)

Dancers also work hard to solicit the gaze of their opponent, sometimes through tricks and burns, but primarily though allowing the technicality, creativity, and musicality of movement to command respect of its own accord. As I described with Mad Hatter at the beginning of the chapter, the opponent on the side may choose to look away as a sign of boredom, lack of interest, or disrespect. For some dancers this would throw them off their game, while others pay little heed as to whether their opponent watches or not. Yet many dancers seemed to stress the importance of a mutual gaze as a central component of battle culture. As Sunny elaborates,

> For me, a battle is more interesting and more engaging when the person is looking at you because there is another factor involved. A battle is supposed to be an interaction between two people . . . So when there's a person that looks up when they're dancing and they're looking at you, it portrays confidence in yourself. I'm here to dance against you, not just anyone else, but this one battle against you.

Along similar lines, Rukkus describes the battle as an intense exchange that signals who people are and what they want:

> You want to make sure they're watching what you're doing, because you're about to show them something. Or you're just trying to get in their head, like "watch!" You know what I mean? I know some people, they just want to be seen. Like if I were to go, you're going to watch me, it's because I want you to watch and you better answer this. I'm hungry. I want to win.[28]

A mutual look forms a central part of battling as both dancers begin the round face-to-face; in spite of the multidirectional use of space while executing their round, dancers regularly return to a face-on position, which allows opportunities for their eyes to meet; dancers almost always end their individual rounds by looking directly at their opponents; and etiquette dictates that whatever the outcome, they finish the round with a congratulatory handshake or embrace to acknowledge the winner. Yet although the gaze is highly interactive between the dancer and their opponent, there are other structures of looking at work in the hip hop battle.

The panel of judges is present to assess the dancers and they issue an evaluative gaze. Judges behave quite differently depending on their personalities: for instance, while some may stare ahead with emotionless expressions, others

will facially engage in the music, grooving out as they watch the round. Some are poker-faced and others smile. It is important for judges not to show their feelings toward a dancer's round, although this is easier said than done.[29] Mad Hatter suggests that judges are generally successful in presenting an impartial look, therefore checking in with how they look does not pay off:

> It doesn't really do me any good when I look at the judges because most of the time, they are like blank faced or like trying to be unbiased with their face.

Yet during their rounds, some dancers clearly sneak a glance to gauge the judges' reception:

> Even though judges aren't necessarily supposed to make facial expressions or give away that they are pleased with certain things, I kind of look for that because it happens. (Jenesis)

A further network of looks emerges from the crowd of onlookers (see Figure 3.2) who can sometimes be a mass of strangers, and on other

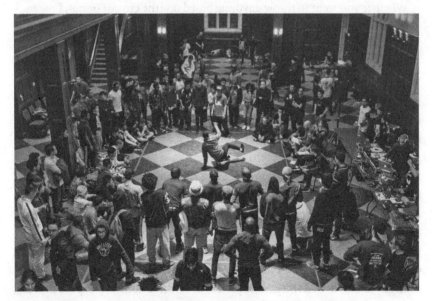

Figure 3.2 The crowd and judges watching a battle at Rhythmic Damage (2016). Photograph by Ed Newton. Used with permission.

occasions be constituted by both supporters and detractors from the local dance community. The gaze of the crowd collectively, or from individuals within that crowd, can certainly shape how people dance. For some dancers, they try not to pay the crowd too much attention as it can prove distracting:

> I've done that before, but I've always felt like if I intentionally make eye contact with people, it kind of throws me off. (Jenesis)

> I've been guilty to that: kind of like just to see how folks are reacting. How the audience is reacting. But ultimately what it does is it pulls you away from the battle itself, which is one on one. So I try not to do that. (Mad Hatter)

For others, it becomes an important measure of how well they are battling or provides energy that they can feed off:

> Sometimes when I'm just in a spot, grooving in one spot, I like to look at the crowd, just to connect with them on that level. (Macca)

> Whether you want to throw anything based on [the crowd] or not, I mean that's what's happening, you're being judged, you're being looked at, and you're participating with their energy also. (Ynot)

Without a doubt, looking constitutes a required and skilled part of the dance. For the dancers, their eyes focus intently on the opponent, both watching and not watching for skill, experience, and attitude. They perform the action of looking to remain focused, to block out distraction, and to mask their mental preparation. While waiting to dance, they shoot out looks to rapidly amass information: the facial tells of the judges, the temperature of the crowd, and the quality of and space on the floor.[30] During their round their eyes direct attention to their virtuosic moves, the intensity of their look alerts us to their desire to win, and the way in which it is received by their opponent shows us the tone and tenor of their danced exchange. At the end of the round, all eyes in the room are set on the judges as they gesture to the best dancer. The decision is called, and the gaze explodes in all directions as people celebrate, commiserate, and look out for the next round.

Feeling the Gaze in Battles

I definitely feel that, or see that, or get that feeling of being looked at a certain way being a young Black woman within America. It's interesting because even though being a so-called international or known b-girl in hip hop, you still get looked at in a certain way too. (Macca)

I don't know when it changed but there was a moment where everybody was so nice to girls and anything she does is okay. And then that made it too soft. It made it like too giving. Like you have to work hard to be in the circle. So if you're looking at me and you're not holding me up to the same standard that you would a guy, that's a disservice that I did not like. There was a lot of easy props. (Rokafella)[31]

These reflections from b-girls Macca and Rokafella indicate how hip hop dance is subject to a racialized and gendered gaze. Although I appreciate that the cypher mobilizes a complexity of gazes, including for males of color who bear the history of a racist gaze, and white dancers who are surveyed for their privilege and authenticity, the intersection of being both female and a body of color leaves these dancers particularly vulnerable to a normative perspective of viewing the world.[32] Macca and Rokafella are highly accomplished dancers, yet voice frustration at how they are seen. Macca, in particular, identifies how this gaze projected upon her is more than an optical power structure. Such is its force that it touches her viscerally and is felt upon her body. Media arts scholar Laura U. Marks (2002) develops the concept of a haptic visuality to illustrate how vision is sensed and embodied and this idea resonates strongly as Macca describes both being seen and feeling this sensation.[33] In this section I explore how women of color experience a hegemonic gaze across lines of race and gender within hip hop battles.

In the "About Face" chapter, I introduced the idea of an *ethical face* rooted in the philosophy of Emmanuel Levinas ([1961] 1969) and a *semiotic face* based upon the scholarship of Gilles Deleuze and Félix Guattari (1987), both of which offer a starting point for examining the face and the politics of the gaze in hip hop battles. Levinas ([1961] 1969) attends to the ethics of a face-to-face encounter, which he conceives as a moral issue. While the temptation might be to turn to murder, hate or violence, Levinas sees this intersubjective ontological experience from a standpoint of generosity as the subject

can learn from the infinite ideas of the Other. Deleuze and Guattari (1987) focus on faciality, a semiotic coding that organizes the human face and other bodily zones. Yet faciality does not pertain to a unique humanistic individual, but is constituted through an abstract machine, which rejects faces that do not conform (Steimatsky 2017). While the two theoretical models sit somewhat uneasily aside each other, in that Levinas conceptualizes the singularity of the face as a resistance to sign systems and their repeatability (Colebrook 2012) and Deleuze and Guattari see the abstract machine of faciality producing a binary logic of difference within specific sign systems (Gallagher 2012), both open opportunities to think about the face, race, and gender.

The look or physiognomy of a face has served as a rationale for inequitable and deleterious power relations, and justification for enslavement and violence on grounds of racial difference.[34] Drawing upon several works by Levinas, philosopher Roger Burggraeve (1999) shows how racism constitutes a failure of the self to appreciate the differences of an Other, and this denial enacts a form of racist violence. Deleuze and Guattari (1987) describe faciality in terms of a white screen and exemplify the white masculine face of Christ as the normative face par excellence. In reference to faciality, women's studies scholar Brianne Gallagher (2012) notes how the visuality of the White Man serves a colonialist agenda, and I would add that its emphasis on the male face supports a patriarchal project with women, trans and queer faces positioned as a deviation from the norm. Similarly, English scholar Ellen Cushman (2005, 390) coins the term "superfacial politics" to show how the whiteness of the face serves as the marker against which all other racial determinations are made.

Dancers come to the battle with a countenance and bodily expression marked in multiple ways. As they stand face-to-face with an Other, this opens an ethical space of encounter between older or younger dancers, novices and OGs, close friends or sworn enemies, dancers with different specialisms, and a spectrum of identity positions across gender, race, class, sexuality, and nationality.[35] Furthermore, as dancers' faces are semiotically coded before they even arrive at the battle, a "superfacial politics" plays out as they enter the cypher arena. During each of their dancing rounds, they come to bear multidimensional gazes from fellow dancers, judges and spectators that make a rapid assessment of their facial appearance, their body type, and how they behave and move in the heat of the cypher. How dancers gaze upon and

respond to one another reflects the politics of their battle philosophy, their attitude to the dance, and their attitude to others in the danced moment. Although the ideas of an *ethical* and *semiotic face* offer a generative place to begin, using three European male scholars to examine dances created by the African and Latin diaspora within the context of the United States, and primarily to think about the experiences of women of color within this field is inappropriate. Consequently, for the remainder of the chapter, I turn to hip hop feminist scholarship (Johnson 2014; Pough et al. 2007) and Black studies (Brown 2008; De Frantz 2004; Fleetwood 2011; hooks 2015) to think about how women of color are positioned and observed under a colonial and patriarchal gaze. Collectively, I use this literature to probe how women of color are envisioned and critique how they have been imagined and invisibilized with hip hop production and performance.

Although hip hop culture appears to represent a diverse and inclusive space given that its foundations developed out of African American, Caribbean, and Latin American expressive practices (Johnson 2015), and its dance forms have attracted wide participation on the global competition stage, how dancers are looked at reflects values and ways of seeing already in circulation and the female dancers of color whom I interviewed sensed the operation of the gaze through their own life experience. As Mad Hatter (see Figure 3.3) reflects,

> As a woman, first and foremost, you're already looked at through a certain lens. Being a woman of color is another layer of that. Being an Asian woman specifically and just like my exterior, like how I look. I look like sixteen, instead of like twenty-four. It definitely takes into play how people perceive me or not. Whether or not they're supposed to take me seriously. Yeah. That's an everyday struggle for me.

Mad Hatter is a petite, Filipino person who at the time of being interviewed identified as female (using pronouns they/she). When I interviewed them, they were in their mid-twenties, had completed a degree in neuroscience, and clearly demonstrated considerable talent as a hip hop dancer, but was frequently infantilized and patronized through a superfacial reading of their gender, race, and youthful visage. Along similar lines, Sunny (see Figure 3.4) also identifies an Orientalist gaze brought to bear upon her as an Asian American woman:

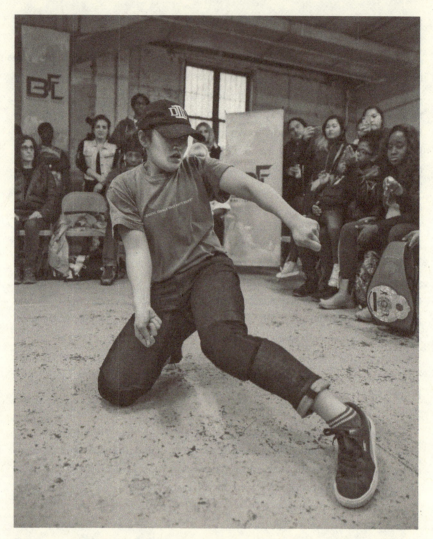

Figure 3.3 Mad Hatter (Béa Martin) battles in New York City. Photograph by Carol Dragon. Used with permission.

There is actually a very big disconnect between how people tell me I portray myself in a dance battle and how I am outside. Growing up in an Asian family, my parents are from Korea, you get taught to be invisible and to kind of hide and not do anything to draw attention to yourself and to be that quiet type of person that goes through life and works hard.

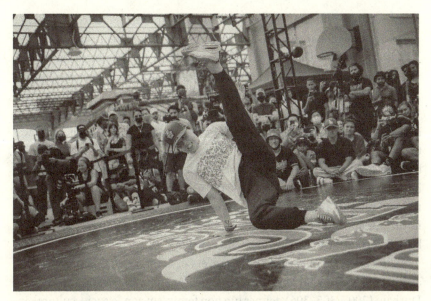

Figure 3.4 B-girl Sunny (Sunny Choi) in the judges' showcase at Red Bull BC One (2021). Photograph by Jeremy Gonzalez. Used with permission.

Here Sunny acknowledges how she is read according to the trope of the Asian model minority (Wong 2010), which excludes the possibility that she can engender the audacious and defiant physicality of a b-girl.

Although all the hip hop dance forms originate as dances of the African diaspora, the position of Black women in hip hop is complicated. Whereas Black men have become hypervisible in contemporary society such that their bodies are constantly screened for measures of normalcy and deviancy (Heynen and van der Muelen 2016), Black women often remain marginalized or invisibilized within the public gaze (Pough 2004). Overall, the continued devaluing of Black bodies within contemporary America cannot be overstated as is evident from the rise of the #Black Lives Matter movement in response to the excessive force against, and unlawful killing of, unarmed Black men and women at the hands of US law enforcement.[36] The fullness of these lost lives is often reduced to a headshot photograph of the victim's face that circulates through the media. Considering the continued racial violence against Black women in the United States, b-girl Macca reflects on her experience in the breaking scene:

> I'm one of the few Black b-girls. It's like people can be in awe, but still have a lack of respect in a sense. I think that also comes with the whole debate of

hip hop being something that was invented within the Black community. You see different acceptance and embracement of different cultures of b-girls. Because there's all these huge communities, these cultures that have taken on breaking, so there's not that much of a Black presence compared to Asians or Latin American or Spanish or white b-girls.

Indeed, the marginalization of Black bodies within breaking generally was the subject of an online debate in June 2020, moderated by Macca and b-boy Box Won, titled the Black Xperience, which addressed topics such as hip hop's birth out of white supremacy, the war on Black people through institutional racism, and microaggressions within breaking events.[37] In spite of its diverse appearance, race occupies a fraught space within hip hop culture both in terms of who dances and who benefits.

As my interest concerns female dancers of color, hip hop feminist scholarship provides a vital lens through which to frame this experience. Aisha Durham (2007, 305–306) defines hip hop feminism as a "a socio-cultural, intellectual movement grounded in the situated knowledge of women of color from the post–Civil Rights generation who recognize culture as a pivotal site for collective intervention to challenge, resist and mobilize collectives to dismantle systems of exploitation." I am mindful of Jessica Nydia Pabón-Colón's (2017) caution that hip hop feminism arises directly from the life experience of Black females and other women of color. Therefore, rather than positioning myself as a hip hop feminist, I am grateful for the opportunity to benefit from this work as a guiding frame to support how I might see female dancers of color within hip hop battle spaces.[38]

While one area of hip hop feminist scholarship focuses on the hypersexualized Black female dancing bodies that feature in rap music videos (Durham 2007; Story 2007; Washington 2007), another substantial area focuses on women in the breaking scene. Women who participate in breaking enter a practice rendered visible as a male-dominated dance form that is discursively framed as masculine (Gunn 2016). Although women have been involved in breaking from its inception (Aprahamian 2020; Washington 2007), hip hop history and scholarship have largely invisibilized women's contribution to the form (Himanee Gupta-Carlson 2010). Sometimes referred to as b-boying rather than breaking (Gunn 2016), women are sidelined because its public image foregrounds athletic power moves, aggressive attitudes, and gestures of violence and derision, hence assumptions regarding a lack of physical capability and competitive drive position b-girls as marginal

figures in the scene (Fogarty et al. 2018; Johnson 2014; Washington 2007).[39] Notably, Pabón-Colón (2017) observes that although viewed as a subcultural space, conservative views on women complicate the mainstream/marginal divide in hip hop, and Mary Fogarty et al. (2018) assert that b-girls are both monitored and trapped within the lens of a patriarchal gaze. Furthermore, while other hip hop styles typically stage mixed sex battles, breaking often divides its participants into b-boy and b-girl competitions and the gender-specific language that characterizes breakers as a b-girl or b-boy delineates a clear binary order. Although I only know of two nonbinary b-girls, as increasing numbers of people identify as nonbinary or gender queer, I anticipate that those within breaking culture will need to address this somewhat conservative position.

The above concerns clearly resonate with both the b-girls whom I interviewed and other female dancers across a range of hip hop styles. Sunny, an elite b-girl and international competitor, draws attention to how she bears a hegemonic gaze and to the fragility of masculinity when it is countered by female superiority:

> It's not expected for somebody who looks like me to be doing what I do and what ends up happening is that men who don't know who I am underestimate me . . . With a lot of them, ego comes into play even more because they don't want to lose against a woman and most won't admit it. But I've had people come to me: "I would throw out all my hardest moves against you because I cannot lose against you."

The same goes for Mad Hatter, who is skilled in locking, popping and krumping, as they explain how superfacial judgments regarding race and gender are proved wrong:

> Often, I do end up battling men. For those who don't know me, of course their impression is like, "Oh. This is another like college Asian woman and she's probably just not as experienced in the battle scene," . . . and not to toot my own horn, but I do prove their impressions wrong. They always underestimate me when I come into the circle and especially if they don't know who I am and they're not familiar with me.[40]

Even in house dance, a scene that is generally considered to be less combative and aggressive within competition battles, Jenesis identifies the same kind of

gendered assumptions regarding physical power and the felt impact of the male gaze:

> I do feel like there is a male ego that isn't said, but it's felt because I think that sometimes males feel like they won a certain battle over a female when they really didn't. They kind of feel like they are better because they're more athletic. . . . Sometimes people think the more athletic that someone dances, means they are a better dancer. Because females don't necessarily go towards that, even though there are plenty of athletic dancing females, females don't necessarily dance that way.

Although I have seen many instances of male dancers treating female dancers with courtesy and respect at battles, the common belief that hip hop dance is male-oriented and men do not like to lose against women continues to circulate in the scene.

The presence of a male gaze undoubtedly operates in hip hop battles and opportunities for women to gain the social and economic capital that benefits male dancers is evident from the institutionalized structures of hip hop that place men at the center. I use the example of Macca, who was the first b-girl to receive corporate sponsorship by Monster Energy, has won multiple breaking battles, and has represented the United States at international breaking competitions as part of a b-boy team. She states,

> Your views or thoughts or opinions or knowledge doesn't get looked up to as high as some other b-boy . . . For example, I've been breaking for almost fourteen years now. There's limited judging and workshop opportunities out there really and you deal with someone who's been breaking for five years getting more work than you are. A lot of people don't want to hire b-girls. They don't want to take this so called risk on b-girls being the judge in these bigger level competitions. You deal with that all the time and I dealt with it a few times firsthand. I remember there was an event that I got flown out to France to be part of a team. I went all the way out there, and we finally compete. Everyone got to go out. And then I was waiting, I was like, "Yo, I need to go out. We're going to win if I go out." But then they just push me aside, and then so-and-so goes out, and his round was so bad. It was not even strong and afterwards they were like, "Damn! We should have had you go out!" You consistently deal with that stuff.

Although women of color are represented on the competition stage and respected as elite dancers, the fact that all the women I interviewed had experienced some degree of misogyny suggests that they continue to be seen as the second sex.[41]

The superfacial politics of how bodies and faces are marked and then gazed upon reveal power structures from quotidian life that enter the hip hop battle scene. For female dancers of color, the haptic operation of a male and colonial gaze gains purchase upon their bodies, which ensures that social, aesthetic, and economic exclusion or marginalization reaps material consequences. Therefore, much remains at stake in terms of how they counter this in their danced response. In the final section, I examine how the creative space of the cypher allows dancers to think carefully about how they look back.

Check Out the B-Girls

> I think that if that person is looking at you, if you can convince them that you're not phased, you're not distracted, you're not convinced that they're better than you, to me, that is defiance and that's hip hop. Hip hop is defined in the very beginning when we were left to rot in those horrible neighborhoods that were burnt down. We were left to die and we came back. And guess what we can do now and give me a mic, and give me a spray can, and check what I can do on this floor that has glass and syringes on it. Check us out! (Rokafella)

Within this quotation, B-girl Rokafella, a highly respected early generation dancer in the breaking scene, encapsulates some essential ideas regarding the operation of the gaze in hip hop. The notion that b-girls can stage a defiant performance that pushes back against a superior (male, colonial) gaze and that they assertively invite an onlooker to "check us out" speaks to their capacity as dancers to take back control of how they are envisioned in the cypher.

Outside the mutuality of all-female battles, female dancers of color have developed strategies to confront reactionary structures of looking that invisibilize or marginalize their bodies. While many spoke of the doubts or insecurities they have experienced, along with micro-aggressions too numerous to mention, through time they have acquired an embodied battle

knowledge that challenges a dominant, yet anachronistic, racialized and gendered gaze. I frame this as a "defiant look" that does not gaze back through simply reversing the field of visuality. Instead, b-girls stage a performance of looking that refutes the gaze projected upon them through the choreography of a hip hop feminist riposte.[42] Earlier in this chapter, I describe the potency of the gaze and structures of surveillance that dominate contemporary society; however, this panopticon model does not account for the pleasurable experiences of being watched or for the agency of determining how one is looked at (Heynen and van der Muelen 2016). Consequently, how b-girls envision their self-production in the creative space of the cypher awards them opportunity to think carefully about how they choose to look back. In this final section, I explore how two b-girls, Sunny and Macca, individually confront this hegemonic gaze within breaking battles through the same sense of embodied defiance described by Rokafella.

In the previous section, I note how the semiotic coding of faciality concerns itself with deviation from a white, masculine norm (Deleuze and Guattari 1987). The colonialist perspective that assumes female bodies of color, which do not conform to Europeanist feminine standards, are "uncivilized" resounds in the advice sometimes uttered to b-girls that irrespective of their capacity to embody a broad range of breaking vocabulary, they should dance in a more feminine style (Gunn 2016; Washington 2007). In thinking about how b-girls negotiate the discourse of masculinity that subsumes the world of breaking, Imani Kai Johnson (2014) proposes the concept of a "badass femininity." She conceives this through attention to marginalized femininities, which she traces back to the bodily behaviors of Black women within blues music. She purposefully rejects that idea that b-girls are "tomboys," which is rooted in masculine characteristics, and instead suggests that most b-girls want to operate within a paradigm of femininity. Yet this is not a normative femininity, but one that embraces a "brazen and authoritative stance" (Johnson 2014, 20). Although I feel frustration that women continue to be delimited by the persistence of a binary gender matrix (Gunn 2016), I appreciate that Johnson's nuanced conception of femininity is rooted in African diasporic performance and resonates positively with the sensibility of defiance described by Rokafella. Furthermore, Johnson's attention to a badass femininity can be deployed along with Gwendolyn Pough's (2004) concept of "bringing wreck." Within hip hop terminology, to "wreck" means to fight or recreate, and a wrecking crew describes a rap group that destroys or "wrecks" another (Pough 2004). In reference to Black female rap artists,

she describes how they "bring wreck" to negative representations of Black women (Pough 2004). Most notably, Pough (2004) conceives this in terms of the gaze issued upon Black women and asserts how female hip hop artists take control of it by showcasing their skills and right to self-determination in the public domain. Pough's (2004) interest in notions of show and spectacle in female rap performance are equally productive for examining women of color in breaking battles, and I look to how Sunny and Macca willfully invite attention in the cypher through an embodied insistence that they should be seriously checked out.[43]

At Skillz Over Politicz Street Dance Competition in 2016 at Johns Hopkins University, at the beginning of her Top 16 round, Sunny looks directly at her opponent, b-boy Akuma, feeling the groove of the music. She opens her arms wide, as if to embrace all that lies before her, and issues the biggest smile before clasping her hands and stepping out exuberantly into the circle. She hits Akuma with an outburst of power moves from the get-go: two flares into hand spin into a back flip. She lands it with hands on hips and a huge smile across her face staring directly at him. She then toprocks toward him, retaining her open and generous smile, not allowing her gaze to drop once: step ball change, twisting feet, kick cross step, delivered with her sweet smile and laser-like gaze. Down to a fast footwork combo of six-step, kick outs, Zulu spins, and back rock, all the while looking and smiling right at her line of attack. She threads like a pretzel, knocks out a little more footwork, then lands a freeze, body reclined, hand clasping ankle. She smiles and nods, still holding her penetrating stare, to punctuate the end of her round. The crowd erupts with cheers and applause. Aside from the clarity, creativity, and musicality of her round, she clearly refutes, or brings wreck on, the role of the invisible Asian female that she describes earlier in the chapter. With apparent ease, she takes on the so-called masculine attributes of power, throwing down moves that are beyond the reach of many b-boys.[44] Throughout, her eyes remain fixed upon her opponent not with the aggression associated with all-male breaking battles, but with a huge smile that variously indexes between her pleasure in dancing, a warmth toward the exchange, and a mischievous knowledge that she has absolutely smoked him. Her facial expression does not allude to the white feminine smile I describe in the previous chapter, but in tandem with her entire danced exchange offers a position of control and defiance. Her bodily state of being looks back at him with confidence, imagination, and aplomb. As she wins the round, her badass corporeality is clearly in play.

Macca, on the other hand, shoots for an explosive attack, often accompanied by a provocative frown, as part of her strategy for defying a hegemonic gaze. In literature scholar Jayna Brown's (2005) study of early twentieth-century theatre, she describes how the Black female performer is gazed upon, but she also gazes back. Brown details how the Taylorized and Fordist practices of early modernity fragmented the worker's body into individual components such as hands, feet, and eyes. For Black women specifically, this produced a double consciousness as they remained unseen in the development of urban cultures, but on stage her body was spectacularized. Brown suggests that the Black female performer needed to look in all directions and suggests that her body worked as a mode of questioning. Fleetwood (2011, 29) also writes about how the Black female body is often rendered invisible yet troubles the visual field because of its fleshy excess: it appears "too much" in relationship to white, feminine norms. For Fleetwood (2011), the Black body has both been held captive and inserted into capitalism, which delimits its agency in the visual field. Although Fleetwood (2011) acknowledges the essentialism that surround Black bodies and performance, she uses the concept of performativity to critique the scopic frameworks that visualize singular Black female representation. I think of Macca's experiences as one of the few African American women dancing in elite breaking competitions and how her body is often sidelined for economic opportunity but made spectacular through her dancing ability in a male-dominated field. Yet I also see how Macca confronts this, in the way that Brown and Fleetwood describe, through a defiant, questioning, and excessive physicality.

Macca brings wreck on the marginalization of Black female bodies through a dynamic set of dance arsenal that absolutely demands that the eyes in the room check her out. She also deploys a badass femininity as her intense breaking persona works her body to bat the gaze right back. She is a petite African American woman who always battles wearing large dangling earrings that dance around her head as she grooves to the beat with musical prowess. Although Macca can throw down power moves if required, her signature style concentrates on highly energized top rock, that constantly cites dances of the African diaspora, and rapid-fire footwork that is slick, clean, and whizzes past in the blink of an eye. Her dancing is rooted in Africanist sensibilities, such as a "flash of the spirit," "high-affect juxtaposition," "ephebism," and "aesthetic of the cool" (DeFrantz 2004), which grounds her body firmly within a Black tradition. Her explosive movement switches from high to low, fast to slow, and in her everyday streetwear of blue jeans and

sneakers, she never breaks sweat in the heat of a battle.[45] Although she sometimes smiles as she dances, I associate her battle face primarily with an intense frown and piercing gaze that cuts straight to the heart of her opponents.

In 2018, she posted an image on Instagram that encapsulates her ability to bring wreck on a normative femininity, which Johnson (2014, 20) describes through a "ladylike" image, racially positioned as white, of "appropriateness, respectability and passivity." Pictured during a battle, dressed in a cherry red shirt, white sneakers, and faded ripped jeans, Macca half kneels, leaning to the side, one hand placed by her hip, the other stylishly raised to her head with fingers artfully splayed. She stares intently at the camera, teeth clenched, and her brow deeply furrowed as though deep in thought. Here I recall hooks's (2015, 129) insistence that Black people should "interrogate the gaze of the Other" and look back as a mode of resistance. Macca's entire image centers on her piercing gaze, and her body seems to simultaneously pose a question and provide the answer: What is it to be a b-girl? Check out how I do this! Beneath the image, her poetic commentary states, "Pretty Face or Not, Grimy or Hot, character doesn't always come easy cheesy." I asked Macca about this post, and her response swiftly eschewed the values of a normative and benign white femininity:

> I think if you're focused on having a pretty face, you're not really in it. You are not a hundred and ten percent in it because you are trying to maintain that pretty face . . . It's important that I show that you don't always have to make a pretty face, have a sexy face on or whatever, and it's okay to look strong. You know, it's *okay* to look strong!

Here Macca unapologetically embraces a badass femininity and brings wreck by forthrightly looking back on a gaze that serves to invisibilize or marginalize her as a Black woman in a commercial male-dominated dance scene. Her refusal to stage a normative face, her slick pose, and her provocative frown forthrightly call upon the spectator to check out an alternative vision of Black womanhood.

Within the creative space of hip hop battles, this chapter establishes that dancers engage in performances of looking that deviate from social norms. While dancers look to amass and evaluate information about their opponents, the judges, and the crowd, they also enter into performances of looking that can disrespect, confront, or intimidate their opponents. This ocular choreography moves beyond the generally acceptable codes of looking

that characterize everyday life. For female dancers of color, a superfacial politics is evidently in operation, which ensures that they are stereotyped, misread, and underestimated according to modalities of race and gender that already circulate outside the battle realm. Yet I resist the idea that dancers are the passive recipients of this gaze.

Using two b-girl case studies, I suggest they harness their corporeal skills to confront an outdated hegemonic gaze head on and deploy the action-expression of a look: in this instance, they look back with a strong sense of defiance. This ocular pushback might also be considered in relation to other female artists of color. I think specifically of the powerful gaze issued by popular music performers, such as Beyoncé, Janet Jackson, Missy Elliott, Cardi B, and Megan Thee Stallion, or the queer *tangueras* and "rebellious wallflowers" who engage in same-sex (female) tango dancing in largely heterosexual dance spaces in Buenos Aires (McMains 2018). Returning to my b-girl examples, Macca and Sunny collectively stage an embodied refusal to internalize sexist and racist structures of looking brought upon their bodies, both in everyday life and within battle culture, through a self-assuredness in their individual styles. They issue a defiant look, refusing to be co-opted by this haptic ocular power structure. Consequently, a hegemonic gaze fails to make purchase on their bodies, and they bring wreck upon how their bodies have been (un)seen. The creative space of the cypher enables them to refute this look for all to see and their resistance stands in plain sight. They take control of their desire to be looked at, and they envision and action how they want to be seen. In the words of b-girl Rokafella, "Check us out!"

4
FROWN

Turn that frown upside down.

A close-up of a ghoulish face, set against a haunting blue night sky, black curls framing the angular cheekbones, lips tightly shut, wide piercing eyes staring intently ahead, and a deeply furrowed brow set in a menacing frown. Cut to a beautiful young woman, dressed in denim, terror imprinted on her face. A bass guitar riff kicks in as the camera returns to the ghoul, wearing a red leather jacket, ripped and soiled, and baring teeth as he pants in time to the music. The camera pulls back further, revealing a dark phalanx of ghouls, faces rotting and clothes in tatters, behind the leading figure. In unison, this motley crew begins a dance of the living dead: tight shoulder isolations, steps forward with sharp pelvic thrusts, shunts to the side throwing scary arm gestures, heads flick up and down, reaching tall with hands stretched up, and then shimmying down in a wide side-step, using biting actions, flashing teeth, and brows casting a dark shadow to create a horror show of facial choreography. Our star ghoul placed front and center, in red trousers, white socks, and black loafers, leads the pack, galloping forward, shoulders shimmying, rocking hips to either side, walking back and forth with claw-like hands, arms wave, hips thrust, pelvises jut, and feet stomp in a spectacular demonic dance. Our beguiling ghoul flashes the whites of his eyes, clenches his snarling teeth, and creates a frown so intense that it appears etched upon his face.

 I suspect that many readers will recognize this iconic movement sequence from Michael Jackson's music video for his single "Thriller" (1983). Given the extent to which Jackson smiled as a child performer and young artist with his *Off the Wall* album, to witness such an abrupt change in facial expression was somewhat arresting. Even more so given the popular English phrase that opens this chapter, which firmly insists that a frown should be eradicated from the face and replaced by a smile. Whereas a smile conveys

pleasure, happiness, and contentment, a frown signals contemplation, displeasure, frustration, confusion, and even rage and anger. To create a frown, the corrugator muscle knits the brow together and the procerus muscle pulls the brows down causing a wrinkling of the forehead (McNeill 1998). Moving the brows in this way can dramatically alter facial expression (Perrett 2010), producing a moment of spectacle and drama. In North America, the frown is not only associated with the brow, but also constitutes a downturned expression of the mouth, hence the command to flip a frown into a smile. Furthermore, the action-expression "to frown" connotes an attitude or point of view, in the sense that one might frown upon something. I therefore develop the idea of a "provocative frown" to show how the face within popular dance might intentionally question or provoke a set of social norms. In writing about African American author and activist James Baldwin, dance scholar Rosemarie Roberts (2021, xiv) describes how his "furrowed brow" embodies a history of social inequality for Black and Brown people.[1] Her attention to the link between racial injustice and Baldwin's frown resonates with this chapter, as I focus on Michael Jackson and my community of hip hop dancers to explore how the frown serves to express discontent and offer provocations regarding the ways in which bodies of color are read but can destabilize those assumptions.

In each of the chapters, I see the face as a historical register, and the FROWN chapter is no exception. I show how the action-expression of a frown both reveals and disrupts popular dance histories, such that at times it works anachronistically and therefore requires modification. First, I return to Michael Jackson and his ascendency as a superstar performer. As Jackson further developed as a solo artist with the release of his second album *Thriller* in 1982, two changes occurred: he began to take a serious interest in working with the screen to present his pop star image; and his smile more or less disappeared from his musical performances and was replaced with a frown. The renunciation of his tenacious smile that was racialized through the machinic systems of Black popular performance marks an epistemic rupture, leaving him somewhat vulnerable regarding the desires of his audience.[2] Needing to animate an alternative set of facial registers, Jackson turned to the frown. Here, I draw on Henry Louis Gates Jr.'s (1988) concept of "Signifyin(g)," to show how Jackson's frown works critically through a choreographic play of double meanings. The second half of the chapter then comes back to hip hop dance, but in this instance I look specifically at the facial choreography of b-boys and b-girls who engage in the art of breaking.

Breaking is perceived as the most aggressive of the hip hop styles as dancers participate in a fierce level of one-upmanship in battles and cyphers. I draw on hip hop scholarship (Aprahamian 2019; Schloss 2009) to examine how the frown engenders actual and mythologized histories of breaking, and how b-boys and b-girls position themselves in relation to this through their facial expression.

Michael Jackson and the Intention to Be Bad

In the introduction, "About Face," I describe the intimate relationship between the face and the screen media as the directorial focus of the camera can capture and compose facial expression in precise and intentional ways (Coates 2012). With the release of the *Thriller* album, Jackson began to work with music videos or short films, which were character-driven, narrative-oriented, spectacular musical performances. As art historian Kobena Mercer (1986, 26) observes, *Thriller* catapulted Jackson into the status of a "megastar" as the album proved to be a huge commercial success and it provided Jackson with a heady personal wealth. Part of its success came about as the album coincided with the development of the cable television station MTV, which was dedicated to screening popular music videos to market the music, and Jackson capitalized on this.[3] In his autobiography *Moonwalk*, Jackson says of the three music videos from *Thriller* ("Billie Jean," "Beat It," and "Thriller"),

> I was determined to present this music as visually as possible . . . I wanted something that would *glue* you to the set, something you'd watch over and over. The idea from the beginning was to give people quality. So I wanted to be a pioneer in this relatively new medium and make the best short music movies we could make. (Jackson 2009, 200, 202, emphasis in original)

Although Jackson did not direct the three short films from *Thriller*, he clearly exercised significant artistic command. As Taraborrelli (2010, 239) notes, "The reason he so enjoyed making music videos was because, in that format, he could have complete control over the final production. Every aspect of his performance could be perfected—either by multiple takes or by careful editing." I therefore consider how Jackson re-choreographed his facial expression away from a glossy and tenacious smile toward an unruly and provocative frown. Although Jackson continued to smile for public appearances

and publicity shots, Fleetwood (2011, 215) notes that images of his smiling face became increasingly rare later in his career, and she describes this smile as "one of self-satisfaction and self-awareness of his accomplishments." Her point underscores the genealogy of his smile that changes from an eager performance seeking to please the racialized demands of a white music industry to a smile that takes pleasure in a willful sense of agency. As Jackson gained greater artistic control, he dropped the minstrel legacy of the smiling entertainer, but as I will show in the SCREAM chapter, he also had less to smile about.

"The Girl is Mine" (1982) was the first single released from *Thriller*, but the second, "Billie Jean" (1983), hit number one on the Billboard charts and was the first to have an accompanying music video, which was played on heavy rotation on MTV (Taraborrelli 2010). In "Billie Jean" the perpetually smiling showman has disappeared and been replaced by a more pensive performer who frowns and purses his lips as he sings. Indeed, he continues to frown his way through multiple musical performances, which I examine in this chapter: "Beat It" (1983) from *Thriller*, and then "Bad" (1987) and "The Way You Make Me Feel" (1987) from the follow-up album, *Bad* (1987). Given that these short films span two LPs, it demonstrates Jackson's sustained commitment to his new mode of facial expression. Across the three films, he explores screen characters that are marked as streetwise and potentially dangerous, which are far removed from the sweet and boyish performances conveyed in his early career.[4]

The fictional scenario for "Beat It" concerns two gangs preparing for a street fight and Jackson plays a lone outsider first introduced in a spartan bedroom. A string of shots shows the gang members, dressed in an assortment of leather, denim, chains, and bandanas, heading off to their rumble while Jackson lies on the twin bed and sings, "You want to be tough, better do what you can, so beat it." Although his face is relatively still in expression, he spits out the words in a staccato and insistent manner. As he rises from the bed, singing the chorus "Just beat, beat it!" we see a slight curl of his nose as his brow tightens. Jackson exits his apartment building, dressed in a sharp red leather jacket, and enters a deserted diner and billiards room, which the gang members had previously occupied. He maneuvers around the space with fast spins, angular arm gestures and a flick kick of his leg onto the billiard table, and while singing his brows pull strongly together and his nose wrinkles in a look of disdain. As he reiterates the words "beat it," a close-up shot centers on his face, and he displays his teeth with an open mouth and lets out short

panting breaths on beat. His intense mouth and heavy brow both visualize the rhythm of the music and foreshadow the physical "beating" that is about to take place. As Jackson enters the warehouse where the fight has just begun, he continues to sing with a slight frown troubling his face. He moves directly between the two gang leaders to prevent their one-on-one knife combat and instead leads them and their members in a unison dance. Initially, his gaze is directed down as he sings intently with a hint of a frown crossing his face. Later he pushes out his lips to produce a rigid lower jaw and heavy brow all the while executing flamboyant body ripples, isolated hip thrusts, quick-fire leg kicks and dazzling spins. Most notably, at no point does he smile.

To return to the idea of a *sociocultural face*, Jackson's frowning countenance cannot be trusted as an authentic expression of his state of mind, but as a performed expression of an attitude he seeks to convey in relation to the theme of the song and film, and how he wishes to project himself as an artist. Unlike the polished yet superficial smile of his early career, Jackson re-choreographed his face to signal frustration, rage, and contemplation. In "Beat It," Jackson exerts his facial disapproval of gang violence, but also distances himself from the joyous expression of his earlier work to emanate a more serious, agitated, and brooding persona.

In an essay on the politics of Black performance, bell hooks (1995) argues that African American expressive practices are either rooted in traditions of ritual play or in a performance of survival. She likens the latter to wearing a mask, and conceives the former as a mode of art. While both might appear similar, she states that the critical attitude differs as the performance of survival "can easily become an act of complicity," whereas ritual play "can serve as a critical intervention, as a rite of resistance" (hooks 1995, 210–211). To return to Jackson's early-career smile, although its glossy, mask-like appearance denied spectators the opportunity to fully comprehend its intent, it served the purpose of allowing the Jackson brothers as young, working-class African American males to survive within the context of a racist popular music industry. As Jackson began to introduce the frown as a performative mode of expression, I ask whether this was simply another form of masking that complied with the demands of a white popular music mainstream, or whether it was a ritual play that allowed him to resist the limited representational framework offered to Black men. To be able to drop the smile, to facially vent or issue a provocation against the demands placed upon him, potentially offers opportunity for a face that purposefully expresses feelings of frustration or a face that intentionally embodies experiences of rage. To

consider this further, I explore two more short films to analyze how Jackson's frown choreographs meaning into his performance.

"Bad" was the second single to be released from the *Bad* album, and the film takes place in a deserted subway station with Jackson as a tough streetwise character.[5]

The film opens with Jackson, dressed in black leather, studs, and fingerless gloves, flanked by a gang or crew of dancers and, in a close-up shot, he gestures a rapid sideways nod and grits his teeth together prompting his nostrils to flare out.[6] As the instrumental introduction kicks in, the dancers commence a stepping motion forward, and throw in isolated hip thrusts to the side, as three solo dancers cross in front with spectacular leaps. Over the low bass riff and rapid snare, a few cries of "ha" and "hoo" are percussively sounded out by Jackson and the dancers as they sporadically kick out a leg, duck down, and cast rapid punches as if in combat. Throughout this, Jackson frowns, purses his lips, juts out his jaw, and bares his teeth. As he sings the chorus, his performance style appears intense and menacing. The camera cuts to close-up as he sneers the words "I'm telling you, oh how I feel" and his face emits disdain: his nose wrinkles, mouth twists down, and brow furrows. The overall look expresses an edgy aggression, echoed in the lyrics, "Gonna go after you, gonna hurt your mind, don't shoot to kill, come on come on." At one point, he grabs his crotch as a potent sign of his command, followed by a close-up in which he lowers his head to produce a deep frown further magnified by his arched eyebrows and downturned mouth in marked opposition to the smile. Again, his teeth flash in warning and, at intermittent points, he crudely wipes his mouth with the back of his hand as if having salivated or feasted. In the lead-up to the chorus, Jackson and his group race through the subway, eventually leaping over the ticket barriers, with no respect for place or authority. He then launches into "You know I'm bad, I'm bad," which repeats several times throughout the chorus. I will come to the double meaning of African American orature in the following section, but for now I note that "bad" also means "good" in Black vernacular speech. Thus, on the one hand, Jackson presents himself as morally bad in that he appears to trespass in a subway station after hours, surround himself with gang members, and show little reverence for property as he pulls the cover from an air vent so that smoky condensation blows into their performance. Yet on the other hand, he is bad in the sense of being incredibly good artistically. His singing and dancing ability are outstanding as his group fall into a precision unison routine reminiscent of the musical numbers from *West Side Story*. All the while, he sings with the same curled nose, intense frown, and tight lips. Although the group

dancing is staged in long shot, the camera regularly closes in on Jackson's face to remind us of his threatening persona. He bites his lip, he snarls, and he glares, frequently accentuated by a pointed frown.

In terms of how the frown and its accompanying facial expressions might be read within the context of "Bad," at face value it seems to play into a pernicious representation of the Black male body. The use of the frown to portray an aggressive and immoral persona are tied to stereotypes of a Black criminality, and the biting and teeth baring convey the savage or animalistic. As several scholars show, ideas of an uncivilized and unruly body have been mapped onto Black male representation. In an essay on Jackson's short film "Black and White," Joseph Vogel (2015, 95) comments on how D. W. Griffith's epic 1915 film *Birth of a Nation* marks the origin of American film within a racist structure of representation and how its racial tropes have persisted; he describes how the Black characters are "most often presented in shadows with manic and animalistic expressions." In a discussion of popular music production, musicologists Susan McClary and Robert Walser (1994) observe how the body is frequently elided in European cultures, whereas African-based music practices seek to bring the body to life through dance. They recall how European colonizers subsequently conceived embodied responses to music as primitive or uncivilized, and the same perceptions have haunted the reception of African American popular music. Theater scholar Annette Saddik (2003) further illustrates this thinking through her notion of an unruly body in relation to African American rap music. She describes how the gangsta rapper's body "threatens the mainstream white authority that seeks to keep the "savage" in its (his) place" (Saddik 2003, 121). Although Jackson may not have consciously been working within tropes of primitivism, he chose to embody the stereotypes of an angry or criminal Black body articulated in part through a raging frown.

It is also worth noting that despite the streetwise persona engendered in the video, the staging of the choreography is highly theatricalized through its unison formation and front-facing presentational style, with Jackson positioned as the star performer. Additionally, Jackson wears his hair in long shoulder-length waves, along with dark eyeliner, eyeshadow, and eyebrow pencil to enhance the shape of his eyes, which feminize his look. Furthermore, the collection of dancers dressed in denim, black leather, and silver studded belts and wrist bands, entertains a queer sensibility. The butch dress code alludes to gay male culture, while the slick dance routines might be read as a camp and hyperbolic performance. Yet during the 1980s, many popular music artists troubled their cis-gender identification through experimenting

with dress and cosmetic appearance, thus Jackson was not alone in this regard. And while this queerness hovers in the look of the performers, the enraged facial expressions and provocative frown issued by Jackson speak to a strictly masculine expression that pushed back against his contented smiling countenance in his early career. I also see this slightly camp theatricality as another mode of Black survival as Jackson had to stage a careful balance between a streetwise adult image and appealing to a broad family audience.

To return to Jackson's changing facial expression, I move on to consider his next short film, "The Way You Make Me Feel," as it also deploys a frown to flirt closely with another injurious representation of the Black male body. It again presents Jackson as a streetwise character but in place of the homosocial interactions with a gang of men, "The Way You Make Me Feel" centers on a heterosexual encounter with a female. Consequently, the frown is less an indicator of moral turpitude than heightened sexual pleasure. The action is set late at night on a grimy street with graffiti-strewn walls and trash on the sidewalk. A rap song plays in the background as a beautiful young woman in a tight black dress and stiletto boots walks toward a figure cast in shadow. She passes by and the camera cuts to reveal a close-up of Jackson, who takes a breath as if to inhale her scent and to compose himself before he shouts "Hey!" Silence falls, she stops, turns back toward him in a close-up of her stunning face, and the camera briefly cuts to several men hanging around on the street who openly stare. The camera returns to Jackson, who wrinkles up his nose, frowns deeply, and curls his lower lip, the mobility of his face magnified by the silent attention. Several tense close-ups quickly follow as she stares, he stares, and his fingers issue a click, before he slowly walks toward her and circles around her. Without warning, he breaks the silence as he passionately sings, "You knock me off of my feet now baby" and emits a high-pitched "Wooh!" As the instrumentation kicks in, Jackson launches into some of his now trademark dance moves: an arm and leg flick out sideways, a fast spin in place, a shuffle of the feet, a pop of the chest, and finger click. The remainder of the film involves the woman walking away from Jackson, and him pursuing and halting her as he sings and dances in her personal space. And although much of the video casts the two protagonists in shadow, we see what have become signature facial expressions: explosive delivery of the lyrics, biting the lower lip, a clenching of the teeth, the flash of a flirtatious smile, a protruding jaw, an extreme pursing of the lips, and a deep penetrating frown. The film ends with a tender hug between the couple.

"The Way You Make Me Feel" maintains Jackson's move away from a persistent smile to a deep-set frown and its related facial expressions. Yet on

this occasion, different meanings are mobilized. The tone is clearly (hetero) sexual as Jackson sings "You really turn me on," and on several occasions marks out a curvaceous womanly shape with his hands while repeatedly thrusting his pelvis forward. Thus, the frown becomes linked to a concentrated sexual desire, occasionally reminiscent of the unleashed and contorted expression associated with sexual climax rather than the studied composure of a chaste smile. At times the issue of consent appears ambiguous as the female struggles to escape his pursuit: either Jackson or the other males block her, and at one point she arrives at a dead end. Yet she eventually meets a group of girlfriends and laughs flirtatiously in Jackson's direction as if their interactions are all a playful exchange, and Jackson sings "I've never felt so in love before, just promise baby you'll love me forevermore." Hence, the frown shifts between denoting a predatory sexual desire and a sincere expression of love. Either way, this film falls into a troubling representation of Black masculinity: that of the hypersexual and predatory Black male.

Several scholars consider this trope both within the popular imagination more broadly, and in response to popular music and Michael Jackson specifically. Sociologist Herman Gray (1995) uses the example of African American jazz performers to show how self-representations of Black masculinity were created in response to dominant structures of race and gender. On the one hand, African American male jazz musicians exceeded codes of white propriety through embracing pleasure, sexuality, and defiance; yet this played into a normative heterosexual framework, which produced unequal power relations between men and women. Comparative literature scholar, Monique Guillory (1998) stages a similar argument in her assertion that male jazz artists sought to correct and overwrite a history of enslavement and discrimination through their self-confidence, aggression, and pleasure-seeking behaviors; however, this creates a Black hypersexuality, which is both celebrated in the white mainstream and perpetuates a misogynistic and patriarchal social order.[7] In his essay on the mobile identity positions of Michael Jackson, English scholar Michael Awkward (1995, 190) suggests that although he often demonstrated the social construction of race and gender through his surgical and cosmetic transformations across supposedly fixed identity markers, he also fell back on essentialist and racially charged signifiers such as his "crotch grabbing," which Jackson claimed to be impulsive rather than premeditated. In an essay that similarly seeks to grapple with Jackson's unstable identity position, popular music scholar Susan Fast (2010) asserts that while he presented a provocative sexuality in his later career, many doubted this as they assumed his (hetero)sexuality was a fiction.

That such attention centered on his adult sexuality perpetuates the narrative of fascination and fear that aligns Black masculinity with an unbridled sexuality.

Given that Jackson expressed such frustration over the way he was trained to smile on command as a child performer and young man in the early part of his career, it bears no surprise that he strategically distanced himself from the tenacious smile that had been imposed upon Black male performers as a facile expression of content. Yet the dominance of the frown within imagery that associated Black male performance with criminality and virility suggests a dangerous or provocative choice. Clearly, he felt restricted by the limited representations he was offered through a seemingly benign and boyish smile. In the following section, I counter these readings of Jackson's frown purely within the discourse of a savage/sexual Black male body to think about what he might have been frowning upon.

Frowning and Facial Signifyin(g)

With Jackson's intentional shift in facial expression to that of a frown, I return to bell hooks (1995) to consider whether the frown simply replaces the smile as a mask of survival within the social and economic constraints of a racist music industry, or whether Jackson deploys it through a critical play. hooks conceives African American performance as a mode of play, and focuses specifically on how Black vernacular speech serves to decolonize the Black subject. She uses the example of how recitations of Black literature and poetry both retain a cultural legacy and resist a dominant white literary canon. In her two-fold model of survival and resistance, performative recitation employs a critical intervention rather than a complicit masking. To further this thinking, I turn to African American literature scholar Henry Louis Gates Jr. (1988) and his concept of "Signifyin(g)" to show how Jackson's frown might be understood both as a form of recitation and as a form of play. In drawing on the work of Gates, I show that Jackson's move from a glossy and tenacious smile to a provocative frown was no accident. In his autobiography, Jackson (2009, 81) recalls his frustration at Motown, even as a child, at being told to sing in a way that he deemed "mechanical," and in response began to introduce "vocal twists" or "ad-libbing." This degree of control by Motown partly led to his departure to Epic records where he sought greater artistic freedom. In his solo career at Epic, Jackson's expressive vocal play

begins to emerge and, from "Thriller" onward, this extends into far greater liberties with his facial performances.

In his influential monograph, *The Signifying Monkey: A Theory of African American Literary Criticism* (1988), Gates explores African American literature as a mode of "Signifyin(g)." He considers how African American vernacular traditions are replete with double meanings and rhetorical devices, which are rooted in the trickster figure of the Signifying Monkey.[8] To theorize this linguistic play, Gates calls upon Saussurean semiotic theory: he argues that whereas white signification assumes a stable relationship between the signified (concept) and signifier (sound-image), Black Signification destabilizes the signifier.[9] For instance, he uses the example of punning to show how Black vernacular language, such as "bad" to mean "good," disrupts white meaning, wherein "bad" means "not good." He therefore coins the term "Signifyin(g)" to describe how Black traditions play with meaning through citation, repetition, and revision, but that such play rhetorically emphasizes the signifier rather than the signified.[10]

In African American popular music performance, stylistic play comes to the fore. For instance, with soul music, popular music scholar Iain Chambers suggests that what is said is less important than how it is said (Manning 2013). Indeed, several scholars demonstrate how African American music artists deploy "Signifyin(g)" to articulate a distinctive Black tradition. Guillory (1998) describes how 1960s jazz musicians resisted a dominant white culture through developing their own language, performing with their backs to the audience, and asserting an unwavering self-confidence. Music scholar David Brackett (1992, 311) explicitly uses the concept of "Signifyin(g)" to show how soul singer James Brown's performance of "Superbad" "places an extreme emphasis on the materiality of the signifier" and "an almost complete lack of emphasis on narrative and on syntagmatic or chain-like continuity." Brackett (1992) describes how Brown's vocal performance employs all manner of grunts and groans, fragments of repetition and subtle variations, which call attention to performance as style rather than its semantic meanings. Similarly, Manning (2013, 158) observes the same in Jackson's later performance career: "Michael's vocal performance is characterized by its texture, its vocables and made-up words, a trend in black vocal performance from Louis Armstrong and Ella Fitzgerald to Little Richard and Chuck Berry." Indeed Vogel (2015, 94) states, "Jackson's body of work is filled with examples of signifyin(g), both by drawing from the rich well of African-American musical, cultural, and vernacular traditions, as well as borrowing

from traditional white Euro-American aesthetic traditions and injecting it with his own accent, intention, and purpose."

I therefore suggest that Jackson's strategic move toward a frown and other accompanying facial expressions is rooted in a rhetorical play of Signifyin(g) that calls attention to the choreographic articulations that his face can convey rather than a stable meaning located in either lyrical content or visual narrative. Consequently, his frown cannot be reduced to a mask of displeasure, aggression, or virility, but as a mobile play that calls attention to African American popular music traditions, and which provocatively critiques the racist social frameworks that seek to position Black masculinity within a primitivist representation. As Roberts (2021) says of Baldwin, Jackson's face feels, senses, and reflects this social injustice through a deeply furrowed frown.

Several scholars observe how Jackson's work firmly identifies with a tradition of African American artists and culture (Awkward 1995; Dyson 2004; Mercer 1986; Vogel 2015), and Jackson himself (2009) reflects on how he sought to emulate seminal African American performers such as Jackie Wilson and James Brown. He says of the latter, "After studying James Brown from the wings, I knew every step, every grunt, every spin and turn ... You'd *feel* every bead of sweat on his face and you'd know what he was going through" (2009, 47). Jackson understood the expressive and affective potential of the face, and his recitation of the vocalizations, moves, and facial contortions that belong to a tradition of African American musicians speaks to hooks's (1995) idea of honoring a legacy of Black performance, but which also serves to critique white popular music and its project of assimilation or segregation. That Jackson consistently expressed allegiance to African American politics and heritage (Dyson 2004; Fast 2010; Pinder 2012; Yuan 1996) strongly indicates that his decision to re-choreograph his face from the tenacious smile of the minstrel tradition to a provocative frown that both signaled displeasure at primitivist conceptions of Black masculinity and celebrated the facial signifyin(g) of African American performance traditions was no accident. Jackson's frown was intended to be "bad."

Mythologies of Mean Mugging in Breaking

Out of the various hip hop dance styles, breaking is perceived to be the most aggressive.[11] Whereas locking, for instance, typically employs zany smiles

and wide-eyed wonder, and house dance engenders a benign countenance of soulful exchange (Dodds 2016), breaking constitutes a fiercely competitive dance in which its practitioners unleash a tactics of intimidation (Chang 2005; Schloss 2006). Consequently, b-boys and b-girls often embody a frowning disposition. While not always literally frowning (although sometimes they do), their facial attitude is nevertheless one of confrontation, tension, and attack. To trace the association between breaking and aggression, a consideration of both its actual and mythologized history helps to explain how and why b-boys and b-girls invoke and critique the deployment of a provocative frown. As I will show, the choreography of the face memorializes that history.

The "b" in b-boy and b-girl is said to originate from DJ Kool Herc in the early 1970s South Bronx, who is credited as one of the founders of hip hop music, as he observed dancers letting loose or going off during the instrumental "break" of the music, hence "break-boy" or "break-girl."[12] Yet the term was already in circulation at this time through the vernacular phrase, "why you breakin' on me?" which was used "as a response to an insult or reprimand" (Pabon 2012, 58). Therefore, some hip hop historians identify breaking and "break-boy/girl" with this idea of letting rip on someone or being at "breaking point."[13] Irrespective of the actual derivation of the term, the emotional tensions implied through the colloquialism of "breakin'" clearly feed into how the dance is understood historically. Specifically, the competition element of the dance assumes qualities that are considered confrontational, masculine, and aggressive (Guevara 1996; Schloss 2006). Jorge "Popmaster Fabel" Pabon, one of the early generation b-boys from the Mighty Zulu Kings crew recalls,

> I'd never seen a dance approached like that original b-boy flavor, that straightforward, aggressive sort of I'ma-tear-up-this-floor feeling. A lot of times in my neighborhood I didn't see smiles on their faces. They were on a mission to terrorize the dancefloor and to make a reputation, ghetto celebrity status. (cited in Chang 2005, 115)

Notably, Fabel indicates an absence of smiling, and its cordial associations, in breaking. Instead, the descriptor typically assigned to the face in breaking is one of "mean-mugging" (Schloss 2009, 85), which I will come to shortly. Before doing so, it is important to understand precisely how breaking is conceived as a competitive dance.

As Fabel's quotation suggests, historically breaking was less associated with a good-natured sporting style of competition than an approach closer to war, and these sentiments are steeped in the language and culture of breaking. Certainly, breaking has been conceived through metaphors of combat, arsenal, and warfare (Banes 1994; Johnson 2011, 2018) and this translates into strategies deployed in breaking battles. In addition to outdancing one's opponent with virtuosic or creative moves that indicate foundational knowledge, musicality, and originality, b-boys and b-girls utilize verbal and gestural insults known as burn moves (Johnson 2011).[14] As Schloss (2009, 111) describes, "creatively insulting" other dancers forms a component of many African diaspora traditions, and therefore trash-talking and derogatory or derisive gestures are an accepted part of breaking culture. In his manual *The Art of Battling*, early generation b-boy Alien Ness states, "one must see the battle as either a fight for your life, or an all out war," and b-boys and b-girls continue to take this approach through the movements that they execute. For instance, dance scholar Imani Kai Johnson (2011, 4) describes a battle she witnessed in which one of the Mighty Zulu Kings issues a "performative spray of gunshots . . . as if completing an execution in an old black-and-white gangster movie" against his rival crew. B-girl Medusa explains, "the whole tradition of burning came from uprocking, which is two people facing one another pretty close and they're using gestures that simulate battles. So guns, bows and arrows, knives, you grab a knife, you grab a grenade."[15] B-boy Hannibal meanwhile lists the kinds of actions and gestures that can be used as a way not only to insult an opponent, but are also considered to challenge the accepted etiquette for battle culture: "middle fingers, harmful words, people deliberately bumping you, stepping on your feet, a violation of space, all these things I take as disrespectful."[16] Thus b-boys and b-girls are sensitive to the ways in which the battle circle becomes a site of contest, provocation, and attack, and are mindful of the generally agreed-upon boundaries between gestural insults versus physical misdemeanors. Given the potency of the battle metaphor, how is this conflict played out in the face?

In December 2019, I attended a small battle in New Jersey called Jingle Jam, although b-boys and b-girls came out from Philadelphia, New York City, and various New Jersey suburbs to represent. Shortly before the winter holidays, the mood was festive, with the host dressed in a Santa Claus outfit with a string of brightly colored lights garlanded around his neck, and young ones of various ages dashing about, energized from participating in the children's

battle. At one point in the evening, a New Jersey b-boy battled against each member of his local crew as an initiation test before he was officially invited to become a member. This public rite of passage that he endured was met with huge celebration and good cheer when it was announced that he had made the grade. Later in the evening, a crash mat was laid down on the floor to give dancers the opportunity to try out the most daredevil air power they could imagine and, as each b-boy egged the others on to throw all kinds of zany moves, the crowd relished in their silly sense of play as the majority came crashing to the ground. Yet despite the jovial atmosphere, interactions between competitors during the actual battle did not remain quite so genial.

In one of the preliminary rounds, two b-boys, both from Philadelphia, came face-to-face.[17] The first, an affable b-boy known for his jokey disposition, goes up first and throws down a solid round of foundational footwork, some intricate threading, a couple of windmills, and a short stack of freezes. All the while his face remains impassive as he focuses on his round. As he steps back to the edge of the cypher, his opponent, a taciturn b-boy from one of the most well-established crews in Philadelphia, explodes across the floor and repeatedly air punches the first b-boy only inches away from his face. As his dynamic fists pummel back and forth, his brow tightens and his mouth turns down into a sneering look of disdain. The recipient tries not to react, maintaining a blank stare, but a sense of discomfort surrounds him as he inches his head back ever so slightly. The second b-boy then skips backward to the center of the circle, maintaining his vicious glare as he executes some carefully timed toprock before twisting to the floor in a corkscrew turn. He immediately lays out some immaculate footwork followed by swipes and then 2000s, which he lands in a bridge position and then grabs his crotch to "cock" straight at his opponent.[18] His set continues with a little more footwork, a series of munchmills and Zulu spins, and then ends directly in front of our first b-boy. Number two stares down at his opponent, jaw set, brow furrowed, and simulates smacking him in the face. Undoubtedly a more skilled b-boy, the second one smoked the first. Notably, he not only achieved this through his strong musicality and well-executed moves, but his face, gestures, and frowning demeanor signaled his utmost confidence that from the get-go he had this round in the bag.

Given that the winner of this round could easily have secured his victory through moves alone, why the need for his aggressive facial disposition? Many of the b-boys and b-girls I interviewed perceive it as an accepted part of the culture:

> Breaking is kind of like a hard, mean, muggy kind of dance. You're kind of hardcore, you're kind of serious . . . Traditionally, you know, cross-arm b-boy stance, mean mug, all that stuff. (Izegbu)[19]

> People come up with all kinds of different ways of simulating that kind of dynamic or violence. That's also when the facial expressions become a lot more purposely intimidating. (Dr. Moose)[20]

> I had times like where somebody called me out . . . So it was like, okay, getting into that mode where it's more confident, it's more of a defensive face, Like, "Okay, I got this! You're not gonna smoke me or you're not gonna win against me!" (Macca)[21]

The idea that breaking calls for faces that are hardcore, serious, intimidating, and defensive all contribute to a facial choreography of "mugging." Clearly its intent falls into the category of a frown. The face signals displeasure, provocation, and attack. Yet many of the dancers to whom I spoke did not necessarily see it as an authentic *physiological face* that expresses one's internal emotional state or skill as a dancer, but as a *sociocultural face* that works performatively to insinuate aggression. B-boy Steve Believe states,

> There's an air of macho-ness to the dance that sometimes people come off very hard and it looks silly because they try and be too rough. But I think that's one thing that youth has to say about it is, like, kids are going to do that. They're naturally going to go for trying to look strong and hard, rather than who they really are. And so I think the face is actually an important indicator of how much experience they have and how they really feel about the dance.[22]

Viazeen meanwhile recalls a face that did not equate with ability:

> This dude has all the garb on that makes a b-boy, he has all the makings of one visually. His face is completely stone. And I looked at him, I was like, "Oh he's really 'bout to do something," because that's what his face looked like. This dude hits the floor and he's all over the place. He's bouncing here, his top rock is like all off, and it's like too aggressive and his face never moves. He gets to the floor and it's super sloppy and all over the place, and

his face never moves.... And he gets up, and his mouth shifts like, "You can't mess with that." I'm like, "Is this guy serious?" Like his face said that he was gonna beat everybody in the place, but his movement said, "You're gonna lose this round."[23]

Indeed, early generation b-boy Ken Swift comments on the façade of b-boys nowadays acting tough and mean mugging without having the background or skills to back this up:

> A lot of kids are from the suburbs, have good parents, and never stole anything, and all of a sudden they are thugs: gangsters coming out with durags. Coming out tough, talking smack, getting close to peoples' faces ... If you have exceptional skills, why are you gonna do that? But it feels like it's trendy. Like that's the way you're supposed to act. You know if you're not tough, don't act tough. It's not organic.[24]

This idea that b-boys and b-girls feel the need to assume a character that bears a tough or thuggish exterior begs the question of where this mean-mugging aggressive persona has come from aside from the competitive element of the dance.

A longstanding belief that breaking came out of gang culture has circulated through both the media and academia (Aprahamian 2019; Chang 2012; Guevara 1996). Dance historian Sally Banes, one of the first scholars to take an interest in breaking as it became increasingly visible in the early 1980s, helped to develop the narrative that gangs would solve disputes through dancing (Chang 2012). In her *Village Voice* article published on April 10, 1981, she recounts the story of a breaking crew being detained by police for fighting while they insisted it was dancing, and she describes breaking as a form of "ritual combat that transmutes aggression into art" (1994, 123). Certainly, the emergence of breaking in the South Bronx during the early to mid-1970s occurred within social and economic hardship for the African American communities residing there due to reprehensible negligence from local government agencies (Chang 2005; Rose 1991). In a nuanced overview of this period, dance scholar Imani Kai Johnson (2018) points out that while the early generations of b-boys were exposed to violence, drugs, and criminality, the same issues occur in the white suburbs, but remain largely hidden due to the workings of politics and privilege. Notably, Johnson (2018,

66) frames 1970s hip hop as an "outlaw" culture, not to suggest danger and deviance among its practitioners, but to emphasize the way the first generation of b-boys had to create "meaningful existences" separate from the white middle-class mainstream.

The prevailing mythology that breaking emerged as a creative response to gang culture, and the violence this idea continues to enact upon Black communities, has been skillfully critiqued by dance scholar Serouj Aprahamian (2019). To deconstruct this narrative Aprahamian (2019) turns to the influential book *Yes Yes Y'all: The Experience Music Project Oral History of Hip Hop's First Decade* (2002), which supports the idea that hip hop was birthed out of gang culture. Through an artful exposé of how primary sources can be manipulated to service particular beliefs, Aprahamian analyzes the original source quotations (now located in an archive) against the same carefully edited quotations used in the book to show how it frames the speech in deceptive ways that imply a factually inaccurate link between hip hop and gang life. He concludes that this fallacy, which has been heavily circulated through popular and academic discourse, dangerously perpetuates the links between poor Black communities and criminality.[25] In my own interview with b-boy Ken Swift, while all-too-aware of the environment in which he grew up, he also firmly disputes any personal connections to gang life:

> I remember what it was like to be tough. To be punk . . . I know gangsters. I know killers. I am not a gangster. I know what that is. I'm like, I know people. They are the real deal, so I don't engage that. That's not who I was. We all kind of have that tough persona in a sense, but I know I'm not one of those dudes who are ruthless, heartless: that's gangsters.

While I would not want to suggest that mean mugging comes directly out of the mythology that links breaking to gang life, the aggressive countenance and tough persona seem to be tied up with the perceived origins of breaking that frame the Bronx (and other New York neighborhoods in which breaking developed) as a site of danger, deviance, and disenfranchised communities. Yet although mugging constitutes part of the expressive practice of breaking, while some continue to frown, stare down, and intimidate their opponents through an aggressive facial choreography, others question the authenticity of this expression. Thus, what are the motivations behind the purposeful use of the frown, and why might it be discarded, particularly for b-boys and b-girls dancing in the present day?

Mugsy, Bugsy, and Keeping It Real

In reflecting on their battle experiences, several b-boys recalled times when they have felt genuine anger, which has revealed itself in a stone-face performance or facial frown:

> Sometimes if I'm really genuinely mad at you over a personal issue or you've done something to offend me, or I think you've taken one of my moves or one of my friends' moves, then I get kind of angry, and I'm gonna stare you down. (Metal, see Figure 4.1)[26]

> I'll only do it if I actually have beef with somebody. If I actually don't like you or whatever you stand for then I'm mean mugging the whole time. Because then I revert to classic b-boy, "I don't like you, you don't like me." I'm gonna burn the hell out of you. (Izegbu)

Yet none of them seem particularly comfortable with, or at least prefer not to reach, that emotional state:

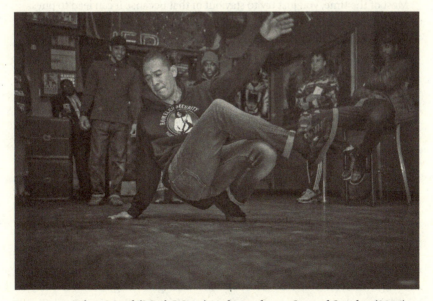

Figure 4.1 B-boy Metal (Mark Wong) in the cypher at Second Sundae (2016). Photograph by Ed Newton. Used with permission.

102 FACIAL CHOREOGRAPHIES

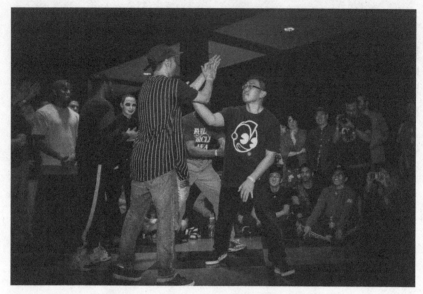

Figure 4.2 B-boy Rukkus (Jay Jao), on the left, gets in the face of b-boy Ma (Alex Ma) at Rhythmic Damage (2016). Photograph by Ed Newton. Used with permission.

> Most of the time, you just try to stay out of that because it can lead to physical violence. And for me, I don't really want it to lead there. But I've been in situations where it has happened. A lot of the times, your facial expression is very angry. You're real serious about it. (Supa Josh)[27]

> One thing that irritates me is when people touch me. So when someone touches me, everything goes out the door . . . I don't like fighting, I don't think it resolves anything. But I'll get to the point where I'll be in your face, like I'm ready to fight you. (Rukkus, see Figure 4.2)[28]

> I'm an emotional dancer so if I'm feeling some type of way or if there's someone I don't like, I have this stale look on my face and I'm aware of it, too, because I always tell myself "yo relax, it's not that big of a deal." (Valme, see Figure 4.3)[29]

Although dancers sometimes experience feelings of anger, frustration and humiliation that might motivate their facial expressions and overall attitude within the battle, they learn to manage and contain them within the

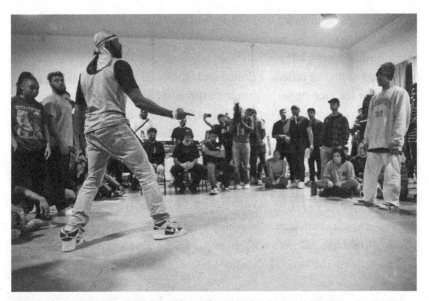

Figure 4.3 B-boy Valme (Jerry Valme) gesturing intently at his opponent at Armageddon (2022). Photograph by Albert Shin. Used with permission.

cypher space. While these heightened emotions occasionally spill over into roughhousing or physical fights, it happens rarely as b-boys, judges, MCs, and event organizers collectively police any behaviors that fall out of line with breaking etiquette.

The capacity to channel strong emotions into a contained form of expression speaks to the values and traditions of breaking. Hip hop scholar Jeff Chang (2005, 116) invokes African American author and anthropologist Zora Neale Thurston's assertion that dances of the African diaspora use "dynamic suggestion" to imply, but not carry through on the possibility, that the dance will exceed what is suggested. Schloss (2009, 107) not only observes that battling allows genuine hostilities or frustrations to take place within a setting that demands measure and control, but that battling helps to develop "fighting strategies that can be used in other kinds of conflict." Thus, impassioned energies can be redirected into areas of life that require conflict resolution. In *The Art of Battling*, Alien Ness warns dancers that anger or hatred toward an opponent can distract from focusing on an individual battle plan, therefore hot emotions need to be kept in check. He acknowledges that while insults and derision are permissible in the battle, b-boys and b-girls must also show respect to their opponents after their rounds are finished. Therefore,

although anger, aggression and rage might play into the battle environment, and can be dynamically expressed through the face and the overall demeanor of the body, to keep control of these emotions and channel them into the movement exchange reflects a skilled and mature dancer.

Whether the face signals a genuine expression of anger or a performed illusion of rage, several b-boys emphasized the need to move on from this outside the battle moment. Conscious of a toxic masculinity, they recognize the labor that needs to go into presenting a vulnerable interior self rather than an anachronistic mask of aggression:

> Yeah you get your beef, which I've also been a part of. But you know, it's like if you're mature enough, you see them in person, you hash it out, and you're like, "alright let's talk, let's really level and see because this is the same culture, we live in the same life, let's just see where you're from." (Izegbu)

> Aggression can be used as a tactic, and it can be faux. You know, it's not real, it's just in the dance. Okay, when the dance time comes, I'm going to be this aggressive individual who's trying to intimidate you and trying to, like, push you out of the circle. But then right afterwards, I'm affable. And I'm like, "hey, yeah, what's going on?" (Steve Believe)

Whether the tough exterior is authentic or faked, irrespective of the desire to control or contain strong emotions within the cypher space, and even though b-boys and b-girls seek to foster positive and respectful relationships after the battle is over, the trope of the frowning countenance has clearly continued into contemporary breaking battles. Although this is partly tied to the historical mythologies between breaking and gang culture, and the overly simplistic links between the socioeconomic hardships that communities of color endured in the Bronx of the 1970s and breaking as a purportedly creative response, another motivation for the frowning persona derives from an altogether different point of origin: a Bugs Bunny cartoon.

Several dancers I interviewed referenced the lineage of the mugging tradition back to Ken Swift's facial expression, popularly known as "Mugsy":

> Ken Swift actually taught me how they used to use their faces. So they would do this thing with the eyebrow, and then you take your tongue and you stuff it in the side of your mouth like that [pause for demonstration]. That's the Mugsy! (Metal)

> If you see people come out looking like the old school Mugsy, they're going to come out with the gruff look. (Steve Believe)

> Ken Swift has this old Mugsy face that literally looks like Mugsy. (Viazeen)

The intertextual reference point for this face derives from the Bugs Bunny cartoon series, which featured two gangster characters, Mugsy and Rocky. Breaking notably draws on several influences from popular culture and Ken Swift recalls the creation of this face with fellow crew member Doze Green:

> We were watching cartoons and all kinds of stuff, and then had a lot of time to play, to bug out. So it was inspired by the Rocky character from the Bugs Bunny cartoons we were watching. It's interesting because Mugsy is the big guy. Rocky is the little guy. We would kind of imitate the Rocky character, not Mugsy. It was this mug that we had. The way he would walk and look, we'd just bug out with that. We'd spend all day trippin' and just acting like a bunch of characters.

Although the facial expression is known as Mugsy, as Ken Swift points out, it is an imitation of the Rocky character. The design of the character was originally based on the real-life mobster Edward G. Robinson, although the image was redesigned as a more generic gangster figure.[30] Rocky is extremely short in stature and wears a huge grey fedora that hides much of his face, although a big cigar frequently protrudes from his mouth. Despite his outsize hat, his facial expression consists of a protruding chin and downturned mouth that characterizes his perpetual disgruntlement and irritation within the series. An old black-and-white photo shot by Martha Cooper captures Ken Swift pulling the "Mugsy" expression, with shoulders hunched forward, fists clenched as two heavy clubs at the end of his arms, chin pushed forward, mouth set in a firm downward curve, and eyes staring out to his opponent. The mood and posture are playful and cartoon-like, however, as several of the crowd around him watch with big smiles plastered on their faces. The frowning expression so heavily associated with breaking has become linked both factually and fictitiously to gangsters real and imagined and is deployed at times as a serious display of an interior mood, and at others as a playful skit on character types. Yet irrespective of the presence of the frown, both genuine and faux, several contemporary b-boys and b-girls perceive it as an

inauthentic and anachronistic trope that does not fit with their current lives or sense of self.

MachPhive suggests that an intimidating face is used to mask nerves:

> The reason why I could identify it as other peoples' fear is because I can see it on how rushed their round is. When someone mean mugs, they usually rush to come out. They skip counts in their toprock. They drop really fast. They rush their footwork. They might hit a freeze and that may be their stopping point. But they are rushing.[31]

Izegbu meanwhile observes that mugging is not appropriate to his own background and environment:

> As much as I can take bits and pieces out of breaking culture and make it my own, breaking didn't save my life in a way that it saved people's lives in the South Bronx, for example . . . So, you know, things like "cocking" and like the pistol, like the gun and stuff like that. It is not really my lifestyle.

And along similar lines, Renaissance Ray questions the need to enact aggression within the dance:

> I think at the end of the day, we all know it's dance. So if someone's trying to be too serious about their seriousness, it's kind of a joke to me. It's just like, "come on, get out of here, you're not really shooting me or punching or any of these things you're pretending to do."[32]

For Ynot, a fake bravado becomes a point of weakness:

> You're just looking for a soft spot, I think. Because most of the time, hip hop has this very heavy, over masculine approach to things, right? So everyone's idea is to be hard or whatever the situation is. I don't always think that's the best approach if that's not really how you are. So I try to see if that person in front of me is actually as genuine as they are trying to be. So if I don't feel that, then I already know that I have an advantage at some point because I'm going to try to expose that they're not being their self right now.[33]

To disarm the mean mugging, frowning and aggressive countenance, several b-boys and b-girls commented on how they counter this with a smile:

Sometimes if they have a serious face, I also smile back because, actually, I tend to smile when I dance and so, for a lot of people, it throws them off because breaking is such an aggressive dance. People like to be very macho and very like, "I'm going to beat you" . . . But for me, breaking is a happy thing. I love doing it and it's not about, "I'm going to crush my opponent." It's like, "I want to show you what I can do." So actually, when a lot of people do things, even when they burn or whatever, I'm actually laughing on the side and smiling because I don't take things seriously. (Sunny)[34]

I *hated* this guy. He was such a jerk. And, all I wanted to do was beat him, and I was genuinely really mad. So I was using this anger and everything that I did, I crashed. I did terrible . . . So the next month I called him out again, and I just hit him with a smile. And he was like, "What're you smiling for? Like, stop fuckin' around, it's not a game, man!" I'm like, this is a game to me, like I enjoy this. And then I feel like I beat him that night, so I always say he taught me how to break because he taught me that you gotta be yourself. (Metal)

Regardless of the strong historical associations between breaking and a frown, dancers are clearly prepared to challenge this with a smile. It is perhaps not surprising that I include b-boy Metal's thoughts on the smile in the previous quotation, given his cheerful disposition in daily life, which frequently extends to his facial attitude in battles. I think back to a 2 v 2 event at Second Sundae in July 2018, which he entered with his Repstyles crewmate Rukkus. In the Top 8 round, Metal and Rukkus go up against Dosu and Som from Funkill Crew, with Som throwing down first followed by Metal. Metal's round features his signature explosive footwork punctuated with sharp freezes clearly directed at his opponents: 3-steps, sweeps, leg circles, Zulu spins, and shuffles, with arms flying through the air as his torso whips in precise geometric momentum; he pauses, somersaults onto his back, pointing accusingly at Dosu and Som, then rebounds into more footwork before landing a half-split freeze with chin resting on hand, mugging at his two adversaries. On each freeze, his face emanates serious, competitive intent, but a smile sneaks across his visage as he runs a monkey swing and reverse corkscrew turn to come back to standing. He exits the circle using big comedic leg kicks, bounding from side to side, arms flailing, grinning in the direction of Rukkus. He is clearly here to play.

In response, Dosu (see Figure 4.4), an extremely talented b-boy from Peru, tries to come back just as strong, but misjudges a side roll that slides into

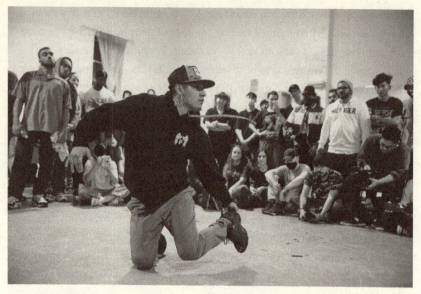

Figure 4.4 B-boy Dosu (Luis Carrera) battles at Techsgiving (2021). Photograph by Albert Shin. Used with permission.

a shoulder freeze, and ends up crashing into Metal and Rukkus. For a moment, Rukkus looks displeased, frowning, wagging his index finger, and animatedly pointing to the floor as a warning that Dosu has exceeded the "no touch" boundary. As Dosu comes up to toprock, Metal also excitedly gestures to the floor, smirking at Dosu's bid to overlook his transgression and continue dancing. Rukkus and Metal persist, however, until Dosu has no choice but to concede. He stops dancing for a moment, smiles and then laughs as he acknowledges his error by gesturing to the floor and back to Rukkus and Metal. Metal beams in return, extending his leg and pointing to his foot in an exaggerated reference to Dosu's physical breach. Quickly, Dosu and Metal shake hands, with warm, good-natured smiles, allowing Dosu then to finish his round. All four competitors continue to smile at this brief but fun exchange, which is echoed by amused members of the crowd. Notably, what could have easily become a heated display of mean mugging and aggression is played out with evident humor and comradeship, largely due to the personalities and disposition of those involved within that precise battle context. I will return to this battle in the LAUGH chapter, but for now I hold on to the idea that some b-boys and b-girls resist the legacy of a frown.

As part of his critique regarding the links between breaking and gang culture, Aprahamian (2019, 309) draws on historian Robin D. G. Kelly to argue against the simplistic supposition that Black expressive practices are a response to the deprivation caused by urban life, and instead portrays them as a "complex articulation of pleasure, community, and symbolic creativity." Although some of the early generation b-boys suggest that the facial choreography of a frown seems to have been prevalent in those initial battles, it was as much an innovative repurposing of a children's cartoon as it was a social exchange between specific personalities in the cypher. While some contemporary b-boys and b-girls still use the cypher to express either personal frustrations or tense social relations that become manifest through their facial expressions, and a few perform this as a generic countenance irrespective of their mood or skill level, others question the authenticity of this visage in the current day.

In this chapter, I analyze how the action-expression of a provocative frown wrestles with the ways in which bodies of color are conceived within popular dance. Dissatisfied with the mechanistic smile that he was forced to endure during his time at Motown and initially at Epic records, as Michael Jackson gained greater artistic and economic success, he abruptly dropped his smile and replaced it with a brooding and contentious frown. This epistemic rupture reveals how facial expression acts as a historical register in dance. Jackson intentionally employed the frown, along with other facial actions such as biting, snarling, and sneering, to reveal edgy, streetwise characters within his music video performance. Although these could easily be read through a racialized lens that fixes him within tropes of primitivism, criminality, and virility, I suggest that Jackson consciously engaged with a choreographic facial play that indicated allegiance to a Black politics and heritage, that critiqued the mono-dimensional smile, and that hovered between being morally bad and artistically good, hypermasculine and slightly feminine. The frustration that Jackson felt gave opportunity for him to sense and articulate this in his frowning persona and, as I will address in the SCREAM chapter, this rage developed even further as his career progressed.

The ambiguity of the frown also pertains to breaking battles as b-boys and b-girls project a mean mug attitude that might be genuine or illusory. The provocative frown within breaking culture traces a complicated history that inaccurately links early generation b-boys of color to a discourse of violence and criminality, and neglects to see their creativity, pleasure, and play. Yet the frown also alludes to a cartoon character, which became a signature facial

expression of Ken Swift, and knowledge of this lineage indicates close allegiance with breaking history and culture. Therefore, while some contemporary breakers re-enact an aggressive and intimidating frown, others feel it to be anachronistic and inauthentic and opt to employ facial expressions that better reflect their sense of self, which I will explore further in the LAUGH chapter.

The facial choreography of a frown that I explore in relation to breaking can likely be extended to other hip hop idioms, such as rap performance and krumping, a form of street dance that also engages in expressions of frustration, rage, and aggression. Yet the kind of frowning that I observe in studio competition dance or reality television shows, in which dancers heavily emote to portray ideas of sadness or struggle, specifically within the commercial genres of lyrical or contemporary dance, do not seem to hold the same space for provocation, ambiguity, or critique. Instead, these dancers take on a mask-like frown that superficially and explicitly signals that the audience should interpret the dance through the lens of sorrow or despair. While these initial thoughts need to be examined in more depth, I suggest that the action-expression of a frown must be read in relation to the precise contexts for popular dance performance in which it appears. To return to the frowning persona of Michael Jackson and the surly facial expressions of b-boys and b-girls immersed in breaking battles, I conclude that although the provocative frown might work choreographically to signal discontent and stimulate aggression, this sits in tension with its capacity to question and reformulate the histories and values of their popular dance practice.

5
CRY

> Yes, Big girls cry when their hearts are breaking . . .

The above comment was posted by Stephanie Amanda, a YouTube viewer, in response to the official music video for "Big Girls Cry," by recording artist Sia from her album, *1000 Forms of Fear* (2014).[1] Her comment is followed by four emojis: two of a "crying face" showing a flood of tears and two of a "weary face" depicting exhaustion and distress. What then occurs in the video that provokes such a dramatic, visceral, and emotive reaction that depicts crying in response?

The video stars Maddie Ziegler, who appears in a black studio in a close-up shot from the shoulders up, wearing a pale, flesh-toned leotard and a peroxide blond wig in the style of a straight, shoulder-length bob. The opening image looks blurred, but as the camera slowly zooms in a little closer, Ziegler's features come clearly into focus and the opening bars of the music gently strike up. Ziegler stares out to the camera, her head dipped slightly so that her eyes look heavy and glum. Her visage remains still, except for a few wisps of hair that blow at the side of her face, and she blinks once. Her face is cast in white light, so that her pale skin appears luminous, and her motionless countenance seems cold and almost sinister. As Sia's taut and raspy voice sings the first few lines, "Tough girl in the fast lane. No time for love, no time for hate," Ziegler embarks on an intricate facial and gestural dance. She rubs her hand straight down her face, pulls at her mouth to turn her head, bangs her ear with the palm of her hand, throws her other hand over her mouth, wiggles her fingers above her brow, wonkily shaking her head with rolling eyes, and then kneads her fist into her cheek sending her head into a juddering vibration. The rapid flow of movement continues as her fingers flicker away from her face, only to rebound back, dragging down her eyes into a ghoulish expression. She repeatedly wipes her mouth, followed by her index finger hooking and pulling on the side of her mouth, and then yanking back and forth while

her eyes flick from side to side in correlation. Her head and eyes drop down thrice, and she pushes her chin back up into an awkward clenched smile. She then points in multiple directions around her head, before sucking on her thumb like a little girl (see Figure 5.1). During this frenzied gestural deluge, Sia slowly sings, "No drama, no time for games. Tough girl whose soul aches."

The single for "Big Girls Cry" was released in 2014, followed by the video in 2015, which marked the third in a trilogy of music video collaborations between Sia and Ziegler.[2] Sia is a white Australian recording artist who is now in her late forties, and in response to her international stardom has been critical of life in the celebrity spotlight (De Bertodano 2015; Knopper 2014; Malkin 2017). For this reason, Ziegler began to perform in Sia's place, beginning with the music video for "Chandelier" at age eleven, and then in "Elastic Heart" (2015) and "Big Girls Cry" (2015) at age twelve.[3]

My interest in "Big Girls Cry" came about as the video consists almost entirely of a close-up, single shot, face-dance. Although the song explores the theme of young or adult women crying, the facial choreography does not depict crying in a literal sense. It is arty and experimental in style. The complex facial choreography draws upon multiple expressions and emotional resonances that convey the stimuli for crying and how it might feel to cry rather than crying itself. In this chapter, I explore crying as an action-expression and its specific deployment in "Big Girls Cry." This forms a departure from other chapters whereby the facial choreography closely aligns

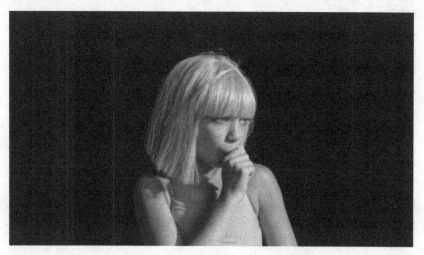

Figure 5.1 Maddie Ziegler sucks her thumb in "Big Girls Cry" (2014) by Sia.

with the same facial expressions used in everyday life. Furthermore, I have found the video to be both incredibly moving and deeply alarming. On the one hand, the music, visuals, and choreography are sensorial and affective. The first time I watched it, and even during subsequent viewings, I developed goosebumps and shivers down my spine. Clearly, this visceral response is shared by others, as seen in the viewer comment that opens the chapter. On the other, it also leaves me extremely uneasy as a young girl is hired as a stand-in to portray the life themes of an adult celebrity. I suggest that the deployment of Ziegler's dancing face in this video prompts both its affective resonance and ethical discomfort to be held in tension. The collaboration with Sia marks a transition in Ziegler's performance career, signaling a shift from the little girl in the reality television show *Dance Moms* to a maturing adolescent performing experimental choreography within the adult world of popular music, and this change is articulated in the face. I develop the concept of a "manipulative cry" to show how this action-expression compels its audience to feel deep empathy toward Ziegler and Sia, but how their unique partnership privileges whiteness, celebrity, and economic gain. Before taking up these ideas, I pause momentarily to consider crying as a human practice.

Although I last discussed Ziegler through her glossy and tenacious smile on *Dance Moms*, the show also depicts multiple instances of crying, shouting, and screaming in the rehearsals for (and behind-the-scenes shots of) the dance competitions. Indeed, the show features a plethora of crying. The young dancers cry frequently because of tiredness, boredom, disappointment, frustration, anxiety, and minor injuries or accidents, and despite her work ethic and drive, Ziegler is no exception. The mothers and Abby Lee Miller also weep on numerous occasions as they bicker about favoritism among the students, the demands of the rehearsal schedules, how moved they are by the children dancing, and about petty disagreements between themselves. Although the act of crying remains separate from the on-stage competition performances, meaning I would not describe it as facial choreography as such, it is such a common trope on *Dance Moms*, with the girls depicted as crybabies and the adult women as excessively emotional, it certainly appears staged and manipulated as a recurring theme of the show. This brings me to consider what is crying and what purpose it serves.

The human body produces three different kinds of tears, each with its own combination of chemicals, proteins, and hormones: basal tears are those that constantly moisten the eyes; reflex tears respond to irritants that affect the eyes; and psychic tears are those associated with different emotional states

(Lutz 1999). It is this latter form of crying that interests me here. Although it might be tempting to conceive crying solely through the idea of a *physiological face*, as the production of tears involves a physiological process (Lutz 1999) and Darwin insisted upon an evolutionary rationale for crying (Neu 1987), compelling evidence suggests that crying is largely shaped through a *sociocultural face*.[4] People cry for wide ranging reasons, and different social, cultural, and historical contexts permit crying to varying degrees (Lutz 1999). While babies cry to articulate basic needs, adults cry to express more complex emotional states (Vingerhoets 2013). People cry due to major emotional events, as well as quite mundane phenomena, and crying can be prompted both for reasons of sadness and in moments of joy (Neu 1987; Vingerhoets 2013). Furthermore, humans can exercise significant control over when and how they cry, such as when actors cry on demand or people subdue tears in public despite profound sadness (Neu 1987).

A common stereotype, pertinent to the focus of this chapter, claims that females are more emotional and prone to crying than males. In most cultures, the emotional work is divided unequally across gender, although it is not always women who take on the labor of crying.[5] Within the US context, research indicates that women cry more frequently and intensely than men (Lutz 1999); as several scholars indicate, however, women are socialized to do so, while men learn to repress tears (Lutz 1996; Vingerhoets 2013). Yet plenty of examples contradict this dominant stereotype. Famously, Jackie Kennedy refrained from crying at her husband President John Kennedy's funeral and, although the construction of the stoic American man developed in the mid-twentieth century, there are numerous instances of male sporting, film, and singing stars who openly wept during this period and beyond (Lutz 1999). As anthropologist Catherine Lutz (1996) suggests, women are discursively framed to be the emotional and irrational sex, hence the belief in their biological propensity to cry.

In *Dance Moms*, a show dominated by women and girls, this stereotype prevails through an abundance of tears. Faces crumple, mouths twist, noses sniffle, and tears fall. Often, several bodies will crowd around, extending arms of comfort or rubbing the backs of the distressed to ameliorate their physical or emotional pain. Indeed, Vingerhoets (2013) observes how tears are conspicuous: they solicit attention and are difficult to overlook. As crying performs such a captivating emotional display, *Dance Moms* then mines this for the benefit of its sensationalist narrative content. To return to the concept of a *semiotic face*, as developed through Deleuze and Guattari's (1987)

theory of faciality, the excessive acts of crying on *Dance Moms* offer a visual shorthand for normative femininity. An assemblage of stereotypes, which Deleuze and Guattari would describe as the "facial machine," depicts women crying and overloads their faces with semiotic meaning: their lips quiver, their eyes leak, and their faces signify upset and distress. The excessive and habitual weeping on *Dance Moms* therefore works semiotically to create an overdetermined connection between women, weeping, and dance.

Although "Big Girls Cry" does not offer the crumpled face and streaming tears that characterize *Dance Moms*, the title and lyrics of the track clearly address crying and Ziegler's face signals the hurt, distress, and heartache that can be associated with its emotional turbulence. To understand the work of Ziegler's face in this music video, first I look at the burden of celebrity and its emotional cost, before turning to an analysis of the choreographic and musical treatment of the theme of crying in "Big Girls Cry." I then set up the manipulative force of the cry as it affectively moves its audiences through a purported feminist agenda but relies upon an unethical use of a child to center and maintain the economic structures of celebrity.

The Surrogate Face of a Reluctant Celebrity

Sia's singing career dates back to the mid-1990s when she provided guest vocals for bands in her native Australia and London, and in the early 2000s began to release albums as a recording artist in her own right.[6] From 2010 to 2014, she took a break from the demands of performance to concentrate on composition, and wrote several hit songs for some high-profile female pop stars (Younger 2016).[7] In 2011, she coauthored and featured on the track "Titanium" by DJ and producer David Guetta, which became a huge chart success and further propelled Sia into the spotlight (Sanders 2014). The commercial popularity of the song brought a level of fame that Sia had not previously experienced, and in 2013 she penned an "anti-fame manifesto" in which she eschews the ills of celebrity (Younger 2016).[8] In 2014 she released her sixth album, *1000 Forms of Fear*, and elected not to reveal her face in any of the publicity shots, visual materials, or public appearances that are traditionally used when promoting new releases (Cragg 2014). It is from this point that Sia became famous for not wanting to be famous and for refusing to show her face in public. In this section, I explore the idea of Sia as a "reluctant celebrity" (York 2018) and how this prompted her desire for a "surrogate

face," which came in the form of Ziegler. In setting up this de facto facial relationship, it enables me to show how a choreography of crying can be used to manipulate affective responses in its spectators and the ethical issues of a child standing in for an adult's aesthetic agenda later in the chapter.

Sia's dislike of fame has been well documented in the media. In various interviews she describes celebrity as "horrible" (Knopper 2014), fame as a "monster" (Malkin 2017), and that she would prefer "to be invisible" (De Bertodano 2015). To this end, she has stopped putting her face on display at least in the context of public images and events (Sanders 2014). She often dons an outsize wig that covers most of her face, typically in the style of a straight blond bob that has become her signature brand (Cragg 2014). Although other female popular music artists, such as Dolly Parton, Tina Turner, Cher and Lady Gaga, have worn wigs that serve as a form of disguise, none intentionally hide the face to the extent that Sia does. She also appeared with a paper bag over her head for the image of her anti-fame manifesto and performs with her back to the audience (Sanders 2014). As journalist Briana Younger notes, "[Sia] has become the rare star without a face who can still thrive in pop music's interdisciplinary spaces" (2016, C01). Sia is clearly aware of the ways in which women in the music industry are required to use their faces and looks to promote their work, and her refusal to conform to this patriarchal capitalist framework comes through her adamant position that she will not "sell" her body (Cragg 2014; Sanders 2014). In denying her face, she openly challenges the social codes and economic values of the popular recording industry:

> What would happen if a pop star were to hold back from public view all but a few of her identifying characteristics? Without a famous face, well-documented dating history, and popular backstory, how then are we to know her? What is left for us to focus on, critique, adore, pin up, or tear down? (Sia quoted in Wiig 2015)

Somewhat ironically, Sia has gone public to critique the consumer demand for the celebrity face, and to make a personal stand against revealing her celebrity face.

In addition to masking her face with various wigs and disguises, one way in which Sia has directed attention away from her face is to reorient it toward the face of Ziegler (Jackson 2016). Described as a "cypher" (Malkin 2017), "avatar" (Aron 2018, 97) or "alter ego" (Younger 2016, C01), Ziegler's

face stands in for Sia in her music videos, live performances, and industry events. Part of Sia's rationale for refusing to show her face in the publicity for *1000 Forms of Fear* was that she had recently become sober and was keen to distance herself from both the demands and excesses of fame (Wiig 2015). Indeed, the personal difficulties that Sia has faced are well reported, including her diagnosis for bipolar disorder, later identified as complex post-traumatic stress disorder, and the sudden death of her partner in a car accident, which led to an unhealthy use of alcohol and drugs, and an attempt to take her life (Aron 2018; Knopper 2014; Malkin 2017; Sanders 2014). Not surprisingly, her music frequently deals with personal issues, such as addiction, grief, and trauma, and Ziegler's body is then deployed to convey the "raw emotion" that Sia reveals (Younger 2016, C01). To understand both the position that Sia adopts regarding fame and her use of Ziegler as a surrogate face, I turn to literature on celebrity culture.

The term "celebrity" refers to a visible subject in the public eye (York, 2018). Media scholar Lee Barron (2015) suggests that modern celebrity emerged with modernization, industrialization, and urbanization, and to be "seen" in the city became fashionable. He notes how the print media focused on the lives of the famous, and this further evolved with the mass media and its capacity to visualize those bodies through images (Barron 2015). Sia's decision to remain "unseen" therefore works in opposition to the demand for visibility that characterizes celebrity culture. Cultural studies scholar Graeme Turner (2013) asserts that celebrity pertains less to the character of a specific individual than the way that they are produced discursively. Consequently, the frequently circulated discourse concerning Sia's troubled personal background, her overwhelming rise to fame, and the move to hide her face collectively constitute what could be described as her "star image."[9]

While not a recluse, Sia's unwillingness to embrace fame positions her within literature scholar Lorraine York's (2018) typology of a "reluctant celebrity." York (2018, 2) describes reluctance as an affective state that encompasses the opposing forces of urge and reticence surrounding fame: it does not embrace a total resistance, but instead a "tepid disinclination." For York, the reluctant celebrity assumes a position of privilege that places reticence on public display. Interestingly, the case study examples that York provides are all white males and I will come to Sia and Ziegler's whiteness later in the chapter.[10] Such reluctance presents a challenge to the usual codes of celebrity, which depend upon visibility and promotion. Although the reluctant celebrity implies a desire not to conform, this figure still maintains

aspects of celebrity life (York 2018). In the case of Sia, she refuses to show her face; however, she continues to release music, go on tour, and produce music videos, which are all requirements of the contemporary celebrity pop star. York (2018, 12) goes on to explain the science of "magnetic reluctance," a concept borrowed from the field of physics in which energy in magnetic circuits does not dissipate, but remains stored. She employs this idea as a metaphor for the reluctant celebrity whose energy does not disappear due to their reticence but is harnessed and made use of by the celebrity or their fans (York 2018). Thus, although Sia expresses reluctance to show her face and engage with the celebrity game, this creates a fascination with her star persona and continued interest from her fan base.

Turner (2013) asserts that publicity and promotion are central to cultivating the celebrity subject and, although Sia flouts fame, she carefully manages her popular image. One way in which she controls her appearance and redeploys the magnetic energy of her reluctant celebrity is through capitalizing on another celebrity: the face of Maddie Ziegler. She states:

> I first laid eyes on Maddie during an episode of *Dance Moms*, which I had gotten sucked into somewhere along the way, and I remember seeing her and just thinking, *That face. That* face. There was something about her expressions that conveyed to me a real depth of wisdom and a feeling that I guess I could attune to. (Sia quoted in Ziegler 2017, vii, emphasis in original)

Evidently, Sia felt the affective resonance of Ziegler's face, and it bears significance here that Ziegler is not a random selection or anonymous child performer. Instead, Ziegler is herself a child celebrity, originally through *Dance Moms*, who possesses a huge fan following.[11] Therefore the absence of one celebrity face is replaced with the presence of another.

The employment of a child star also requires consideration as this demarcates a branch of celebrity that has its own values and agendas.[12] Childhood studies scholar Jane O'Connor (2017) observes how female child celebrities engender both power and powerlessness. She states that while childhood supposes a time of innocence and privacy within the safety of the family, the nature of celebrity assumes immorality, excess, and manipulation within a world that is both public and adult. Yet she also notes that childhood and celebrity are not incompatible: the romantic view that children

demonstrate innocence plays into the desire for novelty and youth within celebrity culture.[13] Childhood celebrities are therefore powerful in that they embody values of purity, naivety and potential; however they are also powerless as they operate in a commercial environment designed by adults and possess little control over how they are perceived by the public (O'Connor 2017). Indeed, the manipulation often experienced by child celebrities makes for a difficult public transition into adulthood: some feel "robbed of their childhood" or feel resentful of "stage parents" for exploiting them financially at a young age (Riley 2010, 42).

Ziegler and Sia make a potent celebrity coupling. While the adult singer Sia performs a reluctant celebrity who wants to make music without the social visibility required of pop stardom, the child dancer Ziegler constitutes a willing celebrity, happy to lend her face to social media, music video, live concerts, and other public appearances demanded in this role. Given that the popular music industry also values youth, it makes sense that a middle-aged pop star might salve the image of her ageing body through replacing it with that of an adolescent child. Furthermore, Ziegler's collaboration with Sia allows her to make the potentially awkward transition from child to adult star with relative ease. She clearly needed to shake off her excessively smiling and crying persona cultivated on *Dance Moms* as a young child.[14] Her collaboration with a pop star who carries a fraught history of addiction and depression but is now sober, successful, and healthy gives Ziegler a greater degree of edge while not entirely alienating her from the wholesome image of her past. This association with the ills and thrills of a pop star allows Ziegler to carefully navigate a role more fitting with her adolescent years.

The first collaboration between Sia and Ziegler from *1000 Forms of Fear* was for the "Chandelier" video, which was choreographed by Ryan Heffington, and codirected by Sia and Australian filmmaker Daniel Askill. The critically acclaimed video won several prestigious awards and has attracted 1.8 billion views on YouTube.[15] The song itself, which achieved four Grammy nominations, deals with "drowning sorrow in excessive partying" and its sound reveals "a triumphal burst of emotion and orchestral arrangements" (Battan 2016). Although I will save a detailed description of the "Chandelier" video until the LAUGH chapter, which examines various parodies of this work, it bears note that it sets up the signature visual themes that come to characterize Ziegler as the surrogate face of Sia. The music video takes place in a stark apartment, and Ziegler wears her characteristic flesh-colored

leotard and peroxide blond wig. The choreography for "Chandelier" is a full-bodied dance within the contemporary dance idiom, although Ziegler's face is a stand-out feature of the performance. While moving in and around the different rooms, she vividly articulates a deluge of emotions, expressions, and states that range from fearful, crazed, confused, and melancholic to happy, gloomy, or lost in wonder. Notably, journalist Hazel Cills (2014) identifies Ziegler as a "child version of Sia," in recognition that she takes on some of the emotional labor of the tormented adult pop star in this music video performance.

The choreography for "Chandelier," in particular the facial performance, placed Ziegler in a quite different context to that of *Dance Moms*. Choreographer Ryan Heffington runs his own commercial dance studio, The Sweat Spot, in Los Angeles, and he has choreographed for several high-profile music videos, advertising campaigns, and feature films.[16] Yet although situated within the realm of West Coast commercial dance, several commentators observe how Heffington's choreographic oeuvre is closer to that of an East Coast avant-garde sensibility. Journalist Gia Kourlas (2016) observes that his choreography "wouldn't feel out of place in the downtown New York dance scene" and Younger (2016, C01) describes his choreography for Sia's live shows as "performance art parading as a concert." Several critics also identify how this marks a significant departure for Ziegler. Jean Lenihan (2015) refers to her as "a skinny-boned 12 year old . . . trained in the rather artless world of competition dance," but describes the video for "Chandelier" as moving down an "edgy dance-driven artistic route." Along similar lines, Cills (2014) states, "the routines Ziegler does on [*Dance Moms*] . . . bear little resemblance to the avant-garde movements Heffington mapped for her." Notably, Brian Schaefer (2017) identifies that Heffington's "focus on the face and frequent use of grotesque facial distortions" have become a signature feature of his work. The shift from her compliant smile in *Dance Moms* to Heffington's weird facial contortions marks her transition from a cute small-town girl attending a dance studio in Pittsburgh to an edgy adolescent mingling with A-list celebrities of popular music and film.

In "Elastic Heart," the second video in this collaborative trilogy, the facial choreography becomes even more pronounced.[17] As before, Sia and Askill direct, Heffington choreographs, and Ziegler dances in her pale leotard and blond bob. This time, however, she costars with Shia LaBeouf, a Hollywood actor in his early thirties at the time of filming who has a reputation for a

turbulent personal and public life.[18] The song is a ballad with "heart-swelling choruses" (Shepherd 2014) that plays on themes of lost love, emotional turmoil, and the resolve to stay strong. The action takes place in a large circular cage within a stark studio or warehouse. LaBeouf wears a pair of flesh-toned underpants and both performers appear sweaty and covered in grime.

The video begins with them standing at opposite sides of the cage, eyeing each other up warily. Like wild animals, they prowl around, until LaBeouf bounds toward Ziegler, though she growls back, teeth bared and eyes wide. LaBeouf stumbles back, pounding his fingers against his heart as if in fear. The exchange continues with each approaching the other. Ziegler becomes the more manic and aggressive, holding her ground as her mouth roars in a threatening display of dominance; LaBeouf looks anxious and retreats. She grabs his wrist and swings him in circles and then kicks out, punches him, and leaps on his back. After a while, she collapses in exhaustion, her skinny girl body lying vulnerably on the ground. He reaches out a hand, but she bites it and bares her menacing teeth. Their fight resumes with him now manipulating her, lifting her off the ground while she struggles wildly. As he lunges toward her, she escapes through the cage bars, and stands looking at him. She draws attention to her face, holding her thumb to her temple in an L-shape, sucks her thumb, wiggles her fingers toward him, holds a fist to her mouth, plasters on an empty smile, and then rubs it away with her fist. In response, he issues a long and silent scream of pain, loss, and frustration having failed to snatch her back into the cage. Thus again, themes of torment and pain continue with the music and the face plays a major role in the embodiment of these emotional states.

Not surprisingly, the video was met with controversy regarding the decision to place a nearly naked adult man in such an intimate physical relationship with a young girl, which led to Sia issuing a public apology.[19] This critique of the adult-child interactions in the video foreshadows further ethical questions regarding the power dynamics between Sia and Ziegler in their continued artistic relationship, and specifically in relation to how Ziegler's face is choreographed in "Big Girls Cry." By the time Sia, Ziegler, Heffington, and Askill collaborate on this video, the tone and aesthetic of the work are firmly in place. The interest in the face now dominates as the music video consists of an entire facial dance and, although the song takes the subject of crying as its theme, not a tear is spilled.[20] Therefore how is the crying choreographed, and to what affect?

Sia and Big Girls Cry

The idea that Sia's music reflects upon her personal difficulties and that Ziegler's face represents a surrogate for Sia's has been well established through the popular press and in the previous two music video examples. In her 2017 autobiography, in reference to "Big Girls Cry," Ziegler also insists that her face forms a choreographic conduit for Sia's emotional state: "There's a lot of emotion behind those faces. It's telling a story: We choreograph my face. It isn't just random or silly; it's projecting what's inside and what Sia was feeling at different times in her life" (Ziegler 2017, 111). Although I introduce the opening of the video at the beginning of the chapter, I pick up where I left off to emphasize further the intricate facial choreography throughout.

As Sia sings the bridge to the chorus, "I'm at home, on my own. Check my phone, nothing, though. Act busy, order in. Pay TV, it's agony," Ziegler continues with her rapid facial gestures. Her hand flies out and she begins to smoosh her mouth in circles with a tightly clenched fist, and her head twitches frenetically. Her small childish hands smear repeatedly over her mouth until she is almost slapping her face as the bridge reaches a crescendo. She stops dead and plasters on a doubtful smile just as Sia begins to sing the chorus: "I may cry ruinin' my makeup. Wash away all the things you've taken. And I don't care if I don't look pretty. Big girls cry when their hearts are breaking." Ziegler's smile meanwhile falls, and her face stands still, while her anxious brow and heavy eyes look fraught with distress. She then rapidly pulls at her ears and eyes as if constantly checking and evaluating the individual components of her face, holds her nose, and opens and closes her mouth as if swallowing a bitter pill. She repeats this phrase several times almost obsessively checking her capacity to fit into norms of beauty and attraction. Ziegler reaches out, throws her body back, jittering and twitchy before she suddenly brings her foot to her ear, like a cell phone. Her face appears utterly anguished as she mouths the word "no" and shakes her head from side to side. Toward the end of the chorus, Ziegler lunges her upper body out of shot and we are left with the empty black screen for several moments. As Sia slowly and emotively sings the last line of the chorus, "Big girls cry when their hearts are breaking," Ziegler rises back into the frame, her face shell-shocked: it looks still and empty, with an inner distress that lies beneath her wide eyes and open mouth. She brings her hand to the side of her head and closes her eyes as though the pain is too much to bear.

Themes of heartache and isolation continue with the lyrics to the second verse: "Tough girl, I'm in pain. It's lonely at the top, blackouts and airplanes. And I still pour you a glass, of champagne. Tough girl whose soul aches." Similarly, the disturbing facial dance also persists. Ziegler's fingers creep around her head and her eyes widen in alarm as if an external presence haunts her. She yanks her mouth into a forced smile and then pulls up her eyes to appear wide awake, creating a ghoulish visage. She mushes her lips into a pout and repeatedly puts her hand to her mouth in a distressing image of bingeing, before putting her fingers into her mouth and then spewing them back out again. As Sia comes to the bridge, Ziegler mimes a continuous scream. She rapidly twitches her head with her fingers in her ears, either to visualize or to block out the constant stream of emotional and sonic noise. The camera slowly rotates 360 degrees so that Ziegler's head turns upside down and then back up again. She holds her hand to the side of her head, breathes slowly and heavily, wide-eyed in a state of absolute trauma. The distress that her face conveys in these moments of near stillness marks an alarming contrast to the frenetic and twitchy gestures that make up the rest of the dance. As the music begins to hit a crescendo, a pair of adult female hands, wearing scarlet nail polish and a wedding ring, comes from behind to clasp at Ziegler's neck. The visceral horror that Ziegler's face reveals is almost too much to bear as her mouth and eyes widen in terror.

Again, Sia sings the haunting chorus with the reminder that "big girls cry when their hearts are breaking." The adult fingers flutter across Ziegler's face, tip it back and forth, pull back her ears as Ziegler forces a grimacing smile (see Figure 5.2), move like fins as Ziegler gulps like a fish, and then clasp tightly across her mouth, only being forced apart as she silently screams. The manipulation of her face is upsetting and unsettling as she is forced into a miscellany of expressions. The fingers return to the choke hold and lift Ziegler off her feet as her small pubescent body is hoisted upward, and all that remains is a pair of dangling feet twitching manically. On the final line of the chorus, sung slowly and mournfully, Ziegler drops back into view to return to the same head shot that has dominated the video. She catches her breath, panting as she recovers from this horrific near strangling. The music shifts into an insistent bridge as Sia repeatedly sings, "I wake up, I wake up, I wake up, . . . Alone." Ziegler meanwhile rapidly slaps at her face, gestures wildly, bites her hand, desperately enunciates the word "sorry," pulls at her face, vomits out her fingers, and manically giggles. Her face appears wild, surpassing the norms of social convention.

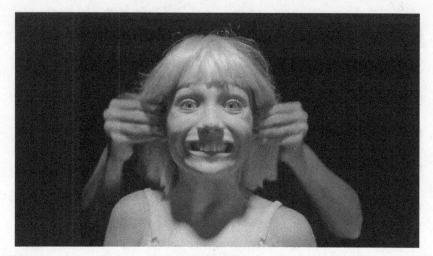

Figure 5.2 Maddie Ziegler grimaces in alarm in "Big Girls Cry" (2014) by Sia.

As the song moves to the closing chorus, the movement slows down and Ziegler clasps her wrist, staring at her hand in disbelief as though perplexed by its ability to manipulate her. She makes her hand into a fist and attempts to swallow it, then wrings her hands repeatedly, her face looking traumatized. She plucks her nose as adults do to tease children, using her thumb as if it was the captured nose end. Such shifts between the infantilized and adultified mark uncomfortable territory for a child in early adolescence. Moments later her fist almost comically punches her in the nose and she blinks in a stupor at its audacity. As Sia repeats the last three lines of the chorus, "Big girls cry when their hearts are breaking," Ziegler stares out to the distance, eyeline set slightly above, head twisting slowly from side to side, breathing heavily, jaw hung loose, unable to hold onto the controlled countenance of adult life, both vulnerable and crazed. The song comes to an end with a few moments of silence and the image goes to blackout.

In *Dance Moms*, the young girls cry excessively and are regularly instructed to stop by Miller and their mothers. In contrast, the song "Big Girls Cry" unapologetically enters the terrain of suffering. Its theme sets up an intertextual relationship with a history of popular music tracks that also deal with the subject of crying, such as "Cry Me a River," "Crying," "Judy's Turn to Cry," "Boys Don't Cry," and "Cry."[21] In particular, the song offers a rebuttal to the 1962 hit "Big Girls Don't Cry" by all-male group the Four Seasons.[22] Sia's defiant response with "Big Girls Cry" provides a dark and vulnerable take on

emotional distress from an entirely female perspective. The track employs a "booming mid-tempo beat" (Wood 2014) with "hints of bass drums and a keyboard melody" (Menyes 2014), and her vocals are bold and impassioned. Indeed, at times, Sia's voice sounds a little damaged, with hints of vocal fry, a rasping tone, and a tension in her neck and throat. These qualities seem to reflect the anguish of the song, which clearly addresses the heartfelt devastation of a relationship break-up, and possibly the trauma experienced in her own life.[23] The idea that her voice both embodies the musical subject matter and her troubled personal background speaks to Barthes's (1978, 188) concept of the "grain" of the voice, which reveals "the body in the voice as it sings." The torment and agony in her vocal delivery then feeds into the choreographic content of the video.

The lyrics of "Big Girls Cry" address themes of lost love, loneliness, and the need to remain phlegmatic in times of romantic break-up, but they also acknowledge the emotional pain involved, critique unattainable feminine ideals, and embrace the fact that "big girls" or women do cry. The complexity of these ideas comes across in the video as the viewer encounters a panoply of choreographic images performed through Ziegler's face: actions of self-monitoring, as she measures, checks, and manipulates her features; binge eating, as she stuffs her hands to her mouth or vomits them back out again; emotional turmoil, as she frowns, apologizes, giggles, or screams; childhood vulnerability, as she sucks her thumb or playfully plucks her nose; self-abuse, as she slaps and punches at her face; and a harrowing image of external social pressures as the gloved hands manipulate her face and almost strangle her.

In the introduction to the chapter, I referenced the trope of the weeping woman in the popular domain. In *Dance Moms*, both the girls and women play out the overblown cliché of the crumpled face and leaking eyes. A trend has also developed across screen performances in which female stars cry in such a way that maintains the beauty and perfection of the face: tears discretely slip out without overly disrupting the countenance of the feminine ideal. This mode of crying has become so dominant across film and television that any deviation stands out. For example, the hit television series *Homeland* frequently features the snotty and twisted "cry face" of lead character Carrie Mathison, which has become a heavily circulated meme, and subject of both fascination and derision, within the popular media.[24] In "Big Girls Cry," while the video takes on a cascade of emotions, Ziegler's face does not mimic literal images of crying. Instead, her face shows fear, terror, loss, trauma, and pain, and it appears at different times to be playful, threatening,

crazed, sinister, and glum. As Neu (1987) observes, crying does not simply convey a generic sadness, but a plethora of emotional states.

Although Ziegler's face does not cry in a conventional sense, the choreography alludes to some of the facial expressions, emotions, and scenarios that are associated with or motivate crying. Furthermore, while the song implies the break-up of a heterosexual romance if read from the position of Sia's sexual orientation, further supported by the normative feminine imagery of the red nails and the wedding ring, the choreography leaves space for a queer reading through Heffington's creative deployment of peculiar and provocative facial expressions. Given that Heffington identifies as a gay man, his grotesque and disturbing facial choreography works against the heteronormative assumptions of the song and the feminine stereotype of the perfect crying face. A further tension occurs as Ziegler's face engenders Euro-American beauty norms, which I will come to in the final section of the chapter; however, her embrace of the ugly, the grotesque, the distressed, and the weird pushes against the ableist norms of a face that labors toward emotional and physical control in public life. Spectators might also tap into a gamut of intertextual references concerning the mistreatment and abuse of young female bodies in sport and performance that foreshadow or echo Ziegler's image in "Big Girls Cry."[25] Certainly, the choreographic complexity of Ziegler's "crying" face resists a definitive reading, but instead displays a myriad of potential interpretations.

The video has been viewed on YouTube almost 270 million times and has attracted over 70,000 comments. Notably, several scholars suggest that despite a distance between a celebrity and fans, a sense of intimacy prevails (Barron 2015; Turner 2013). As Barron (2015) describes, fans actively make associations between celebrities as cultural products and meanings that exist in their own lives. Although some of the YouTube comments directed at the "Big Girls Cry" video deride the choreography, many describe how they relate to Ziegler's dancing face and how they were profoundly moved by it. Such personal revelations, almost exclusively by females, suggest that the video produces intimate and affective relations:[26]

> It breaks my heart how awkward yet accurate these actions/feelings are. (Sara Fulmer)

> This is how my depression and anxiety, and some of other things I don't want to talk about, feel. (Star Dust)

This is how sensitive people feel on a daily basis. Struggling, thinking and overthinking, striving, pining, rejoicing (Hermetic Kitten)

The whole time Maddie was doing those dance moves I could feel the emotion both through the song and the facial expressions! This is truely [sic] Art! (Awkward Crybaby)

This looks like what having an anxiety attack feels like. Sometimes I just can't keep myself from crying and shaking when I feel out of control. (JoAnna Jensen)

This is the first and only video to make me cry because it is so relatable. Especially towards the end when she is biting her hand and pulls it away mouthing "sorry" [loud crying emoji and two red hearts]. Sick girl, just like me. (Emerald Eye)

To consider why viewers were so moved by this facial choreography, I turn to Paul Frosh's (2009) article "The Face of Television." Frosh asserts that the frontal head shot dominates television and, although "Big Girls Cry" is a music video, throughout most of the video Ziegler's visage remains face on to the audience in close-up.[27] Frosh considers the reciprocal gaze between the face on screen and the viewer at home. He conceives this as a direct mode of interpersonal address, which he describes as a "parasocial interaction" to explain its assumed intimacy (Frosh 2009, 90). Frosh argues that the face on television has a deictic role as it explicitly points to or directs its attention to the viewer.[28] Thus, although the audience constitutes an absent or virtual object, the face resolves this distance and separation through a "deictic gaze" (Frosh 2009, 91). He describes how the television presenter or personality develops a rehearsed professionalism that demands careful facial control as if communicating with a singular viewer in an intimate face-to-face exchange. In "Big Girls Cry," Ziegler's emotionally expressive face takes on a deictic role as it appears to invite individual viewers into this intimate relationship, which might explain the deluge of highly personalized responses in the comments section on YouTube.

In "Big Girls Cry," the emotional texture of the song, Ziegler's youth and vulnerability, and the multitude of fraught facial expressions impress upon the viewer a flurry of images and feelings that resonate with the experiences of girls and women: feminine ideals, broken relationships, emotional

traumas. I have already mentioned my own affective response and, similarly, music critics also refer to bodily sensations and intensities that occur when watching the video:

> Your entire body clenches up in fear for her. (Griffiths 2015)

> The overwhelming, eerily unchildlike character that burst out of Maddie's facial expressions that made that video such an intense watch. (Cliff 2015)

> When a pair of strange hands enter the frame and begin to manipulate Ziegler's face, the video becomes strangely moving. (Bradley 2015)

> The focus on Ziegler, as a mini-Sia, is even more intense—we see only her eerily expressive face. (De Bertodano 2015)

I therefore ask, what makes "Big Girls Cry" such an affective performance and what work does this facial choreography do?

Maddie Ziegler and Her Affective Cry

Although "Big Girls Cry" typically features on television and other digital screens, film scholars have noted the affective capacity of the close-up face on the cinematic screen. Béla Balázs (Davis 2004) observed how the magnified face offered new forms of perception and Gilles Deleuze (1986) describes an affection-image as the close-up of the face.[29] The detail of the face holds fascination for Deleuze (1986, 87–88), which he conceives as an "organ-carrying plate of nerves which has sacrificed most of its global mobility and which gathers or expresses in a free way all kinds of tiny local movements which the rest of the body usually keeps hidden." The ability to witness nuanced expressions and emotional resonances through the facial close-up indicates its affective power. Deleuze coins the term "faceicity" to explain the way a face is "envisaged" through its expressive lines (Deleuze 1986, 88).

I find, however, that Deleuze (1986) places affect and expression in such a symbiotic relationship that it fails to account for the work of affect as a social phenomenon. He suggests that affect does not exist independently of the thing that expresses it, although it is separate from it. Hence the face makes an expression and affect is that which is expressed. Yet other scholars assert that

affect already circulates in the social domain (Ahmed [2004] 2015). In the "About Face" chapter, I suggest that emotions are learned modes of behavior, therefore the sensations or intensities experienced when watching "Big Girls Cry" are also part of this discursive framework. I appreciate that the plethora of emotional states that Ziegler reveals are so diverse, complex, and overwhelming that they cannot easily be accounted for. Evidently, fans and critics have a strong embodied reaction to the work, and perhaps summarize this within a relatively catch-all language of being "moved" or experiencing an "eerie" feeling. What I hope to show is that these sensations can be accounted for in a more precise way through attention to the social context in which they arise. I therefore turn to feminist scholarship to help me address the social and cultural politics of facial expression and to understand the affective work of Ziegler's face in "Big Girls Cry."

In her essay "Punk Women and Riot Grrls," Rosi Braidotti (2015) describes how feminists are attentive to images of power and the norms they uphold. She begins with the "public face as the dominant emblem of sovereign power" and, drawing upon Deleuze and Guattari's concept of "faciality," shows how the face acts as a comforting representation of power as it codifies power according to norms of race, gender, and class. Consequently, normality is that which most closely approximates the dominant face or the *semiotic face* that I discuss in the introduction to the book.[30] Braidotti (2015) observes that within contemporary life, the faces of power are not only national or political leaders, but also the overcoded celebrity faces of popular culture. In response, Braidotti asks how feminists can be visible, but avoid a reterritorialization in Deleuze and Guattari's terms whereby women's faces are simply incorporated into patriarchal norms, such as the weeping woman face I describe earlier in this chapter. She suggests that one tactic has been for feminism to "put on different faces" (Braidotti 2015, 247).

In line with Braidotti's thinking, one argument avers that Sia has sought to resist the codifed semiotic faces of female celebrity. In her study of "girl singers," popular music scholar Laurie Stras argues that these young women are the focal point for the audience, they serve as a commodity for a band, and are rendered "so *available*" (2010, 3 emphasis in original), either sexually or platonically. She further explains that girl singers become women when they refuse to engage with this objectification, and when they prove themselves as serious musicians or artists. In these terms, I would characterize Sia as a "woman," both because of her age and life experience, and by merit of her critically acclaimed songwriting. Equally, she also departs from the

girl singer image by refusing to show her face or be semiotically marked by Deleuze and Guattari's (1987) facial machine. Thus Sia snubs the standards of perfection and objectification demanded by the music industry. Through her outsized wig or brown paper bag, she sports a mask that insists she cannot be judged by her looks. Frequently, she opts for a different face: the surrogate face of Maddie Ziegler. Furthermore, this is a new or different formulation of Ziegler's face, which refrains from the glossy and tenacious smile demanded of the studio competitions in *Dance Moms*. Instead, this face looks distorted, crazed, and grotesque. It creates an onslaught of expression, which is dynamic, assertive, and confident in its performance, even when Ziegler appears vulnerable or traumatized. This choreographic intensity seems to be one reason why the video has provoked such an affective response in viewers, and I further this idea through the work of Sara Ahmed.

I have already set up some of Ahmed's thinking ([2004] 2015) concerning emotion and affect in the "About Face" chapter, and here I continue with her assertion that although emotions involve thought and judgment, they are also "felt" by the body. Ahmed ([2004] 2015) suggests that emotions are always oriented toward something and I explore this in relation to "Big Girls Cry." The emotional issues that Sia has faced in her past life regarding mental health, bereavement and substance use, and her extreme dislike of the demands of fame, are evident in *1000 Forms of Fear* and its trilogy of music videos. Her pain and frustration are oriented into "Big Girls Cry" in two notable ways: as a feminist commentary on the unattainable ideals put upon women in the music industry; and in response to the impossible duality that women are perceived as the emotional sex, but that social convention insists that mature women's emotions should be repressed in public life. Although I appreciate that Sia's music is a performance, this does not prevent her from bringing aspects of her life trauma into her vocal style, in the lyrics, and in the emotional drive of the music, as well as the content of the accompanying music video. And even if she does not intend to bring any of her personal experience into her public performance, critics and fans nevertheless read it as such. As Ziegler becomes Sia's surrogate face, she acts as a conduit for this torrent of emotions and, in watching the video, both fans and critics orient their own emotional lives toward the traumatic facial expressions evoked by this young female dancer. As Ahmed ([2004] 2015) describes, one's feelings toward an object are dependent upon histories that have already been impressed upon people. Therefore, the pressures on women to look flawless, the limited stereotypes available to them, the idea that women

cry easily but should not cry, and the impact of this on women's psychological health are already in circulation before the viewer comes to the video. Certainly, for female-identifying viewers, knowing that Ziegler is still a girl child, and witnessing the manipulative and harmful effects of the adult female hands upon her, becomes even more poignant as they intimately know the gendered framework that will judge her and seek to delimit her emotional expression.

The tensions evident in "Big Girls Cry," between crying and not crying, childhood and adulthood, naivety and sexuality, are what Stras (2010, 19) describes as a "lenticular logic" in relation to girl singers.[31] Like the lenticular postcard, which plays a visual trick by depicting two different images depending on the line of sight, the girl singer can hold contradictions in tension. Although I suggest earlier that Sia is more appropriately classified as a "woman," her employment of a young girl enables her to interface with the figure of a girl singer and the ideas and values associated with her. Therefore, Ziegler's dancing face contains the same multiplicity or paradox that Stras (2010) characterizes as a lenticular logic: her aplomb and vulnerability, her smiling and sadness, her facial perfection and distortion, her crying and not crying.

What I describe above are some of the potential discourses available to spectators that make the video particularly affective. In recognizing these discourses at work, spectators are moved, haunted, or chilled through their intimate parasocial interaction between Ziegler's face and theirs. Yet I do not want to suggest that all viewers are moved in the same direction. Ahmed ([2004] 2015) resists the idea that emotions spread contagiously. Although emotions can circulate through people and objects, in this case Ziegler's face, and become sticky with affect, which is evident from the reception of "Big Girls Cry" by critics and viewers who are clearly moved by the experience, these emotions do not pass unchanged. Consequently, emotional responses may vary and interpretations may be contradictory. In the final part of this chapter, I consider how some spectators are moved to celebrate Sia and some are moved to critique.

A Cry of Outrage

For some critics, Sia's decision to hide her face and replace it with Ziegler's constitutes an important feminist intervention into the music industry, and

it is conducted ethically and with care. Journalist Gabrielle Jackson (2016) implores,

> Please Sia, don't show us your face. It's not because I don't want to see Sia's face that I make this impolite request. It's just that I'd prefer to enjoy Sia's music uninhibited by how sexy she is or isn't, by how beautiful she may or may not be, by whether she has a big nose or thin lips.

This comment clearly critiques the standards of beauty expected of female artists within the music industry and applauds Sia's decision to resist this. Similar sentiments come from Younger (2016, C01), who states, "[Sia's] refusal to let the art and, by extension, fame control her is admirable," and Aron (2018, 76) recalls, "[Sia's] refusal to show her face felt almost transgressive." Younger (2016) suggests that demanding attention as a singer, but then redirecting it toward Ziegler's dancing, forces audiences to actively participate rather than passively consume. And in an interview with journalist Gia Kourlas (2016), Sia insists that she was against any sexualization of Ziegler, at one point requesting that gyrating hip movements be changed to "gorilla dancing and belly patting," and encouraging weird facial contortions.

Yet although Sia clearly wants to protect her personal privacy, by replacing her face with Ziegler's, what is at stake here? Journalist Bonnie Malkin (2017) raises a similar question regarding the ethics of relying upon Ziegler's surrogate face. Although reviewing a live concert performance in which Sia stands on the sidelines masked with her oversized wig, and the now fifteen-year-old Ziegler performs choreography adapted from the music videos, the same arguments hold for the trilogy of music videos I discuss in this chapter. Malkin (2017) writes,

> Where Furler was concealed, Maddie was exposed. Where Furler was still, Maddie was moving. Where the singer was in darkness, the child was in the spotlight. Where Furler's face and body was carefully hidden from the eyes of a stadium full of strangers, Maddie's face and body was offered up instead.

Malkin (2017) acknowledges that the face constitutes a major component of Ziegler's dancing, and that she is not afraid to show her face as part of the fame she willingly courts through her performance career and visibility on social media. Yet Malkin (2017) reminds the reader that Sia is an adult who

has experienced the difficult side of celebrity, which raises the question of what responsibility she holds toward Ziegler, "a minor who is yet to learn about, or tame, the monster."[32]

Sia's ventriloquizing of her adult emotional experiences through that of a girl child makes for deeply disturbing viewing, and the discomfort of Ziegler's crazed and manipulated face echoes other child stars who have fallen foul of the demands that celebrity life has placed upon them.[33] Although, at present, Ziegler's personal and professional life appears stable and well managed, the trauma that she enacts in "Big Girls Cry" foreshadows what might lie in store for her as she matures. Indeed, my companion case study example of Michael Jackson offers a chilling vision of child exploitation and failure to adapt to adult life (Hamera 2017), which is further complicated by the horrific accusations against him in relation to the minors with whom he worked and interacted. Jackson himself occupies a place within a lineage of African American child performers that emerged with the "picaninny chorus" of the late nineteenth and early twentieth century. Although Jayna Brown (2008, 24) shows how picaninny choruses were actively in dialogue with ideas about blackness and the laboring body, she also reveals how the trope of the "mischievous and unruly" picaninny became a deleterious stock type. Notably, Brown's (2008, 40) description of the picaninny chorus as specializing in eccentric dance that demonstrated a mix of "the elegant and the grotesque" resonates strongly with the ethereal yet peculiar facial choreography designed for Ziegler. Her facial dance also bears similarities to that of African American dance artist Josephine Baker, who was renowned for her zany and rebellious facial expressions (Smith 2019). Yet the fact of her whiteness, combined with her carefully choreographed career, ensures that Ziegler's face maintains a safe distance from that of the unruly African American child (or adult) dancer.

Significantly, Sia elects to replace her own face not with an unknown dancer, but within the ableist paradigm of a beautiful celebrity child. Ziegler has big blue eyes, plump lips, a mane of dark blond hair, straight white teeth, and she is slim, with long, toned arms and legs. Like Sia, she is white. Although it might make sense for Sia to opt for a racial match when selecting her doppelganger, the relationship between celebrity and whiteness bears further interrogation. Media and communications scholar Sean Redmond (2007) argues that when stars and whiteness come together, this produces the highest form of idealized whiteness. He describes this as an ethereal or almost angelic quality, and we only need to think of Ziegler with her blond

bob, pale complexion, and light skin-toned leotard, bathed in a brilliant white light throughout "Big Girls Cry" to recall how her luminous features and youthful innocence play into this celestial image.

Redmond (2007) asserts that stars are both extraordinary, in that they possess a special talent, and ordinary, as their success is based on hard work; and that they are both present in the ordinary world as they must labor to be where they are, yet they are simultaneously absent as their glamorous existence removes them from everyday life. Notably, the same ideas of absence and presence are used to describe Sia, who is present in her music and body, but frequently absent in her refusal to show her face (Younger 2016). Redmond (2007) states that whiteness is such a ubiquitous part of the everyday world, it is invisible as a racial signifier. Hence for whiteness to be noticed, it must be idealized to the highest degree, which we see in "Big Girls Cry." Yet the tensions that lie between the extraordinary/ordinary, present/absent character of the star reveals whiteness to be a construction. He describes the labor that must go into the performance of the heavenly white star, but when stars fail to live up to this ideal, the construction of whiteness is exposed. Redmond (2007) demonstrates that when white stars are either unable to maintain, or choose to rebel against, the ideals of beauty, health, and strict codes of morality, these "unruly" bodies reveal the performative nature of whiteness.[34]

Both Sia and Ziegler bear the privilege of an unmarked whiteness, and this is idealized through the signature brand of their brilliant blond bobs. Certainly, Sia indicates her unruliness or reluctance to be an ideal white star by refusing to show her face, and she is critical of the labor that goes into maintaining this ideal star image: "I'm going to need to have my roots done. I'm going to have extensions, probably. I'm going to get a stylist for sure. I'm going to have to work out five times that week" (Sia quoted in Wiig 2015). Yet although her unruly behavior potentially uncovers and critiques the construction of whiteness, to return to York's (2018) concept of "magnetic reluctance," this energy is stored up and redeployed. Part of Sia's attraction comes from her refusal to show her face and this has produced serious attention from the press. This reluctance makes Sia an alluring celebrity figure and the energy garnered from this attention is redirected into the choreographic vitality of Ziegler's beautiful, ethereal, and emotive face. Consequently, Sia's privileged celebrity is maintained and, as Redmond (2007) notes, stardom feeds into and relies upon consumer capitalism to support its own ends. Along similar lines, Ahmed ([2004] 2015) draws upon Marxist theory to

argue that although it appears that emotions naturally reside in people or objects, they are in fact part of a history of economic production. Thus, while Sia eschews the ideals of stardom in masking her face and embracing an emotional honesty through her insistence that "Big Girls Cry," in conveying this message through the innocence of a young celebrity dancer's face in a promotional music video, she helps to uphold an entire conglomeration of supporting industries, such as media outlets, personal stylists, artistic management, legal teams, and publicity firms (Turner 2013).

In this chapter, I argue that Ziegler's face is at work in many ways. Through a choreographic reworking of the crying face, Ziegler's visage is financially and artistically employed to critique the reductive associations between women and emotion, and the idealized faces that are on show within the music industry. Her face works to mask Sia's face as a reluctant celebrity, critical of the treatment of women and the cost of celebrity within popular music production. The complex choreographic rendering of the act of crying in "Big Girls Cry" cannot be easily explained as her face is awash with different meanings. Yet clearly the torrent of emotional states expressed by Sia in her music, and conveyed by Ziegler through her face, produce affective relations between the singer, dancer, fans, and critics: they are haunted, chilled, and moved by what they experience and bring their own interpretations to explain their embodied reactions to the work. This collective response indicates that affect cannot be reduced to a presubjective or prelinguistic sensation. The discourses that concern women, emotion, trauma, perfection, and manipulation, and their potential to evoke bodily sensations and intensities, are already in circulation and available to spectators. To some extent, this deeply affective reception aligns with the political critiques staged by Sia. She speaks openly about her mental health, refuses to play the celebrity game, and stops showing her face. Yet the power structures that support the popular music industry ensures that the energy of Sia's feminist intervention, which could also be termed "magnetic reluctance" (York 2018), is redirected in ways that maintain the hegemony she critiques. Although she masks power in masking her face, it is simply rerouted to the surrogate face of Ziegler. Sia's refusal to sell her face superficially hides the privilege of white celebrity and the commercial intent at work, but both are fully operative.

I noted in the introduction to this chapter that it is an outlier in the book as the facial choreography does not straightforwardly mimic the facial expression of crying; rather the action-expressions deployed in the video express the complex emotional states and experiences that may be associated

with crying. Indeed, instances of dancers literally crying as a purposeful facial performance within the context of popular presentational dance occurs rarely, if at all. That said, I can envisage future research into a range of popular performances that intersect with the act of crying in some capacity: for instance, the facial expressions deployed by performers within the context of music videos or stage acts in response to songs that take crying as their theme; popular dancers who cry in response to performance mishaps or failures in the midst of dancing, particularly in the competition arena; popular music artists who do produce tears as part of their recorded performances; and audience members who cry in response to popular dance performance. I can think of at least several examples of each, and it would be interesting to consider the extent to which these visible displays of crying play between notions of genuine sorrow and manipulative affect.

Returning to Ziegler's performance, the most progressive dimension of the video resides in the facial choreography. Here Ziegler is allowed to move on from the contorted features and leaking eyes that dominate the cry-baby faces of *Dance Moms* as she transitions into the unstable and confusing territory of an adolescent girl. In "Big Girls Cry," her face engenders the complex emotional experiences that young girls and women endure, and she confidently appears freakish, crazed, and ugly. Yet the literal and metaphorical manipulation of her body by adult hands is both distressing and ethically questionable and, to place the burden of adult celebrity and experience onto a young girl, flies in the face of Sia's critique. To conclude, Ziegler's moving facial performance stages a highly manipulative cry.

6
SCREAM

> Dance is my medicine. It is the scream which eases for a while the terrible frustration common to all human beings who, because of race, creed, or color, are "invisible." Dance is the fist with which I fight the sickening ignorance of prejudice.
> —Pearl Primus quoted in Schwartz and Schwartz (2011)

In 1968, anthropologist and choreographer Pearl Primus famously described dance as a physicalized scream against racial injustice. In 1995, Michael Jackson released a double album, *HIStory: Past, Present and Future, Book I*, and the first song to go on sale was a duet with his sister, Janet Jackson, titled "Scream."[1] I last considered Jackson following the release of his *Bad* album in 1987, which saw the mobilization of his face from a glossy and tenacious smile to an agitated and provocative frown. In 1991 Jackson released his third album with Epic, *Dangerous*, which deals with themes of gender and sexuality, social and racial inequity, and, in contrast to his earlier work, popular music scholar Susan Fast (2014, 2) suggests that he offers a "darker vision of the world" and seems to be "at a genuine emotional breaking point."[2] In this chapter, I make a link between the sickening scream articulated by Primus, a Black dance artist's response to the pain of systemic racism, and Jackson's increasing attention to social injustice within his music, which continued with the *HIStory* album, and specifically a vocal and choreographic scream.[3] "Scream" was promoted through a short film directed by Mark Romanek, featuring the two Jackson siblings. Shot in black and white, it cost $7 million to produce, which at the time was reputedly the most expensive music video on record (King 1999), and it received substantial critical acclaim for its artistry and innovation.[4]

It opens with a white saucer-shaped craft, against a black star-filled sky, flying deep in outer space. Buzzing electronic sounds invade the silence as if machines are slowly coming to life. The shot shifts to the inside of the

spaceship and we see angular white walls and panels with knobs and buttons straight out of a sci-fi comic book. Cut to a small white window that reveals Michael, eyes closed, and arms tightly crossed against his chest as if embedded in a futuristic sleep capsule.[5] His eyes suddenly open wide and, for a moment, he stares intently back at us. His face looks pale, his wavy black hair hangs well past his shoulders, and his eyes and brows are sculpted with heavy black make-up. Other parts of the ship come to life as screens switch on and Janet, with a short choppy hair-cut and dark smoky eyes, slowly rouses from her slumber. The sound of static crackles loudly, followed by a piercing electronic tone, and Michael, wearing large headphones, throws his head back, twists his mouth in agony, and clasps his hands to his ears as if trying desperately to cut out the painful noise. Janet too twists her head uncomfortably in response to the discordant sound. Cut to a screen on which Akira, an anime figure, screams and a long vocal scream bursts out on the soundtrack. The shot moves back to Michael whose intense facial scream shatters the window of his sleep capsule (see Figure 6.1). Shards of glass explode outward as the musical introduction kicks in.

Within the mise en scène, it bears note that as soon as Jackson awakens, he emits a potent vocal and facial scream, which prompts the question of what propelled him to employ such a visceral emotional expression as the source of this artistic work. In the lead-up to *HIStory*, Jackson's life had become the subject of serious public scandal and intense media scrutiny. In 1993 he was accused of molesting a young boy, Jordan Chandler, which led to a humiliating criminal investigation that was subsequently dropped the following year.[6] In 1993, Jackson also appeared in an Oprah Winfrey interview in which he was pushed to talk publicly about his changing facial features. Awkwardly, he discusses his vitiligo, a condition that affects the pigmentation of the skin resulting in blotchy white patches, and his plastic surgery, which he had briefly addressed in his autobiography *Moonwalk* (2009). In the same interview, he also confirmed a period of rehabilitation for addiction to prescription painkillers, which he began taking to medicate against the injuries he sustained while filming the Pepsi Cola commercial, which I briefly reference in the SMILE chapter.[7]

In the two years leading up to *HIStory*, Jackson was vilified in the news media for these perceived indiscretions and misdeeds, where his portrayal ranges from an eccentric weirdo through to a monstrous criminal (King 1999; Stillwater 2014; Vigo 2012). In a *New York Times* review of the album, popular music critic Jon Pareles draws parallel between the music and

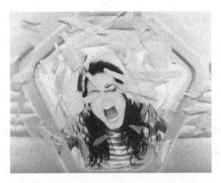

Figure 6.1 Michael Jackson shatters the glass of his sleep capsule in "Scream" (1995).

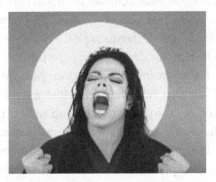

Figure 6.2 Michael Jackson emits a scream prior to his dance duet with Janet Jackson in "Scream" (1995).

Jackson's psyche at the time: "Michael Jackson is back, and he's furious. On his new double album, 'HIStory: Past, Present and Future, Book I,' his rage keeps ripping through the sweet, uplifting façade he has clung to throughout his career" (1995). Although I will come to detail how "Scream" undoubtedly stages Jackson's raging response to his treatment in the popular press, my analysis is further complicated by the release of the documentary film *Leaving Neverland* in 2019, directed by Dan Reed, which centers on new allegations by two men, Wade Robson and James Safechuck, who describe how Jackson sexually abused them as young boys over a period of several years. I therefore begin with the notion of "re-facing" Michael Jackson.[8]

Given the slippery nature of his public image and shifting perceptions of his visage, I consider how I might treat such a polarizing figure particularly

in light of contemporary social justice initiatives that seek to cancel support of abusive individuals who hold prominent positions across society, art, and culture. While this discussion might appear to have little relevance to Jackson's face and his impulse to scream two decades earlier, it reveals the changing public reception toward him over time, which has often centered on judgments regarding his face. As I will come to show, the news media narratives that portrayed his face as monstrous or freakish are re-confirmed through the documentary, which alleges horrifying criminal behavior against vulnerable minors. And, although at the time when "Scream" was released both fans and critics were sympathetic to Jackson's urge to scream back at a news media and music industry that had harangued him about his face, dress, and behavior, the documentary clearly deflated the justification for his protest, which leads me to consider the impact of a scream over time.

Several scholars have written about "Scream" (Cannon 2010; Carpenter 2014; King 1999; Manning 2013; Steinskog 2015; Stillwater 2014; Vigo 2012); however, I approach it specifically from the perspective of Jackson's face and the choreography of the scream. I turn to anthropologist Michael Taussig's (1999) concept of "defacement," which provides a useful lens to consider Jackson's altered face and the public outrage and anxiety that this provoked. By attending to the media furor that surrounded Jackson's face, it is evident why he turned to what I conceive as the action-expression of a "potent scream." I opened the chapter by making a connection between Pearl Primus and Jackson, whose lives were bound by racist structures that compelled them to respond through both a literal and metaphorical corporeal scream. I therefore draw upon the work of performance studies scholar Fred Moten (2003), who writes about the scream as an originating point of trauma and subjectification for Black people that lives on through generations but also offers opportunity for a radical breakdown through Black art and culture. Yet while the drama and spectacle of a scream forms a potent experience both for those who emit it and those who witness it, I ask whether its power can be maintained.

Re-Facing Michael Jackson

In the "About Face" chapter, I introduce the concept of an *identifiable face* to convey how notions of identity are rooted in perceived facial phenotypes. Yet Jackson's face has proved extremely troubling for some observers: although

it remained identifiable throughout his career in terms of its wide global recognition, it also became unidentifiable in the sense that it changed to such an extent that he appeared to transgress stable identity positions. Indeed, his face has garnered significant interest amongst scholars for its capacity to unsettle identity. English scholar Willa Stillwater (2014) conceives it as a visual art project stating, "His face is a work of art so revolutionary we don't yet even recognize it as art, though it has deeply troubled and passionately engaged us for decades—as powerful works of art often do." Other scholars have described it as a mask: art historian Kobena Mercer (1986) suggests it reflects broad social concerns that coalesce around ambiguous racial, sexual and gender identity; popular music scholar Sheila Whiteley (2005) considers the lightness and tautness of Jackson's skin which distance him from his purported origins as an African American man; and literature scholar David Yuan (1996) portrays Jackson's face as a self-determined mask that models multiple and inclusive identity positions. Although I appreciate that this scholarship reveals how Jackson undermines the possibility of a stable *identifiable face*, the conception of his face as an artwork or mask places too much emphasis on his face being looked at. The mask suggests a rigid framework and, while this might be appropriate for the glossy and tenacious smile I discuss earlier in the book, for a man so committed to motion, it fails to honor the choreographic flexibility that his face and body assumed as he developed as a solo artist. Thus, rather than being observed through a visual art paradigm, the choreographic places greater emphasis on an active, sensing, compositional intent and I see this as Jackson's will to employ his facial expression as a creative and critical commentary on his public reception. As communications scholar Julie-Ann Scott (2012) observes, his facial innovations were as original as his musical ones.

That so much changed with his face, the idea of re-facing Jackson alludes both to the creative and cosmetic changes that he initiated, as well as the urge for music critics, scholars, and Jackson fans to reposition themselves as his face changed, as he produced fresh artistic work, or when new revelations appeared regarding his personal life. Although I come to further analysis of the "Scream" video later in the chapter, the two Jackson siblings clearly intended to vent. In the next few shots that follow Michael's awakening howl of despair that literally breaks the glass capsule in which he is encased, images of anger and rage abound. Both are dressed in shiny black PVC pants, chunky platform shoes, and black tops covered in spikes: Janet comes to standing with vicious gritted teeth, she drags her nails up her thighs, Michael punches

his fist to the camera with a clenched jaw, flicks his chin in an aggressively dismissive gesture, edges across the screen with sharp shoulder isolations, watches Akira scream out, and smashes a flying-V guitar into pieces while screaming. Each facial scream corresponds to a sustained scream on the track. While my original analysis of this video took a predominantly sympathetic position to Jackson's treatment by the media, I have had to revisit this work and therefore re-face Jackson in light of *Leaving Neverland*. The documentary not only prompted cause for hesitation, but also raised difficult questions about the ethics of scholarly research.

Although Jackson's professional image was already haunted with previous accusations, he continued to be treated as an outstanding musical artist and a substantial body of scholarship and critical journalism, particularly following his death, sought to complicate the "Wacko Jacko" narrative that persisted in the popular imagination through focusing on his artistic skill and prejudiced treatment in the media (Fast 2010, 2014; Fisher 2009; Manning 2013; Smit 2012; Vogel 2012, 2015).[9] The release of *Leaving Neverland*, however, led to intense public debate (Boyd 2019; Harvey 2019). The documentary followed in the wake of the 2017 #MeToo movement, a viral hashtag produced in response to the sexual impropriety and predatory behavior of celebrated male figures in the public domain. This reckoning prompted a "cancel culture" or "call-out culture" that sought to expose and withdraw support for any individual engaged in abusive behavior. *Leaving Neverland* is four hours long and makes for an uncomfortable and distressing viewing experience as the two men recount in vivid detail how they were groomed and abused by Jackson. The documentary came out after I had completed the first draft of this chapter and, as both a scholar and fan of Jackson, this led to a period of personal reckoning during which I questioned whether I should drop the project entirely.

Although I want to be respectful and take seriously the position of the two men featured in the documentary, my aim of this writing is not to establish the veracity of the allegations.[10] Instead, I ask what my ethical responsibility is as a scholar and what can I salvage from this experience as I come to re-face Jackson with this new information. To assist me in navigating this precarious territory, the coverage of the documentary in the highbrow press offers some useful thinking concerning the relationship between the work of art and the artist. Certainly, Jackson is not alone as several journalists pointed out multiple artists of extremely dubious character, both morally and politically, whose work continues to be visible and celebrated in the public arena (Aaronovitch 2019; Petrusich 2019; Rifkind 2019). This is not intended to

absolve Jackson of any alleged crimes, but to acknowledge how complicated it becomes to police art through the conduct of the artist. Some commented on how it would be almost impossible to "cancel" Jackson given that he is now deceased (Petrusich 2019; Sturges 2019), thus withdrawing economic support would have little impact, and attempting to undermine the artistic reach of his work is pointless given the breadth and influence of his prolific musical output (Klosterman 2019; Morris 2019). Yet irrespective of whether individuals continue to engage with his music and dance performances, Chuck Klosterman (2019, 6) warns that the "non-musical events" that shaped his life will always impact the musical meaning.

Some of the coverage centers on his privileged position as a celebrity in the sense that his wealth and fame awarded him power to navigate outside the bounds of quotidian life and everyday social expectations. This idea indicates the exceptional position that artistic genius continues to hold in society which assumes that celebrity supersedes criminality (Dowd 2019; Petrusich 2019; Sturges 2019).[11] Many of the commentators describe how the families of the two men in the documentary were in such awe of Jackson's celebrity that any reservations that would normally be held regarding the interactions of an adult man and a young boy were dispelled.[12] Notions of visibility are attached to this idea of celebrity in the way that it has the potential to blind onlookers and supporters (Driscoll 2019), that its "dazzling glare" feeds into a collective ignorance (Reed 2019, 46), and that Jackson was "hiding in plain sight" (Harvey 2019, 25; Sturges 2019, 22). Again, while I do not intend to diminish the severity of the accusations directed at Jackson, with the exception of Greg Tate (2019), an African American writer and cofounder of the Black Rock Coalition, the question of race both within the coverage of *Leaving Neverland* and in the documentary itself remained largely unaddressed. I will explore this issue later in the chapter, but it strikes me that throughout his career Jackson was held to a level of scrutiny not applied to his white male counterparts.[13]

In terms of re-facing Michael Jackson, I conclude that there is no absolute position, but that each person needs to take an individual stance on how they decide to engage—or not—with his artistic output moving forward. I hold in tension the paradox that I have taken great pleasure in his musical and dance performance and that a documentary exists that presents persuasive allegations about his personal conduct with minors. The conflicting feelings continue to hover over my work, but as a scholar, I committed to completing my research on his facial choreography because any attempt to expunge him

from the historical record would be to deny an artist hailed as one of the most original and talented global superstars to emerge in the late twentieth century. In terms of my interest in the face, the documentary offers yet another reading position that makes a direct link to, and implicit confirmation of, news media narratives that exposed Jackson's face as monstrous, freakish, and an index to his alleged life as a sexual predator and pedophile. Notably, in an article on *Leaving Neverland*, journalist Wesley Morris (2019) entertains the idea that Jackson's cosmetically spoiled face was a part conscious externalization of the sickening demons living inside him. As I move on through the chapter, I examine the "Scream" music video and the discourse that surrounds it by music critics, journalists, scholars, and fans. Undoubtedly, Jackson created "Scream" as an autobiographical commentary on his treatment by the news media, but I do not intend to produce a psychoanalytical reading of the artwork as a symptom of his inner psyche based upon posthumous allegations of his sexual conduct with minors.[14] Instead, I return to his face to examine its (re-)construction and reception and how this laid some of the foundations for his potent scream.

Defacement, Freakery, and Race

In response to the *HIStory* album, pop critics identify a shift in Jackson's music toward a turbulent emotional state: writing in the *New York Times*, Pareles (1995) notes, "In his new songs, he is paranoid and cagey, messianic and petty, vindictive and maudlin"; in *Rolling Stone* magazine, James Hunter (1995) comments, "He's angry, miserable, tortured, inflammatory, furious"; and in a retrospective review, twenty years on, *Dazed and Confused* critic Michael Cragg (2015) reflects: "Michael Jackson's music—often imbued with something close to pure joy—had become polluted by solipsism." In each of these reviews, the writer makes some allusion to the recent revelations over Jackson's personal life, implying they are the source of his charged musical output.

"Scream" is the opening track on the album and was cowritten by Michael and Janet Jackson and its producers Jimmy Jam and Terry Lewis. Musically, it features "a mixture of electrorock, new jack swing (typical of much of Jackson's later output), dance-pop and funk" (Manning 2013, 156). The feel of the track is edgy and restless, with clanking, buzzing, and sounds of shattering glass over a persistent and percussive groove, and it is punctuated

with repetitions of Jackson's extended vocal scream. Popular music critic Michael Cragg (2015) notes, "'Scream' finds the pair spitting out tightly wound lines railing against the press almost through gritted teeth, the industrial beats and clattering percussion encasing an incredible vocal performance from Michael." The lyrics certainly point to Jackson's deep frustration over the media intrusion into his personal life with the opening verse, "Tired of injustice, tired of the schemes, the lies are disgusting, so what does it mean," and the chorus repeating, "Stop pressurin' me, make you just wanna scream."

While the news media reported on and sensationalized many aspects of Jackson's personal life leading up to the release of "Scream," for the purposes of this chapter I look at the public fascination with his face.[15] To makes sense of this, I draw on Michael Taussig's (1999) concept of defacement in addition to a cluster of scholarship that centers on Jackson's visage. In his 1999 book *Defacement: Public Secrecy and the Labor of the Negative*, Taussig explores the act of despoiling a precious object. Although this could be a statue, a flag or money, he uses the idea of the face and defacing to examine the attraction to this shocking act and how this assault exposes a secret. Taussig argues that defacing a body produces "a strange surplus of negative energy" (1999, 1). This unmasking illuminates a truth, or secret, in the moment of self-destruction, yet the secret is not destroyed. Taussig describes what he terms a public secret as *"that which is generally known but cannot be articulated"* (1999, 5, emphasis in original), and he conceives public secrecy as a basis of power. I use these ideas in relation to Jackson's face, and specifically the secret of race as a social construction. Although Taussig's model could also be applied to other public secrets concerning Jackson, such as gender and sexuality, I focus on race as the way in which Jackson's face and body are racialized throughout his career forms a central theme of the book.

Jackson's face has provoked extensive interest and performance studies scholar Judith Hamera (2012) suggests that in terms of his physicality, Jackson is remembered most for his changing face. In 1993, Jackson, who had not made a television appearance for several years, performed in a television special, *Motown 25: Yesterday, Today and Forever*, and his face had radically altered:

His nose was now streamlined and sculpted . . . The new face had been skillfully enhanced: almond-shaped eyes outlined in black and lightly shadowed, high cheekbones emphasized by the merest hint of rouge, lips

glossed to a subtle sheen. His former Afro hairstyle had been replaced by soft curls that framed his face. (Taraborrelli 2010, 242–243)[16]

Further descriptions of this period detail his lightened skin, wide eyes, and cleft chin that appeared to depart significantly from images of him as a young man (Albrecht 2013; Carpenter 2014; Scott 2012; Vogel 2015). It is the reception of these cosmetic changes that confirms Jackson's transformation as an act of defacement.

Taussig (1999) asserts that defacement happens to objects that have become routine, and I suggest that the face typically fits into this taken-for-granted status in the everyday world. Jackson's face as a child, and in the early part of his adult career, was taken at "face value" (Taussig 1999, 7) in that the idea of race as a social discourse remained secret; the assumption held that his face was natural, biologically determined as African American. Notably, while his countenance was understood as a natural *physiological face*, this sits uneasily with the public desire to see it as a coded *semiotic face* or an *identifiable face* that observes a structural racial order in which he presents as Black. As Jackson began to cut his face through surgical interventions and dramatically alter it through cosmetic means, this produced a defacement of his everyday face. His face was despoiled in the public imagination, and it questioned the idea of race as natural. Taussig (1999) describes how defacement occupies the border of self-destruction and has the potency to agitate authority. The artist who defaces violates a norm, which then takes on a religious or magical fervor, and the media can play a significant role in heightening the frenzy (Taussig 1999). Jackson's face has been portrayed in the media as freakish, grotesque, and monstrous, and much of the anxiety directed at it centers on how its transformation created an ambiguity as to whether he was Black or white, masculine or feminine, heterosexual or homosexual, child or adult, and in later years, father or mother (Albrecht 2013; Fast 2010; Mercer 1986; Stillwater 2014; Yuan 1996). In short, his visage was no longer semiotically legible or identifiable according to social norms.

Although cosmetic surgery had become more commonplace in the 1980s and 1990s (Scott 2012) and other white male popular music artists have also played with androgynous looks (Mercer 1986), the media insisted that Jackson had "'ravaged' his face through obsessive plastic surgery" (Stillwater 2014).[17] Part of the obsession over Jackson's face concerns pathologizing his cosmetic changes as symptoms of a troubled past. These start with relatively benign rationales that blame low self-esteem (Taraborrelli 2010)[18] or

his vitiligo condition, which was initially met with skepticism but confirmed posthumously (Fast 2010), through to a range of disturbing motivations that served to enhance his reputation as a weirdo: to fulfil an addiction to plastic surgery (Awkward 1995), to mimic women he deeply admired (Holland 2009; Manning 2013),[19] to disclaim any resemblance to his allegedly abusive father (Yuan 1996; Whiteley 2005), to reclaim the loss of his childhood (Fuchs 1995), or as a form of racial self-hatred (Awkward 1995; Manning 2013; Yuan 1996). While my interest here is not to speculate on the extent of his cosmetic surgery, nor to psychologize why Jackson chose to transform his face in the ways he did, these accounts indicate the fascination with and anxieties provoked through his facial changes. Clearly, his facial modifications mobilize complex questions concerning identity.

Returning to Taussig (1999), I begin with the premise that although race is a discursive category, this remains a public secret, and instead race is taken to be a set of biological attributes. Although contemporary scholars and sections of the media are alert to the social construction of race, hence the public nature of this secret, the discourse that circulated around Jackson's facial transformations called upon the fallacy of naturalized racial characteristics. And even though Jackson's defacement revealed the construction of race, Taussig (1999) maintains that the truth is not destroyed through its exposure; indeed, an object needs to be defaced for it to be elevated and maintain its power. The media narrative concerning Jackson insisted that his natural young face was outrageously defaced through surgical and cosmetic interventions. This potential exposure of race as a social construction and the media response at the way his defacement reveals the secret strengthens the power of racism and the appeal to the natural.

Jackson's facial transformations opened up questions of identity that reveal the instability and ambiguity of markers such as race, gender, and sexuality. His changing façade shifts from socially constituted markers of African American racial features (brown skin, full lips, wide nose) to European characteristics (white skin, thin lips, narrow nose), and from masculine and heterosexual facial signifiers (no cosmetic enhancement, pale lips, plain eyes, short hair) to feminine and queer ones (heavy make-up, rouge lips, exaggerated eyes, long hair). Jackson's face revealed the social construction of identity through troubling its binary assumptions, which placed his visage in a liminal space that exceeded its physical and social heritage through a performative critique (Albrecht 201; Awkward 1995; Carpenter 2014; Pinder 2012; Vigo 2012). This ambiguity, or in the media's terms extreme

defacement of the heterosexual African American male face, thus exposes the mythology of biological identity. Yet the revelation of this public secret does not do away with belief in an essential racial and gender difference but reinforces it through the language employed to comment on this unmasking.

Albrecht (2013, 717) states that Jackson's skin lightening created the most disquiet as it failed to "perform his authentic blackness correctly." Performance scholar Faedra Carpenter (2014, 9) describes such moves toward the values of whiteness as "naturalized whiteface," but also critiques the ways in which blackness is policed through turning to an essentialized conception that relies upon a normative phenotype. Indeed, the narratives of racial self-hatred directed toward the whitening of Jackson's face assume a biological essentialism in that to identify as African or African American the skin must be visually marked as Black (Vigo 2012; Vogel 2015). Notably, although Jackson explained the lightening of his skin as a means to blend his face with the white patches caused by vitiligo, other commentators question why he did not cover the blemishes with darker hues to match the rest of his skin, thus insisting on a biological determination that he is Black (Scott 2012). Despite the postfeminist and post–Civil Rights era in which Jackson became a celebrity, as he began to challenge the binary signifiers of race, gender, and sexuality, the public anxiety around them reified those boundaries to reveal their ideological reality (Scott 2012). Carpenter identifies this fear over the collapse of identity categories as a form of "binary terror" for those most invested in their stability (2014, 31).[20] Drawing on the idea of colonial mimicry, Tamara Roberts (2011) observes that Jackson's transition from Black to white could never be fully realized as the Other cannot occupy the same space as the colonizer because of their assumed racial difference. In similar theoretical territory, multicultural studies scholar Sherrow Pinder (2012) argues that Jackson's racial ambiguity fails to transgress blackness as it is always understood in relation to whiteness through a power dynamic of domination and subordination. And English scholar Michael Awkward (1995, 179) describes how the public's knowledge of Jackson's "dark past" can be traced through widely dispersed images of him as a youth in the Jackson Five, which depict his darker skin tone as absolute proof of his African ancestry. As this discussion shows, the secret of race is exposed, but the structural power of racism remains. Although race is founded on socially constituted values and beliefs that uphold uneven distributions of social, economic, and political power, the exposure of this through Jackson's defacement brings into effect racist structures of understanding. Attempts to prove Jackson's African

heritage or authenticate his blackness plays into a commitment to natural or biological interpretations of race.

For Taussig (1999, 49), the unmasking of the secret is associated with an "off-kilter, creepy feeling of the uncanny," and this perspective plays into the discourse of weirdness and freakery that surrounded Jackson's face. His failure to perform an *identifiable face* in accordance with the logic of race proved a monstrous affront to the natural order of white supremacy. While the media highlighted discomfort at Jackson's body overall, his face specifically was deemed abnormal, grotesque, and a spectacle (Albrecht 2013; Pinder 2012; Scott 2012). Media scholar Julian Vigo (2012) points out the racist legacy in naming Jackson a freak as African American bodies were frequently exhibited in the freak shows of the nineteenth century.[21] Furthermore, Yuan (1996) asserts that the more successful Jackson became as an artist, the more the public focused on his perceived peculiarities, often indexed through the moniker Wacko Jacko. Yet Yuan argues that rather than being subject to "static enfreakment" (1996, 371), which is dictated by the way in which audiences fix and view a freak, Jackson was the "agent of his own enfreakment" (1996, 369) as he needed "always be moving, evolving, transforming himself" (1996, 371). This sense of mobility lends itself well to dance and I would add that it is not simply the modifications to his face that resisted static enfreakment, but his dynamic facial expressions that enabled him to present a critical choreographic response.

Given that the mainstream news media was, and to an extent continues to be, dominated by white, male journalists it bears little surprise that Jackson's face was racialized according to a racist supposition: that he should wear his face as an authentic Black heterosexual male and any departure from this renders him a freak. The degree of permissiveness granted to other white male pop artists was evidently not awarded to Jackson, therefore the white audience imagined within the news media inevitably misread Jackson's creative innovations to his visage as disturbing transgressions. Indeed, the essentialist expectations to which he was held accountable across lines of race, gender, and sexuality reveal not only the racism of the media at this time, but also its misogyny and homophobia. While the straight white press then positioned him as creepy (Fast 2012), a queer of color critique helps to re-envision the self-determined strategies that he employed to question the limits placed upon his body. Although there was considerable speculation in the press regarding Jackson's sexuality, which variously read him as asexual, bisexual, homosexual, and a pedophile (Abdur-Rahman 2012), I am more

concerned here with the way in which he took creative pleasure in his facial appearance and was unapologetic in his decision to showcase his countenance both through temporary and permanent cosmetic modifications that troubled normative expectations.[22] As queer scholarship shows, musical and dance performance offer opportunity to slip away from and reorient that which is assumed to be essential (Croft 2017; Ellis 2020).[23]

Although the news and entertainment media characterized Jackson as a weirdo and freak, this narrative was not reproduced among his fans. While his commercial popularity had waned from the era of *Thriller*, in the subsequent years leading up to and following his death he continued to attract a global fanbase, which is evident from the number of international fan clubs dedicated to his celebrity and artistry.[24] Even in response to *Leaving Neverland*, there have been lengthy fan posts that dispute the credibility of the documentary and some fans mobilized to counter it through an #MJInnocent campaign and attempted to flood social media with Jackson's music during the period in which the film was screened (Coscarelli 2019).[25] Irrespective of whether this displays naivety at best or dangerous collusion at worst, it signals an unrelenting loyalty to Jackson as an artist. And despite media attempts to discredit Jackson personally and professionally in the two years leading up to "Scream," Jackson's fanbase remained solid as the single came in at the number 5 position in the Billboard Hot 100 Charts and in the United States it became a platinum record selling 700,000 copies.[26] So why was the racialized narrative of freakery so compelling?

Taussig (1999) suggests that secrecy animates reality and, without it, reality would be dull. The drama of concealment and revelation is key to defacement and the unmasking paradoxically creates a mystery. The mystique of Jackson as a global superstar fueled the public and media obsession with his face, body, and lifestyle. Furthermore, I would not want to suggest that Jackson was a passive recipient of the narratives placed upon him. He often encouraged speculation about his face by wearing surgical masks or bandages for reasons that were nonmedical, but this augmented the idea that he was obsessed with plastic surgery or played into the rumor that he had destroyed his old nose through excessive rhinoplasty thus requiring a prosthetic one instead (Stillwater 2014). Taussig (1999) explains that unmasking the secret consecrates that which it destroys. Therefore, as Jackson's face exposes the fiction of race as natural, it renders the secret to be even more powerful due to the public and media outrage that race might or can be constructed. Through his facial transformations Jackson shockingly illuminates the public

secret that is known but cannot be fully articulated. As Vigo (2012, 34) states, "What was freakish about Jackson was that he brought the historical metaphor of hybridity—very much part of American history—to the fore and evidenced that which we all knew, but did not dare act or say." The drama of Jackson's face, as a source of fascination and disgust, fueled public interest and allowed racist (and andocentric and homophobic) mythologies about the face to remain entrenched within popular thought. While I appreciate that I have discussed his defacement at length, the characterization of him as a freak explains part of his motivation to scream musically, sonically, and choreographically.

A Choreographic Scream

In the short film of "Scream," Jackson's sonic and facial scream prefaces the track and sets the music and visuals into motion. He awakens and he screams. Although Jackson's earlier musical work was frequently punctuated with expressive vocalizations such as whoops and yelps, a full-bodied scream is rare (Steinskog 2015). Yet the "Scream" single is not the first time it occurs. In "Thriller," Kobena Mercer (1986, 43) identifies Jackson screaming in a manner that "articulates the erotic materiality of the human voice," and in "Black and White," Joseph Vogel (2015) highlights the "panther dance" scene at the end of the video, in which Jackson falls to the ground in a puddle and lets out a gut-wrenching howl. He states, "the performer has stopped performing (at least for entertainment), the dancer has been brought to his knees, the effervescent voice transformed into a guttural scream. He is expressing the unspeakable" (Vogel 2015, 116). Also, in reference to "Black or White," English scholar Francesca T. Royster is similarly absorbed by Jackson's final scream that attempts to communicate the ineffable: "I have been most haunted by this cry and what it refuses to articulate as full explanation" (2012, 141). As Jackson's late-career music increasingly conveyed, particularly through the release of the *Dangerous* and *HIStory* albums, he began to articulate his disquiet with the world through his music and this sense of rage and injustice also extended into his performance style. That he releases a single titled "Scream," that he screams throughout the song, and that his face also emits a scream in the video signals a clear intention to express his ongoing fury. He screams linguistically, sonically, and choreographically.

The structure of the "Scream" video does not follow a linear narrative but shows a montage of scenes that feature Michael and Janet within the spacecraft interior deep in outer space. Their futuristic vessel is stylishly minimalist with long white corridors and portholes dotted about the walls. The siblings wear cool, space-age costumes that switch between tight shiny silver pants, with a metallic long-sleeved shirt for Michael and bikini top for Janet under a luscious fur-trimmed coat, and the black unisex outfits I describe earlier. As the Jacksons each take their turn to sing, they spit out the lyrics with absolute contempt. Throughout the video, instances of frustration, antagonism, and petulance are embodied through their interactions with each other and through their performance to the camera. During Michael's first verse, he begins to make the sign of the cross while Janet issues a smug closed-mouth smile, but then sharply elbows her and both turn to pull snarling faces at the other. At another moment she walks full of swag toward the camera, waves a finger that signals "no way," then karate kicks out, which leads to another montage of vocal and facial screams. During her first verse, she struts forward throwing her arms in the air, sits on a white armchair glancing idly at her nails while Michael literally dances up the side of the wall with angular knee rotations. Janet gestures angrily at camera, walks moodily from her seat, and throws herself forward to her knees singing "I won't give up the fight." Later, we see Janet aggressively grab her breasts, as if to claim ownership of her body and exercise frustration over how she is sexualized in the media, and when they sing "stop fucking with me," she gives a truculent middle finger to the camera and makes a snarling face and claw shapes with her hands perhaps to convey the predatory relationship they have experienced as victims to celebrity.

Notably, the sound of Jackson's screaming punctuates the track and, although music video images do not need to correlate with the musical text, the visuals display repeated shots of his face choreographed into an extended yowl to correspond with each sonic scream. The critical consensus agrees that Jackson wrote "Scream" in response to his treatment by the media (King 1999; Manning 2013; Vigo 2012), and some critics have argued that he brings a false victimhood to his art (Morris 2019; Pareles 1995).[27] Yet to return to *Leaving Neverland* for a moment, Greg Tate (2019) provides a more nuanced argument about Jackson's response to the press that takes the matter of race into account. Here, while Tate makes clear that he does not assume the documentary is untrue, he calls out the racial burden placed upon Black people to have to justify the actions of Jackson and other Black cultural figures in ways

that white people are not held accountable to.[28] As I have already shown, Jackson was vilified in the media for the presentation of his countenance through an injurious racist perspective. Notably, Tate (2019) suggests that by necessity, Black people have strategically compartmentalized Jackson as a way to hold in tension both his genius and his flaws. He states, "he became an inextractable and irrevocable piece of Blackfolk's story that can only be crooned, shouted, stomped, screamed and sanctified into the public record" (Tate 2019, 6). With this in mind, to consider why Jackson screamed both into the HIStory album and into the history of Black expressive practice, I now turn to the work of Fred Moten.

Moten's book, *In the Break: The Aesthetics of the Black Radical Tradition* (2003), offers a useful lens to think through Jackson's scream. As with Taussig, Moten's writing is complex and diffuse in its intellectual breadth, therefore I attempt here to take a few of his ideas to examine the artistic and social interventions that Jackson initiated from the perspective of his face. Although Moten's work addresses the 1960s Black avant-garde, he has commented elsewhere that "the rubric of the black vernacular is as much an experiment as that which is coded as avant-garde" (Rowell and Moten 2004, 965); thus I hope to show how Jackson's popular music performance lends itself well to Moten's thinking. In the introduction to his book, Moten (2003, 1) states "I'm interested in the convergence of blackness and the irreducible sound of necessarily visual performance at the scene of objection." To explain this he calls upon Frederick Douglass, who recounts his introduction to enslavement through witnessing the traumatic scream of his Aunt Hester as she is beaten by her master.[29] For Douglass, this experience constitutes an origin act, a primal scene, and Moten (2003) asserts that it lives on in Black life after emancipation. As film and literature scholar Akira Mizuta Lippit (2003, 1336 emphasis in original) explains:

> Moten's book opens with a cry, *that* cry, which cannot be reduced to one cry, any one cry in particular, although there are many particular cries—memorial, historical, and indelible—that reverberate throughout his work. The cry remains instead an ensemble of cries—one after another and through one another.

Moten (2003) questions whether the performance of subjectivity can ever exist outside reproduction; since the origin performance cannot simply disappear, it is both present in and disruptive of the reproduction of the original

primal scene. For Moten, reciting it is a form of repression that holds in tension repetition and disappearance. It is repressed because it is unspeakable yet recited in everyday life. The question then that motivates Moten's book is whether this performance can ever be given a radical breakdown.

I think back to the comments by Vogel (2015) and Royster (2012), who suggest that Jackson's scream in "Black or White" expresses the unspeakable, and the scream of Black suffering described by Douglass through Moten can be heard again in "Scream" as Jackson recites this sense of an origin performance. Jackson scholar Harriet Manning (2003, 157) provides a detailed musicological analysis of Jackson's voice on the track, suggesting his "vocals are characterized by a gravelly, gritty timbre . . . [his] delivery is guttural and aggressive and his words are forceful and have purpose." Similarly, musicologist Erik Steinskog (2015, 135) comments, "The fury in his voice can hardly be contained; it is as if his scream threatens to come out of the loudspeakers, almost like they will materialize." King (1999, 86) meanwhile conceives the scream as Jackson's utter despair and defiance against the social pressures that have surrounded his personal life in recent years, which he connects to "the politics of his larger, presumably racialized community," and further traces Jackson's scream back to Marvin Gaye's call to "holler" in protest as part of a 1960s civil rights agenda. Indeed, popular music reveals an entire history of Black men screaming, crying, and yelping sonically, which includes artists such as Little Richard, James Brown, and "Screamin'" Jay Hawkins. While Moten's thinking connects well to a scream recited through Black musical expression, as Pearl Primus reflexively asserts, her dance and choreography engendered a corporeal scream against the pain and injustice experienced by Black people within the fabric of US life. This visceral response, or potent physicalized scream, to systemic racism is also well documented by scholars who focus on other Black dance artists, such as Katherine Dunham (Dee Das 2017), Alvin Ailey (DeFrantz 2006), and Joan Myers Brown (Dixon Gottschild 2012), and examples within the realm of Black vernacular dance, which might include breaking (Johnson 2011), turf dance (Bragin 2014), and tap (George-Graves 2017), although in reality are too numerous to mention. This lineage of the desire to yell, to scream, to cry out in the most audible and somatic level of emotional intensity certainly recalls Moten's description of the performance of Black subjectivity which both represses the originating act and recites it.

The video itself, however, offers more than an unbridled fury. Through the video, we also see the siblings pursue activities that focus on leisure

and contemplation. At one point, in a gallery space, Jackson switches on a screen and flicks through various canonical Western art works by Jackson Pollock, René Magritte, and an image of Andy Warhol.[30] In a gaming room, the siblings sit side-by-side and play a video game reminiscent of Atari Pong, playfully jostling each other in a moment of friendly competition. Later, Michael sits cross-legged with hands together like a Buddha figure in the center of a Zen meditation garden, both siblings stretch out at a ballet barre, and they bounce up walls and fly in circles in an anti-gravity chamber. Uncluttered and free of the detritus of domestic life, the Jacksons are free to do as they please within this high-tech playground. Popular music scholar Jason King (1999) notes how the look of the video positions it within the imagery of the avant-garde, and Steinskog (2015) locates it within the aesthetic of afrofuturism. The term "afrofuturism" was developed by Mark Dery (1994), and while early applications were used to discuss avant-garde Black music, it can also be applied to popular music genres. Steinskog (2015) defines afrofuturism as fictions that bring together imagined technologies with African American interests and he argues for the importance of the genre for African Americans, whose history has been invisibilized and whose future is held within a white, male vision of technology.[31]

In King's (1999) reading of "Scream," he argues that although the space-age imagery is rooted in an avant-garde aesthetic, the video produces normative images of blackness in relation to whiteness; Jackson remains alienated on the spaceship, marginalized from society and, like the spaceship, his celebrity works to both liberate and confine him. Indeed, King (1999) observes that the siblings appear to live a luxurious and leisurely existence on the spaceship and, in reality, Jackson's economic and social capital places him literally and metaphorically among the stars. This even extends to his facial modifications: "If he looks weird, it is because he is not of this world" (King 1999, 188). Ultimately, this positions him as an ambivalent figure as King (1999) questions whether Jackson's politics are democratic in nature: Does he scream in response to systems of marginalization that serve to oppress Black people or does his vast material wealth and celebrity status alienate him from everyday Black life, thus implying his scream is self-serving and elitist?

Given that Jackson awakens and immediately screams evokes both his own psyche at the time as well as to the experience of Black consciousness more broadly. While afrofuturism dares to imagine an alternative life ahead it also reveals a fraught racial past. Across the video, although the Jacksons

engage in playful distractions and moments of calm, their anger and rage propel the action from beginning to end. Notably, Michael looks most at home in the short dance sequences that are interspersed through the video. Although these snippets (wide legged knee rotations, jutting torso isolations, hand gestures of frustration, and a fitting moment of "moonwalking") flash by quickly, toward the end of the video, the two siblings execute a longer unison duet.[32] After another vocal scream (see Figure 6.2), the camera cuts to a circular room with shiny white floor and the Jacksons appear side by side in their matching black space wear. They throw themselves forward in a dynamic knee slide, immediately return to standing, take a couple of fast rhythmic steps to one side, twist their feet in sharp isolations, slam back down to their knees, jump back up, and then spin rapidly on the spot. The movement is sharp, angular and, while its taut execution explodes with tension, the Jacksons are at ease in their bodies and at one with each other. Their near-identical movement not only emphasizes their clone-like appearance, but also conveys an emotional and familial allyship. The dancing offers both a place of comfort in that its flawless virtuosity reveals the siblings' life history as professional entertainers, and its expression allows them to corporeally vent their outrage and anger at their treatment by the media. It is the dancing that seems to link their past, present, and imagined future.

Not surprisingly, their faces contribute significantly to the duet and in other sections of the video as they engage in highly stylized movement excerpts. As they dance, their faces stare insolently at the camera as if masking a raging fury that flies out anyway in their bound, yet spirited movement attack, and at other moments they snarl, sneer, and Jackson recites his signature biting action. The times of smiling contentedly in performance are long gone. And, of course, throughout the video Jackson screams over and over again. Considering my project overall, I see his scream as purposeful choreographed movement. Drawing on the oft-cited idea within performance studies, English scholar Nadia Ellis (2020, 158) recalls that performance constitutes restored or "twice-behaved behavior," which separates intentionally repeated actions from the infinite mass of all behavior.[33] The repetition of extended screams moves Jackson's facial design well beyond the everyday. While Jackson's scream certainly recites the originating trauma of Black subjectification, given the queerness that haunts his face and body, his scream potentially also troubles normative conceptions of Black masculinity. In his article on Jackson's representation in the media, humanities scholar John Nguyet Erni (1998, 164) states that "queer figurations are hyperbolic

poses of the body and other significatory practices drawn toward the parodic dramatizing, and the political questioning, of normalcy." Within the music video, Jackson's light, feminized face screams passionately, yet somewhat delicately: he is furious yet also fragile, and this uncertainty undoubtedly queers the ontology of Black masculinity. Furthermore, I consider what it might have been like for Jackson to scream in this way. Moving away from a position of pure spectatorship that visualizes the recitation, and potential breakdown, of his Black subjectivity, I shift to the sensorial and experiential. For Jackson to scream many times over suggests a choreographic catharsis. A letting out of all that had been held in throughout his career. At the beginning of the video, we see a literal explosion of this mask of benign contentment as he shatters the glass that encases him. The video then ends with a rapid series of shots of the siblings independently screaming, a brief embrace between the two of them, and Michael's face juddering in close-up as if about to explode. The repeated scream is undoubtedly a stylized choreographic performance, but one that was both timely and necessary.

Michael Jackson: The Commodity and the Cut

In this final section, I move on to Moten's (2003) notion of the cut to show how Jackson's scream and its relationship to his purported defacement offers a critical and creative intervention against a racist culture industry and hostile media that he and other Black artists were subject to throughout their careers. As a move against philosopher Karl Marx, Moten (2003, 6) suggests that a commodity, in this case the labor of enslaved peoples, can in fact speak, and while this heritage of Black subjugation continued into emancipation, Moten expresses interest in the breaking of this speech. Although well past the egregious era of chattel slavery, Jackson was undoubtedly treated as a performing commodity whose singing and dancing expertise could easily be inserted into the capital exchange system of the popular music industry. Indeed, several scholars suggest that Jackson's compulsion to keep modifying his face was in response to the consumerist desires of white audiences (Belting 2017; Whiteley 2005).[34] And while Jackson evidently benefited socially and economically from his position as a revered cultural property, as a performing commodity he was also subject to a level of exploitation and abuse deemed appropriate within the public arena. Irrespective of what the *Leaving Neverland* documentary might reveal in hindsight, the news media

assumed a right to make racialized, gendered, sexualized, and class-based commentaries upon his private, as well as professional, choices.

To identify the radical breakdown of the scream that echoes through Black subjectification, Moten (2003, 6) looks to the relationship between Aunt Hester's "heart-rending shrieks" in response to the master's violent beating, Douglass's thinking on music, and the inclusion of sound that is typically considered outside music and speech yet situated within Black music and speech.[35] He describes this break as a "cut," which represents a double movement: first it is an aurality that disrupts certain identities and interpretations in relation to norms and conventions of meaning and music; and secondly it is a broken link between Africa and Africa America which might be conceived as a "wounded kinship" or "sexual cut" (Moten 2003, 6). As dance scholar Rachel Fensham (2013, 42) explains, "For Moten, a cut, which is the quasi-instantaneous experience of a new perception, applies not only to the formal logics of a work of art and its ordering of form and expression, but also admits to the work of art the gendered, racial, geographic, and economic interventions of historical experience." Calling upon the logic of structural linguistics, Moten (2003) reminds us of Ferdinand de Saussure's assertion that the sign is arbitrary and conventional, and its value is only realized through its abstraction from sounded speech. However, the shrieking commodity challenges this through breaking down what is internal and what is given externally. Black performance potentially disrupts speech and writing as the shriek constitutes the object's resistance to hermeneutics. Although Moten's work looks at music, poetry, and photography, his idea of the cut can also be extended to Jackson's aural performance in "Scream" and the choreography of his face.

While I assert that the most significant break comes with the scream that forms the conceptual, musical, choreographic, and lyrical content of the video, I want to briefly highlight a number of other cuts that are key to Jackson's performance in "Scream" to elucidate Moten's argument. First, King (1999) describes how a break from the limelight is a common narrative in pop stardom. After a period of high-profile musical output, the pop star enters a mysterious period of recluse, which allows both for a musical break, in which the record company is relieved of the demands of expensive marketing and promotional activity, and a psychic break for the audience to transition between the star's old and re-emergent image. With the *HIStory* comeback we see a break from previous incarnations of Jackson: his face has altered, which the news media interprets as a bizarre and troubling

defacement against the natural order, and he is no longer a sweet and contented young artist, but an agitated man who voices his disquiet against the social order.

Secondly, there is the literal cutting of his face. Architect Charles Holland (2009, 205) suggests that although plastic surgery is meant to be seamless and invisible, Jackson's was "spectacularly *visible*." Holland (2009) likens it to a collage in which the cuts between displaced images is where meaning is generated, and Whiteley (2005, 44) similarly conceives it as a "totality out of its disparate parts." The composite face that Jackson inhabited with red lips, feminine eyes, masculine chin, tapered nose, long hair, and pale complexion constituted a radical intervention against expectations of an African American male face and a severing of links with his assumed biological heritage. Notably, Taussig (1999) conceives defacement through the language of a cut, asserting that a cut into a sacred whole, in this instance the taken-for-granted natural face, causes a surplus energy or revelation of a secret. Therefore, the wounded kinship described by Moten in relationship to Taussig's concept of defacement transcends beyond the individual actions concerning Jackson's face, and instead points to a collective wounding in which Jackson breaks from not only his birth family but his African heritage overall.

This ties to my third point, developed by media studies scholar Kristopher L. Cannon (2010), who explores cutting as a lens through which to consider identity construction, spectatorship, and hermeneutics. He suggests that Jackson's face interrogates race in a manner that is cut, or untethered, from the chromatic binary of black and white. This cutting operates as a mode of transgression, transformation, or splitting from, all of which are characterized through motion. From here, Cannon (2010) then draws on the analogy of filmic editing to show how an image is cut into a relationship with another image to produce meaning. He suggests, however, that a particular visual detail might be so compelling that it cuts the viewer's attention away to pursue this attraction further. Therefore the "cut-away" creates a proliferation of meaningful connections that redirect our interest away from the narrative or events of the film. Cannon (2010, 30) suggests that Jackson's face and body are always in transition, splicing together different configurations of "epidermal signifiers" that cut and hold our attention. Undoubtedly, Jackson's face held a sustained attraction for media detractors and music critics who discursively framed it as weird and monstrous through to scholars and fans who have made claim for its innovations and artistry. Yet these examples of

cutting, or of a wounded kinship, are not concerned with the Black aurality that interests Moten (or the choreographic interventions of Jackson's dancing face that concern this book) but sit firmly with the visual, the spectacular, and the perspective of the spectator or consumer of his work.

For the purposes of this chapter, I am most interested in the expressive and experiential actions of a potent sonic and choreographic scream. Moten (2003) observes how gesture is never privileged over sounded words, but nor are these independent of gesture. Notably, he sees gesture as not simply sounding out words, but also "re-sounding" them through transformation, extension, and improvisation. Since Jackson began to manipulate facial expression beyond the glossy and tenacious smile of his early career, he has choreographed his face to play on verbal language until he has reached a pinnacle of gesture with the scream. Although there may be words to describe this facial expression, his gesture has exceeded the need for lyrical content, and we are left with the sight and sound of a raging scream.

Repeatedly throughout the video, we see Jackson's face stretched into a wide-mouthed scream. His mouth extends open, wider and wider until its interior is exposed, and we can see deep inside. At this point, the conventions of the linguistic signs that make up the rest of the lyrics are redundant. The sound does not relate to a specific signifier within the lexicon of the English language. We know he is screaming, although he is not sounding out the word "scream." He emits a painful noise, a radical break from the conventions of word and sound in Western popular music. He may not be the first Black artist to scream, and this is not the first time Jackson has screamed, but this is the first time Jackson has screamed so persistently, forthrightly, and angrily. Furthermore, this sound only comes about through the cavernous mouth that throws forth the energy required to sound out the torturous wail. The sonic is dependent upon the choreographic, and Jackson takes this vocal to an extreme. The yelps, woos, and cries of earlier tracks are by comparison lightweight, and his expression extends way beyond the somewhat ambiguous and mild provocation of a frown. His powerful scream exceeds all we have seen before, and he recites it many times over. It is not an impulsive scream, but one that has been creatively developed through his artistic process, therefore calculated and carefully designed. He screams against the mockery and humiliation he has endured in the press; he screams against the child labor he experienced as a young boy in which he was constantly put out to work; he screams against the manipulative demands of Motown that insisted his body should move in ways that conformed to the tastes of white

audiences; he screams against the smiles that persisted in his early years as a young entertainer when perhaps he did not feel like smiling; he screams against the probing questions from interviews that dig deep into his personal life; and he screams against the relentless and insulting commentary on his face. I imagine that his scream contains some of this history I detail here, while also expressing ideas and experiences that are unspeakable and inexpressible through conventional language, and some of which are uniquely personal to him.

In drawing this chapter to a close, I cannot be certain whether Jackson's scream provided a feeling of catharsis. I do know, however, that he deemed it necessary. In "Scream," Jackson awakens and screams as an aural, and I argue choreographic, recitation of Black subjectification. As other Black artists before him, including Pearl Primus, who eloquently identifies a triad of dancing, screaming, and racial injustice, Jackson screams vocally and choreographically throughout the video. In terms of popular presentational dance, there may be limited instances in which dancers choreograph a facial scream, although the art of krumping forms a notable exception in which facial expressions depict rage, trauma, and pain to articulate a complex invocation of Black experience that includes creativity, community, joy, uplift, spirituality, and sorrow (Batiste 2014). In "Scream," both Jackson and his sister repeatedly scream with their faces, and through their gestures and dance moves that further express the lifetime of tensions they have experienced across lines of race, gender, and sexuality. Jackson screams so powerfully that he literally shatters the glass in which he is encased. Returning to Moten's (2003) invaluable thinking, the explosion of glass shards signals another cut; a breaking down or breaking out to imagine a new Black freedom.[36] In line with an afrofuturist perspective, Jackson's anger over the past emanates through his scream to shatter his sterile existence within his sleep capsule and fantasize about a future liberation roaming in outer space.

Jackson's potent scream comprises both a choreographic expression and an emotional release. It offers a creative and critical intervention against his treatment by the news media obsessed with his purported defacement. He is a commodity that screams back against essentialist concepts of race and gender that seek to delimit him to a singular *identifiable face*. Clearly Jackson was a troubled figure and his life toward the end reveals increasing complications around his health and wellbeing.[37] Furthermore, I am left with the uncomfortable knowledge of the allegations presented in *Leaving Neverland* that means I re-face him with strong feelings of unease, and the content of the

documentary potentially undermines the justification for and power of his scream. I end this chapter with the knowledge that a scream is potent. It calls attention to itself, sonically and choreographically, and its visceral power can easily shatter an equilibrium. Yet I wonder the extent to which this can be maintained. A scream might repeat itself, but the energy and rage required suggest that this forceful and spectacular action-expression cannot endure. Its affect might continue to resonate, but the immediacy of its power ultimately comes to an end.

7
LAUGH

> Laughter can be such a powerful heuristic for understanding human character both within social interaction and cultural artifacts because of its baseline association with positivity, not in spite of it.
> —Nikopoulos (2017, 2)

Although laughter can spring forth across diverse occasions to express a multiplicity of sentiments, this opening quotation argues that its association as a positive response enables its participants or recipients to ascertain the extent to which it honors or departs from this emotional barometer. Within the context of dance, the dancer's face might actively laugh, which may or may not stimulate laughter from an audience, or the dancer can pull a face devoid of laughter, which might nevertheless generate laughter from its onlookers. A laugh sits on a continuum from a smile, although the latter tends to be larger, noisier, and express greater positivity than the former (Nikopoulos 2017).[1] The positivity of the laugh is sensorial and affective and, while this expression is bound by social codes and conventions, it can be infectious, prompting a collective, felt response. As laughter explodes from the face it offers the potential for catharsis. This hyperbolic action-expression works to release tension through a mutual moment of community affiliation. Unlike the glossy and tenacious smile in popular dance, which often serves as a fictional mask of contentment, the "cathartic laugh" bursts out from the faces of dancers and/or spectators to generate a feelgood collective response.

I think back to one of the first international breaking battles to take place entirely online, Break Free Worldwide SOULidarity 2020 Championship, early in the COVID-19 pandemic. After several months of lockdown, as everyone got to grips with the fear of this unknown virus, the excitement of witnessing a virtual breaking battle revealed how desperate the international breaking community was to engage with the culture.[2] In the b-girl battle, participants showed up from across the globe, dancing in kitchens,

bedrooms, basements, and backyards.[3] In the first round, Macca, an internationally renowned and corporate-sponsored b-girl representing the United States, whom I have spoken of in detail in the LOOK chapter, was up against b-girl Bunny, from Guatemala. As Macca tries to set her phone the right way up, Bunny crouches down in front of her camera wearing large blue bunny ears, and host b-boy Moy jokes that judge Beast Boogie might also have the very same ears. In response, Beast Boogie gestures to his head, wiggling fingers in a v-shape, and laughs out loud as Bunny responds with the same signature move. This sets a playful and upbeat mood before the round has even commenced. Macca throws down first and, although fiddling with her phone at the time, the humorous exchange between Bunny and Beast Boogie had not gone unnoticed. She takes a few steps back from the camera, and crouches down with her hand placed under her chin in "thinker pose" as she takes a moment to contemplate her opponent. She then emphatically gesticulates one hand as a pair of scissors, throws out the other hand with fingers in a V to mimic the bunny ears, inches toward the camera now wiggling two pairs of bunny ear fingers by her head, and then chops one off with her imaginary scissors and tosses them away. She issues a single derisive laugh while dismissively gesturing her hand as if to say, "just kidding," before launching into a swift round of explosive toprock and footwork.

How do we then make sense of Macca's laugh? Returning to the idea that laughter is associated with positivity, circus studies scholar Paul Bouissac (2015) asserts that laughing is generally conceived as a welcome experience as it brings about a sense of euphoria in response to the release of the neurotransmitter dopamine. We feel good when we laugh. I introduced the work of literature scholar James Nikopoulos (2017) at the beginning of the chapter, who argues that because laughter is aligned with positivity it acts as a constant and reliable social signal: although some laughter might be negative or malicious, the onlooker or recipient can measure this through the extent to which it deviates from positivity.[4] Using these ideas to assess the temperature of Macca's single laugh, it appears both intentional and good-natured. Macca is quick to pick up on the bunny persona of her opponent and, thinking back to the goofy vision of the big blue ears, the comical way in which she chops them off indicates that this is all in good fun. Yet the fact she mimics disabling b-girl Bunny also signals her desire to win. Thus, her laugh hovers on the right side of positivity and play, while also retaining the spirit of breaking that pits one opponent against another.[5] This cathartic laugh offers a release of tension for the community of b-girls, judges, hosts, and audience

invested in this competitive battle under the additional pressure of national lockdowns due to the global pandemic.

In this chapter I explore the choreography of a cathartic laugh in popular dance, which includes the action-expression of dancers who laugh to produce an intentional performance affect and dancers who pull other facial choreography to generate laughter in their audience. In the first two sections I return to the face of Maddie Ziegler and focus on two parodies of her music video performance of Sia's "Chandelier." In the second two sections, I revisit hip hop battles, focusing on how several b-boys both laugh and create laughter in the cypher crowd. Before looking at these examples, I pause to consider: What is laughter, and what is its purpose?

While laughter is not uniquely a human trait, humans have a distinct vocalization that is not found in other species (Kerner and Knapp 2016).[6] Indeed, the verb "to laugh" comes from the old English *hliehhan*, rooted in an onomatopoeic derivation (Kerner and Knapp 2016). As I suggested at the beginning of the chapter, laughter is interactive and affective. We laugh in response to a stimulus and it creates bonds (or sometimes divisions) between people (Boryslawski, Jajszczok, and Wolff 2016; Nikopoulos 2017; Weitz 2016). In the arena of performance, comedy works to produce feelings, sensations, and affects in the audience members' bodies, which arise in the form of laughter (Kerner and Knapp 2016; Weitz 2016), and the production of laughter depends upon social conventions as well as the cultural background, aesthetic tastes, political values, and emotional mood of the recipients (Reichl and Stein 2005; Weitz 2016). Although I set up the notion that positivity offers a yardstick for laughter, it can move "from sedate amusement to mirthful hysteria" (Weitz 2016, 11); it can provide release, protection, and rejuvenation (Boryslawski, Jajszczok, and Wolff 2016: Kerner and Knapp 2016); and it can be generous or wicked as we laugh *with* or *at* others (Reichl and Stein 2005).

Although a number of scholars have sought to develop a singular theory of laughter, recent thinking posits that it remains too complex to pin down (Reichl and Stein 2005).[7] Broadly speaking, three modern theories of laughter have persisted: incongruity theory, which supposes a dissonance between two images or ideas; superiority theory, which imagines a higher status set up against an inferior target; and relief theory, which sees that a tension is relieved in a social situation (Weitz 2016; Wickberg 2015). Many scholars agree that laughter disrupts the social order in some way (Bouissac 2015; Kerner and Knapp 2016) and can reveal power relations in terms of

who laughs and at whose expense (Weitz 2016). Furthermore, questions arise from whether laughter operates as a "safety-valve" (Nikopoulos 2017, 9) or "*authorized* transgression" (Kerner and Knapp 2016, 94, emphasis in original) that maintains the social order, or whether laughter has the capacity to subvert the status quo (Reichl and Stein 2005; Weitz 2016). In his study of theater and laughter, performance scholar Eric Weitz turns attention to the body and how its movement is regulated through laughter: "Through laughter we make sure that no one strays too far from approved thought and comportment, literally giving our bodies over to the laughter that keeps *others* in line and the threat of being laughed at that keeps *us* in line" (Weitz 2016, 71, emphasis in original). Building on this literature, I resist notions of universalism to argue that laughter in dance is produced through a *sociocultural face*. In each of my case studies, I explore how the laugh works as a form of release produced through the affective relations between the dancer's face and its onlookers enmeshed in its choreographic expression. I show how this can work both conservatively and progressively while a feelgood community spirit is maintained.

The Viral Face of Maddie Ziegler

In the SMILE chapter, I introduced Ziegler and the magnetism of her face, and in the CRY chapter, I looked at her emotive facial performance in the music video "Big Girls Cry" by Sia. In the CRY chapter I also briefly introduce "Chandelier," the first in the trilogy of videos with Sia in which Ziegler acts as Sia's surrogate face. In this and the following section, I examine the circulation of Ziegler's facial choreography from "Chandelier" across late-night television and YouTube parody videos to produce audience laughter. Before doing so, I provide a description of the original Chandelier video on which these parodic performances are based.

The video begins in silence with a face-on view of a shabby living room containing a few items of furniture, before cutting to a dark corridor, and a dank-looking bedroom. It contains a twin bed with a bare mattress, a sofa bed, and a few pictures scattered across the walls. As Sia commences the opening verse, the shot switches to reveal Ziegler suspended in the bedroom doorway like an eerie sprite, in her flesh-colored leotard, blond bobbed wig, and luminous pale skin. The camera zooms slowly toward her and just as she jumps down to the floor, the image cuts to a close-up rear view of her

feet landing and her hands steadying the impact of her fall. She comes to standing and runs into the bedroom, circles her hands around her head, then throws her head back and forth with hands gesturing manically, eyes wild and mouth almost in a scream, hinting at a sense of trauma or mania. The lyrics speak of partying and excess and as Sia sings the bridge, which describes counting and knocking back drinks, Ziegler sits on the bed and marks out the counts with her hands, fingers cupped slightly as if holding a glass, and on the word "drink," tosses her head back and throws a flexed foot in the air as if downing alcohol. Her eyes are unhinged and face blank, until she kicks out and clenches her teeth in frustration. From here, she twirls and spins around the room, falls on the bed kicking wildly, lands back on the floor circling her hands around her head, jumps up to a deep angular bend, drags herself along the floor, scrambles up the wall, falls backward on to the sofa, jumps manically in circles, kicks and hops while patting her belly, and then runs out the room pulling at strands of the wig with her eyes rolling and a sinister smile. This long sequence of wild and seemingly erratic movement accompanies the main chorus in which Sia sings of wanting to swing from a chandelier in what might be a desolate state of drunken abandon.

Ziegler arrives at a grungy kitchen and, seated at a table, makes a screwing action with her fist, plows it into the wall, throws her head on the table, comes to rest her chin on her hands in a cutesy pose, except for the panic written over her face. She stuffs imaginary food into her mouth, growls in anger, and then walks to the living room, rubbing her stomach with a despondent face as if starving for companionship and sustenance. She slowly sinks to the ground in deep splits and then repeats the counting and drinking choreography of the musical bridge before returning to her manic turns, leaps, and kicks with the chorus. At one point she runs behind some curtains, gathers them by her shoulders, and the camera centers on her face: she pulls at her eyelid, drags her thumb down her cheek like a slow-running tear, accentuating her sadness with a down-turned mouth and sinking body, before edging back up gulping for air. As the song closes, Ziegler races back from wall to wall, stops dead and repeatedly waves her finger as if reprimanding someone. She returns to the corridor, and takes several slow curtsies, each time manipulating her face into an empty fake smile. The video ends with her standing in stillness, a small haunting figure staring out from a doorway.

The official music video for "Chandelier" is housed on YouTube, which also features several "cover" versions (Bleeker 2012, 14) of "Chandelier" by celebrities and amateurs who either copy or adapt the choreography through

a creative re-enactment of the dance. Dance scholar Harmony Bench (2013, 129) employs the term "viral choreographies" to describe how these re-performances of music video dance circulate through the digital media in a "complex network of movement citations." Although Bench uses the term to describe the repetition of entire dances, I suggest that the ways in which Ziegler's face is mimicked and adapted across parody performances speaks to the same transmissions and mutations that characterize other viral videos. I located about twelve parody versions of "Chandelier," three of which were celebrity performances on late-night US television entertainment shows: *Saturday Night Live*, *Jimmy Kimmel Live!*, and *Late Night with Seth Meyers*.[8] This is not surprising given that in 2005, *Saturday Night Live* began to include SNL Digital Shorts, which were prerecorded skits of music videos that clowned the music industry and its recording artists.[9]

The idea that Ziegler's facial choreography possesses a viral quality can be seen in the transmission of her expression across different media platforms and audiences. The original music video of "Chandelier" from YouTube is parodied on popular television network shows, and these clips are then extracted and placed on YouTube for further viewings beyond the live television audience. Media scholar Henry Jenkins (2006, 2) deploys the term "convergence culture" to describe "the flow of media across multiple media industries, and the migratory behavior of media audiences who will go almost anywhere in search of the kind of entertainment experiences they want." The convergence of old and new media forms attracts consumers who are often eager to participate as producers of their own content that re-envisions traditional media forms (Jenkins 2006). Yet Jenkins (2006) observes that not all participants have the same degree of power and that corporations typically hold more social and economic capital in the field of cultural production. In this section I therefore focus on a parody of "Chandelier" on *Jimmy Kimmel Live!* for the ABC television network and in the following section I examine an "amateur" YouTube parody to think through how the laughter generated by parodying Maddie Ziegler's viral face benefits each producer in different ways.

Jimmy Kimmel Live! is a popular late-night television talk show featuring celebrity guests, musical entertainment and various novelty segments, and its YouTube channel has 18 million subscribers. The clip of the "Chandelier" parody was uploaded in 2014, the same year that the single and music video were released, and it has solicited just under a million views.[10] The eponymous host, Jimmy Kimmel, starts by telling the audience that Sia will be

performing "Chandelier" later and shows a clip of its accompanying music video starring Ziegler. His presentation style is slick and relatively serious as if he is simply promoting his guest's new work. He goes on to explain, maintaining his formal delivery, that after watching the video he decided that he "should know how to dance like that." This immediately gets a laugh from the audience as the thought of an adult man with no obvious dance training mimicking eleven-year-old Ziegler's virtuosic performance appears ridiculous. Kimmel then turns to his sidekick Guillermo Rodriguez, a rotund middle-aged man, and suggests "Both of us, right?" Rodriguez responds with a sarcastic "Right!" and chuckles audibly, which prompts further laughs from the audience. While Kimmel goes on to explain how they connected with Ziegler, he name-drops *Dance Moms* as another part of his promotional discourse, and then seriously says, "Maddie was nice enough to take the time to help us 'fly like a bird through the night and swing from the chandelier.'" Although directly quoting lyrics from the song, the idea of these sturdy grown men embodying Ziegler's fleet-foot ethereality sets up the comedic hook of the skit.

In a studio set that closely replicates the spartan bedroom from the "Chandelier" video, Ziegler is limbering up as Kimmel and Rodriguez enter identically dressed in bath robes and the signature blond wigs. After brief introductions, Ziegler, also wearing the same blond wig and her flesh-toned leotard, sets about teaching them the choreography. She swiftly runs through the section in the bedroom, which begins with the counting and drinking bridge section and into the chorus where she wildly spins, falls, and kicks. The two men, standing in the corner of the room, gamely mark out some of the hand gestures. The audience laughs, knowing that even the most expert dancers would be unable to learn such a complex excerpt of choreography after a single rapid viewing. In a voiceover Kimmel reflects to himself, "Was I intimidated by the choreography?" which produces more laughter as he and Rodriguez look to each other nervously. Yet in a cut-away shot, typical of a documentary format, Kimmel then subverts the idea of performance anxiety as he responds to the camera, "You know what, they haven't choreographed choreography that intimidates this guy yet!" The audience laughs at his deadpan response and the anticipation of how his bulky masculine frame will mimic that of a nimble girl-child. The shot returns to the rehearsal where Ziegler now schools them in the facial expression that forms such an important component of the dance: "You have to use your face a lot. You have to make crazy eyes." Kimmel asks her how to do the "crazy eyes thing" to which

Ziegler opens her eyes wide and stares with a blank expression devoid of social niceties. Rodriguez responds, "Ah, scary!" before trying out the eyes, although his eyes judder up and down in their sockets and his jaw hangs slack for comical effect. Whereas Ziegler's face only hints at madness, Guillermo's plays on a stock image of the "lunatic" or "simpleton."[11] Ziegler goes on to explain, "If you can't do the choreography, then you just have to sell it with your face" while gesturing toward her face. This fleeting intertextual reference both alludes to the language of *Dance Moms* that links facial expression in dance to labor and capitalism, and to the promotional videos of Sia which sell her music through Ziegler's expressive surrogate face. Kimmel repeats the mantra back, "sell it with your face, I like that," at which point Rodriguez repeats the "crazy eyes" look, producing further laughter from the audience.

Kimmel performs first and, as the familiar musical introduction to the song strikes up, along with shots of a dark corridor and frame of a doorway, two legs jump into view in keeping with the original video. These are not the legs of a young girl, however, but the muscly legs of an adult man. As the image shifts to the bedroom, Kimmel bounds into view, now wearing only a flesh-toned leotard stretched over his stocky male frame. He approximates the choreographic structure, clearly signposting certain signature moves, such as the emphatic hand gestures and flexed foot kicks of the counting and drinking moves. His face appears tender and serious, with fluttering eyelashes, and this earnest approach garners loud audience laughter. As Sia breaks into the chorus, Kimmel launches into the wild choreography demonstrated earlier by Ziegler. Lacking in technical skill, his movement is stiff and bumbling, but his commitment to the dance wins supportive laughter from the audience. A particularly hearty roar comes when he wiggles his fingers around his face, this time sending his eyes into loopy circles and pulling maniacal smiles in the spirit of Ziegler's instructions. His set abruptly finishes as the music is cut short, and attention then turns to Rodriguez.

While Kimmel appears comedic in the leotard and wig, Rodriguez looks even further out of place with his chubby physique, thick moustache, and hairy chest. As with the previous version, the same signature images follow with Rodriguez's legs dropping to the floor. Yet whereas Kimmel's attempt to render the choreography lacked nuance, Rodriguez demonstrates greater clarity and specificity. His hands circle his head with precision, he places his hands firmly over his mouth, he carefully points to his eyes, and he remembers to pull his version of the rolling-eyed, slack-jawed expression of lunacy. This not only prompts laughter but also loud cheers of

encouragement as he commits to the corporeal character of the video. This continues as he manages to articulate the correct moves for the counting and drinking section. Overall, his movement recall is closer to the original as he falls to the bed, rebounds up, rolls onto the floor, and gesticulates wildly before hopping in circles. While the audience laughter is even more intense, so too are the whoops and hollers. As with Kimmel, the video is cut short and he enters into a short feedback session with Ziegler, who complements him: "You have like a dancer's face, your eyes were pretty good!" Kimmel then enters, supportively saying, "Did you hear that? Like a dancer's face! That's pretty good." Of course, the dissonance of Rodriguez's plump visage, dark moustache, and feminine blond wig creates further mirth at the idea that he has a dancer's face.

To end the segment, Kimmel suggests all three perform the dance together, which produces much hilarity as the sylph-like Ziegler knocks out the moves with clarity and speed, while the two men blunder around behind her. As Ziegler and Kimmel come to a halt at the close of the sequence, Rodriguez continues spinning with his crazed eyes and slack jaw as if somehow overtaken by the passion of the music and dance, and Kimmel remarks, "he's flying!" Ziegler looks on, slightly awkwardly and slightly giggly, both acknowledging the premise of the skit and responding genuinely to the humor of watching Rodriguez. As Rodriguez self-consciously comes to a stop, Kimmel comments on his facial expressions, one moment describing him having a seizure and the next suggesting he looks adorable. In a final cut-away interview, Ziegler confides to the camera that both are bad at dancing, although the scene ends with slow motion shots of the two men pulling their facial expressions of madness and then bouncing on the bed like exuberant children.

I intentionally describe this example in detail to underscore the extent to which the *Jimmy Kimmel Live!* performance copies or departs from the original and how this might produce laughter. In terms of mimicry and art, whereas satire tends to be critical and pastiche is a straight imitation (Spirou 2017), parody both relies upon its host but undergoes some degree of transformation typically through the use of humor (Dentith 2000; Ross 1998). This sketch show performance by Kimmel and Rodriguez is neither biting enough for satire nor similar enough for pastiche and its clear comedic intent places it within the domain of parody. Returning to the laughter theory I mentioned at the beginning of the chapter, the Kimmel skit works through the paradigm of incongruity as two grown men evidently unskilled in the

art of dance attempt to stand in for a petite young girl whose reputation rests on her television profile as a star competition dancer. Although some dance scholars have observed how male-identifying performers who seriously imitate music videos by female-identifying music artists can expose and critique gender construction (Bench 2013; Liu 2013), music video parodies of men copying women (or in this case a young girl) often reinforce normative gender roles (Boxman-Shabtai 2018). As Bench (2013, 143) suggests,

> For comedians and others who perform parodies of gender for the sake of humor, the gender fail is necessarily double: one must initially fail at one's own gender and then fail at the gender one portrays in order to rescue the first. The second failure must be greater than the first, outwitting it.

The double failure that Bench describes can be easily identified in the Kimmel parody. First, Kimmel and Rodriguez fail as men in that they appear serious about their intent to perform the dance dressed in a girlish leotard and wig and to engage in its emotional content, all of which are socially coded as feminine. Secondly, and more importantly, they outrageously fail to be feminine as their oversize hirsute male bodies spill out of the costumes, they lack the grace and finesse to replicate Ziegler's skillful execution of the dance, and their portrayal of the emotional content through their facial expression misfires through gross exaggeration. As Weitz (2016) suggests, laughter can serve to police the body and keep it in line.

The Kimmel parody certainly reinforces normative gender roles, which generates audience laughter, but for the purposes of my study, I am specifically interested in how the face labors to produce laughter beyond the incongruity of a hairy and weathered male face substituting that of a fresh-faced girl. Except for Ziegler's little giggle that momentarily disrupts the serious premise of the skit, the two male performers never laugh as the joke rests on the earnest manner in which they approach the dance. In her study of *kuso* (parody) videos of Taiwanese pop star Jolin Tsai, dance scholar Chih-Chieh Liu (2013, 167) suggests that fan performances always recite a "corporeal signature" to authenticate a pop star's image. In the case of Sia's "Chandelier," Ziegler's expressive face, or what she describes as "crazy eyes," constitutes the distinctive bodily gesture that characterizes this and the entire trilogy of Sia videos. While Kimmel and Rodriguez do not replicate the entire dance in the skit and their limited movement range fails to capture the choreography

fully, they both work their faces to mimic the expressions of madness evoked by Ziegler.

Media scholar Jenny Spirou (2017) suggests that music video parodies rely upon intertextual references to other media forms, which often help to produce parodic humor through the idea of incongruity. As stated earlier, incongruity forms a major mode within the theory of laughter. Already in the Kimmel parody, there are several intertextual references at work. Maddie's expressive face references her emotive visage on *Dance Moms*, and the signature blond wig and traumatized face point to the original "Chandelier," as well as the trilogy of music videos. As Kimmel and Rodriguez crudely mimic her facial expression, they too begin to reference other faces in the popular imagination, which recall the normative representations of the *semiotic* or *identifiable face*: Kimmel's earnest face and fluttering eyes as he begins the dance allude to stereotypes of the female ballerina or lyrical competition dancer; Rodriguez's slack jaw points to the generic fool; and both of their attempts at wildly rolling eyes collectively signal faces of the insane, the possessed, or the epileptic that circulate in popular culture. When spelled out in this way, the faces alone indicate a superiority theory of laughter as these able-bodied male television celebrities are essentially mocking the feminine, those with learning and/or physical disabilities, and people with mental illness. While this departure from positivity is somewhat uncomfortable, the fact the television audience laughs so uproariously suggests that any ill sentiments are superseded by the extent to which Kimmel and Guillermo make fun of themselves in their tight leotards, blond wigs, and fumbling dance moves. This cathartic laugh offers a release from the serious issues invoked in Sia's work, that speak to experiences of female trauma, and instead deploys incongruity to make light of these themes. Overall, there is little critique at work in this parody. Although it might gently poke fun at the emotional intensity of Sia's promotional videos, ultimately this skit serves to benefit the celebrities involved socially and economically: *Dance Moms* receives a promotional name check; Sia's musical career is celebrated as a featured guest on the show; Ziegler is set up as a star dancer and a good sport for playing along with the pretense of the parody; Kimmel produces a parodic and self-deprecating performance which generates extensive feelgood laughter in his audience, who will likely return for further entertainment of this kind; and Ziegler's viral face continues to circulate across the digital landscape. Clearly, they are "selling it with the face" many times over.

Maddie, Eddie, and a Wookie

In the previous example, the viral face of Maddie Ziegler is enabled by a convergence culture (Jenkins 2006) in which visual texts circulate across old and new media to the delight of eager consumers. The opportunity for fans to create their own digital content on interactive social networking sites, such as YouTube and Facebook, has led to the notion of a "participatory culture" (Jenkins, Ito, and boyd 2016). More than simply spectatorship, fans engage critically and creatively to construct their own media texts, which enables greater opportunity for engagement than traditional media outlets such as film and television (Boxman-Shabtai 2019; Jenkins, Ito, and boyd 2016).[12] In relation to dance, Bench (2010) observes the shift from passive spectators in a theatrical setting to active participants who create their own dance content in the digital domain. She states, "works of social dance-media present themselves as evidence that dance should be shared, copied, embodied, manipulated, and recirculated rather than preserved for the professional and elite dancer" (Bench (2010, 184).[13] In her study of Taiwanese *kuso* videos, Liu (2013) identifies a "performative translation," in which fans copy the original in a playful or mischievous manner and the same can be said of the small collection of "Chandelier" parodies on YouTube by everyday members of the public. One man dances in a pink wig in what appears to be a school building, at one point getting shooed away by an irate colleague from his office; two Australian radio presenters re-enact the choreography intercut with the original video; a woman in a green wig duplicates the choreography in a split-screen performance with the original; a man wreaks chaos parodying the video in an IKEA home furnishing store much to the amusement of its customers and wrath of the staff; and a large bearded man in ballet slippers duplicates the whole dance with such a good level of grace and precision that it is closer to homage or pastiche than parody, as indicated by multiple viewers in the comment section. Notably, all mimic Ziegler's viral facial choreography whether it be the crazy eyes, the traumatic expression, or the vacant smile. The version I turn to now, however, was by far the most inventive.

Produced by Teddie Films, "Bandolier" is a parody mash-up of *Star Wars* and "Chandelier," the title referring to the iconic bandolier worn by Han Solo's friend and copilot, a wookie named Chewbacca. The scene begins with a face-on shot of a shabby living room with the same layout of furniture as the original "Chandelier," along with a few framed pictures (in this instance of Chewbacca) on the walls. This follows with the familiar shot of the corridor,

bare bones bedroom and, as the musical introduction strikes up, the image of a figure suspended in a doorframe. Unlike Ziegler, however, this is a portly young man, named Eddie King, dressed in Princess Leia's "slave costume" from *Return of the Jedi*. He wears a bikini top, long red panels of fabric hanging from bikini bottoms, the classic Princess Leia hair twirled into two large buns on either side of the head, as well as the addition of flesh-colored tights and leotard beneath the costume and a pair of thick black spectacles. Like the original "Chandelier," the camera cuts to a rearview shot of King's legs landing on the floor, with hands that gently steady the impact. In fact, the exactness with which King mimics the choreography is certainly noteworthy as he precisely articulates the gestural vocabulary, reenacts the counting and drinking choreography on the bed, and then launches into a full-blown duplication of the kicks, leaps, and spins of the chorus. Unlike "Chandelier," however, the lyrics do not concern excessive drinking and social isolation, but center on the topic of Chewbacca and *Star Wars*: "He's the one, that cute fuzz ball, the best sidekick of them all, I wanna feel the force, I feel the force... I'm going to swing from his bandolier, his bandolier..." Despite the shift in lyrical content, the music otherwise sounds identical to the original and the vocalist perfectly captures the same throaty singing style as Sia.

As King kneels on the floor at the height of the chorus, like Ziegler, his hands circle his head, but he has grabbed a bandolier from the bed, which he brandishes above him. After replicating the gestural and facial choreography at the kitchen table, he similarly moves into the living area where a big hairy Chewbacca is standing next to the wall. King impressively sinks into almost full splits and Chewbacca begins to move gently around him, partnering him occasionally, even though King's movement remains faithful to the original solo choreography. On the chorus, where Ziegler simply leaps across the room, King takes an enormous leap into Chewbacca's arms, who spins him around for a moment or two. The video continues with King following almost the exact same choreography, except for Chewbacca engaging in brief moments of partner work. Unlike the *Star Wars* original, where Hans Solo is Leia's main love interest, in "Bandolier," this relationship is reimagined and Leia turns her romantic attentions to Chewbacca. Much like the tormented nature of the song, their relationship is a fraught one, with King pretending to kick at Chewbacca when Ziegler kicks at a wall, and King repeatedly waving her finger at Chewbacca when Ziegler simply does this to the empty room. Although King lacks the technical training of Ziegler, his approximation of the choreography from start to finish is impressive, including the

precise facial choreography.[14] Whereas Fallon and Rodriguez clearly played this for laughs by exaggerating the face into a clichéd lunacy, King carefully captures the nuance of Ziegler's face: his eyes hold an empty expression as he engages in the counting and drinking section and he reperforms the frenzied feeding and growling in the kitchen, the panicked face behind the curtains (now replaced with Chewbacca's shaggy arms), and the same vacant smile as he curtsies at the end.

YouTube has provided a platform for amateur cultural producers to create parodic versions of popular music videos, often garnering such extensive audience interest that they reap more revenue than the original works (Boxman-Shabtai 2019). Jenkins (2006) suggests that these amateur film-makers sometimes have professional aspirations and use YouTube as a site to showcase their skill and artistry. Yet communications scholar, Lillian Boxman-Shabtai (2019, 5) suggests that the characterization of amateur versus professional in reference to YouTube parody overly simplifies this cultural work given that some of these "celebrity amateurs" bring a high level of professionalism to their passion projects, and some "home-grown" professionals begin to generate considerable income through advertising revenue. Teddie Films, the creator of "Bandolier," is a media partnership between film-makers Eddie King and Tyler Marshall, which states on its YouTube subscription channel that they specialize in "music video parodies and other comedic/nerdy stuff."[15] Although the duo has a website, a Facebook page, and a LinkedIn account, the last film they uploaded was in 2015, which suggests they might no longer be actively creating music video parodies. Nevertheless, the fifteen or so films housed on their YouTube channel are sophisticated media texts: although they all employ a DIY-style aesthetic, they are detail-oriented in their execution, demonstrate high production values, and play on witty themes in reference to the original source material.

In her study of music video parody, Boxman-Shabtai (2019) elucidates that these cultural producers are motivated either by passion for their endeavor or by strategic professional aims, and sometimes both. As well as a variety of music video mash-ups, Teddie Films has created several short works based on *Star Wars* themes.[16] Jenkins (2006) describes how fans are the most participatory group within media audiences and he details a huge body of artistic work created by *Star Wars* fans who actively reimagine the characters and their universe. Clearly, King and Marshall employed their knowledge of

the *Star Wars* series and invested in multiple props and costumes to re-create this rich fantasy world within their music video skits. It appears, however, that they are more than simply enthusiastic amateurs. Marshall studied photography and King studied communications at Brigham Young University, and both are currently listed on LinkedIn as "film producers" for a data management company. Their high level of professionalism and their media-savvy approach comes through in their "Behind the Scenes" film of "Bandolier" in which they also offer a compare-and-contrast analysis of the iPhone 6 and Red Epic digital camera as part of a promotional feature for the Pocket Film Festival.[17] Thus music video parody affords them opportunity to explore their artistic passions and to engage in commercial interests as media content creators and promoters.

To return to the concept of laughter, I consider where "Bandolier" positions itself in relation to parody. To ascertain the relationship between the original and the parody, Boxman-Shabtai (2018) uses five interpretive strategies from frame alignment theory to analyze YouTube music video parodies: "frame abandonment" keeps only a small component of the original, such as a melody, thus departing from the original meanings; "frame duplication" provides a faithful mimicry of the original; "frame extension" extends the existing frame to add new, but usually related, meanings; "thematic frame transformation" communicates the opposite meanings to the original; and "meta-critical frame transformation" clearly focuses on and critiques the original.[18] Whereas the first three strategies are uncritical, the fourth might be critical, and the fifth is explicitly critical.

Unlike the Kimmel parody, there is no live audience to gauge the laughter that "Bandolier" produces, although the viewer comments on the YouTube page are overwhelmingly positive and many state how "funny," "hilarious," and "LOL [laugh out loud]" the video is. Overall, "Bandolier" takes a relatively benign stance toward "Chandelier" and shows an affectionate knowledge of *Star Wars* as it does not engage in any serious critique. Boxman-Shabtai (2019, 15) uses the term "positive mimicry" to describe music video parodies that are deemed funny but not offensive. That said, a slight queering might be identified in the parody. First, the revised content pushes against the heteronormative cliché of Princess Leia becoming romantically attached to Hans Solo, and instead it imagines an interspecies attraction between a human woman and a wookie. Secondly, King's dancing neither lampoons the original nor fails as a male body embodying a female

dance solo, thus gesturing toward a queer sensibility. Indeed, several viewers commented on his deft handling of the choreography: "how legitimately graceful this portly manprincess is"; "the guy absolutely killed it with that insane movement"; "his dancing skills in this choreo are amazing." In terms of Boxman-Shabtai's (2019) typology of interpretive frames, I suggest that "Bandolier" falls into the category of "thematic frame transformation" as its meanings shift from "Chandelier" to the universe of *Star Wars*; this distance from both originals pokes gentle fun at the heightened drama and emotional excess of "Chandelier" and subverts the romantic tropes of *Star Wars*. Notably, Boxman-Shabtai (2018, 2019) argues that parodies can simultaneously critique and be complicit with the mainstream media and "Bandolier" clearly holds this duality in place. Although engaging in professional level production, its entertainment value places it in the realm of the recreational for both the producers and consumers of this parody, thus its humor offers a cathartic release from the serious business of work and the emotional trauma of the original "Chandelier."

With both the Kimmel and "Bandolier" parodies, the two skits obviously intend to generate a community of feelgood laughter for their audiences and they succeed in this endeavor. Part of their strategy to create laughter, as with all the "Chandelier" video parodies, comes from drawing attention to the "corporeal signature" of Ziegler's viral dancing face with its expressive choreography framed by a bobbed wig. The Kimmel parody does this through a crude exaggeration of her facial expressions and a failed copy of the dance. This version stages no critique and carefully holds constructions of an ableist masculinity in place, as well as a feminine submission in the sense that Ziegler is the support act to Kimmel, Sia, and *Dance Moms*. Instead, the production of laughter serves to promote a convergence of popular media: the Lifetime series *Dance Moms*: Sia's recording career; the ABC television show *Jimmy Kimmel Live!*; and Ziegler as a dance artist and evolving social media influencer. "Bandolier" on the other hand offers a witty, and gently mocking, new approach to the original. It succeeds in its replication of the facial and bodily choreography, which solicits more admiration than laughter, although overall the video prompts extensive audience mirth. It too intersects with commercial interests but offers a more innovate and radical interpretation of the original, through a cathartic distance from the hold of the mainstream commercial media. "Bandolier" prizes creativity and humor thus, untouched by the pressures of a network schedule, advertising revenue, and audience ratings, its creators enjoy the last laugh.

Laughter and Derision in Hip Hop Battles

In the previous two sections I examined instances of laughter that were premeditated. In both cases, the creators carefully planned and produced humorous video performances that intentionally provoked laughter in their respective audiences, and they partly did so by keeping a straight face. I don't mean a straight face in the sense of a still and expressionless visage. Rather their faces mimicked and alluded to a range of emotional expressions, but at no point did they laugh. In these final two sections, I now turn to examples that are quick improvised responses within the context of hip hop dance battles in which faces sometimes laugh *at* and/or laugh *with* their opponents. I also look at how faces generate other comedic expressions that tickle the cypher crowd. Although these are fast-thinking and apparently spontaneous danced responses, as with other improvised dances of the African diaspora, these choreographic facial gestures can also be emitted by design. While hip hop battles are competitive events in which dancers set forth in a serious contest of bettering their opponent, there are multiple opportunities for humor, play and laughter. I open by discussing this across a range of hip hop styles, but then focus on breaking battles which, as I address in the FROWN chapter, have sometimes been misconceived as intimidating and aggressive encounters. As with the example between Macca and Bunny at the beginning of the chapter, I am keen to explore the ways in which laughter enters the live danced exchange between b-girls and b-boys and the cathartic work that it performs.

Across the spectrum of hip hop dance forms, dancers explained when and why they might laugh in the midst of a battle. In some instances, it may not be anticipated in advance. Jip the Ruler (see Figure 7.1) recalls laughter as a means to express the joy of dancing: "Well, me personally, I had so much fun dancing that I could just be laughing and having fun just with the music, with the dance, with the moves, and just enjoying the moment."[19] Glytch also refers to spontaneous and organic laughter: "Now there's other times where something would be just straight funny and you're naturally laughing or you do something and you may feel silly and that laughter just happens out of the moment."[20] Several dancers also talked specifically about locking as a genre known for its light-hearted sensibility:

> Locking, since it's a more funky, playful, dance style, a lot of them have a more playful face, like how a clown kind of looks. Like a lot of eyebrows

Figure 7.1 Jip the Ruler (Phil Cuttino), on the right, at King of the Ring (2013). Photograph by Brian Mengini. Used with permission.

going up and down, and a lot of open jaw, and a lot of smiling because locking is a more fun dance style. (Mad Hatter)[21]

All of my battles have been in the style of locking and so that's intrinsically a cheerful style. And so laughter is part of the choreography, smiling is part of the choreography, but it's all within the cheerfulness of the dance. It's a funky dance. Locking is never angry. (Funky Van-go)[22]

In addition to the laughter generated through the joy of participation, unanticipated moments of humor, or playfulness engendered within the style itself, some dancers also spoke of instances in which laughter would be purposefully elicited as an improvised response that reacts to the energy and character of a specific battle.

I introduced Professor Lock at the beginning of the book and return to him here as he details a specific instance of how he both provoked laughter and laughed at his opponent:

I remember one battle, the way I won that battle was it was the right moment with the audience in just the right mood to catch it. I started taking the wave,[23] playing with the rhythm pattern of the music, and the lyricist,

Busta Rhymes, "Don't Touch Me Now," that song, and kind of turnin' my movements into like, "Ha! Ha!" Laughter! Like I did all my thing, kind of did what he [the opponent] did too, and then laughed it off... With mockery you gotta be careful, 'cuz it's one of those things where if it's not at the right moment, it's just like a comedian—your timing is off, you're gonna have a stale moment, you gonna have a stale audience. But if your timing is on point, then everybody instantly becomes your fan. And that's what happened there.[24]

Here, Professor Lock identifies how he creates humor through the way his body moves and he further expresses this through issuing a visible laugh with his face. Interestingly, he conceives that his bodily movements translate into laughter, thus extending beyond the limits of the face into a full-bodied action. Furthermore, he recollects a clear intention to poke fun at his opponent and, in doing so, is sensitive to the nuance of this comedic tactic. For strategic humiliation to work he needed to be attentive to the audience, the timing, and to his opponent. Notably, many dancers spoke of the relationship between laughter and mockery within hip hop battles, and as Queen Dinita notes, this shows up across all forms: "You get a lot of mocking. It doesn't matter if you're locking, if you're popping, if you're waacking, whatever. You'll get a lot of mockery."[25]

The presence of mockery and laughter in hip hop battles bears little surprise given that they are a form of community contest that sits within Africanist values and traditions. In his influential study, *Aesthetic of the Cool: Afro-Atlantic Art and Music*, Robert Farris Thompson (2011, 6) identifies "dances of derision" as a signature trait of those expressive movement forms that hail from West African cultures and the African diaspora.[26] Indeed, several scholars observe how African American humor possesses distinctive modes of expression and content that often include mockery, ridiculing, wit, signifying, and the presence of a trickster figure (Nilsen and Nilsen 2018).[27] Across many forms of African diaspora dance, creative insult and derisive critique is essential to its form (Hazzard-Donald 1996; Schloss 2009). As De Frantz (2014, 231) illuminates, "black social dances tend toward the space of derision; dancers tease those who are not dancing (or not dancing well) through their gestures."

To examine derision more closely, I return to a battle from 2018 at Second Sundae, which I first mentioned in the FROWN chapter. In that chapter, I describe how a 2 v 2 exchange between Metal and Rukkus, and Dosu and Som, briefly sparks displeasure and heat as Dosu crashes into Rukkus and Metal

at the beginning of his round. Although this is smoothed over with some genial mockery and smiles, largely due to the personalities of those involved, their familiarity with each other, and the lower stakes of this local community battle, the competitive element does not get lost. As Dosu's round comes to an end, the mellow groove of Bobby Byrd's "I Know You Got Soul" is still in mid flow. Rukkus is ready to throw down the final round and he casually two-steps into the cypher clapping his hands in time to the track. He turns back to face Metal, gestures with his hand as if something is resting upon it, and then indicates it is a ball by tossing it to Metal through an overthrow. The pair of them toss it back and forth for a moment and, in perfectly timed precision, both point down to Dosu's knees to ridicule the volleyball pads that he is wearing. As the crowd audibly laughs at this choreographed moment of derision, Metal laughs heartily, Dosu smiles sheepishly, and Rukkus launches into his round, full of tight footwork and emphatic gesticulation. The judges call this battle a draw, therefore Metal and Dosu go up against each other one more time before Dosu and Som move on to the quarter finals and go on to win the entire battle. Although Metal and Rukkus are knocked out at this point, this exchange clearly indicates the clowning, mockery and derisive choreography that can bring play and laughter to the energy of a battle. Metal and Rukkus's quick-thinking, in-the-moment response to Dosu's kneepads speaks to their knowledge and values of the breaking scene. Dosu is an elite b-boy who is regularly invited to participate in prestigious international competitions. Metal and Rukkus cleverly exploit this idea, insinuating that he is overly precious, protecting his knees from scuffing and injury; they on the other hand present breaking in its rawness, they value its street mentality, prepared to throw down at any moment in any situation irrespective of dress or venue. Clearly, their tone is good-natured and they hold huge respect for Dosu, but they strategically deploy mockery as a battle tactic to bring laughter into the cypher and embarrass their opponent.

Although b-boys and b-girls take the competition component of breaking seriously, this contest also holds space for fun and humor. The idea that Metal (see Figure 7.2) laughs openly in the face of his opponent fits into the paradigm of superiority theory in which one person exposes the inferiority of another. In this case, Dosu's kneepads are ridiculed as a weakness, even though he moves on to win the entire battle. Laughter is part of the keen creativity that bursts out along with fast-paced moves and in-the-moment musicality in the dynamism of the live vernacular event. Given that Metal and Rukkus strategically responded through their choreographic play of a volleyball skit

Figure 7.2 B-boy Metal (Mark Wong) playing around at a breaking workshop (2016). Photograph by Ed Newton. Used with permission.

indicates that this laughter is not by accident but by shrewd design. The face and its expressive delivery form an important part of a b-boy or b-girl persona and the laughter produced through wit, mockery, clowning, and insult forms a vital component of breaking history (Chang 2005; Pabon 2012; Schloss 2009). Ken Swift recalls,

> I think the thing that is directly related to the face, looking back in time, is once again that teenage honesty and creativity. It was okay to act silly. I mean, so if there were only ten moves in your vocabulary, right? Everybody has those ten moves. How do you come across? I mean, a lot of it is just personality and some people use their face in aggressive ways, and some people use their face in a clowny way. Frosty [Freeze] used to stick out his tongue and do silly things with his hands. But it's all childish kind of play.[28]

Although breaking vocabulary has developed considerably beyond the limited repertoire of moves to which Ken Swift alludes, this lineage of mockery and derision through facial expression has not been lost. Indeed, this history of play, wit and laughter is also recounted by Metal, who brings this into his own performance: "Frosty [Freeze] had the like, you know, the makin' fun

of you on the playground type thing, where you make the little glasses or somethin' like that. You give 'em the big eye roll, like whatever. Those are like the classic ones to me from, like, the 70s."[29]

With this history in mind, several dancers spoke of how they would strategically use a playful, and almost child-like humor, through which to deride their opponent. Supa Josh states how he engages his face as a way to generate mockery:

> I use my face to do a lot of things. I'm very childlike [Josh laughs], so I do things, like, I'll put my finger on my nose and wiggle my fingers. I'll stick my tongue out at people. I'll suck my thumb, calling them a baby or something like that. It's just the way I like to tease people and play around with them.[30]

Rukkus describes how he has some stock actions that provoke humor and why this is central to the battle event:

> I've had people's hat fall off and I'll play around and put a dollar in it, like they're doing a street show or something. In a sense you really can't get too butt hurt about people mocking your dance because in a competition format, they're just trying to take you out of your game.[31]

MachPhive (see Figure 7.3) meanwhile details a complex corporeal pun which provoked both laughter in the crowd and his own laughter:

> This guy, he was like [miming] making this sandwich and then he took a bite of the sandwich and then he put the sandwich down then he put the knife to the sandwich. And I was like, you know how uprock is supposed to be kind of violent right? Like alright, you could have made the sandwich, but you didn't do anything with the knife. You didn't do anything with the sandwich. So, I came up, I picked the sandwich, I ate it and was like, "Ugh!" [expressing facial disgust at the taste], unraveled it, pulled out my own ingredients, and made a sandwich. Bit it, stabbed him, rubbed it off with my sandwich, and ate it. I was like, "Ah, this sandwich tastes pretty good!" He was like, "Man! That was a bite!" Everybody laughed, so I was laughing. It's just funny.[32]

It is not uncommon for some b-boys to enact elaborate scenarios to deride their opponent and this is one such example. The fact that the first b-boy mimes making a sandwich as part of his round shows some level of imagination, but

Figure 7.3 B-boy MachPhive (Christian MachPhive Walker) laughing as one of the judges at Armageddon (2022). Photograph by Albert Shin. Used with permission.

then MachPhive astutely responds by "dissing" his adversary's sandwich, stabbing him with the knife in an aggressive b-boy style, smears it with blood, then takes a bite in a sharp-witted display of one-upmanship. Furthermore, the idea of stealing moves in breaking is termed "biting" and MachPhive cleverly plays on this by literally and metaphorically "biting" as he bites into his sandwich after having copied the idea of the move. This prompts him to laugh as an act of superiority, his opponent to laugh as a mark of concession, and the crowd to laugh in response to this clever response.

Although laughter emerges across a range of hip hop battles, I have focused here on how b-boys laugh in the face of their opponent as an act of derision. This expression of superiority bursts out forthrightly and unapologetically across the face as a sanctioned component of battling. Furthermore, laughter does not remain solely in the countenance but extends out into a full-bodied motion that can mock, humiliate, and pun on an opponent. Each b-boy then takes on the role of a trickster figure setting out to clown and undermine their adversary, frequently offering a breath of catharsis from the tension of competition and the pressure to win. In the following section, I extend these ideas further to imagine laughter as a community endeavor, how the b-boy trickster tickles the cypher crowd, and the work that laughter does.

Tickling the Cypher Crowd

I emphasized at the beginning of this chapter that laughter constitutes an interactive exchange that depends upon context-specific knowledge. To stress this point, literature scholar Susanne Reichl and writer Mark Stein (2005) develop the idea of a "community of laughter" to convey how audiences share codes and values that enable them to interpret humor, and how these common points of reference facilitate notions of group boundaries and belonging.[33] As a community-generated dance and culture, hip hop offers a space to examine how laughter is produced, shared, and understood particularly within the cypher. Here, I turn to another example of a breaking battle to look at how an individual b-boy engages specific facial expressions in relationship to the body to prompt laughter in the audience.

At the 2019, Break LA: Philly Edition, one of the Top 8 rounds brings together several crew mates going up against each other in a 2 v 2 battle: MachPhive and Wiz from Illadelph Phlave are bracketed with Renaissance Ray and Native, also from Illadelph Phlave. Given the intimacy of this local scene already, combined with the familiarity and familial-like connections between dancers, this battle was ripe for playing on one anothers' idiosyncrasies. MachPhive comes out first, strutting flamboyantly toward his opponents. He is a strong technical b-boy and, after some stylish and inventive footwork, Wiz also joins him briefly in the cypher in a commando routine. MachPhive retreats and Wiz advances, both doing identical foot shuffles, then both switch directions walking on their hands, before MachPhive resumes the round with flares, a freeze stack, and a final face-to-face series of combative gestures forthrightly directed at Native and Ray. Neither are flawed, and both hold out their palms as a brush off, unwilling to engage in this strategy of intimidation. Although Ray smiles genially, knowing this kind of in-your-face attack is a common way to burn an opponent, and the crowd makes hyped noises to reflect the heat in the room, there is little humor to the exchange. As MachPhive exits the cypher, without missing a beat, Native comedically struts in, chest and chin thrown forward, back arched, face deadly serious, and then points to MachPhive indicating that he is the butt of the joke. The crowd around him erupts into laughter, and Native immediately goes to grab MachPhive's head, enacts twisting it off, and rolls it on the ground like a bowling ball toward his opponent's feet. Native then returns to center, does an exaggerated cross step, with puffed out chest and clenched teeth, in another pointed imitation of MachPhive,

before launching into his round and laughing as he goes down to the ground. Again, the crowd roars with laughter at his accurate caricature and comedic humiliation of his opponent. Wiz and Ray each execute an explosive round, and their battle comes to an end with all of them goofing around with silly gestures aimed at each other.

Although I introduce the term "dances of derision" (Farris Thomspon 2011) to describe the mockery that takes place across many African diaspora dance forms, the term "clowning" is frequently used by dancers to describe the physical play and strategic humiliation within breaking battles. Indeed, on reflecting upon the battle I have just described, Native commented,

> I'll literally do the same thing that you did, but make it even funnier ... Let me see what they did and see if I can actually clown them on that to make the audience more involved, to make people laugh, and make people more involved in me and what I'm gonna do.[34]

During my interview with Native (see Figure 7.4), he explained that his b-boy persona is a comical one, and some of this plays out through his use of facial expression.[35] In his semiotic analysis of circus clowns, Bouissac (2015,

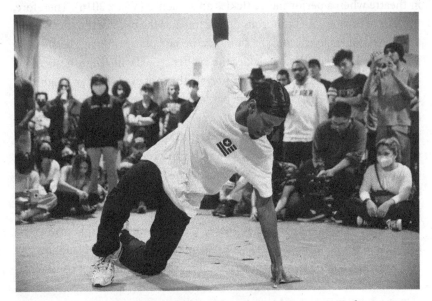

Figure 7.4 B-boy Native (Tyrell White) in a serious moment at Techsgiving (2021). Photograph by Albert Shin. Used with permission.

19) observes, "[Clowns] transform and filter the expressive movements of the facial muscles in a way consistent with the narrative functions of the characters they portray." Thus, he emphasizes the degree to which the face labors to bring a clown's personality to life and that this is not by chance, but purposeful, practiced and performative. We then see this in the way Native holds his head, juts his chin, and clenches his teeth to comment on the pomposity of MachPhive as he enters the dance circle. Yet as I have already stated, the face does not act alone but always works in relationship to the rest of the body. Native's clowning extends to the body through his exaggerated strutting, arched back, and thrusting chest thus embodying the humor to produce a corporeality that laughs. Notably, returning to Native's quote, he explains the intention behind his clowning serves to both involve the audience and generate laughter. The audience certainly responds positively through audible laughter, pointing, and shifting their bodies around with the electric energy that comes through the danced exchange, along with shout-outs such as, "Let's go," "Yeah," "Let's do it!"

In relation to theater performance, Weitz (2016) explains that tickling provides one of the first ways in which children are stimulated to laugh, which requires another person as one cannot successfully tickle oneself. This mutual interaction creates a social bond, and this same connection occurs in theatre when a performance tickles an audience (Weitz 2016). Therefore, the idea of tickling as a humorous device impacts the body of the spectator in their physical response, and the same can be said of the cypher. The affective and comical action of Native tickles the cypher crowd who laugh, gesticulate, and call out in response. While I appreciate that not every person laughs visibly, and there are occasions in the battle setting when a joke misfires or an individual takes some clowning badly, the cypher offers a community space in which laughter can be generated and held. Specifically in this local scene within the Philadelphia area, b-boys and b-girls know the personalities and dance styles of each other, thus clowning can be highly targeted and legible to the cypher crowd. Collectively, the crowd is easily tickled by the humor and play that comes to life through facial and bodily expression.

While the hip hop cypher can enable a community of laughter to come into being, some of the dancers whom I interviewed spoke of laughter can also work as a coping strategy or a form of masking. Jip the Ruler comments,

> To be a dancer is to be able to live through depression ... We find something to give that energy towards ... Dance is really a release and if you

don't get that expression, sometimes you could pop. Some people they really need like a powerful release. They need sometime where they can almost give that last little bit of dying energy just so they can feel that sense of "I gained enough. Now I'm satisfied." . . . It's that sense of satisfaction to self, then seeing it amongst your peers. Those smiles, those laughs, that stuff generates from all the ups and downs.

Riot tha Virus similarly reflects,

I feel like in order to survive, when you get to a certain age, you start to realize how the world works. You have to kind of mask a lot of your emotions with optimism. I was about to say fake, but it's really not fake, its optimism. Because really for me, if I'm in a certain situation, regardless how bad it is, I still have to keep my head up, you know.[36]

Both Jip the Ruler and Riot are African American men in their late thirties, and while I do not want to reproduce the narrative, as discussed in the FROWN chapter, that hip hop can only be read through the lens of oppression, their comments both acknowledge the trials of their life experience and what dance might be able to offer in response. The idea that hip hop harnesses negative emotions, but then channels them into a positive embodied experience for a community of dancers forms a powerful claim. In all these examples, the laugh works as a form of catharsis: an expression of pleasure in dancing, a relief of tension in a competitive exchange, and an opportunity to alleviate the stressors of life. The face clearly participates in this both through openly laughing and through laboring to make others laugh. In the examples I have discussed, the face and body jointly engage in a corporeal laughter through astute improvised responses. Therefore, the community space of the cypher offers a shared opportunity for creative play, quick-thinking derision, feelgood catharsis and performances of full-bodied laughter as a life-affirming act of self-efficacy. As laughter bursts out it tickles the crowd into a state of affective excitable agitation that builds communal bonds.

Reflecting on this chapter, I imagine there are many ways in which laughter can function in relation to popular dance. Given the vast terrain of video-sharing platforms such as YouTube and TikTok, this landscape is ripe for parodies, satires, and skits of dance that is originally intended to be taken seriously. Furthermore, as dances of the African diaspora are embedded with ideas of play, derision, and call-and-response, I perceive vast scope

for laughter within the performance and reception of social and competitive Black vernacular dance. In the case study examples discussed here, I reflect on how each produces laughter, either in the performer, the audience, or both, and how such laughter relates to positivity and power. The two music video parodies are preplanned and carefully orchestrated performances that keep a straight face to generate audience laughter. The Kimmel parody takes an uncritical stance toward the original, ensures that any gender transgression is carefully policed, and that its feelgood humor works to sell a network of media texts. While Bandolier gently pokes fun at its sources, it balances professional interests with creative innovation. Its emphasis on play and recreation enables catharsis from the serious world of work and commerce. In contrast, the hip hop and breaking battles demonstrate spontaneous, yet intentional, quick-witted responses in an arena of contest, community, and play. I show how b-boys and b-girls laugh in the face of their opponents through a full-bodied corporeal clowning. In doing so, they foster collective engagement and can channel negative energies and emotions into a positive embodied experience for self and others through an affective feelgood connection. Unlike the smile, which fixes and masks, the laugh explodes from the face as a cathartic release for both performers and audiences.

8

Face the Facts

I opened this book with two research questions: What does the face do in dance, and what does it mean? Although my focus addresses the field of popular presentational dance, I aver that the face constitutes an active and intentionally expressive component of any dance form that assumes an audience of spectators or fellow dancers observing, even when it appears to do very little. A so-called neutral, blank, or disengaged expression represents a choreographic choice that must be adopted, practiced, and maintained. In popular presentational dance specifically, the face labors according to the codes and conventions of its generic traditions. Hence dancers are schooled in facial expressions that conform to the demands of different styles. Through these persistent and stylized facial modalities, meaning is produced in the face both in relationship to the rest of the body and through the contexts, values, and traditions in which it is located.

Although I examine the idea of a *physiological face* that directly expresses interior thoughts and feelings, I primarily work with the concept of a *sociocultural face* which assumes that facial expression is learned behavior. This attention to the influence of environment allows me to show how the dancing face develops through the display rules of a given performance culture across my case study examples: Michael Jackson, Maddie Ziegler, and a community of hip hop dancers. As young children, Jackson and Ziegler were trained in the art of facial choreography in the respective areas of popular music performance and studio competition dance. Although they would sometimes falter or their faces would slip up to reveal feelings and attitudes that intruded upon their performance, the insistent schooling that they received ensured that their youthful malleable expressions would ultimately conform to meet the requirements of their performance idioms. Such was the extent of this facial training that as they matured both were able to maintain the correct facial choreography irrespective of experiences and emotions to the contrary. Similarly, my community of hip hop dancers also observe and replicate facial expressions appropriate to their various styles. While moments of error or

unanticipated events within the context of hip hop battles sometimes prompt a loss of face, resulting in expressions that echo the surprise or distress they have just encountered, these facial gaffes serve as exceptions that reveal the choreographic rules.

My analysis ranges across a spectrum of notoriety, from the global superstar face of Jackson, the comparatively lesser celebrity face of Ziegler, and the relatively anonymous faces of hip hop dancers affiliated with a local East coast scene. From this, I demonstrate how celebrity faces are carefully constructed but heavily scrutinized. On the one hand, celebrity faces have access to economic and social capital that ensures they can exercise significant artistic control over how their faces are framed. They creatively labor to produce flawless facial presentation, particularly in their staged screen performances, in which their visages are cosmetically enhanced, and their facial choreography is carefully designed to achieve a perfect show of face. On the other hand, the public fascination with their celebrity status and an intrusive media intent on their exposure motivates a disruptive or cruel desire to feature celebrities through candid and unflattering portraits. In opposition to his remarkable performances as a child star, Jackson is displayed as a grotesque monster who desecrated his face and, contrary to her poised performance in dance competitions, Ziegler is at times revealed as a tearful, sulky, and indulged child.

While my study examines the perfectly choreographed celebrity faces of Jackson and Ziegler in screen performances, I look to the live vernacular performances of hip hop dancers within the context of dance battles and cyphers. I witness these largely anonymous faces without the artifice of multiple takes, cosmetic enhancement, and flattering composition. Instead, these live battle events offer scope for a much greater range of facial expressions, which provides a rich mix of performative masquerade and genuine revelation. The dynamic space of real-time performance invites quick-thinking choreographic expressions that show imagination, wit, and creativity. Yet the pressures of a live crowd and line-up of judges can lead to glimmers of anxiety, intimidation, perspiration, exhaustion, error, humiliation, and shame inscribed upon the face. These anonymous faces, unencumbered by the trappings and expectations of celebrity within the controlled environment of a screen performance, offer a more honest depiction of their relationship to the dance. While many of the dancers are skilled in the conventions of facial choreography, they collectively reveal different levels of experience, proficiency, care, and investment in the art of the hip hop battle face.

Unlike the predominantly solo performances of Jackson and Ziegler, the hip hop battles I observe always involve an exchange between two or more dancers. This face-to-face encounter invites consideration of an *ethical face* that brings into play the social and political values of each participant. Such ethics are negotiated through facial expressions of the self that convey an attitude to the other, across a spectrum of possibility that can include intimidation, comradeship, derision, aggression, playfulness, and so on. While such faces might only be an act of bravado in the direct battle exchange, hip hop dancers think carefully about what these faces might do in relation to their opponent and how this facial point of view fits with their beliefs about the role of battling within the broader field of hip hop history and culture. Indeed, hip hop dancers place considerable emphasis on authenticity or "keeping it real" in the battle exchange, therefore facial expressions that do not sit comfortably with their sense of self are often dismissed or dropped in favor of other facial modalities.

Across all three case studies, I argue that faces articulate ideas concerning identity. One conceptual approach considers a *semiotic face* that is structured according to social norms. Rooted in the privileging of a white, male face, this acts as a barometer against which other faces and their expressivities can be understood as deviant or otherwise. Along similar lines, given that faces are categorized as unique bodily signatures, an assumption relies upon the veracity of an *identifiable face* organized across configurations of gender, race, age, ability, sexuality, class, and other identifiers to award each countenance with distinction and character. As I come to show, facial choreographies can both reproduce and critique such identity norms. Specifically, scholarship from Black, queer, and disability studies, which privileges alternative epistemologies, helps to reveal the dominant constructions and values of a white, ableist male visage.

To think about the choreographic meanings of the face, I identify six facial typologies through my popular dance case studies. I conceive these purposeful faces as action-expressions that are performative and choreographic as each demands training, imagination, and intent. These are active faces laboring to create affective expressions: the glossy and tenacious smiles of Jackson and Ziegler; a defiant look produced by b-girls of color; a provocative frown issued by Jackson and b-boys; a manipulative cry executed by Ziegler as the surrogate face for Sia; a potent scream reiterated by Jackson; and a cathartic laugh engendered through YouTube parodies of Ziegler's viral face and a community of laughter within hip hop battles. Each of these faces

then mobilizes ideas regarding gender, sexuality, race, class, age, nation, and ability. While I did not set out to map a comprehensive history of these six facial choreographies, I have tried to show how different facial compositions act as historical registers of specific periods and how facial performances are subject to change according to the shifting values of a particular era. For example, I trace the genealogy of the smile from blackface minstrelsy, through the class act tradition, and into the slick performances of Motown artists; I look at the persistent smile of the kickline chorus girl across a range of female-oriented performance traditions, but which was partially ruptured through the anti-smiling critique of second-wave feminism; and I follow the intensity of the frown in the street battles of 1970s New York, in spite of its connection to a playful cartoon character, which is memorialized by some b-boys in the present day, yet rejected by others who view it as anachronistic and inauthentic.

Within each chapter, beyond my case study examples, I allude to other areas of popular dance where the same action-expressions show up, although their meanings are always dependent on the specificities of each performance context. I anticipate that the glossy and tenacious smile is the most pervasive as I list numerous performance sites where it appears and I trace its presence over a century and a half, beginning with blackface minstrelsy. The tenacious quality of the billion-dollar smile ensures that it perpetually appears within the capitalist endeavors of commercial popular dance, and I suspect it will continue to thrive as long as entertainment spectacles attract pleasure-seeking audiences. Yet I am also mindful that a smile can take many forms, and this offers scope to explore other modes of smiling in popular dance. Following the glossy and tenacious smile, the provocative frown, the defiant look, and the cathartic laugh also provide fertile territory for further research as each is manifest across a variety of popular dance contexts. And while the manipulative cry and potent scream are probably the least common action-expressions, their scarcity perhaps signals their powerful impact and possibility when they do appear. Aside from the field of popular presentational dance, I hope that these facial choreographies can be applied to other styles and genres of dance, or that other variations might evolve, such as a sneering smile, a coy look, or a camp frown. I also look forward to seeing how the concept of facial choreography overall might be developed in relation to dances beyond the North American context that I explore here.

To wrestle the face from the dominance of the semiotic and visual in the construction of meaning, I additionally consider the face from the

perspective of the sensorial and experiential. To engage in facial choreography supposes feeling, sensing, and expressivities that are replete with affective potential. I think about the exhausting labor of maintaining a bright, tenacious smile, particularly in times of emotional distress; the power felt through issuing a direct and challenging look in the face of an oppressive gaze; the relief of exhibiting, or rejecting, a frown that questions a history of dance values and traditions; the discomfort of witnessing a celebrity child express the pain of crying on behalf of a powerful adult woman; the unbridled fury released via a scream against child exploitation, media bullying, and a collective history of racial trauma; and the pleasurable and critical possibilities afforded through laughing at and laughing with. In thinking about the entire dancing body engaging in mockery within hip hop battles or the pent-up rage of the Jackson siblings as they execute their taut and percussive dance sequences in "Scream," I see how the sensorial dimension of facial choreography extends into a full-bodied presentation. In producing facial choreographies dancers embody the evocation of those expressions, whether they are congruous with their internal feelings or whether they are acting those emotions in accordance with desired performance codes. Meanwhile, audiences are sensitive to how those action-expressions rouse their own affective responses irrespective of whether the facial performance is genuine or otherwise.

I intentionally organize each chapter around named facial expressions that are prevalent in everyday life: smile, look, frown, cry, scream, and laugh. I do so because spectators and audiences can easily identify these commonplace faces within the realm of popular dance and an extant language rather than a specialist vocabulary helpfully describes them. Yet although these known quotidian faces are replicated across the field of popular performance, their choreographic potential lies in their capacity to move in ways that exceed the norms of socially acceptable behavior. I therefore emphasize the idea of an action-expression to underscore that these are intentional faces rooted in effortful movement even when maintaining a fixed expression. The faces I explore are hypermobile and hyperbolic, creatively deploying compositional strategies that call attention to the visage and provoke onlookers to question their meanings. Popular dance can fix faces in ways that might appear intimidating, insistent, or odd; it can exaggerate expressions that feel offensive, aggressive, or unhinged; and it can rapidly switch faces such that they are bewildering, nonsensical, or deeply compelling.

Ultimately, facial choreography is an imaginative act that positions the face in popular dance as a spectacular attraction, rich in affect and meaning. Although I identify ways in which facial choreography conforms to and perpetuates dominant ideas regarding gender, sexuality, race, class, and ability, which centers whiteness, masculinity, heteronormativity, neoliberalism, and ableism, popular dance artists can re-choreograph their faces to critique and reimagine those norms: the intentional failure to uphold a polished smile; a sustained look back at a hegemonic gaze; a winning smile to replace an intimidating frown; investing in a cry to destabilize female contentment; a scream back at decades of smiling; or an unruly laugh that mocks, parodies, and tickles its onlookers. Facial choreography offers scope for a spectrum of experimentation, which ranges from strict rules that allow for little deviation without serious consequence, through to a sophisticated knowledge of the codes and conventions of a form that opens exciting opportunity for play, provocation, and subversion. Although everyday life bears witness to a similar range of conforming to and departing from socially accepted facial behavior, these action-expressions are intensified and distorted through the commercial stakes of the entertainment industry, while consenting and participatory forms of popular dance negotiate these rules in ways that foster notions of agency and community. The facial choreographies of popular dance do not simply produce and reiterate stable conventions and meanings, but can destabilize and question their construction, knowing that the power of the face lies in the fact that it is both taken for granted and deeply compelling.

As a coda to these concluding thoughts, I completed the writing of this book through the global COVID-19 pandemic that came to prominence in early 2020. Its virulence, particularly before the development of a vaccine, led to periods of state-controlled lockdowns to prohibit face-to-face encounters, and the mandate that people wear face masks in public settings to mitigate against the spread of this infectious disease. Prior to the pandemic, masks were rarely worn in the Western region of the world (Klucarova 2021), but by July 2020, more than a hundred countries had introduced the required adoption of face masks, which cover the nose and mouth, in heavily populated public areas (Lupton et al. 2021). The deployment of face masks in everyday life has implications for the face aesthetically, politically, and socially. The demand for this new facial accessory has created a booming economy of masks, which come in a myriad of materials, prints, and slogans that speak to the

aesthetic style, personal interests, and value systems of an individual. The willingness, or otherwise, to wear masks in public life has also become a political statement that tussles between the rights of the individual and the commitment to collective health (Lupton et al. 2021). Although the eyes remain visible, the covering of the lower part of the face hinders facial expression and communication given that the cheeks, mouth, and chin heavily contribute to articulating emotional states (Klucarova (2021). From the field of cosmetics and dermatology, Mark Nestor, Daniel Fischer, and David Arnold (2020) argue that the face is responsible for 55 percent of communication and that if faces cannot be read easily, there is less incentive for the mask wearer to express the emotion, which leads to them struggling to recognize both their own emotions and the emotions of others.

As an embodied art, the requirement to wear masks in training and performance has heavily impacted dance practice. Across multiple dance communities, conversations have centered on the challenges of wearing a face covering that hinders the ability to breath quickly and easily during heightened aerobic activity, and frustration over the masking of expressions and emotions in performance, which reinforces my central argument regarding the importance of the dancing face and its choreographic meanings.[1] During the various lockdowns of the pandemic, live performance events were cancelled or postponed, therefore not surprisingly many dance artists turned to the screen media to stage their work. Although the TikTok platform, a social network site through which its users share short-form video clips, existed prior to the pandemic, it experienced a surge in popularity during this time and dance has become a major feature of its content (Blanco Borelli and moore 2021; Harlig et al. 2021). It was the most downloaded media application of 2020 (Oh in Harlig et al. 2021), and in addition to its former youth market, it also began to attract older populations and adults across a range of occupations (Zeng, Abidin, and Shäfer 2021). Given that TikTok relies upon mobile uploads, dance scholar Chuyun Oh (in Harlig et al. 2021, 199 emphasis in original) describes its dance content as a "*performance of entrapment*" to analogize the tight frame of the smartphone with the restrictive space of lockdown. As the platform only hosts vertical or portrait shots, this limits lateral movement and the focus typically centers on the upper body, which privileges the face, arms, torso and hips, rather than legs and feet (Krayenbuhl in Harlig et al. 2021). Given that its performance space has diminished to the scale of a smartphone screen, the expressivity of

the face has become a prominent feature of TikTok dance (Oh in Harlig et al. 2021). Consequently, TikTok dances tend to be highly gestural, rarely travel, and deploy hyperbolic facial choreography.

TikTok attracts both professional dance artists and amateur social dancers, and dance challenges, in which users upload clips of themselves executing the same section of choreography, became extremely popular during the pandemic (Borelli and moore, 2021). As the movement remains the same, Oh (in Harlig et al. 2021) suggests that distinct facial expression delineates one performance from another. Across endless clips of TikTok dances, I see glimpses of faces that I have covered at length in this book, such as the glossy and tenacious smile or a snarling and frowning air of disdain, along with other facial choreography, such as a disrespectful or flirtatious sideways glance, an exaggerated pouting (or "duckface" as it is called in studio competition dance), a lip synching of song lyrics, a deadly serious countenance, a flood of hysterical mirth, a visage contorted in psychic pain, an entire eyebrow dance, and a cheeky flash of the tongue. I will leave other researchers working in this exciting new area to explore the use of the face in TikTok dance (Boffone 2021; Oh 2022), but want to bring this book to a close through restating the primacy of the face both in social life and in popular dance. Although we collectively mourned the absence of the face through mask-wearing and social distancing during the months of the pandemic, faces continued to find novel ways to assert their presence and choreographic potential across zoom platforms, social media, and cinematic performance. While I insist upon reading dance as a full-bodied expression, I hope we can appreciate how we look to the face and use our faces to articulate a sense of self and to offer critical perspectives on our values and beliefs. Although we might assume we know the face, choreographically it can surprise, shock, and offer alternative visions of the world.

Notes

Chapter 1

1. Author interview with Professor Lock (Brice Johnson) on February 20, 2015.
2. In several chapters, I address the complex relationship between the personal life of Jackson and his art. In the SCREAM chapter, I discuss the 2019 documentary *Leaving Neverland*, which focuses on experiences of sexual assault. I caution the reader to take care when embarking on this material and, if you are a survivor of sexual assault, you may wish to skip this chapter.
3. Gosselin, Kirouac, and Doré (1997) reference the Stanivlaski acting method in which performers attempt to access authentic emotions, although they suggest it remains unclear as to whether the emotion is genuine or not.
4. The experimental dance film *Monoloog* (1989), and the music videos for Peter Gabriel's *Sledgehammer* (1986) and Godley and Creme's *Cry* (1985), offer other examples of screen "choreographies" that focus entirely on one or more close-ups of the face.
5. In Kathakali, dancers learn how to exercise control of the eyeballs and isolate precise facial muscles in pursuit of the technique (Devi [1972] 1990).
6. Dance scholar Kariamu Welsh (2004, 15) observes that mask performances fulfill several functions: "warding off evil spirits; story telling; suggesting supernatural or mystical powers; spreading good feelings; honoring African deities; and/or embodying animal, human, or spiritual figures."
7. Even if the audience knows who the performer is, a taboo surrounds the acknowledgment of this (Okafor 1991).
8. Yoruba belief asserts that elderly women in particular hold a power likened to that of the gods and ancestors (Drewal and Drewal 1983).
9. As DeFrantz (2004, 71) clearly notes, he employs Robert Farris Thompson's idea of the "aesthetic of the cool" to support his thinking on hip hop.
10. This idea that an expressive face as a site of subjectivity that is devalued in favor of a universal white mask within Euro-American (post-)modern dance resonates with the scholarship of Deleuze and Guattari (1987), which I come to in the following section.
11. An entire pseudoscience of physiognomy developed, which claims to show how the composition of the face represents the innate characteristics of the person (Magli 1989).
12. President Ronald Reagan exploited the stereotype of the Black welfare queen (Brockell 2019); fears of the Muslim terrorist that developed under President W. George Bush have continued with President Donald Trump's 2017 travel ban to restrict entry to the US from several Muslim majority countries (Gladstone and Sugiyama 2018); and

President Trump used the notion of the bad hombre to justify his executive order to build a wall along the US border with Mexico (Smith 2019).
13. Although Darwin also considered posture and gesture in the articulation of expression, and I will come to discuss the importance of reading the entire body in relation to the face, at this stage I focus on how he theorizes the disposition of the face.
14. Darwin's evolutionist perspective challenged tenets of creationism and imperialism as his argument that humans evolved from a single progenitor critiqued the racist supposition that Europeans and Africans emerged from separate lines of descent (Ekman 1998b).
15. Neu (1987) argues that the questions Darwin used to solicit information presuppose a universal set of emotions and concomitant expressions, and Ekman (1998a) observes that he approached only one missionary in each country for his data collection. His findings reflect the social values of the period: for instance, his references to "children of savages" set in contrast to "civilized Europeans" (Darwin [1872] 1998, 230) reveal a colonialist perspective, and his supposition that the muscles that display grief are animated more frequently in women supports an andocentric reading that positions them as the emotional sex.
16. To facilitate detailed facial analysis, in 1978 Ekman and his research partner Wallace Friesen created the Facial Action Coding System (FACS), a complex analytical framework that compartmentalizes the face into forty-four "unique action units" and can account for the totality of facial expressions (Rosenberg 1997, 12). Gosselin, Kirouac, and Doré (1997) note that while FACS provides extremely detailed information about the anatomical configuration of expression, it is difficult to grasp the overall picture of the face.
17. Several scholars question his study protocols arguing that his practice of providing his test subjects with photographs of preselected emotions primes them to identify specified readings of facial expression (Feldman-Barrett 2014).
18. Despite these critiques, Ekman's work has proved influential across various fields. Within the field of computer engineering, a cluster of scholars have employed FACS and Ekman's typology of six universal emotions to produce facial animation software that corresponds with speech patterns (Byun and Badler 2002; Pelechaud, Badler, and Steedman 1996; Pelechaud, Steedman, and Badler 1991); psychologists Ahalya Hejmadi, Richard J. Davidson, and Paul Rozin (2000) undertook a positivist study of facial expression recognition using images of Hindu classical dance, which concurred with Ekman's universalist claims; and performance studies scholar Richard Schechner (1988) builds on the Darwinian interest in shared human and animal behaviors through exploring the continuation of "animal cultures" in theatrical performance and examines Ekman's universal facial expressions through cross-cultural acting techniques.
19. Leys (2011) states that Tomkins's work bears the influence of Darwin and Ekman's legacy in describing affects as automated responses independent of cognition.
20. Wetherell (2015) provides an extensive critique of how key affect theorists base their work on multiple and not necessarily compatible studies of emotion, which range from social and cognitive to semiconscious and contagious.

21. See Lutz and White (1986) for a detailed survey of the literature on emotions across psychology, sociology, philosophy, history, and gender studies.
22. In a later article that focuses specifically on women and emotion, Lutz (1996) argues that this rhetoric operates to control women discursively, yet the supposed lack of control over emotional expression offers a potentially powerful position.
23. Besnier (1990) argues that the intentionality and sincerity of emotional expression changes across cultural contexts and looks at how laughter can signal embarrassment for middle-class British and American people, shame for the inhabitants of the Melanesian island of Nissan, and as a strategy to acknowledge ethnic differences for Italian Americans; Lutz (1985) focuses on depression as a Euro-American construction and, through research into the Ifaluk people of Micronesia, observes that "depression" does not translate easily into other cultural systems; and in a study of anger among the Pintupi Aborigines, Myers (1988, 591) conceives it as a "logical form" that illuminates how emotions are socially structured and semiotically legible.
24. Birdwhistell's method was influenced by the field of structural linguistics: "Using filmed data, he applied a linguistic model, attempting to identify movement units based on contrastive analysis in a manner similar to that established by structural linguists for establishing the phonemes and morphemes of a spoken language" (Farnell 1999, 351).
25. Farnell (1999) reflects that both Goffman and Birdwhistell only focused on everyday social interaction, therefore the potential of their work for dance and other formalized performance modes was not developed.
26. In the Introduction to *Totality and Infinity*, philosopher John Wild (1969) describes totality in terms of a subject who is satisfied with the systems they organize and embraces power, control, and order, whereas infinity calls to those who are dissatisfied and willing to embrace what is other to them in the pursuit of freedom.
27. Philosopher Roger Burggraeve (1999) describes how the ethics of the face-to-face exchange raises issues of violence, hate and murder rooted in the morality of good and evil. As the "I" possesses a self-interested desire to exist (or rather not be killed by the other), they are presented with a temptation to murder (Burrgraeve 1999). Therefore the subject must put effort into not harming this vulnerable other through resisting the desire to reduce this stranger to their countenance. Burrgraeve (1999) explains that by only seeing the other as a set of facial features, it is both a form of violence and a lack of respect. By checking physical appearance, we reduce the stranger's countenance to spectacle and their infinite otherness becomes limited.
28. Deleuze also offers a complex theorization of the face through the lens of the filmic close-up in *Cinema 1: The Movement-Image* (1986). See Brannigan (2011), Rushton (2002), Dodds and Hooper (2014), and Dodds (2014) for an explication and application of Deleuzian thinking in relation to screen and dance performance.
29. Here they refer to a European face and the face of Christ (Deleuze and Guattari 1987).
30. Fleetwood (2011) comments on how frequently Fanon's work is invoked, which not only rehearses Fanon's traumatic encounter, but also centers the experience of the Black male subject (thus negating Black female experience). See the Introduction to *Troubling Vision: Performance Visuality and Blackness* (Fleetwood 2011) for a full

discussion of how the extent to which Fanon is cited forecloses other ways to conceive blackness and visuality.

31. Notably, at the time of writing, Ahmed did not necessarily see her work as part of the affective turn; however, in the afterword to the second edition, she retrospectively places her study of emotions in conversation with the burgeoning corpus of affect theory.
32. Wetherell (2015) comments upon Ahmed's lack of clarity about whether emotion is situated inside or outside of the subject, although Ahmed ([2004] 2015) herself observes in hindsight how she struggles to differentiate affect from emotion.
33. Here Ahmed ([2004] 2015) reminds us of the notion of "press" in impression to show how emotions leave a trace or mark. While this process can involve thought and judgment, it can also be "felt" by the body.
34. In some regards, Ahmed's work answers those critiques that accuse affect studies of failing to attend to questions of the ideological or political: her research is grounded in the social domain rather than preconscious or prelinguistic sensations.
35. A few of the dancers carry a national or international reputation within either the US or global hip hop community, but they are in the minority.
36. Jackson's face forms the subject of much debate, both in terms of how it changed cosmetically and the life that it allegedly disguised, and I will deal with both topics in later chapters.
37. I describe this as a "loss of face," and examine this phenomenon elsewhere in relation to concepts of error and failure within hip hop battles, which I assert offer productive life lessons (Dodds 2019b; 2020).

Chapter 2

1. Jackson biographer J. Randy Taraborrelli (2010) details how Jackson was concerned that the advertisement might lead to overexposure as he did not fully endorse the soft-drink product.
2. The deal with Pepsi resulted in several advertisements for different international markets. One involved a street scene featuring Jackson, his brothers, and a group of children who dance with bottles of Pepsi, in which his hit single "Billie Jean" is reworked to include references to the drink. As negotiated, Jackson only makes a few brief appearances in the commercial, although he is featured smiling on several occasions. See https://www.youtube.com/watch?v=po0jY4WvCIc (accessed July 10, 2023).
3. Thank you to Karen Schupp, former competition dancer and professor of dance at Arizona State University, for alerting me to the terminology of "facials" in dance competition.
4. In terms of muscular organization of the face, Paul Ekman has identified eighteen types of smile, but notes there could be as many as fifty (Niedenthal et al. 2010).
5. For clarity, I occasionally use Jackson's first name when I am discussing him in relation to other members of the Jackson family.

NOTES 203

6. The "chitlin circuit" covered large-scale theaters in urban centers such as Cleveland, Baltimore, and Washington, DC that would specifically cater to African American musicians and entertainers (Taraborrelli 2010).
7. The first television performance by the Jackson 5 was on *The Hollywood Palace* (October 18, 1969), hosted by Diana Ross. I focus on their performance on *The Ed Sullivan Show* (December 14, 1969), which ran from 1948 to 1971, because of its popularity among US audiences and its reputation for showcasing breakthrough performances by celebrated music artists.
8. For my analysis, I refer to a YouTube clip of this performance: https://www.youtube.com/watch?v=GP5qFx2yAtU (accessed July 10, 2023).
9. Although Judith Hamera's book *Unfinished Business: Michael Jackson, Detroit, and the Figural Economy of America's Deindustrialization* (2017) does not focus on the presentation and choreographic workings of Jackson's face beyond a few brief mentions, Hamera is the first dance scholar to produce a substantial study of Jackson as a cultural figure and how his performing body illustrates processes of deindustrialization that have taken place in the United States since the mid-1980s and the relationship of this economic change to matters of race.
10. Other scholars also comment on the preternatural maturity of Jackson's performances as a child (Fast 2010; Whiteley 2005), as well as the experiences he endured as a child, such as witnessing adult sexual behaviors (Taraborrelli 2010).
11. Motown fabricated the narrative that Ross had discovered the Jackson 5 at a benefit concert in Gary, Indiana in 1968 as a marketing ploy, although they were already signed to Motown at that point and Ross was not actually in attendance (Taraborrelli 2010).
12. Tensions existed between Motown and the Jackson family, as the group was never allowed opportunity to write and produce its own music or have any control over publishing rights. Although the group negotiated a deal with CBS records (under the subsidiary Epic label), Jermaine initially refused to sign the contract, which would show a lack of loyalty to Motown, as he was married to Berry Gordy's daughter Hazel. These fraught personal and contractual relations remained for several years, and included multiple lawsuits between the two labels (Taraborrelli 2010).
13. See Johnson (2012) for a concise history of the development of blackface minstrelsy.
14. Hartman (1997) critiques the way in which Black pain has been spectacularized for white pleasure as Black bodies have been forced to dance on slave ships, displayed on the auction block, and humiliated on the minstrel stage, which she conceives as "scenes of subjection."
15. The most substantial examination can be found in Harriet Manning's book *Michael Jackson and the Blackface Mask* (2013). I find Manning's discussion of the relationship between minstrelsy and Jackson's performances to be extremely generative in thinking about his use of facial expression; however, the links she makes between minstrel dancing and Jackson's dance performances are underworked. The lack of information about the historical dance content of minstrel performances in comparison to the complex movement influences that shaped Jackson's dance idiom (see Bergman

2019) suggests that a straight genealogical lineage between the two is in danger of over simplification.

16. Southern (1996) notes that some African American minstrel performers were present in the 1850s, although they become more commonplace after the Civil War.
17. The third single, "She's Out of My Life" (1979), does not feature the excessive smiling countenance of the previous releases; however, the song relays the dramatic loss of a loved one and Jackson therefore assumes a melancholic facial expression more suited to this subject matter.
18. *New York Times* journalist Claudia La Rocco (2010) describes how *Dance Moms* shows a distorted image of dance competition life, and dance education scholar Marita Cardinal (2013) points to the abusive dance pedagogy modeled by Miller. Notably, the show has dealt with accusations of child cruelty, lawsuits, and bankruptcy.
19. Season 1: Episode 4, "Stealing the Show."
20. Season 1: Episode 7, "She's a Fighter."
21. Season 1: Episode 8, "Love on the Dance Floor."
22. Adah Isaacs Menken played a male lead in *Mazeppa* (1861) wearing flesh-colored tights that suggested naked legs; while this offered titillation for male spectators, she also represented a figure of female emancipation in escaping the restrictive corsets and skirts of the period (Ashby 2006). In *Ixion* (1868), a lampoon based on classic mythology that featured women in short tunics, burlesque performer Lydia Thompson and her troupe the British Blondes used popular song and dance to satirize New York social life (Allen 1991).
23. Notably, Jayna Brown (2008) observes how white chorus lines employed an uncredited Black vernacular dance aesthetic within the movement idiom.
24. LaFrance (2011) references the work of Arlie Hochschild, who describes the smiling professionalism of service culture as a form of emotional labor.
25. Drawing on Hannah Arendt, Franko (2002) describes "work" as a productive activity that creates an end product, whereas "labor" describes the process, action, effort, or force of doing work, but not the end product. In these terms, dance bears more similarity to the idea of "labor" as it produces no concrete commodity.
26. Both Franko (2002) and Elswit (2014) offer critiques of the "mass ornament" model using the face as a critical intervention, and I will come to this in the final section of the chapter.
27. Although many children attend ALDC and studios of this kind for purely recreational purposes, the children on the elite team show serious interest in pursuing professional dance careers. For instance, they meet with talent agents, perform in a music video, audition for a summer program with a preprofessional dance school, and record tracks in commercial music studios. Furthermore, competition dance has become a lucrative market for the event organizers and the dance studios that participate.
28. Although a few male dancers feature on *Dance Moms*, ALDC and competition dance are dominated by girls and young women.
29. The one exception to this is Nia, a young African American girl who is often cast in solo dances that exploit ethnic stereotypes.
30. Season 1: Episode 5, "When Stars Collide."

31. Season 2: Episode 24, "New Girl in Town."
32. Season 3: Episode 32, "The Dancing Dead."
33. Season 2: Episode 26, "Nationals 920210."
34. The link between Temple and Ziegler also resonates with another uncomfortable parallel between Michael Jackson and Bill "Bojangles" Robinson. Robinson, who featured as a dance partner to Temple across several feature films, also bore the contented smile of a laboring Black male body intended to service the gaze of a white spectator (see Morrison 2014).
35. Ehrenreich (2009) traces the development of positive thinking in the United States from Calvinism and its belief in a Protestant work ethic, through to the New Thought movement of the nineteenth century, which took a more caring perspective as individuals developed anxiety and exhaustion over industrialization and urbanization. Ehrenreich (2009) observes that New Thought did not entirely break with Calvinist belief as both centered on extreme self-monitoring: the god-fearing Calvinist was constantly checking for signs of idleness or self-indulgence, and the positive thinker is always vigilant around negative thinking.
36. In Season 1: Episode 3 Brooke complains of a sore hip and visits a medical consultant, and in Season 2: Episode 19 she has a sore back and is pulled from the dance.
37. At the beginning of each episode, Miller reveals headshots of the girls organized in a pyramid to indicate who has been the most successful or hardworking over the previous week. The pyramid was introduced specifically for *Dance Moms* and was not a component of her teaching prior to this (Miller 2014).
38. Although Candy Apples becomes one of the main competitors of ALDC through the course of the series, initially Nesbitt-Stein enrolls Vivi-Anne in ALDC and she is a part of the competition team.
39. Season 1: Episode 3, "Cheerleader Blues."
40. Season 1: Episode 4, "Stealing the Show."
41. Season 1: Episode 9, "From Ballerinas to Showgirls."
42. Season 2: Episode 4, "No-One Likes a Bully."
43. These quotations are taken from Miller's (2014) book *Everything I Learned About Life, I Learned in Dance Class*; however, she frequently uses these or similar words in *Dance Moms*.
44. Season 2: Episode 12, "Waiting for Joffrey."
45. Season 2: Episode 14, "The Battle Begins." The previous week (Season 2: Episode 13, "Abbygeddon") Ziegler's name is entered for a solo, but Miller decides she should not do one. At the last moment Miller wants her to enter, but Ziegler refuses, and sits in floods of tears as her name is called out over the public address system.
46. In her book *The Feminine Mystique* (1963), Friedan argues that the smiling housewife offers a fantasy that women are content in their domestic labor, although feminist scholar bell hooks argues that this is a privileged position as some women do not have the option to stay at home and be economically supported (Ahmed 2010). For Ahmed (2010), both Friedan and hooks, in their different approaches, are "feminist killjoys" as they expose the construction of happiness and who is entitled or has proximity to it.

47. Here Elswit's (2014) argument is in dialogue with Walter Benjamin's 1935 essay "The Work of Art in the Age of its Mechanical Reproducibility."
48. Season 3: Episode 32, "The Dancing Dead."

Chapter 3

1. When I first interviewed Mad Hatter, they identified as a woman and they describe themself as a woman in one of the quotations I use later in the chapter, in the section where I discuss female dancers of color. Mad Hatter now identifies as nonbinary and uses the pronouns they/them. I therefore use they/them pronouns throughout the chapter in reference to Mad Hatter, but leave the quotation and discussion of them in the section where I specifically address how women of color experience the gaze within the battle scene.
2. Thanks to my colleague YaTande Whitney Hunter for encouraging me to think about the idea of "projection" in this chapter.
3. Although a handful of the dancers have cultivated a national or international reputation, their notoriety remains predominantly within the hip hop community.
4. I have attended Second Sundae, The Gathering, Battle for Your Life, Survival of the Illest, King of the Ring, For the Love, 360 Flava Anniversary, Rhythmic Damage, Ladies of Hip Hip, Soul 2 Sole Streetdance Competition, Tuner Evolution, King of What, Jingle Jam, Silverback Open, Red Bull BC One Cypher, Prime Breaks, B-boy World, Battle on the Pier, Techsgiving, and Smoke Sesh Monthly.
5. I have used research funds to hire several photographers and videographers to document the battles I have attended, and possess over two thousand photographs and video clips which I have used to support my facial choreography analysis.
6. My teacher-mentors are b-boy Metal (Mark Wong) and b-boy Valme (Jerry Valme), and I have also been offered valuable advice from b-boy Rukkus (Jay Jao), b-boy Renaissance Ray (Raymond Trinh), and b-girl A-Tek (Autumn Dziegrenuk). It was Rukkus who told me it was time to take a b-girl name, and he and Kanye East (Walter Drummond) came up with the name S-Dot.
7. A discussion panel titled The Black Xperience (aired on June 13, 2020), facilitated by b-girl Macca (Macca Malik) and b-boy Box Won (Ben Barnes), interrogates the question of being a guest within Black culture: see https://www.youtube.com/watch?v=gzrTy1FTycI (accessed July 25, 2023).
8. The panopticon comes from Jeremy Bentham's vision of an institutional building for prison populations in the eighteenth century, but its capacity for surveillance has crossed into education and the military for example (Heynen and van der Muelen 2016).
9. Communications scholar Robert Heynen and criminologist Emily van der Muelen (2016) build upon Foucault's thinking to describe contemporary life as a surveillance society through the way that national borders are policed, streets are watched, and social media systems track people's habitual moves.

10. Mulvey argued that based upon sexually differentiated structures of looking in everyday life, an active male gaze, driven by a scopophilic desire, is directed at the cinematic image of a passive female body that becomes the bearer of an erotic look. Although Mulvey's essay was critiqued for its failure to account for alternative viewing positions that might include female or queer spectatorship, its examination of the gaze as a gendered phenomenon has widely impacted arts and humanities disciplines that deal with visual orders of representation and looking.
11. See also the Watching Dance project (https://gtr.ukri.org/projects?ref=AH%2FF011229%2F1 accessed August 23, 2033) and some related publications concerning "dance spectatorship" and ideas of "kinesthetic empathy" (Foster 2011; Reynolds and Reason 2012).
12. Foster (1986) discusses the mutual gaze in relation to dancer Deborah Hay and the disconnect between dancer and spectator in relation to choreographer Martha Graham.
13. Both Knuckles and Are You Randy hail from New Jersey and, although they partnered for this event, Knuckles belongs to Repstyles crew and Are You Randy belongs to Retro Flow.
14. Author's interview with Sunny (Sunny Choi) on May 27, 2018. I provide the interview date with the first quotation only, unless I have interviewed a dancer more than once, in which case I provide the date of the specific interview.
15. Author's interview with Renaissance Ray (Raymond Trinh) on December 19, 2019.
16. Author's interview with Steve Believe (Steve Lunger) on October 17, 2018.
17. The trope of the stare down is so prevalent in breaking battles that b-boy Native (Tyrell White) has created a parody video of this: https://www.youtube.com/watch?v=zWJL15Bwj_g&feature=youtu.be&fbclid=IwAR1P2tuazjYdX2pnTVZdqkpyGWKnWN_eDUaz6zfqAChu0NfFilAYFAU-ZhI (accessed July 25, 2023).
18. Author's interview with Sk8z (Davion Brown) on September 4, 2014.
19. Author's interview with Macca (Macca Malik) on April 18, 2018.
20. Author's interview with Dosu (Luis Carrera) on March 19, 2019.
21. Author's interview with Mai Lê (Mai Lê Ho-Johnson) on October 7, 2015.
22. Author's interview with Jenesis (Jazmine Gilbert) on May 10, 2018.
23. Author's interview with Metal (Mark Wong) on May 2, 2018.
24. Author's interview with Ynot (Tony Denaro) on March 22, 2018.
25. Author's interview with Mad Hatter (Béa Martin) on June 2, 2018.
26. Author's interview with Rokafella (Ana Garcia) on January 13, 2019.
27. Author's interview with Tony Teknik (Leantonio Kenan) on October 25, 2013.
28. Author's interview with Rukkus (Jay Jao) on May 2, 2013.
29. There is often much debate within the hip hop community about judging bias (Fogarty 2019). Notably, judges are frequently fellow dancers with whom battle competitors have relationships within the hip hop community, therefore the interactions of looking might signal the quality and status of those relations.
30. For breaking in particular, several b-boys and b-girls have told me how they look at the quality and surface of the floor to decide on what moves they will throw down, as a

slightly tacky surface may prevent effective spinning, but might work well for holding certain freezes.

31. Within the b-girl community, the idea of being awarded "easy props" (respect or credit) for simply being a woman in a male-dominated dance is frowned upon. B-girls want to be held to the same standards as males in the scene.

32. One white b-boy, who is extremely well-known and highly respected in the breaking scene, explained how he was questioned in his younger years regarding his capacity to dance a Black style, which plays into essentialist ideas that white men can't dance; and another white b-boy reflected on how important it is for him to research the history and values of the dance so that he can be a good advocate for a dance born out of systemic oppression, but not exploit his privilege.

33. In her study of Kathak, Pallabi Chakravorty (2008) notes that unlike the objectifying Western gaze, which assumes a distance between the observer and observed, in Kathak dance, seeing embraces gazing, knowing, *and* touching, such that it creates an awakening of *rasa* (emotion) within the spectator.

34. Linguist Bernadette Wegenstein (2012) shows how physiognomy supported the racist agendas of nineteenth-century eugenics and justification for the genocide issued through the Third Reich.

35. OG stands for "original gangsta" and, along with the term "old head," is used to describe either pioneers or long-standing members of the hip hop scene.

36. As a reminder of #Black Lives Matter call to say her name, the memory of Sandra Bland and Breonna Taylor continue to inform the treatment of Black women in US public life.

37. The motivation for this debate was in concert with the surge of social protests in Summer 2020 against the killing of George Floyd by a uniformed police officer. The panel discussion is archived on YouTube: https://www.youtube.com/watch?v=gzrTy1FTycI (accessed July 25, 2023).

38. Although the majority of scholarship that I draw upon below is by women of color, I reference three white authors (one male and two female) all of whom are experienced breakers and have offered important scholarly contributions on the place of b-girls in breaking history and culture.

39. For an interesting feminist intervention into the rationale for using the term "b-boying" to describe breaking, see b-girl Jilou's interview with b-boy Dyzee from December 2019 (https://www.youtube.com/watch?v=nFWNQlkhavo, accessed July 25, 2023) and her further reflections on this through a personal blogpost on "why hip hop is highly political" (Just Jilou, January 4, 2020, https://justjilou.wordpress.com/2020/01/04/culture-and-politics-why-hip-hop-is-highly-political/).

40. In my interviews with them, both Mad Hatter and Sunny mentioned an assumption that Asian American hip hop dancers learn their craft within university or college student organizations, which is perceived as a position of privilege and a lack of authentic engagement with the dance.

41. In the wake of the #MeToo movement, there have been numerous discussions of sexual violence against women across all of the hip hop styles. In a blog post by b-girl Jilou, she writes eloquently about sexual harassment in the breaking scene: see Just

Jilou, May 17, 2020, https://justjilou.wordpress.com/2020/05/17/raising-awareness-sexual-harassment/.
42. Thank you to Carrie Noland for encouraging me to think about a feminist response to the male gaze.
43. I use the term "willfully" to invoke the idea of a "political will" employed by Nadine George-Graves (2017) to discuss the quiet assertiveness of virtuoso tap dancer Jeni LeGon as she encountered the racist structures of Hollywood film-making.
44. Here I am thinking of b-boys at various levels of expertise. At elite competition, a belief exists that women will never have the same level of power moves as men. Yet if breaking is viewed across multiple performance contexts, which include the kinds of regional events that I regularly attend, then Sunny's skills are beyond what many of the male competitors are able to achieve. This is evident as she frequently wins against b-boys in mixed-sex battles.
45. My point here is that while I am sure Macca perspires through the intense physicality of the dance, I recall her telling me that the face should never reveal exhaustion, and even in the most high-stakes battles she carries a cool edge as if she is simply here to dance.

Chapter 4

1. Roberts (2021, xiii) is describing an interview with James Baldwin by anthropologist Margaret Mead in which Baldwin's "furrowed brow" both articulates his dissatisfaction and reveals a collective consciousness as Mead doubts that the enslavement of Black bodies produced a historical trauma felt in the body of all Black people.
2. I would like to thank one of the anonymous readers for this book who helped me to develop this point.
3. MTV came on air in 1981 and Mercer (1986) describes how it initially neglected to feature music by Black artists. The music videos from *Thriller* "were the first to penetrate this racial boundary" (Mercer 1986, 29).
4. Notably, Jackson's career ran parallel with the development of hip hop and rap music from the early 1970s onward, and Jackson has sometimes incorporated elements of hip hop into his work. The street sensibilities of hip hop may have influenced his increasingly tough, streetwise persona, although I am cautious that the link between hip hop and "the street" is overly reductive.
5. "I Just Can't Stop Loving You" (1987) was the first single to be released but it had no accompanying music video.
6. I am cautious of employing the term "gang" as it indexes the African American male body to the stereotype of Black criminality, although the street location, the urban dress, and the tough facial attitudes (reminiscent of the *Beat It* video) certainly encourage the spectator to read the group as a closely affiliated collective.
7. As queer of color scholars have indicated, this compulsory African American male heterosexuality allows no space for a Black, queer intervention (Ferguson 2003; Johnson 2003).

8. The Signifying Monkey is a manifestation of Esu-Elegbara, the divine trickster from Yoruba mythology, who emerges in the vernacular traditions of African peoples who survived the violent deracination of the Middle Passage voyage to America.
9. Gates (1988) employs a capital S to demarcate this strategic intervention of Black Signification.
10. Gates (1988) strategically puns with the spelling of "Signifyin(g)" to demonstrate how the "g" in Black vernacular marks difference between Black spoken traditions and formal written language.
11. I would add that krumping also deploys a highly animated face that uses frowning, biting, and vomiting actions.
12. Kool Herc started to use two turntables to lengthen the instrumental break and give dancers more opportunity to participate during these percussive interludes (Pabon 2012). For a detailed historicization of the term "breaking," and contention over the name b-boy or b-girl, see Schloss (2009).
13. See the breaking documentary, *The Freshest Kids: A History of the B-boy* (2002), in support of this idea.
14. As well as a gestural insult, a burn can also showcase a move that humiliates or outshines an opponent through skill and virtuosity.
15. Author's interview with Medusa (Michelle Lerner) on September 12, 2019. I provide the interview date with the first quotation only, unless I have interviewed a dancer more than once, in which case I provide the date of the specific interview.
16. Author's interview with Hannibal (Brian Newby) on November 27, 2012.
17. In this instance, I preserve the anonymity of both dancers as they are presented in a less favorable light.
18. "Cocking" or "throwing cock" is a burn move in breaking that uses a phallic gesture directed at an opponent.
19. Author's interview with Izegbu (Alex Izegbu) on September 6, 2019.
20. Author's interview with Dr. Moose (David Heller) on March 17, 2015.
21. Author's interview with Macca (Macca Malik) on December 18, 2012.
22. Author's interview with Steve Believe (Steven Lunger) on April 9, 2013.
23. Author's interview with Viazeen (Raphael Viazeen) on December 11, 2012.
24. Author's interview with Ken Swift (Kenneth Gabbert) on June 18, 2018.
25. See Aprahamian (2019) for examples of popular media and academic texts reproducing the narrative that breaking was birthed out of gang culture.
26. Author's interview with Metal (Mark Wong) on November 17, 2014.
27. Author's interview with Supa Josh (Joshua Culbreath) on August 14, 2013.
28. Author's interview with Rukkus (Jay Jao) on May 2, 2013.
29. Author's interview with Valme (Jerry Valme) on October 11, 2019.
30. See the Loony Tunes wiki at https://looneytunes.fandom.com/wiki/Rocky_and_Mugsy (accessed July 25, 2023).
31. Author's interview with MachPhive (Christian MachPhive Walker) on May 14, 2019.
32. Author's interview with Renaissance Ray (Raymond Trinh) on December 19, 2019.
33. Author's interview with Ynot (Tony Denaro) on March 22, 2018.
34. Author's interview with Sunny (Sunny Choi) on May 27, 2018.

Chapter 5

1. Although Sia Kate Isobelle Furler is the legal name of the artist I discuss in this chapter, I refer to her professional name "Sia" throughout. See the official video and viewer comments for "Big Girls Cry" at https://www.youtube.com/watch?v=4NhKWZpkw1Q&lc=UgzrYz2N0jEa7EeA6bp4AaABAg (accessed July 25, 2023).
2. The video for "Big Girls" cry was released on Sia's Vevo channel on YouTube.
3. Their artistic collaborations have continued with further music videos, live performances, television appearances and a feature film.
4. See Neu (1987) for a further discussion of Darwin's evolutionary analysis of crying and Neu's critique of the idea that psychological states alone produce physiological reactions.
5. For example, at Montenegrin funerals, men rather than women are expected to cry (Lutz 1999).
6. See https://www.grammy.com/artists/sia/15372 (accessed August 24, 2023).
7. For example, she wrote the following songs: "Diamonds" (2012) by Rihanna, "Double Rainbow" (2013) by Katy Perry, and "Pretty Hurts" (2014) by Beyoncé (Younger 2016).
8. See "My Anti-Fame Manifesto," Billboard, October 25, 2013, https://www.billboard.com/articles/5770456/my-anti-fame-manifesto-by-sia-furler.
9. The idea that stars can be read intertextually was developed by film scholar Richard Dyer in his book *Heavenly Bodies: Film Stars and Society* (1986).
10. In York's book, *Reluctant Celebrity: Affect and Privilege in Contemporary Stardom* (2018), she analyzes the white male film actors John Cusack, Robert De Niro, and Daniel Craig.
11. In terms of her social media, she has secured over one million likes and follows on Facebook, 11.7 million followers on Instagram, 1.37 million followers on Twitter, and 2.6 million subscriptions on her YouTube channel. For her official website see https://maddie-ziegler.com/ (accessed August 24, 2023).
12. My concerns over Maddie Ziegler as a child celebrity also apply to Michael Jackson as a child celebrity, and, as I will come to in the SCREAM chapter, the young children who in turn worked with Jackson as an adult artist.
13. See O'Connor's (2017) history of the child celebrity through talented child musicians and composers, such as Wolfgang Amadeus Mozart and Ludwig van Beethoven, who came into prominence in the eighteenth and nineteenth centuries. The economic potential of child stars was further realized in the late nineteenth century with British theater and US traveling carnivals, which by the 1920s, were considered exploitative and reformists petitioned against this kind of child labor. The 1920s also saw the introduction of the child star in Hollywood (O'Connor 2017).
14. Ziegler left *Dance Moms* in 2016 and seems to have intentionally distanced herself from the show, which has been linked to a series of scandals including Abby Lee Miller's conviction of bankruptcy fraud.
15. The music video for "Chandelier" was nominated for awards at Camerimage and the Grammy Awards and won the Gay and Lesbian Entertainment Critics Association

award for Music Video of the Year and the category for Best Choreography at the MTV Music Video Awards (IMDB, https://www.imdb.com/title/tt4235706/awards, accessed July 25, 2023). See the official video at https://www.youtube.com/watch?v=2vjPBrBU-TM (accessed July 25, 2023).

16. Among other commissions, Heffington has choreographed a Kenzo perfume advertisement, music videos for Florence + The Machine, Arcade Fire and FKA Twigs, and the feature film *Baby Driver* (2017). See Ryan Heffington, http://cargocollective.com/heffington (accessed July 25, 2023).

17. See the official video at https://www.youtube.com/watch?reload=9&v=KWZGAExj-es (accessed July 25, 2023).

18. See Sullivan (2018).

19. See Kory Grow, "Sia Apologizes for Controversial 'Elastic Heart' Video with Shia LaBeouf," Rolling Stone, January 8, 2015, https://www.rollingstone.com/music/music-news/sia-apologizes-for-controversial-elastic-heart-video-with-shia-labeouf-62021/.

20. Notably, this is not the first video by Sia in which the face has dominated to this extent. The music video for "Buttons" (2007) focuses entirely on Sia's face, which she describes as a "poppy fun vibe" with "disturbing facial manipulation" (Cragg 2014).

21. "Cry Me a River" (1955) by Julie London and (2002) by Justin Timberlake; "Crying" (1961) by Roy Orbison; "Judy's Turn to Cry" (1963) by Lesley Gore; "Boy's Don't Cry" (1979) by The Cure; and "Cry" (1985) by Godley and Creme.

22. A different song of the same title was also released by Fergie in 2007.

23. Here, I owe thanks to Dr. Lawrence Indik, Associate Professor of Voice and Opera at Temple University, for helping me to identify Sia's vocal style, and to the TransX research group, specifically musicologists Dr. Susan C. Cook, Dr. Rachel Cowgill, and Dr. Marta Robinson, who discussed with me the emotional trauma that seems to be held in Sia's throat as she sings.

24. For more on Carrie's "cry face" see Ester Bloom, "*Homeland*'s Best Carrie Cry-Faces," Vulture, October 2014, https://www.vulture.com/2014/10/homeland-best-carrie-mathison-cryfaces.html.

25. I think specifically of the murder of child beauty pageant queen JonBenét Ramsey (De Witt 1997), the systematic sexual abuse of young females in the US national gymnastics team by doctor Lawrence Nassar (Freeman 2018), and even the bullying behavior by dance teacher Abby Lee Miller toward Ziegler and her peers as depicted on *Dance Moms*.

26. Although it cannot be guaranteed, I assume the comments are by females as they are either posted under female names or names that are feminine in character.

27. Frosh (2009) notes the particularity of a television screen, in which the image of a face is of a similar size and set at a similar height to that of the viewer, compared to a film screen. He also observes how his arguments might change according to developments in screen devices, which range from small hand-held platforms such as smart phones through to large flat-screen television sets that occupy a vast space in the domestic setting. While I appreciate that Ziegler's face in "Big Girls Cry" might be observed on a range of devices, the type of intimate relations that Frosh (2009) discusses, and

which I explore here, can only take place through a spectator that seeks to watch in a sustained and concentrated manner.
28. Deictic refers to a word or expression, such as "this" or "that," which refers or points to something, and is only meaningful if the context in which it is being used is made explicit.
29. In *Cinema 1: The Movement Image* (1986), Deleuze suggests that a movement-image, which is the intermediate moment between shots, can be divided into three types: a perception-image, an action-image, and an affection-image, and the affection-image is a close-up of the face.
30. Braidotti (2015, 243) refers here to the "zero-degree of deviancy" described by Deleuze and Guattari.
31. Stras (2010) notes that this concept comes from Tara McPherson's 2003 book *Reconstructing Dixie: Race Gender and Nostalgia in the Imagined South* (Durham, NC: Duke University Press).
32. This is the only article I have discovered that directly questions the ethics of Sia's collaboration with Ziegler. The day after its publication, the same newspaper published a short article describing how Sia had responded to "concerns" over her partnership with Ziegler: "I do check in with Maddie weekly about whether she wants this, and assure her if she ever wants it to stop it stops" (McGowan 2017).
33. I recall the public breakdowns or personal traumas of former child stars such as Britney Spears, Lena Zavaroni, Demi Levato, Justin Bieber, Marie Osmond, and Lindsay Lohan.
34. Redmond (2007) uses the example of film star Kate Winslet, but child stars, such as Britney Spears shaving her head and Lena Zavaroni's anorexia nervosa, also show the limits of whiteness as an ideal construction.

Chapter 6

1. The first disc comprises a greatest hits compilation and the second disc features newly released material.
2. Tracks such as "In The Closet," "Heal the World," and "Black or White" address more mature or socially conscious themes than his previous work.
3. On this latest album, tracks such as "They Don't Care About Us," "Earth Song," and "Tabloid Junkie" address Jackson's ongoing interest in social and political themes.
4. "The video received constant airplay on MTV and received 11 VMA nominations that year, winning three. The video remains one of the most memorable in pop history, lauded both for its obvious trendsetting production values and its mastery of themes of power and defiance." See "The Most Stylish VMA-Nominated Videos," Rolling Stone, August 30, 2011, https://www.rollingstone.com/music/music-lists/the-most-stylish-vma-nominated-videos-11854/michael-jackson-thriller-1984-19542/.
5. In this and other descriptive passages of the video throughout the chapter, I use first names to distinguish Michael from his sister Janet.

6. See Stillwater (2014) for a detailed account of the Chandler case, which was resolved out of court through a substantial financial settlement, and the 2005 criminal trial in which Jackson was accused of sexually assaulting another young boy, which reached a not guilty verdict.
7. Jackson's hair caught fire during shooting due to a pyrotechnic mishap, and he suffered serious burns to his scalp (Taraborrelli 2010).
8. I want to thank the anonymous external reader of my book proposal who generously offered the idea of "re-facing" celebrities through time.
9. For examples of the Wacko Jacko narrative in the news media, see Heard (1987), Madigan (1993), and Newsweek Staff (1993).
10. Given that survivors of sexual abuse have often been doubted, I take the position of Robson and Safechuck seriously. Both have been subject to criticism and hate among some Jackson supporters, which I would not want to condone. Yet my aim is not to attempt to prove Jackson's innocence or discredit the documentary in the way that a few scholars have sought to do. See Vogel (2019) and Willa Stillwater and Lisha McDuff's blog discussion "Leaving Neverland: Why You Wanna Trip on Me?" at https://dancingwiththeelephant.wordpress.com/?s=neverland (accessed July 25, 2023).
11. Sturges (2019) uses the example of David Bowie, who continues to be a revered artist but who allegedly had sex with a minor. Although I appreciate that this does not compare to the extent of the Jackson allegations, it still signals a serious abuse of power by a male adult. The well documented relationship between Bill Wyman of The Rolling Stones and Mandy Smith when she was still a minor also comes to mind.
12. Jackson was well known for his identification with childhood and love of children (Nyong'o 2011).
13. I think specifically of the ways in which David Bowie and members of The Rolling Stones pushed against norms of masculinity through wearing long hair and make-up, and also had alleged associations with underage girls.
14. See Nyong'o's (2011) work on the queer presence of the child in Jackson's music videos.
15. For news media coverage of Jackson's unorthodox life, see Durkee (1987), Goldberg and Handelman (1987), and Milloy (1987).
16. Some initial changes had already been noted by Mercer (1986, 27–28) on the cover image of the *Thriller* album: "The glossy sheen of his complexion appears lighter in colour than before; the nose seems sharper, more aqualine, less rounded and 'African' and the lips seem tighter, less pronounced."
17. In spite of the perceived modifications, Stillwater (2014) claims that the structure and shape of Jackson's face changed little over the years, and that his main transformations were aided through make-up.
18. Stemming from his youth, Jackson reportedly felt self-conscious about his appearance as his brothers called him "big nose" as a child (Taraborrelli 2010) and he suffered from acne as an adolescent (Jackson 2009).
19. Scholars have claimed he aspired to look like Diana Ross, Elizabeth Taylor, and his sister Janet (Holland 2009; Manning 2013).

20. Carpenter (2014) attributes binary terror to Vivian Patraka's article "Binary Terror and Feminist Performance: Reading Both Ways" (1992).
21. Here, Vigo (2012) is in conversation with Margo Jefferson's (2012) study which examines Jackson as a freak.
22. Irrespective of the truth about Jackson in light of *Leaving Neverland*, I exercise caution here about supporting the links between male homosexuality and pedophilia, a deeply homophobic fallacy that also circulates in the popular press.
23. A rich area of queer scholarship exists on Michael Jackson, which variously attends to how he queers rock music (Fast 2012); how his voice engages in gender transgression (Royster 2012); how his sexuality pushes against a stereotypical hypersexuality of Black masculinity and his erotic self remains a place for reflection (Abdur-Rahman 2012); and the homophobic coverage of his 1992 child molestation accusations (Erni 1998).
24. For example, see MJ Vibe (https://www.mjvibe.com), MJJ Community (https://www.mjjcommunity.com/), The Michael Jackson World Network (https://www.mjworld.net/), Michael Jackson Fanclub (http://www.m-jackson.com/), The Michael Jackson Archives (http://themichaeljacksonarchives.com/the-jackson-5-fan-club-uk), and MJJSTREET Michael Jackson Ireland Fan Club (http://www.mjjstreet.com/), all accessed July 25, 2023.
25. For a range of fan discussions questioning the credibility of *Leaving Neverland* and the accusations against Jackson see "How Are Michael Jackson Fans Reacting to Documentary *Leaving Neverland: Michael Jackson and Me*?, https://www.quora.com/How-are-Michael-Jackson-fans-reacting-to-documentary-Leaving-Neverland-Michael-Jackson-and-Me and "What Are Your Thoughts About the Michael Jackson Documentary Leaving *Neverland: Michael Jackson and Me*?, both on Quora, https://www.quora.com/What-are-your-thoughts-about-the-Michael-Jackson-documentary-Leaving-Neverland-Michael-Jackson-and-Me (accessed July 25, 2023).
26. For further information on "Scream" see: https://en.wikipedia.org/wiki/Scream_(Michael_Jackson_and_Janet_Jackson_song) (accessed August 25, 2023).
27. King (1999) also suggests that Janet Jackson was frustrated by allegations in the media about her weight and reclusive lifestyle.
28. Tate is also critical of the "tabloid true-crime" style of the documentary and how it "depends on the film-makers selling several racially burdened oxymorons at once: white-male innocence, white-male fragility and white-male truth-telling" (2019, 6).
29. Moten calls upon Saidiya Hartman's *Scenes of Subjection* (1997) to recount this scene.
30. Notably, Stillwater (2014) draws comparison between Warhol and Jackson in relation to the face: "Like Jackson, Warhol cultivated both an enigmatic public persona as well as an eccentric public appearance. Interestingly, Warhol suffered from auto-immune disorders that attacked the pigment of his skin. He also disliked the shape of his nose and reportedly had plastic surgery to make it smaller and thinner."
31. Steinskog (2015) offers en extensive discussion of afrofuturism in the *HIStory* album and points out that Jackson's political interests in this area are often overlooked.

32. The correct name for "moonwalking" is the backward slide, but it is fitting that Jackson performs a "moonwalk" while deep in outerspace.
33. The concept of "twice-behaved behavior" comes from performance studies scholar Richard Schechner (2002).
34. Whiteley (2005) also argues that Jackson's teen look of dark skin and an afro hairdo carried too much association with Black Pride and the Black Power Movement.
35. Moten (2003, 7) exemplifies this idea through reference to Edouard Glissant's writing on the Caribbean. Glissant explains that speech was forbidden among enslaved people, therefore they masked their words within a scream: while slave owners misread this to be like the sound of a wild animal, speech was hidden within this "extreme noise."
36. I would like to thank Mora-Amina Parker for suggesting this reading of the shattering glass to me.
37. Jackson died in 2009 from a drug overdose that was ruled a homicide (Grad 2019).

Chapter 7

1. As with the smile, the same dual typology has been applied to the laugh: the Duchenne laugh is an involuntary response to external stimuli, and the non–Duchenne laugh is strategic and managed for social effect (Weitz 2016). See the SMILE chapter for this discussion.
2. This was evident from extremely positive comments toward the organizers and competitors from online spectators in the digital chat section throughout the entire competition.
3. Competitors were required to submit a prerecorded preliminary round in advance and, from this, the top 64 were selected.
4. Nikopoulos (2017) insists that positivity forms a benchmark for laughter because early in a child's life smiling and laughter are encouraged to ensure attachment to a care giver. From this, Nikopoulos builds his argument that laughter communicates ideas and the form of the communication (i.e. laughing) demonstrates little variation. He goes on to state that although the content of laughter can be highly variable, in that it might express mean-spirited intentions, we assess the degree of variation due to its baseline association with positivity.
5. Notably, in the live comments, one spectator named LaKatrina1212 added "Fun fact Macca actually helped get Bgirl Bunny the information to battle and get support through Hall Of Femme in Central America," which further supports the idea that her laugh is largely in jest.
6. Although Aristotle describes the unique phenomenon of *homo ridens* ("laughing man") (Boryslawski, Jajszczok, and Wolff 2016), other species are believed to emit laughter (Kerner and Knapp 2016).
7. From the ancient philosophy of Plato and Aristotle (Weitz 2016; Wickberg 2015) through the nineteenth- and twentieth-century scholars, such as Charles Darwin, Henri Bergson and Sigmund Freud (Bouissac 2015; Weitz 2016), the

phenomenon of laughter can not be contained within a universal theory. For a detailed historicization of how laughter has been conceived as a social concept, see Wickberg (2015).

8. The *Saturday Night Live* version features *SNL* regular Kate MacKinnon and special guest star Jim Carrey performing to *Chandelier* in a skit of a competitive office party and, while they comedically mimic Ziegler's crazed face, they do not stay faithful to the original choreography (https://www.youtube.com/watch?v=LGYBFu4RHcE, accessed July 25, 2023); the performance on *Late Night with Seth Meyers* is by actor and comedian Lena Dunham, and although she employs some components of the original video, she uses her own choreographic ideas and her approximation of Ziegler's wild-eyed look is somewhat diluted as she lip syncs to the music (https://www.youtube.com/watch?v=UOX8f_-cw10, accessed July 25, 2023). I will come to the *Jimmy Kimmel Live!* version as part of my case study analysis.

9. Indeed music videos have been parodied since the 1980s when they largely developed as a media form (Spirou 2017).

10. See https://www.youtube.com/watch?v=LGYBFu4RHcE (accessed July 25, 2023).

11. I come to this later in the section, but note here how Rodriguez's facial expression relies upon ableist values that suppose a slack, open-mouthed jaw signifies a physical or intellectual disability.

12. Jenkins, Ito, and boyd (2016) point out that being active on digital media sites alone does not constitute a "participatory culture" but rather it describes engaging in a shared culture or practice on- or off-line.

13. In line with Jenkins, Ito and boyd's concept of a "participatory culture," Bench's characterization of social dance-media is not simply adding to the text, such as posting a comment to a clip, but rather it involves some degree of collaboration, which changes the content, such as reperforming a performance.

14. This is evident from a split-screen video on YouTube, which places the original Chandelier next to the video of Bandolier whereby it is easy to see how closely the parody mimics the original: see https://www.youtube.com/watch?v=qeknSsE0dAI (accessed August 26, 2023).

15. The Teddie Films channel has about 134K followers and other music video mashups are of Taylor Swift and *Breaking Bad*, Psy's *Gangham Style* and the Olympics, and will.i.am and *Les Miserables* (see https://www.youtube.com/user/teddiefilms/featured, accessed July 25, 2023).

16. Their YouTube channel uses a *Star Wars* theme in their music video parodies of Kesha and Rebecca Black as well as a spoof documentary, *How Star Wars Characters Eat Their Food.*

17. See https://www.youtube.com/watch?v=ItjCvC2sQc4 (accessed July 25, 2023).

18. Frame alignment theory is rooted in Erving Goffman's idea of a frame as a way to make sense of the world through emphasizing some elements over others, and then developed to describe the "framing strategies social movements utilize to in order to tie organizational operations with individual interests, values and beliefs" (Boxman-Shabtai 2018, 3).

19. Author's interview with Jip the Ruler (Phil Cuttino) on January 30, 2019. I provide the interview date with the first quotation only, unless I have interviewed a dancer more than once, in which case I provide the date of the specific interview.
20. Author's interview with Glytch (Ricky Evans) on October 19, 2019.
21. Author's interview with Mad Hatter (Béa Martin) on June 2, 2018.
22. Author's interview with Funky Van-go (Vince Johnson) on October 24, 2019.
23. Waving is part of the vocabulary of popping in which ripples appear to move through the body and the limbs.
24. Author's interview with Professor Lock (Brice Johnson) on February 20, 2015.
25. Author's Interview with Queen Dinita (Dinita Clark) on April 5, 2013.
26. In an analysis of the Africanist presence in flamenco, Meira Goldberg (2014) identifies "dances of derision" in the form *bulerías*, which incorporates moments of satire, mockery, and a cool and subversive dissent. Thomas A. Green (2012) observes a similarity between the 52s (an African American vernacular martial art) and breaking as both deploy physical and verbal derision as identified by Robert Farris-Thompson.
27. In the FROWN chapter, I draw on Henry Louis Gates Jr (1988) and his concept of Signifyin(g) which is conceptualized through a trickster, in this case Esu-Elgebara. The trickster is a figure which appears in multiple forms across African culture and philosophy.
28. Author's interview with Ken Swift (Kenneth Gabbert) on June 18, 2018.
29. In addition to Ken Swift and Metal invoking the name of Frosty Freeze (RIP), in an interview with Jeff Chang (2005), Doze Green, an early generation b-boy from the Rock Steady Crew describe how he and Frosty Freeze were the jokers of the crew, goofing and clowning to humiliate their opponents.
30. Author's interview with Supa Josh (Joshua Culbreath) on August 14, 2013.
31. Author's interview with Rukkus (Jay Jao) on May 2, 2013.
32. Author's interview with MachPhive (Christian MachPhive Walker) on May 14, 2019.
33. Reichl and Stein (2005) develop this idea from the scholarship of Stanley Fish and Benedict Anderson. For them, although laughter is an intersubjective phenomenon, in line with Anderson's thinking of an "imagined community," the individual need not know the other group members, nor need their co-presence for laughter to occur.
34. Author interview with Native (Tyrell White) on June 21, 2021.
35. On his personal YouTube channel, Native has uploaded a number of videos that parody b-boy behavior.
36. Author's interview with Riot tha Virus (Andrew Ramsey) on September 8, 2019.

Chapter 8

1. This is one such document that elaborates on why and how dancers should wears masks: see "Dancing in a Mask," https://www.thedancedocs.com/episodes/dancing-in-a-mask (accessed July 10, 2023).

References

Aaronovitch, David. 2019. "We Can't Airbrush Over Every Sinful Artist." *The Times*, March 7, 2019.
Abdur-Rahman, Aliyyah I. 2012. *Against the Closet: Black Political Longing and the Erotics of Race*. Durham, NC: Duke University Press.
Adair, Christy. 1992. *Women and Dance: Sylphs and Sirens*. Basingstoke, UK: Macmillan.
Adams, Natalie, and Pamela Bettis. 2003. "Commanding the Room in Short Skirts: Cheering as the Embodiment of Ideal Girlhood." *Gender and Society* 17 (1): 73–91.
Ahmed, Sara. [2004] 2015. *The Cultural Politics of Emotion*. 2nd ed. New York: Routledge.
Ahmed, Sara. 2010. *The Promise of Happiness*. Durham, NC: Duke University Press.
Albrecht, Michael Mario. 2013. "Dead Man in the Mirror: The Performative Aspects of Michael Jackson's Posthumous Body." *Journal of Popular Culture* 46 (4): 705–724.
Allen, Robert. 1991. *Horrible Prettiness: Burlesque and American Culture*. Chapel Hill: University of North Carolina Press.
Aron, Hillel. 2018. "How Sia Saved herself." *Rolling Stone*, September 2018.
Ashby, LeRoy. 2006. *With Amusement for All: A History of American Popular Culture Since 1830*. Lexington: University Press of Kentucky.
Atkins, Cholly, and Jacqui Malone. 2001. *Class Act: The Jazz Life of Choreographer Cholly Atkins*. New York: Columbia University Press.
Aprahamian, Serouj. 2019. "Hip-Hop, Gangs, and the Criminalization of African American Culture: A Critical Appraisal of *Yes Yes Y'All*." *Journal of Black Studies* 50 (3): 298–315.
Aprahamian, Serouj. 2020. "'There Were Females That Danced Too': Uncovering the Role of Women in Breaking History." *Dance Research Journal* 52 (2): 41–58.
Auslander, Philip. 2006. "Musical Personae." *The Drama Review* 50 (1): 100–119.
Awkward, Michael. 1995. *Negotiating Difference: Race, Gender, and the Politics of Positionality*. Chicago: University of Chicago Press.
Banes, Sally. 1987. *Terpsichore in Sneakers*. Middletown, CT: Wesleyan University Press.
Banes, Sally. 1994. *Writing Dancing in the Age of Postmodernism*. Hanover, NH: Wesleyan University Press.
Barron, Lee. 2015. *Celebrity Cultures: An Introduction*. London: Sage.
Barthes, Roland. 1973. *Mythologies*. London: Paladin.
Barthes, Roland. 1978. *Image-Music-Text*. Translated by Stephen Heath. New York: Hill and Wang.
Batiste, Stephanie. 2014. "Affect-ive Moves: Space, Violence and the Body in *Rize*'s Krump Dancing." In *The Oxford Handbook of Dance and the Popular Screen*, edited by Melissa Blanco Borelli, 199–224. New York: Oxford University Press.
Battan, Carrie. 2016. "Hidden Wonders: Sia's Response to Stardom." *The New Yorker*, January 31, 2016.

Bean, Annemarie, James V. Hatch, and Brooks McNamara. 1996. "Editor's Preface." In *Inside the Minstrel Mask: Readings in Nineteenth-Century Blackface Minstrelsy*, edited by Annemarie Bean, James V. Hatch and Brooks McNamara, xi–xiv. Hanover, NH: Wesleyan University Press.

Belting, Hans. 2017. *Face and Mask: A Double History*. Princeton, NJ: Princeton University Press.

Bench, Harmony. 2010. "Screendance 2.0: Social Dance-Media." *Participations: Journal of Audience and Reception Studies* 7 (2): 183–214.

Bench, Harmony. 2013. "Single Ladies is Gay." In *Dance On Its Own Terms*, edited by Melanie Bales and Karen Eliot, 127–153. Oxford: Oxford University Press.

Berger, John. 1972. *Ways of Seeing*. London: Penguin.

Bergman, Elizabeth. 2019. "Behind the Scenes and Across Screens: Michael Jackson, His Dancing Chorus, and the Commercial Dance Industry." PhD diss., Temple University.

Berlant, Lauren. 2011. *Cruel Optimism*. Durham, NC: Duke University Press.

Besnier, Niko. 1990. "Language and Affect." *Annual Review of Anthropology* 19: 419–451.

Bharata-Muni. [1951] 1967. *The Natyasatra*. 2nd ed. Translated by Manomohan Ghosh. Calcutta: Granthalaya.

Bielski, Zosia. 2011. "The Grin's Hidden Agenda." *The Globe and Mail*. August 26, 2011.

Birdwhistell, Ray L. 1970. *Kinesics and Context: Essays on Body Motion Communication*. Philadelphia: University of Pennsylvania Press.

Blanco Borelli, Melissa, and madison moore. 2021. "TikTok, Friendship and Sipping Tea, or How to Endure a Pandemic." *International Journal of Screendance* 12 (2021). https://doi.org/10.18061/ijsd.v12i0.8238

Blassis, Carlo. 1888. *The Theory of Theatrical Dancing*. Translated by Stewart D. Headlam. London: Frederick Verinder.

Bleeker, Maaike. 2012. "(Un)Covering Artistic Thought Unfolding." *Dance Research Journal* 44 (2): 13–26.

Boffone, Trevor. 2021. *Renegades: Digital Dance Cultures from Dubsmash to TikTok*. New York: Oxford University Press.

Borysławski, Rafał, Justyna Jajszczok, and Jakub Wolff. 2016. *Histories of Laughter and Laughter in History*. Newcastle upon Tyne: Cambridge Scholars Publishing.

Bose, Mandakranta. 1970. *Classical Indian Dancing: A Glossary*. Calcutta: General Printers and Publishers.

Bouissac, Paul. 2015. *The Semiotics of Clowns and Clowning: Rituals of Transgression and the Theory of Laughter*. London: Bloomsbury.

Boxman-Shabtai, Lillian. 2018. "Reframing the Popular: A New Approach to Parody." *Poetics* 67 (April): 1–12.

Boxman-Shabtai, Lillian. 2019. "The Practice of Parodying: YouTube as a Field of Cultural Production." *Media, Culture & Society* 41 (1): 3–20.

Boyd, Brian. 2019. "Michael Jackson: The Boys, the King, the Shouting Match." *The Irish Times*, February 2, 2019.

Brackett, David. 1992. "James Brown's 'Superbad' and the Double-Voiced Utterance." *Popular Music* 11 (3): 309–324.

Bradley, Laura. 2015. "Watch Sia's Emotional 'Big Girls Cry' Video Featuring Dancer Maddie Ziegler." *Slate*, April 2, 2015. http://www.slate.com/culture/2018/07/how-to-make-threaded-spaghetti-hot-dogs.html.

Bragin, Naomi. 2014. "Shot and Captured: Turf Dance, YAK Films, and the Oakland, California, R.I.P. Project." *TDR: The Drama Review* 58 (2): 99–114.

Braidotti, Rosi. 2015. "Punk Women and Riot Grrls." *Performance Philosophy* 1 (1): 239–254.

Brannigan, Erin. 2011. *Dancefilm: Choreography and the Moving Image*. Oxford: Oxford University Press.

Brockell, Gillian. 2019. "Ronald Reagan and the 'Welfare Queen.'" *Washington Post*, May 21, 2019.

Brophy, John. 1946. *The Human Face*. New York: Prentice Hall.

Brown, Jayna. 2008. *Babylon Girls: Black Women Performers and the Shaping of the Modern*. Durham, NC: Duke University Press.

Burggraeve, Roger. 1999. "Violence and the Vulnerable Face of the Other: The Vision of Emmanual Levinas on Moral Evil and Our Responsibility." *Journal of Social Philosophy* 30 (1): 29–45.

Burt, Ramsay. 1995. *The Male Dancer: Bodies, Spectacle, Sexualities*. London: Routledge.

Buszek, Maria E. 2006. *Pin-Up Grrrls: Feminism, Sexuality, Popular Culture*. Durham, NC: Duke University Press.

Byun, Meeran, and Norman Badler. 2002. "FacEMOTE: Qualitative Parametric Modifiers for Facial Animations." Symposium on Computer Animation, San Antonio, TX: 65–71.

Cannon, Kristopher L. 2010. "Cutting Race Otherwise: Michael Jackson." *Spectator* 30 (2): 28–36.

Cardinal, Marita, K. 2013. "Deciphering Dance in Reality Television: The Good, the Questionable, and the Unconscionable." *Journal of Physical Education, Recreation & Dance* 84 (1): 7–10.

Carpenter, Faedra Chatard. 2014. *Coloring Whiteness: Acts of Critique in Black Performance*. Ann Arbor: University of Michigan Press.

Chakravorty, Pallabi. 2008. *Bells of Change: Kathak Dance, Women and Modernity in India*. Calcutta: Seagull Books.

Chang, Jeff. 2005. *Can't Stop Won't Stop: A History of the Hip Hop Generation*. New York: Picador

Chang, Jeff. 2012. "Zulus on a Time Bomb." In *That's the Joint: The Hip-Hop Studies Reader*, edited by Murray Forman and Mark A. Neal, 2nd ed., 23–39. New York: Routledge.

Chatterjee, Sandra, and Cynthia Ling Lee. 2012. "Solidarity–Rasa / Autobiography–Abhinaya: South Asian Tactics for Performing Queerness." *Studies in South Asian Film and Media* 4 (2): 131–142.

Cills, Hazel. 2014. "The Choreographer Behind 'Chandelier' Knows Just How to Move You." *Buzzfeed*. June 6, 2014. https://www.buzzfeed.com/hazelcills/the-choreographer-behind-chandelier-knows-just-how-to-move-y?utm_term=.li8O2Y02v#.uoM4MPzM6.

Clay, Andreana. 2011. "Working Day and Night: Black Masculinity and the King of Pop." *Journal of Popular Music Studies* 23 (1): 3–18.

Cliff, Aimee. 2015. "Maddie Ziegler stars in her final Sia video 'Big Girls Cry.'" *Dazed*, April 2, 2015. http://www.dazeddigital.com/music/article/24282/1/sia-video-big-girls-cry-maddie-ziegler.

Coates, Paul. 2012. *Screening the Face*. Basingstoke, UK: Palgrave Macmillan.

Cockrell, Dale. 2012. "Of Soundscapes and Blackface: From Fools to Foster." In *Burnt Cork: Traditions and Legacies of Blackface Minstrelsy*, edited by Stephen Johnson, 51–72. Amherst: University of Massachusetts Press.

Cole, Catherine M., and Tracy C. Davis. 2013. "Routes of Blackface." *TDR: The Drama Review* 57 (2): 7–12.

Cole, Jonathan. 1998. *About Face*. Cambridge, MA: MIT Press.

Colebrook, Claire. 2012. "Face Race." In *Deleuze and Race*, edited by Arun Saldanha and Jason M. Adams, 35–50. Edinburgh: Edinburgh University Press.

Cooper Albright, Ann. 1997. *Choreographing Difference: The Body and Identity in Contemporary Dance*. Hanover, NH: Wesleyan University Press.

Coorlawala, Uttura A. 2010. "It Matters for Whom You Dance: Audience Participation in Rasa Theory." In *Dance Matters: Performing India*, edited by Pallabi Chakravorty and Nilanjana Gupta, 177–139. New Delhi: Routledge.

Coscarelli, Joe. 2019. "Michael Jackson Fans are Tenacious." *New York Times*. March 4, 2019.

Cragg, Michael. 2014. "Sia on Taking Performance Art to the Masses." *Dazed Digital*, May 21, 2014. http://www.dazeddigital.com/music/article/19982/1/sia-on-taking-performance-art-to-the-masses.

Cragg, Michael. 2015. "How 'Scream' Became the Craziest Video of the 90s." *Dazed and Confused*. May 29, 2015. https://www.dazeddigital.com/music/article/24901/1/how-scream-became-the-craziest-video-of-the-90s.

Croft, Clare, ed. 2017. *Queer Dance: Makings and Meanings*. New York: Oxford University Press.

Cushman, Ellen. 2005. "Faces, Skins, and the Identity Politics of Rereading Race." *Rhetoric Review* 24 (4): 389–395.

Daly, Ann. 1987. "The Balanchine Woman: Of Hummingbirds and Channel Swimmers." *TDR: The Drama Review* 31 (1): 8–21.

Daly, Ann. 1988. "Movement Analysis: Piecing Together the Puzzle." *TDR: The Drama Review* 32 (4): 40–52.

Danielson, Anne. 2006. *Presence and Pleasure: The Funk Grooves of James Brown and Parliament*. Middletown, CT: Wesleyan University Press.

Darwin, Charles. [1872] 1998. *The Expression of the Emotions in Man and Animals*. 3rd ed. London: Harper Collins.

Das, Joanna D. 2017. *Katherine Dunham: Dance and the African Diaspora*. New York: Oxford University Press.

Das, Joanna D. 2019. "Choreographic Ghosts: Dance and the Revival of Shuffle Along." *Dance Research Journal* 51 (3): 84–96.

Davies, Victoria A. 2007. "Creative Endurance and the Face Machine: RoseAnne Spradlin's Survive Cycle." *TDR: The Drama Review* 51 (3): 156–166.

Davis, Therese. 2004. *The Face on the Screen: Death, Recognition & Spectatorship*. Bristol, UK: Intellect.

De Bertodano, Helena. 2015. "Billion Hit Baby." *Sunday Telegraph*, May 10, 2015.

DeFrantz, Thomas. 2004. "The Black Beat Made Visible: Body Power in Hip Hop Dance." In *Of the Presence of the Body: Essays on Dance and Performance Theory*, edited by Andre Lepecki, 64–81. Middletown, CT: Wesleyan University Press.

DeFrantz, Thomas. 2006. *Dancing Revelations: Alvin Ailey's Embodiment of African American Culture*. Oxford: Oxford University Press.

DeFrantz, Thomas. 2014. "Hip-Hop Habitus v.2.0." In *Black Performance Theory*, edited by Thomas De Frantz and Anita Gonzalez, 223–242. Durham, NC: Duke University Press.

De Laet, Timmy. 2017. "Giving Sense to the Past: Historical D(ist)ance and the Chiasmatic Interlacing of Affect and Knowledge." In *The Oxford Handbook of Dance and Reenactment*, edited by Mark Franko, 33–56. New York: Oxford University Press.

Deleuze, Gilles. 1986. *Cinema 1: The Movement Image*. Translated by Hugh Tomlinson and Barbara Habberjam. Minneapolis: University of Minnesota Press.

Deleuze, Gilles, and Guattari, Félix. 1987. *A Thousand Plateaus: Capitalism and Schizophrenia*. Translated by Brian Massumi. Minneapolis: University of Minnesota Press.

Dentith, Simon. 2000. *Parody*. London: Routledge.

Dery, Mark. 1994. "Black to the Future: Interviews with Samuel R. Delaney, Greg Tate, and Tricia Rose." In *Flame Wars: The Discourse of Cyber Culture*, edited by Mark Dery, 179–222. Durham, NC: Duke University Press.

Desmond, Jane. 1997. "Embodying Difference: Issues of Dance in Cultural Studies." In *Meaning in Motion: New Cultural Studies of Dance*, edited by Jane Desmond, 29–54. Durham, NC: Duke University Press.

Devi, Ragini. [1972] 1990. *Dance Dialects of India*. Delhi: Motilal Banarsidass.

De Witt, Karen. 1997. "Never Too Young to be Perfect." *New York Times*, January 12, 1997.

Dixon Gottschild, Brenda. 2002. "Crossroads, Continuities, and Contradictions: The Afro-Euro-Caribeean triangle." In *Caribbean Dance from Abakuá to Zouk: How Movement Shapes Identity*, edited by Susanna Sloat, 3–10. Gainsville: University Press of Florida.

Dixon Gottschild, Brenda. 2003. *The Black Dancing Body: A Geography from Coon to Cool*. New York: Palgrave Macmillan.

Dixon Gottschild, Brenda. 2012. *Joan Myers Brown and the Audacious Hope of the Black Ballerina: A Biohistory of American Performance*. New York: Palgrave Macmillan.

Dodds, Sherril. 2011. *Dancing on the Canon: Embodiments of Value in Popular Dance*. Basingstoke, UK: Palgrave Macmillan.

Dodds, Sherril. 2014. "The Choreographic Interface: Dancing Facial Expression in Hip-Hop and Neo-Burlesque Striptease." *Dance Research Journal* 46 (2): 39–56.

Dodds, Sherril. 2016. "Hip Hop Battles and Facial Intertexts." *Dance Research* 34 (1): 63–83.

Dodds, Sherril. 2019a. "Introduction." In *The Bloomsbury Companion to Dance Studies*, edited by Sherril Dodds, 1–33. London: Bloomsbury.

Dodds, Sherril. 2019b. "Loss of Face: Intimidation, Derision and Failure in the Hip-Hop Battle." In *The Oxford Handbook of Dance and Competition*, edited by Sherril Dodds, 473–494. New York: Oxford University Press.

Dodds, Sherril. 2020. "Crashing Creatively: Trial and Error in the Hip-Hop Battle." In *Error, Ambiguity, Gravity: Multidisciplinary Perspectives*, edited by Sita Popat and Sarah Whatley, 211–233. Basingstoke, UK: Palgrave Macmillan.

Dodds, Sherril, and Colleen Hooper. 2014. "Faces, Close-ups and Choreography: A Deleuzian Critique of *So You Think You Can Dance*." *The International Journal of Screendance* 4 (2014). https://doi.org/10.18061/ijsd.v4i0

Domenici, Kathy, and Stephen W. Littlejohn. 2006. *Facework: Bridging Theory and Practice*. Thousand Oaks, CA: Sage.

Dowd, Maureen. 2019. "King of Pop, and Perversion." *New York Times*, February 17, 2019.

Drewal, Henry John, and Margaret Thompson Drewal. 1983. *Gelede: Art and Female Power Among the Yoruba*. Bloomington: Indiana University Press.

Driscoll, Margarette. 2019. "The Parent Trap: How Paedophiles Groom the Grown-ups." *The Daily Telegraph*, March 7, 2019.

Durham, Aisha. 2007. "Using [Living Hip-Hop] Feminism: redefining an Answer (to) Rap." In *Home Girls Make Some Noise: Hip Hop Feminism Anthology*, edited by Gwendolyn D. Pough, Elaine Richardson, Aisha Durham, and Rachel Raimist, 304–312. Mira Loma, CA: Parker.

Durkee, Cutler. 1987. "Unlike Anyone, Even Himself." *People*, September 14, 1987. https://people.com/archive/cover-story-unlike-anyone-even-himself-vol-28-no-11/.

Dyer, Richard. 1986. *Heavenly Bodies: Film Stars and Society.* New York: St Martin's Press.
Dyson, Michael, E. 2004. *The Michael Eric Dyson Reader.* New York: Basic Civitas.
Ehrenreich, Barbara. 2009. *Smile or Die: How Positive Thinking Fooled America and the World.* London: Granta.
Ekman, Paul. [1972] 2013. *Emotion in the Human Face.* Los Altos, CA: Malor Books.
Ekman, Paul. 1980. *The Face of Man: Expressions of Universal Emotions in a New Guinea Village.* Shrewsbury, MA: Garland.
Ekman, Paul. 1998a. "Afterword: Universality of Emotional Expression? A Personal History of the Dispute." In *The Expression of the Emotions in Man and Animals*, 3rd ed. by Charles Darwin, 363–393. London: Harper Collins.
Ekman, Paul. 1998b. "Introduction to the Third Edition." In *The Expression of the Emotions in Man and Animals*. 3rd ed. by Charles Darwin, xxiii–xxxv. London: Harper Collins.
Ekman, Paul, ed. 2006. *Darwin and Facial Expression: A Century of Research in Review.* Los Altos, CA: Malor Books.
Ekman, Paul, and Erika Rosenberg, eds. 1997. *What the Face Reveals: Basic and Applied Studies of Spontaneous Expression Using the Facial Action Coding System (FACS).* New York: Oxford University Press.
Ekman, Paul, and Richard Schechner. 1988. "What Interests Me About Performance." *TDR: The Drama Review* 32 (4): 80–81.
Ekman, Paul, and Wallace Friesen. [1975] 2003. *Unmasking the Face: A Guide to Recognizing Emotions from Facial Clues.* Los Altos, CA: Malor Books.
Ekman, Paul, Wallace Friesen, and Phoebe Ellsworth. 1972. *Emotion in the Human Face: Guildelines for Research and an Integration of Findings.* New York: Pergamon.
Ellis, Nadia. 2020. "Trace a Vanishing, or Queer Performance Study." In *The Cambridge Companion to Queer Studies*, edited by Siobhan Somerville, 156–171. Cambridge: Cambridge University Press
Elswit, Kate. 2014. *Watching Weimar Dance.* New York: Oxford University Press.
Erni, John Nguyet. 1998. "Queer Figurations in the Media: Critical Reflections on the Michael Jackson Sex Scandal." *Critical Studies in Mass Communication* 15 (2): 158–180.
Everett, Anna. 2001. *Returning the Gaze: A Genealogy of Black Film Criticism, 1909–1949.* Durham, NC: Duke University Press.
Fabius, Jeroen. 2015. "All of the Person: Kinaesthetic Explorations of the Dancer's Gaze." In *Danswetenschap in Nederland*, 8 edited by Hanneke Koolen, Jochem Naafs, Ruth Naber, and Liesbeth Wildschut, 69–79. Amsterdam: Vereniging voor Dansonderzoek.
Fanon, Frantz. [1952] 2008. *Black Skin, White Masks.* Translated by Richard Philcox. New York: Grove Press.
Farnell, Brenda. 1999. "Moving Bodies, Acting Selves." *Annual Review of Anthropology* 28: 341–373.
Farris Thompson, Robert. 2011. *Aesthetic of the Cool: Afro-Atlantic Art and Music.* New York: Periscope.
Fast, Susan. 2010. "Difference that Exceeded Understanding: Remembering Michael Jackson (1958–2009)." *Popular Music and Society* 33 (2): 259–266.
Fast, Susan. 2012. "Michael Jackson's Queer Musical Belongings." *Popular Music and Society* 25 (2): 281–300.
Fast, Susan. 2014. *Dangerous: 33 1/3.* New York: Bloomsbury.
Feder, Abigail. 1994. "'A Radiant Smile for the Lovely Lady': Overdetermined Femininity in 'Ladies' Figure Skating." *TDR: The Drama Review* 38 (1): 62–78.
Feldman-Barrett, Lisa. 2014. "What Faces Can't Tell Us." *New York Times*, March 2, 2014.

Fensham, Rachel. 2013. "'Breakin' the Rules': Eleo Pomare and the Transcultural Choreographies of Black Modernity." *Dance Research Journal* 45 (1): 40–63.
Ferguson, Roderick. 2003. *Aberrations in Black: Toward a Queer of Color Critique*. Minneapolis: University of Minnesota Press.
Fisher, Mark. 2009. *The Resistible Demise of Michael Jackson*. Winchester, UK: Zero Books.
Fleetwood, Nicole R. 2011. *Troubling Vision: Performance, Visuality, and Blackness*. Chicago: University of Chicago Press.
Flom, Ross, Kang Lee, and Darwin Muir, eds. 2007. *Gaze-Following: Its Development and Significance*. Mahwah, NJ: Lawrence Erlbaum.
Fogarty, Mary. 2019. "Why Are Breaking Battles Judges? The Rise of International Competitions." In *The Oxford Handbook of Dance and Competition*, edited by Sherril Dodds, 409–428. Oxford: Oxford University Press.
Fogarty, Mary, Erica Cleto, Jessie Zsolt, and Jacqueline Melindy. 2018. "Strength in Numbers: B-girls, Gender Identities and Hip-Hop Education." *Journal of Popular Music Education* 2 (1 & 2): 115–132.
Foley, Brenda. 2005. *Undressed for Success: Beauty Contestants and Exotic Dancers as Merchants of Morality*. Basingstoke, UK: Palgrave Macmillan.
Foster, Susan L. 1986. *Reading Dancing: Bodies and Subjects in Contemporary American Dance*. Berkeley: University of California Press.
Foster, Susan L. 2005. "Choreographing Empathy." *Topoi* 24 (1): 81–91.
Foster, Susan L. 2011. *Choreographing Empathy: Kinesthesia in Performance*. London: Routledge.
Foucault, Michel. [1975] 1991. *Discipline and Punish: The Birth of the Prison*. London: Penguin.
Franko, Mark. 2000. "Figural Inversions of Louis XIV's Dancing Body." In *Acting on the Past: Historical Performance Across the Disciplines*, edited by Mark Franko and Annette Richards, 35–51. Hanover, NH: Wesleyan University Press.
Franko, Mark. 2002. *The Work of Dance: Labor, Movement and Identity in the 1930s*. Middletown, CT: Wesleyan University Press.
Franko, Mark. 2014. "Dance Studies." In *Encyclopedia of Aesthetics*, 2nd ed., edited by Michael Kelly. Oxford: Oxford University Press.
Freeman, Hadley. 2018. "How was Larry Nassar Able to Abuse so Many Gymnasts for so Long?" *The Guardian*, January 26, 2018. https://www.theguardian.com/sport/2018/jan/26/larry-nassar-abuse-gymnasts-scandal-culture.
Friedan, Betty. 1963. *The Feminine Mystique*. New York: Norton.
Frosh, Paul. 2009. "The Face of Television." *Annals of the American Academy of Political and Social Science* 625: 87–102.
Fuchs, Cynthia. 1995. "Michael Jackson's Penis." In *Cruising the Performative: Interventions into the Representation of Ethnicity, Nationality, and Sexuality*, edited by Sue-Ellen Case, Philip Brett, and Susan Leigh Foster, 13–33. Bloomington: Indiana University Press.
Gallagher, Brianne. 2012. "Between Facialisation and the War Machine: Assembling the Soldier-Body." In *Deleuze and Race*, edited by Arun Saldanha and Jason M. Adams, 144–167. Edinburgh: Edinburgh University Press.
Gates Jr., Henry Louis. 1988. *The Signifying Monkey: A Theory of African American Literary Criticism*. Oxford: Oxford University Press.
George-Graves, Nadine. 2017. "Identity Politics and Political Will: Jeni LeGon Living in a Great Big Way." In *The Oxford Handbook of Dance and Politics*, edited by Rebekah Kowal, Gerald Siegmund, and Randy Martin, 511–534. New York: Oxford University Press.

Giersdorf, Jens Richard. 2009. "Dance Studies in the International Academy: Genealogy of a Disciplinary Formation." *Dance Research Journal* 41 (1): 23–44.

Gladstone, Rick, and Satoshi Sugiyama. 2018. "Trump's Travel Ban: How It Works and Who Is Affected." *New York Times*, July 2, 2018.

Glass, Barbara. 2007. *African American Dance*. Jefferson, NC: McFarland.

Goffman, Erving. 1959. *The Presentation of Self in Everyday Life*. New York: Anchor Books.

Goldberg, K. Meira. 2014. "Sonidos Negros: On the Blackness of Flamenco." *Dance Chronicle* 37 (1): 85–113.

Goldberg, Michael, and David Handelman. 1987. "Is Michael Jackson for Real." *Rolling Stone*, September 24, 1987.

Gosselin, Pierre, Gilles Kirouac, and François Doré. 1997. "Components and Recognition of Facial Expression in the Communication of Emotion by Actors." In *What the Face reveals: Basic and Applies Studies of Spontaneous Expression Using the Facial Action Coding System (FACS)*, edited by Paul Ekman and Erika Rosenberg, 243–269. New York: Oxford University Press.

Grad, Shelby. 2019. "Michael Jackson's Final Day." *LA Times*, June 25, 2019.

Gray, Herman. 1995. "Black Masculinity and Visual Culture." *Callaloo* 18 (2): 401–405.

Green, Thomas A. 2012. "Sick Hands and Sweet Moves: Aesthetic Dimensions of a Vernacular Martial Art." *Journal of American Folklore* 125 (497): 286–303.

Griffiths, Kadeen. 2015. "Sia's 'Big Girls Cry' Video Stars 'Dance Moms' Star Maddie Ziegler in her Most Intense and Terrifying Performance Yet." *Bustle*, April 2, 2015. https://www.bustle.com/articles/73698-sias-big-girls-cry-video-stars-dance-moms-star-maddie-ziegler-in-her-most-intense.

Guarino, Lindsay. 2014. "Jazz Dance Training via Private Studios, Competitions, and Conventions." In *Jazz Dance: A History of the Roots and Branches*, edited by Lindsey Guarino and Wendy Oliver, 197–206. Gainesville: University Press of Florida.

Guevara, Nancy. 1996. "Women Writin' Rappin' Breakin'." In *Droppin' Science: Critical Essays on Rap Music and Hip Hop Culture*, edited by William E. Perkins, 49–62. Philadelphia: Temple University Press.

Guillory, Monique. 1998. "Black Bodies Swingin': Race, Gender, and Jazz." In *Soul: Black Power, Politics, and Pleasure*, edited by Monique Guillory and Richard C. Green, 191–215. New York: New York University Press.

Gunn, Rachael. 2016. "The 'Systems of Relay' in *Doing* Cultural Studies: Experimenting with the 'Body Without Organs' in B-girling Practice." *Continuum: Journal of Media and Cultural Studies* 30 (2): 183–194.

Gupta-Carlson, Himanee. 2010. "Planet B-Girl: Community Building and Feminism in Hip-Hop." *New Political Science* 32 (4): 515–529.

Harlig, Alexandra, Crystal Abidin, Trevor Boffone, Kelly Bowker, Colette Eloi, Pamela Krayenbuhl, and Chuyun Oh. 2021. "TikTok and Short-Form Screendance Before and After Covid." *The International Journal of Screendance* 12 (2021). https://doi.org/10.18061/ijsd.v12i0.8348

Hamera, Judith. 2012. "The Labors of Michael Jackson: Virtuosity, Deindustrialization and Dancing Work." *PMLA* 127 (4): 751–765.

Hamera, Judith. 2017. *Unfinished Business: Michael Jackson, Detroit, and the Figural Economy of American Deindustrialization*. New York: Oxford University Press.

Hartman, Saidiya. 1997. *Scenes of Subjection*. New York: Oxford University Press.

Harvey, Chris. 2019. "'Jackson Was Raping Those Children Night After Night': Shocking Revelations of Alleged Child Abuse by Michael Jackson Air in Britain This Week." *The Daily Telegraph*, March 4, 2019.

Hazzard-Donald, Katrina. 1996. "Dance in Hip Hop Culture." In *Droppin' Science: Critical Essays on Rap Music and Hip Hop Culture*, edited by William E. Perkins, 220-235. Philadelphia: Temple University Press.

Heard, Alex. 1987. "Weird Michael and the Telltale Heart." *Washington Post*, October 4, 1987.

Hejmadi, Ahalya, Richard J. Davidson, and Paul Rozin. 2000. "Exploring Hindu Indian Emotion Expression: Evidence for Accurate Recognition by Americans and Indians." *Psychological Science* 11 (3): 183-187.

Heynen, Robert, and van der Muelen, Emily. 2016. "Gendered Visions: Reimagining Surveillance Studies." In *Gender and the politics of Surveillance*, edited by Emily van der Muelen and Robert Heynen, 3-32. Toronto: University of Toronto Press.

Holland, Charles. 2009. "A Design for Life: Making Michael Jackson." In *The Resistible Demise of Michael Jackson*, edited by Mark Fisher, 201-209. Winchester, UK: Zero Books.

Hood, Bruce, M., and C. Neil Macrae. 2007. "Look Into My Eyes: The Effect of Direct Gaze on Face Processing in Adults and Children." In *Gaze-Following: Its Development and Significance*, edited by Ross Flom, Kang Lee, and Darwin Muir, 283-296. Mahwah, NJ: Lawrence Erlbaum.

hooks, bell. 1995. "Performance Practice as a Site of Opposition." In *Let's Get It On: The Politics of Black Performance*, edited by Catherine Ugwu, 210-219. Seattle: Bay Press.

hooks, bell. 2015. *Black Looks: Race and Representation*. 2nd ed. New York: Routledge.

Hunt, Tamara, L. 2002. "Introduction." In *Women and the Colonial Gaze*, edited by Tamara L. Hunt and Micheline R. Lessard, 1-15. Basingstoke, UK: Palgrave.

Hunter, James. 1995. "HIStory: Past, Present and Future, Book 1." *Rolling Stone*, August 10, 1995.

Jackson, Gabrielle. 2016. "Please Sia, Don't Show Us Your Face." *The Guardian*, May 3, 2016. https://www.theguardian.com/commentisfree/2015/dec/02/please-sia-dont-show-us-your-face.

Jackson, Jonathan D. 2001-2002. "Improvisation in African-American Vernacular Dancing." *Dance Research Journal* 33 (2): 40-53.

Jackson, Michael. 2009. *Moonwalk*. New York: Harmony.

Jefferson, Margo. 2012. "Freaks (from *On Michael Jackson*)." In *Michael Jackson: Grasping the Spectacle*, edited by Christopher R. Smit, 11-21. Farnham UK: Ashgate.

Jenkins, Henry. 2006. *Convergence Culture: Where Old and New Media Collide*. New York: New York University Press.

Jenkins, Henry, Mizuko Ito, and danah boyd. 2016. *Participatory Culture in a Networked Era*. Cambridge: Polity.

Johnson, E. Patrick, 2003. *Appropriating Blackness: Performance and the Politics of Authenticity*. Durham, NC: Duke University Press.

Johnson, Imani Kai. 2011. "B-Boying and Battling in a Global Context: The Discursive Life of Difference in Hip Hop Dance." *Alif* 31: 1-23.

Johnson, Imani Kai. 2014. "From Blues Women to B-girls: Performing Badass Femininity." *Women and Performance: A Journal of Feminist Theory* 24 (1): 15-28.

Johnson, Imani Kai. 2015. "Hip-Hop Dance." In *The Cambridge Companion to Hip-Hop*, edited by Justin A. Williams, 22-31. Cambridge: Cambridge University Press.

Johnson, Imani Kai. 2018. "Battling in the Bronx: Social Choreography and Outlaw Culture Among Early Hip-Hop Streetdancers in New York City." *Dance Research Journal* 50 (2): 62-75.

Johnson, Stephen. 2012. "Introduction: The Persistence of Blackface and the Minstrel Tradition." In *Burnt Cork: Traditions and Legacies of Blackface Minstrelsy*, edited by Stephen Johnson, 1–17. Amherst: University of Massachusetts Press.

Jones, Douglas A. Jr. 2013. "Black Politics but Not Black People: Rethinking the Social and 'Racial' History of EarlyMinstrelsy." *TDR: The Drama Review* 57 (2): 21–37.

Kasson, John F. 2011. "Shirley Temple's Paradoxical Smile." *American Art* 25 (3): 16–19.

Keltner, Dacher. 2009. "Unlock the Secret of the Smile." *The Times*, January 31, 2009.

Kerner, Aaron Michael, and Jonathan L. Knapp. 2016. *Extreme Cinema: Affective Strategies in Transnational Media*. Edinburgh: Edinburgh University Press.

Kesner, Ladislav. 2007. "Face as Artifact in Early Chinese Art." *RES: Anthropology and Aesthetics* 51: 33–56.

King, Jason. 1999. "Form and Function: Superstardom and Aesthetics in the Music Videos of Michael and Janet Jackson." *The Velvet Light Trap* 44 (Fall): 80–96.

Kirstein, Lincoln. 1983. "Classical Ballet: Aria of the Aerial." In *What is Dance?*, edited by Roger Copeland and Marshall Cohen, 238–243. Oxford: Oxford University Press.

Klosterman, Chuck. 2019. "Too Big to Cancel." *The Guardian*, March 1, 2019.

Klucarova, Sona. 2021. "Do Masks Matter? Consumer Perceptions of Social Media Influencers Who Wear Face Masks Amid the COVID-19 Pandemic." *Applied Psychology* 1–15.

Knopper, Steve. 2014. "Sia Furler, the Socially Phobic Pop Star." *New York Times*, April 18, 2014.

Kourlas, Gia. 2016. "For Sia, Dance is Where the Human and Weird Intersect." *New York Times*, July 19, 2016.

Kraut, Anthea. 2015. *Choreographing Copyright: Race, Gender, and Intellectual Property Rights in American Dance*. New York: Oxford University Press.

LaFrance, Marianne. 2011. *Why Smile? The Science Behind Facial Expressions*. New York: Norton.

La Rocco, Claudia. 2010. "Tap-tap-tapping into a National Obsession." *New York Times*, September 2, 2010.

Lenihan, Jean. 2015. "Ryan Heffington on Choreographing Sia's 'Chandelier' and 'Elastic Heart' Videos." *KCET*, January 15, 2015. https://www.kcet.org/shows/artbound/ryan-heffington-on-choreographing-sias-chandelier-and-elastic-heart-videos.

Lepecki, André. 2007. "Machines, Dances, Neurons: Towards and Ethics of Dance." *The Drama Review* 51 (3): 119–123.

Levinas, Emmanuel. [1961] 1969. *Totality and Infinity: An Essay in Exteriority*. Translated by Alphonso Lingus. Pittsburgh, PA: Duquesne University Press.

Leys, Ruth. 2011. "The Turn to Affect: A Critique." *Critical Inquiry* 37 (3): 434–472.

Lhamon, W. T. Jr. 1998. *Raising Cain: Blackface Performance from Jim Crow to Hip Hop*. Cambridge, MA: Harvard University Press.

Liepe-Levinson, Katherine. 2002. *Strip-Show: Performances of Gender and Desire*. London: Routledge.

Lippit, Akira Mizuta. 2003. "In The Break: The Aesthetics of the Black Radical Tradition (Review)." *MLN* 118 (5): 1336–1340.

Liu, Chih-Chieh. 2013. "Superficial Profundity: Performative Translation of the Dancing Body in Contemporary Taiwanese Popular Culture." In *Bodies of Sound: Studies Across popular Music and Dance*, edited by Sherril Dodds and Susan C. Cook, 165–178. London: Routledge.

Loh, Maria H. 2009. "Renaissance Faciality." *Oxford Art Journal* 32 (3): 341–363.

Lott, Eric. 1995. *Love and Theft: Minstrelsy and the American Working Class.* New York: Oxford University Press.
Lupton, Deborah, Clare Southerton, Marianne Clark, and Ash Watson. 2021. *The Face Mask in COVID Times: A Sociomaterial Analysis.* Berlin/Boston: Walter de Gruyter
Lutz, Catherine. 1985. "Depression and the Translation of Emotional Worlds." In *Culture and Depression: Studies in Anthropology and Cross-Cultural Psychiatry of Affect and Disorder*, edited by Arthur Kleinman and Byron Good 62–100. Berkeley: University of California Press.
Lutz, Catherine. 1986. "Emotion, Thought and Estrangement: Emotion as a Cultural Category." *Cultural Anthropology* 1 (3): 287–309.
Lutz, Catherine. 1996. "Engendered Emotion: Gender, Power, and the Rhetoric of Emotional Control in American Discourse." In *The Emotions: Social, Cultural and Biological Dimensions*, edited by Rom Harré and W. Gerrod Parrott, 69–91. London: Sage.
Lutz, Catherine, and Geoffrey M. White. 1986. "The Anthropology of Emotions." *Annual Review of Anthropology* 15: 405–437.
Lutz, Thomas. 1999. *Crying.* New York: Norton.
MacKethan, Lucinda H. 2002. "Happy Darky." In *The Companion to Southern Literature: Themes, Genres, People, Places, Movements and Motifs*, edited by Joseph M. Flora and Lucinda H. MacKethan, 327–28. Baton Rouge: Louisiana State University Press.
Madigan, Charles. 1993. "Jackson Case: Sharks, Eccentricity and the Price of Fame." *Chicago Tribune*, August 31, 1993.
Magli, Patrizia. 1989. "The Face and the Soul." In *Fragments for a History of the Human Body: Part Two*, edited by Michel Feher, 86–127. New York: Zone.
Maher, William J. 1996. "Ethiopian Skits and Sketches: Contents and Contexts of Blackface Minstrelsy." In *Inside the Minstrel Mask: Readings in Nineteenth-Century Blackface Minstrelsy*, edited by Annemarie Bean, James V. Hatch, and Brooks McNamara, 179–220. Hanover NH: Wesleyan University Press.
Mair, Michael. 1975. "What Do Faces Mean?" *Royal Anthropological Institute News* 9: 1–6.
Malkin, Bonnie. 2017. "The Sia Conundrum." *The Guardian*, December 5, 2017. https://www.theguardian.com/music/2017/dec/06/the-sia-conundrum-if-fame-is-so-damaging-why-pass-it-on-to-a-child.
Malone, Jacqui. 1988. "'Let the Punishment Fit the Crime': The Vocal Choreography of Cholly Atkins." *Dance Research Journal* 20 (1): 11–18.
Manning, Harriet J. 2013. *Michael Jackson and the Blackface Mask.* Farnham, UK: Ashgate Publishing.
Manning, Susan. 1997. "The Female Dancer and the Male Gaze: Feminist Critiques of Early Modern Dance." In *Meaning in Motion: New Cultural Studies of Dance*, edited by Jane Desmond, 153–166. Durham, NC: Duke University Press.
Marks, Laura U. 2002. *Touch: Sensuous Theory and Multisensory Media.* Minneapolis: University of Minnesota Press.
McClary, Susan, and Robert Walser. 1994. "Theorizing the Body in African-American Music." *Black Music Research Journal* 14 (1): 75–84.
McGowan, Michael. 2017. "Sia: Ethics of Fame and Maddie Ziegler 'A Question I Have Asked Myself Often.'" *The Guardian*, December 7, 2017. https://www.theguardian.com/music/2017/dec/07/sia-ethics-of-fame-and-maddie-ziegler-a-question-i-have-asked-myself-often.

McMains, Juliet. 2018. "Rebellious Wallflowers and Queer *Tangueras*: The Rise of Female Leaders in Buenos Aires' Tango Scene." *Dance Research* 36 (2): 173–197.

McMains, Juliet. 2019. "Reclaiming Competitive Tango: The Rise of Argentina's Campeonata Mundial." In *The Oxford Handbook of Dance and Competition*, edited by Sherril Dodds, 305–330. New York: Oxford University Press.

McNeill, Daniel. 1998. *The Face*. Boston: Little Brown.

Menyes, Carolyn. 2014. "Sia 'Big Girls Cry' Lets it all Out Ahead of '1000 Forms of Fear' Release." *Music Times*, June 26, 2014. https://www.musictimes.com/articles/7073/20140626/review-sia-big-girls-cry-lets-out-ahead-1000-forms.htm.

Mercer, Kobena. 1986. "Monster Metaphors: Notes on Michael Jackson's *Thriller*." *Screen* 26 (1): 26–43.

Miller, Abby L. 2014. *Everything I Learned About Life, I learned in Dance Class*. New York: Harper Collins.

Milloy, Courtland. 1987. "Michael Jackson from 'Bad' to Worse." *Washington Post*, September 8, 1987.

Morgan, David. 2005. *The Sacred Gaze: Religious Visual Culture in Theory and Practice*. Berkeley: University of California Press.

Morris, Wesley. 2019. "The Long Shadow of Michael Jackson." *New York Times*, March 3, 2019.

Morrison, Margaret. 2014. "Tap and Teeth: Virtuosity and the Smile in the Films of Bill Robinson and Eleanor Powell." *Dance Research Journal* 46 (2): 21–37.

Moten, Fred. 2003. *In the Break: The Aesthetics of the Black Radical Tradition*. Minneapolis: University of Minnesota Press.

Mules, Warwick. 2010. "This Face: A Critique of Faciality as Mediated Self-Presence." *Transformations* 18. http://www.transformationsjournal.org/wp-content/uploads/2017/01/Mules_Trans18.pdf.

Mulvey, Laura. 1975. "Visual Pleasure and Narrative Cinema." *Screen* 16 (3): 6–18.

Myers, Fred R. 1988. "The Logic and Meaning of Anger Among Pintupi Aborigines." *Man* 23: 259–610.

Nelson, Lisa. 2001. "Before Your Eyes." https://tuningscoreslog.files.wordpress.com/2009/11/before-your-eyes.pdf (accessed July 10, 2023).

Nestor, Mark, Daniel Fischer, and David Arnold. 2020. "'Masking' our Emotions: Botulinum Toxin, Facial Expression and Well-being in the Age of COVID-19." *Journal of Cosmetic Dermatology* 19 (9): 2145–2160.

Neu, Jerome. 1987. "A Tear Is an Intellectual Thing." *Representations* 19 (Summer): 35–60.

Newsweek Staff. 1993. "Is Michael Dangerous or Off the Wall?" *Newsweek*, September 5, 1993. https://www.newsweek.com/michael-jackson-dangerous-or-wall-193108.

Niedenthal, Paula M., Martial Mermillod, Marcus Maringer, and Ursula Hess. 2010. "The Simulation of Smiles (SIMS) Model: Embodied Simulation and the Meaning of Facial Expression." *Behavioral and Brain Sciences* 33 (6): 417–480.

Nikopoulos, James. 2017. "The Stability of Laughter." *Humor* 30 (1): 1–21.

Nilsen, Don L. F., and Alleen Pace Nilsen. 2018. *The Language of Humor: An Introduction*. Cambridge: Cambridge University Press.

Ntarangwi, Mwenda. 2010. *Reversed Gaze: An African Ethnography of American Anthropology*. Champaign: University of Illinois Press.

Nye, Edward. 2009. "The Eighteenth-Century Ballet-Pantomime and Modern Mime." *New Theatre Quarterly* 25 (1): 22–43.

Nyong'o, Tavia. 2009. *The Amalgamation Waltz: Race, Performance and the Ruses of Memory*. Minneapolis: University of Minnesota Press.

Nyong'o, Tavia. 2011. "Have You Seen His Childhood? Song, Screen and the Queer Culture of the Child in Michael Jackson's Music." *Journal of Popular Music Studies* 23 (1): 40–57.

O'Conner, Jane. 2017. "Childhood and Celebrity: Mapping the Terrain." In *Childhood and Celebrity*, edited by Jane O'Connor and John Mercer, 5–15. Abingdon, UK: Routledge.

Oh, Chuyun. 2022. *K-pop Dance: Fandoming Yourself on Social Media*. London: Routledge.

O'Shea, Janet. 2007. *At Home In the World: Bharata Natyam on the Global Stage*. Middletown, CT: Wesleyan University Press.

Okafor, Chinyere Grace. 1991. "Behind the Inscrutable Wonder: The Dramaturgy of the Mask Performance in Traditional African Society." *Research in African Literatures* 22 (4): 39–52.

Pabon, Jorge "Popmaster Fabel." 2012. "Physical Graffiti: The History of Hip-Hop Dance." In *That's the Joint: The Hip-Hop Studies Reader*. 2nd ed., edited by Murray Forman and Mark A. Neal, 56–62. New York: Routledge.

Pabón-Colón, Jessica N. 2017. "Writin', Breakin', Beatboxin': Strategically Performing Women in Hip-Hop." *Signs: Journal of Women in Culture and Society* 43 (11): 175–200.

Pareles, Jon. 1995. "Michael Jackson Is Angry, Understand?" *New York Times*, June 18, 1995.

Pelachaud, Catherine, Norman Badler, and Mark Steedman. 1991. "Linguistic Issues in Facial Animation." In *Computer Animation '91*, edited by N. M. Thalmann and D. Thalmann. Tokyo: Springer.

Pelachaud, Catherine, Norman Badler, and Mark Steedman. 1996. "Generating Facial Expressions for Speech." *Cognitive Science* 20 (1): 1–46.

Perron, Wendy. 2002. "The Face Can Say as Much as the Legs." *New York Times*. January 13, 2002.

Perrett, David. 2010. *In Your Face: The New Science of Human Attraction*. Basingstoke, UK: Palgrave.

Petrusich, Amanda. 2019. "A Day of Reckoning for Michael Jackson with 'Leaving Neverland.'" *The New Yorker*, March 1, 2019. https://www.newyorker.com/culture/cultural-comment/a-day-of-reckoning-for-michael-jackson-with-leaving-neverland.

Pinder, Sherrow O. 2012. "Michael Jackson and the Quandary of Black Identity." In *Michael Jackson: Grasping the Spectacle*, edited by Christopher Smit, 51–63. Farnham UK: Ashgate

Pough, Gwendolyn. 2004. *Check It While I Wreck It: Black Womanhood, Hip-Hop Culture, and the Public Sphere*. Boston: Northeastern University Press.

Pough, Gwendolyn, Elaine Richardson, Aisha Durham, and Rachel Raimist, eds. 2007. *Home Girls Make Some Noise: Hip Hop Feminism Anthology*. Mira Loma, CA: Parker.

Preston, Carrie. 2011. *Modernism's Mythic Pose: Gender, Genre, Solo Performance*. New York: Oxford University Press.

Rameau, P. 1728. *The Dancing Master, or The Art of Dancing Explained*. London, UK.

Redmond, Sean. 2007. "The Whiteness of Stars: Looking at Kate Winslet's Unruly White Body." In *Stardom and Celebrity: A Reader*, edited by Sean Redmond and Su Holmes, 263–274. London: Sage.

Reed, Dan. 2019. "I'm Shocked by Those who Still Won't Accept." *The Observer*, March 12, 2019.

Reichl, Susanne, and Mark Stein, eds. 2005. *Cheeky Fictions: Laughter and the Postcolonial.* Amsterdam: Rodopi.

Reynolds, Dee, and Matthew Reason. 2012. *Kinesthetic Empathy in Creative and Cultural Practices.* Chicago: University of Chicago Press.

Rifkind, Hugo. 2019. "This Was Kids Fooling Around, Only One of Them Wasn't a Kid." *The Times*, March 9, 2019.

Riley, Sam G. 2010. "Child Celebrity." In *Star Struck: An Encyclopedia of Celebrity Culture*, edited by Sam G. Riley, 37–43. Santa Barbara, CA: Greenwood.

Roberts, Rosemarie, A. 2021. *Baring Unbearable Sensualities: Hip Hop Bodies, Dance, Race and Power.* Middletown, CT: Wesleyan University Press.

Roberts, Tamara. 2011. "Michael Jackson's Kingdom: Music, Race, and the Sound of the Mainstream." *Journal of Popular Music Studies* 23 (1): 19–39.

Robin, Diana, and Ira Jaffe, eds. 1999. *Redirecting the Gaze: Gender, Theory, and Cinema in the Third World.* New York: State University of New York Press.

Rose, Trisha. 1991. "A Style Nobody Can Deal With: Politics, Style and the Postindustrial City in Hip Hop." In *Microphone Fiends: Youth Music and Youth Culture*, edited by Andrew Ross and Trisha Rose, 71–88. London: Routledge.

Rosenberg, Erika. 1997. "Introduction: The Study of Spontaneous Facial Expression in Psychology." In *What the Face reveals: Basic and Applies Studies of Spontaneous Expression Using the Facial Action Coding System (FACS)*, edited by Paul Ekman and Erika Rosenberg, 3–12. New York: Oxford.

Ross, Alison. 1998. *The Language of Humour.* London: Routledge.

Rowell, Charles H., and Fred Moten. 2004. "Words Don't Go There: An Interview with Fred Moten." *Callaloo* 27 (4): 953–966.

Royster, Francesca T. 2012. *Sounding Like a No-No: Queer Sounds and Eccentric Acts in the Post-Soul Era.* Ann Arbor: University of Michigan Press.

Rushton, Richard. 2002. "What Can a Face Do? On Deleuze and Faces." *Cultural Critique* 51: 219–237.

Ruyter, Nancy L. C. 1996. "The Delsarte Heritage." *Dance Research* 14 (1): 62–74.

Saddik, Annette J. 2003. "Rap's Unruly Body: The Postmodern Performance of Black Male Identity on the American Stage." *TDR: The Drama Review* 47 (4): 110–127.

Sanders, Sam. 2014. "A Reluctant Star, Sia Deals with Fame on her Own Terms." *NPR*, July 8, 2014. http://www.npr.org/2014/07/08/329500971/a-reluctant-star-sia-deals-with-fame-on-her-own-terms.

Saxton, Alexander. 1996. "Blackface Minstrelsy." In *Inside the Minstrel Mask: Readings in Nineteenth-Century Blackface Minstrelsy*, edited by Annemarie Bean, James V. Hatch, and Brooks McNamara, 67–85. Hanover, NH: Wesleyan University Press.

Schaefer, Brian. 2017. "Ryan Heffington: Hollywood's Delightfully Absurd Dancemaker." *Dance Magazine*, October 2, 2017. https://www.dancemagazine.com/ryan-heffington-2491084283.html.

Schechner, Richard. 1988. *Performance Theory.* New York: Routledge.

Schechner, Richard. 2002. *Performance Studies: An Introduction.* New York: Routledge.

Schloss, Joe. 2006. "The Art of Battling: An Interview with Zulu King Alien Ness." In *Total Chaos: The Art and Aesthetics of Hip-Hop*, edited by Jeff Chang, 27–32. New York: Basic Civitas.

Schloss, Joseph G. 2009. *Foundation: B-boys, B-girls, and Hip-hop Culture in New York.* New York: Oxford University Press.

Schwartz, Peggy, and Murray Schwartz. 2011. *The Dance That Claimed Me: A Biography of Pearl Primus*. New Haven, CT: Yale University Press.

Scott, Julie-Ann. 2012. "Cultural Anxiety Surrounding a Plastic Prodigy: A Performative Analysis of Michael Jackson as an Embodiment of Post-Identity Politics." In *Michael Jackson: Grasping the Spectacle*, edited by Christopher R. Smit, 167–180. Farnham UK: Ashgate.

Seigworth, Gregory J., and Melissa Gregg. 2010. "An Inventory of Shivers." In *The Affect Theory Reader*, edited by Melissa Gregg and Gregory. J. Siegworth, 1–25. Durham, NC: Duke University Press.

Seppänen, Janne. 2006. *The Power of the Gaze: An Introduction to Visual Literacy*. Translated by Aijaleena Ahonen and Kris Clarke. New York: Peter Lang.

Shepherd, Julianne Escobedo. 2014. "1000 Forms of Fear." *Rolling Stone*, July 8, 2014.

Shteir, Rachel. 2005. *Striptease: The Untold History of the Girlie Show*. Oxford: Oxford University Press.

Siebers, Tobin. 2013. "Disability and the Theory of Complex Embodiment: For Identity Politics in a New Register." In *The Disability Studies Reader*, edited by Lennard J. Davis, 278–297. Florence: Taylor & Francis.

Smit, Christopher R, ed. 2012. *Michael Jackson: Grasping the Spectacle*. Farnham, UK: Ashgate.

Smith, David. 2019. "Trump Declares National Emergency to Build US-Mexico Border Wall." *The Guardian*, February 15, 2019. https://www.theguardian.com/us-news/2019/feb/15/national-emergency-border-wall-trump-latest-news.

Spirou, Penny. 2017. "The Lonely Island's 'SNL Digital Short' as Music Video Parody: Building on Saturday Night Live's Legacy." In *Music in Comedy Television: Notes on Laughs*, edited by Liz Giuffre and Philip Howard, 129–141. New York: Routledge.

Southern, Eileen. 1996. "The Georgia Minstrels: The Early Years." In *Inside the Minstrel Mask: Readings in Nineteenth-Century Blackface Minstrelsy*, edited by Annemarie Bean, James V. Hatch, and Brooks McNamara, 163–175. Hanover NH: Wesleyan University Press.

Stearns, Marshall, and Jean Stearns. 1994. *Jazz Dance: The Story of American Vernacular Dance* New York: Da Capo.

Steimatsky, Noa. 2017. *The Face on Film*. New York: Oxford University Press.

Steinskog, Erik. 2015. "Michael Jackson and Afrofuturism: *HIStory*'s Adaptation of Past, Present and Future." In *The Politics of Adaptation: Media Convergence and Ideology*, edited by Dan Hassler-Forest and Pascal Nicklas, 126–140. Basingstoke, UK: Palgrave.

Stillwater, Willa. 2014. "Monsters, Witches, Michael Jackson's Ghosts." *Popular Musicology Online*. http://www.popular-musicology-online.com/issues/02/stillwater.html.

Stokes, Adrian. 1983. "'The Classical Ballet." In *What is Dance?*, edited by Roger Copeland and Marshall Cohen, 244–254. Oxford: Oxford University Press.

Story, Kaila, A. 2007. "Performing Venus—From Hottentot to Video Vixen: The Historical Legacy of Black Female Body Commodification." In *Home Girls Make Some Noise: Hip Hop Feminism Anthology*, edited by Gwendolyn D. Pough, Elaine Richardson, Aisha Durham, and Rachel Raimist, 235–247. Mira Loma, CA: Parker.

Stras, Laurie. 2010. "Introduction: She's So Fine, or Why Girl Singers (Still) Matter." In *She's So Fine: Reflections on Whiteness, Femininity, Adolescence and Class in 1960s Music*, edited by Laurie Stras, 1–29. Farnham, UK: Ashgate.

Sturges, Fiona. 2019. "Can We Love the Work and Loathe the Man?" *Financial Times*, March 9, 2019.

Sullivan, Eric. 2018. "Shia LaBeouf is Ready to Talk About It." *Esquire*, March 13, 2018.
Taraborrelli, J. Randy. 2010. *Michael Jackson: The Magic, The Madness, The Whole Story, 1958–2009*. New York: Grand Central.
Tate, Greg. 2019. "Too Big to Cancel." *The Guardian*, March 1, 2019.
Taussig, Michael. 1999. *Defacement: Public Secrecy and the Labor of the Negative*. Stanford, CA: Stanford University Press.
Toll, Robert C. 1996. "Social Commentary in Late Nineteenth-Century White Minstrelsy." In *Inside the Minstrel Mask: Readings in Nineteenth-Century Blackface Minstrelsy*, edited by Annemarie Bean, James V. Hatch, and Brooks McNamara, 86–109. Hanover, NH: Wesleyan University Press.
Turner, Graeme. 2013. *Understanding Celebrity*. 2nd ed. London: Sage.
Urry, John, and Jonas Larsen. 2011. *The Tourist Gaze*, 3rd ed. London: Sage.
Valis Hill, Constance. 2010. *Tap Dancing America: A Cultural History*. New York: Oxford University Press.
Vatsyayan, Kapila. 1967. "The Theory and Technique of Classical Indian Dancing." *Artibus Asiae* 29 (2/3): 229–238.
Vigarello, Georges. 1989. "The Upward training of the Body from the Age of Chivalry to Courtly Civility." In *Fragments for a History of the Human Body: Part Two*, edited by Michel Feher, 149–199. New York: Zone.
Vigo, Julian. 2012. "Michael Jackson and the Myth of Race and Gender." In *Michael Jackson: Grasping the Spectacle*, edited by Christopher R. Smit, 23–37. Farnham UK: Ashgate.
Vingerhoets, Ad. 2013. *Why Only Humans Weep*. Oxford: Oxford University Press.
Vogel, Joseph. 2012. *Featuring Michael Jackson: Collected Writings on the King of Pop*. New York: Baldwin Books.
Vogel, Joseph. 2015. "I Ain't Scared of No Sheets: Re-Screening Black Masculinity in Michael Jackson's *Black or White*." *Journal of Popular Music* 27 (1): 90–123.
Vogel, Joe. 2019. "What You Should Know About the New Michael Jackson Documentary." *Forbes*, January 29, 2019. https://www.forbes.com/sites/joevogel/2019/01/29/what-you-should-know-about-the-new-michael-jackson-documentary/?sh=1e3b9606640f.
Volinsky, A. K. 1983. "The Vertical: The Fundamental Principle of Classical Dance." In *What is Dance?*, edited by Roger Copeland and Marshall Cohen, 255–257. Oxford: Oxford University Press.
Washington, Alesha D. 2007. "Not the Average Girl From the Videos: B-Girls Defining their Space in Hip-Hop Culture." In *Home Girls Make Some Noise: Hip Hop Feminism Anthology*, edited by Gwendolyn D. Pough, Elaine Richardson, Aisha Durham, and Rachel Raimist, 80–91. Mira Loma, CA: Parker.
Wegenstein, Bernadette. 2012. *The Cosmetic Gaze: Body Modification and the Construction of Beauty*. Cambridge, MA: MIT Press.
Weitz, Eric. *Theatre & Laughter*. London: Palgrave, 2016.
Welsh, Kariamu. 2004. *African Dance*. New York: Chelsea House.
Wetherell, Margaret. 2015. "Trends in the Turn to Affect: A Social Psychological Critique." *Body and Society* 21 (2): 139–166.
Whiteley, Sheila. 2005. *Too Much Too Young: Popular Music, Age and Gender*. London: Routledge.
Wickberg, Daniel. 2015. *The Senses of Humor: Self and Laughter in Modern America*. Ithaca, NY: Cornell University Press.

Wiig, Kristen. 2015. "Sia." *Interview Magazine*, March 27, 2015. http://www.interviewmagazine.com/music/sia/.

Wild, John. 1969. "Introduction." In *Totality and Infinity: An Essay in Exteriority*. Translated by Alphonso Lingus, edited by Emmanuel Levinas, 11–20. Pittsburgh, PA: Duquesne University Press.

Winter, Marian Hannah. 1996. "Juba and American Minstrelsy." In *Inside the Minstrel Mask: Readings in Nineteenth-Century Blackface Minstrelsy*, edited by Annemarie Bean, James V. Hatch, and Brooks McNamara, 223–241. Hanover, NH: Wesleyan University Press.

Wittje, Gavin. 2015. "Ethics in a Time of AIDS: DV8 Physical Theatre's *Dead Dreams of Monochrome Men*." *Dance Research Journal* 47 (2): 63–78.

Wood, Mikael. 2014. "Sia Keeps the Pain Alive on '1000 Forms of Fear.'" *Los Angeles Times*, July 9, 2014.

Wong, Yutian. 2010. *Choreographing Asian America*. Middletown, CT: Wesleyan University Press.

York, Lorraine. 2018. *Reluctant Celebrity: Affect and Privilege in Contemporary Stardom*. Basingstoke, UK: Palgrave Macmillan.

Younger, Briana. 2016. "Heard But Not Seen." *Washington Post*, October 21, 2016.

Yuan, David. 1996. "Celebrity Freak: Michael Jackson's 'Grotesque Glory.'" In *Freakery: Cultural Spectacles of the Extraordinary Body*, edited by Rosemarie Farland Thompson, 368–384. New York: New York University Press.

Zeng, Jing, Crystal Abidin, and Mike S. Shäfer. 2021. "Research Perspectives on TikTok and Its Legacy Apps." *International Journal of Communications* 15: 3161–3172.

Ziegler, Maddie. 2017. *The Maddie Diaries*. New York: Gallery Books.

Zimmer, Carl. 2011. "More to a Smile Than Lips and Teeth." *New York Times*, January 25, 2011.

Index

For the benefit of digital users, indexed terms that span two pages (e.g., 52–53) may, on occasion, appear on only one of those pages.

Figures are indicated by *f* following the page number

ableism, 196
ableist, 17, 46–47, 53, 126, 133–34, 178, 193, 217n.11
acting, 6–7, 99, 195, 199n.3, 200n.18
action-expressions, 21–22, 24, 29, 38, 53, 83–85, 109, 110, 112–13, 135–36, 140, 161–62, 163, 165, 194–96
adolescence, 124
adolescent, 20, 24–25, 112–13, 119, 120, 214n.18
adult, 20, 24, 34–35, 89–90, 91–92, 112–13, 118–20, 121, 123–24, 130–31, 132–33, 136, 143, 146, 168–69, 170, 194–95, 203n.10, 211n.12, 214n.11
adults, 38, 113–14, 118–19, 124, 197–98
adulthood, 20, 29, 40, 118–19, 131
adultified, 33–35, 123
aesthetic of the cool, 8–9, 80–81, 181, 199n.9
affect, 12, 13, 16–17, 128–29, 135, 196
Africa, 158
African American, 30–33, 36–37, 87–89, 91–92, 93, 94, 146, 147–49, 159, 181
 African American men, 33–34, 41–42, 189
 African American music, 5, 23–24, 35–36, 93–94
 African American performers, 33, 34–35, 36, 37–38, 133
 African American women, 44–45, 80
African diaspora, 60–61, 96
 dances of African diaspora, 8–9, 73, 80–81, 103–4, 179, 181, 187, 189–90
Africanist, 19, 59–60, 80–81, 181, 218n.26
afrofuturism, 154–56, 215n.31
age, 16, 20, 55, 112, 129–30, 193–94

 young age, 27, 30–32, 33–34, 118–19
aggression, 23–24, 79, 88–89, 91–92, 94–95, 98, 99–100, 103–4, 107–8, 110, 193
Ahmed, Sara, 16–17, 49–50, 129–30
amateur, 167–68, 176–77, 198
anachronistic, 77–78, 104, 105–6, 109–10, 193–94
androgynous, 146–47
anger, 12–13, 83–84, 101, 102–4, 107, 141–42, 155–56, 161, 167, 201n.23
animalistic, 89
Aprahamian, Serouj, 100, 109
Asian, 71, 72, 79
 Asian model minority, 73
Asian American, 71, 208n.40
assimilation, 35–36, 94
Atkins, Charles "Cholly," 33
aurality, 158, 159–60
authentic, 13–14, 34–35, 87, 98, 104, 148–50, 199n.3, 208n.40
authenticity, 45–46, 49–50, 69, 100, 109, 193
avant-garde, 120–21, 153, 154–55
awarishness, 52–53
Awkward, Michael, 91–92, 148–49

ballet, 5–7, 59
"Bandolier," 174–78, 189–90, 217n.14
Barthes, Roland, 5, 124–25
B-boys
 Alien Ness, 96, 103–4
 Are You Randy, 60–61, 207n.13
 Box Won, 74, 206n.7
 Dosu, 62, 107–8, 108*f*, 181–82
 Doze Green, 105, 218n.29

B-boys (cont.)
 Dr. Moose, 98
 Duron, 60–61
 Frosty Freeze, 183–84, 218n.29
 Hannibal, 96
 Hussain, 60–61
 Izegbu, 98, 101, 104, 106
 Ken Swift, 99, 100, 104–6, 109–10, 182–84, 218n.29
 Knuckles, 60–61, 207n.13
 MachPhive, 106, 184–85, 185f, 186–88
 Metal, 62, 63, 101, 101f, 104, 107, 181–84, 183f, 206n.6
 Native, 186–88, 187f, 207n.17, 218n.35
 Renaissance Ray, 61–62, 106, 186–87, 206n.6
 Rukkus, 60–61, 66, 102, 102f, 107–8, 181–83, 184, 206n.6
 Som, 107, 181–82
 Steve Believe, 61, 98, 104, 105
 Super Josh, 102, 184
 Valme, 65f, 102, 103f, 206n.6
 Viazeen, 98, 105
 Wiz, 186–87
 Ynot, 63, 68, 106
B-girls
 check us out!, 23, 77, 82
 Chronic SASS, 56
 Macca, 23, 62, 68, 69, 73, 74, 76, 77–79, 80–81, 82, 98, 163–65, 179, 206n.7, 209n.45
 Medusa, 96
 nonbinary "b-girls," 74–75, 206n.1
 Rokafella, 64, 69, 77–79, 82
 Sunny, 23, 61, 63, 66, 71–73, 73f, 75, 77–79, 82, 107, 208n.40
beauty, 24, 44–46, 55, 58–59, 122, 125–26, 132, 134
beauty pageants, 44–45, 212n.25
Bench, Harmony, 167–68, 171–72, 174
Berlant, Lauren, 49–50
binary, 15–16, 69–70, 74–75, 78–79, 147–48, 159–60
 binary terror, 148–49, 215n.20
Birdwhistell, Ray, 14, 28–29, 201n.25
biting, 1–2, 40–41, 83, 89, 90, 109, 127, 156–57, 210n.11
"biting," 184–85

Black, 146, 148–49
 angry Black woman, the, 16–17
 Black aesthetics, 16
 Black art, 140
 Black artists, 33, 36, 137, 157–58, 160–61, 209n.3
 Black Arts Movement, 40
 Black avant-garde, 153
 Black b-girls, 73–74
 Black body/bodies, 33, 40, 58–59, 73, 74, 80, 89, 203n.14, 205n.34, 209n.1
 Black childhood, 33–34
 Black community, 73–74, 100
 Black consciousness, 40, 155–56
 Black criminality, 89, 209n.6
 Black dance, 137, 154, 181
 Black dancing body, 22, 38
 Black entertainer, 34–35, 40–41
 Black experience, 161
 Black expression, 24–25, 109, 152–53, 154
 Blackface, 36, 37–38, 39–40, 53, 193–94
 Black faces, 36–37
 Black female, 74, 80–81, 201–2n.30
 Black freedom, 161
 Black heritage, 109
 Black hypersexuality, 91–92
 Black identity, 34–35
 Black life, 40, 153, 155
 Black literature, 92–93
 Black lived experience, 38
 Black lives, 37
 #Black Lives Matter, 73, 208n.36
 Black male, 32, 33–34, 89, 90–91, 92, 149–50, 201–2n.30
 Black male sexuality, 33–34
 Black masculinity, 23–24, 33–34, 41–42, 53, 90–92, 94, 156–57
 Black men, 73, 87–88, 154
 Black music, 154–55, 158, 215n.23
 Black Other, 34–35
 Black people, 37, 39–40, 58–59, 81, 83–84, 140, 152–53, 154, 155, 209n.1
 Black performance, 84–85, 87–88, 93–94, 158
 Black performers, 38
 Black pleasure, 35–36
 Black politics, 109

Black primitivism, 37
Black self, 36–37
Black signification, 93, 211n.9
Black studies, 12, 16, 23, 58–59, 70–71, 193
Black subject, 92–93
Black subjectification, 156–57, 158, 161
Black subjectivity, 24–25, 154, 156–57
Black suffering, 154
Black survival, 89–90
Black tradition, 80–81, 93–94
Black vernacular, 19, 88–89, 92–93, 211n.10
Black vernacular dance, 19, 153, 154, 189–90, 204n.23
Black welfare queen, 11, 199–200n.12
Black woman, 69, 81
Black women, 73, 78–79, 80, 208n.36
Blackness, 34–35, 36–37, 38–40, 133, 148–49, 153, 155, 201–2n.30
Boxman-Shabtai, Lillian, 176–78
Braidotti, Rosi, 129–30
breaking
 burn, 63, 66, 96, 101, 107, 186–87, 210n.14, 210n.18
 easy props, 69, 208n.31
 footwork, 60–61, 64, 79, 80–81, 97, 106, 107, 164–65, 182–83, 186–87
 freeze, freezes, 61, 64, 65*f*, 79, 97, 106, 107–8, 186–87, 207–8n.30
 "no touch," 107–8
 power, 64, 74–75, 79, 80–81, 96–97, 209n.44
 toprock, 60–61, 79, 97, 106, 107–8, 163–64
 uprock, 96, 184
Bronx, the, 95, 99–100, 104, 106
brow, 10, 83–84, 86–87, 97, 111–12, 122
 furrowed brow, 81, 83–84, 88–89, 97, 209n.1
Brown, James, 93–94, 154
Brown, Jayna, 46–47, 80, 133, 204n.23
Bugs Bunny, 104, 105
burlesque, 1–2, 44–45, 52, 204n.22

camp, 89–90, 194
cancel culture, 142
capital, 157–58

economic, 76, 155, 178, 192
social, 76, 155, 178, 192
capitalist, 17, 46–47, 48, 53, 116, 194
catharsis, 156–57, 161, 163, 185, 189–90
cathartic, 25–26, 177–79, 189–90. *See also* laugh: cathartic
celebrity, 5, 24, 27–28, 53, 95, 112–13, 115–21, 126, 129–30, 132–35, 143, 148–49, 150, 152, 155, 167–69, 192. *See also* face: celebrity
 adult celebrity, 112–13, 136
 "celebrity amateurs," 176
 celebrity child/child celebrity, 24, 27–28, 133–34, 194–95, 211n.12
 global celebrity, 3, 19–20
 reluctant celebrity, 115–21, 135
cheeks, 10, 15, 28–29, 196–97
cheerleading, 44–45, 48–49, 53
Chewbacca, 174–76
chin, 7–8, 10, 105–6, 107, 111–12, 141–42, 146, 159, 163–64, 167, 186–88, 196–97
choreography, 43–45, 47, 58–59, 61, 77–78, 89–90, 112–13, 115–16, 119–20, 126, 132, 140, 154, 165, 167–68, 169–71, 172–73, 174–76, 177–78, 180, 181–82, 198
 choreographic, 2–3, 4, 7, 9, 18–26, 38–39, 53, 60, 94, 115, 120, 122, 124–25, 126, 129–30, 134–35, 137, 140–41, 149, 151–57, 158–62, 165–66, 170, 191–92, 193–94, 195, 197–98
 choreographic play, 23–24, 84–85, 109, 182–83
 "choreography," 18–20
 ocular choreography, 81–82
chorus line, 22–23, 44–45, 46–47, 52
 chorine, 44–45, 52
class, 21, 55, 70–71, 129, 157–58, 193–94, 196
 middle class, 44–45, 99–100, 201n.23
 working class, 39–40, 44–45, 87–88
class act tradition, 33, 38–39, 40, 53, 193–94
clown, 179–80, 185, 187
 circus clown, 187–88
 clowning, 25, 181–83, 187–88, 189–90, 218n.29
 clowns, 38

collective, 43–44, 49–50, 59, 74, 135, 143, 159, 163, 189–90, 194–95, 196–97, 209n.1, 209n.6
collective body, 11, 30
colonial, 148–49
colonialist, 8–9, 23, 58–59, 70, 78–79, 200n.15
color
 bodies of color, 78–79, 83–84, 109
 dancers of color, 23, 71, 74, 77–78, 81–82
 women of color, 69, 70, 74, 77, 79, 208n.38
comedic, 38, 107, 168–69, 170–72, 176, 179, 181, 186–87
comedy, 165
comical, 52–53, 164–65, 169–70, 187–88
commercial dance, 120
commodity, 129–30, 157–62, 204n.25
community 8–9, 39–40, 55, 56, 73–74, 109, 154, 161, 163–66, 178, 181, 185, 188, 189–90, 196
competition, 42, 44, 50, 56, 71, 75–76, 79, 95, 96, 113, 172, 182–83, 185
 competition dance, 1–2, 22–23, 27, 45–46, 47–48, 52–53, 120, 191–92
competitive, 63, 64, 74–75, 94–95, 99, 107, 164–65, 179, 181–82, 189–90, 217n.8
conflict, 96, 103–4
confrontation, 14–15, 94–95
convergence culture, 25, 168, 174
corporeal signature, 25, 172–73, 178
cosmetic surgery, 24–25, 46, 146–47
countenance, 1–2, 4, 7–9, 11, 18–19, 27–28, 36–37, 70–71, 87, 90, 94–95, 100, 104, 106, 109, 111–12, 124, 125–26, 146, 149–50, 152–53, 185, 193, 198, 201n.28, 204n.17
COVID-19 25–26, 163–64, 196–97
crazed, 120, 124, 125–26, 129–30, 133, 136, 171, 217n.8
creative, 19–20, 21–22, 96, 100, 104, 126, 140–42, 149–50, 157–58, 161–62, 167–68, 181, 189–90
 creative space, 23, 77–78, 81–82
creativity, 25–26, 66, 79, 109–10, 161, 178, 182–83, 192
criminal, 89–90, 138–40, 214n.6

criminality, 33–34, 92, 99–100, 109–10, 143. *See also* Black criminality
criminalization, 33–34
critic, 1, 58–59, 138–39, 144–45
critics, 7, 120, 128–29, 130–31, 135, 139–40, 144, 152–53
 music critics, 24, 127–28, 141–42, 159–60
cruel optimism, 49–50, 53
cry (*also see* weeping)
 crybabies, 113
 cry face, 125–26, 212n.24
 manipulative cry, 24, 112–13, 136, 193–94
 men crying, 114
 women crying, 112–13, 114–15
cultural theory, 3
cypher, 55–56, 64, 69, 70–71, 77, 78–79, 97, 109, 181–82
 center of the cypher, 59, 60–61
 cypher crowd, 25, 165, 179, 185, 186–90
 cypher space, 23, 77–78, 82, 102–3, 104

Dance Moms, 1–2, 19–20, 24, 27, 42, 46–47, 48–49, 52–53, 112–13, 114–15, 120, 168–70, 173, 178
dance studies, 2–3, 5, 7, 9, 34–35
dance studio, 22–23, 27, 48–49, 120
 studio competition, 45–46, 53, 110, 191–92, 198
dangerous, 23–24, 58–59, 86, 92, 150
Darwin, Charles, 12–13, 28, 113–14, 200n.13, 200n.15, 200n.19, 216–17n.7
defacement, 24–25, 140, 144–51, 157–59, 161–62
Deleuze, Gilles, 15–16, 17–18, 69–70, 114–15, 128–30, 199n.10, 201n.28, 213n.29, 213n.30
Delsarte, François, 6–7
depression, 119, 126, 188–89, 201n.23
derision, 37, 74–75, 103–4, 125–26, 179–85, 189–90, 193
 dance of derision, 181, 187, 218n.26
disability, 12, 17, 193, 217n.11
disco, 38–39, 40–41, 54
discrimination, 91–92
display rules, 28–29, 191–92

disrespect, 66, 81–82
distress, 50–51, 111, 114–15, 122, 123, 124–25, 191–92, 194–95
DJ
 DJ Fleg, 60–61
 DJ Kool Herc, 95, 210n.12
"Don't Stop 'Til You get Enough," 38–39
Douglass, Frederick, 153, 154
dramatic, 3–4, 27, 48, 50–51, 111
Duchenne de Boulogne, G.B.A. 28, 216n.1
 Duchenne smile, 28

eccentric dance, 133
economic, 39–40, 44, 77, 80, 92–93, 99–100, 109, 112–13, 115, 116, 134–35, 142–43, 148–49, 158, 203n.9, 211n.13
 economic capital (*see* capital)
 economic mobility, 33
 economic privilege, 24
Ed Sullivan, 30–32, 31*f*, 34–35
Ed Sullivan Show, The, 29, 33–34, 203n.7
Ekman, Paul, 12–13, 200n.16, 202n.4
Elswit, Kate, 46, 52, 204n.26
emotion, 12, 13, 14, 16–17, 48, 122, 130–31, 135, 196–97
enslavement, 70, 91–92, 153, 209n.1
entertainer, 20, 34–36, 40–41, 85–86, 160–61
 child entertainers, 34–35
 entertainers, 38, 155–56
entertainment, 10, 29, 46–47, 53, 150, 151, 167–69, 173, 177–78, 194
 African American entertainment, 38
 entertainment industry, 44, 196
 female entertainment, 44–45
 mass entertainment, 36
 popular entertainment, 44–45
Epic Records, 35–36, 38–39, 93, 109, 137
epistemic, 19–20, 84–85, 109
epistemologies, 16, 193
epistemology, 15–16
Ehrenreich, Barbara, 48, 205n.35
essentialism, 17–18, 80, 148–49
essentialist, 34–35, 91–92, 149–50, 161–62, 208n.32
ethereal, 133–35
ethnographer, 56
ethnographic, 21, 55, 57

etiquette, 32, 33, 34–36, 62, 66, 96, 102–3
European, 9, 27–28, 57, 70–71, 89, 147–48, 201n.29
 Europeanist, 19, 57, 78–79
 Eurocentric, 58–59
 Euro-American, 4, 7, 9, 13, 14, 93–94, 126, 199n.10, 201n.23
evolutionist, 28–29, 33, 200n.14
expression, 1–4, 5–8, 12–14, 16, 18–19, 21–22, 28–29, 33, 37–38, 46, 52, 83–85, 87–88, 90–91, 100, 105–6, 128–29, 135–36, 160, 165–66, 168, 181, 191–92
 expressionless, 179
 expressivity, 1, 3–4, 6–7, 27, 197–98
 full-bodied expression, 29, 198
 superficial expression, 41–42
eyes, 7–8, 15, 28–29, 30, 43–44, 54, 55, 57, 60–61, 64–65, 68, 111–12, 113–14, 122–23, 137–38, 166–67, 169–71

façade, 30–32, 41–42, 45–46, 99, 138–39, 147–48
face
 about-face, 3, 7
 anonymous face, 20–21, 192
 celebrity face, 20–21, 27–28, 55, 116, 118, 129, 192
 cinematic face, 4
 close-up of face, 4, 5, 24, 30, 35, 38–39, 40–41, 48–49, 83, 86–87, 88–89, 90, 111–13, 127, 128, 156–57, 199n.4
 duckface, 198
 ethical face, 14, 69–70, 193
 everyday face, 10–11, 18–19, 146
 excess, face of, 2–3, 18–19
 face, dancing, 2–3, 5, 9, 12, 17–21, 22, 25–26, 42, 112–13, 126, 131, 178, 191–92, 197–98
 face-to-face, 14–16, 54, 66, 70–71, 97, 127, 186–87, 193, 201n.27
 facework, 11, 18–19
 face value, 10–11, 25–26, 30–32, 89, 146
 facial freakery, 25
 facial society, 11
 facial tics, 40–41
 game face, 47, 51
 habitual face, 18–19

face (*cont.*)
 hyperbolic face, 10, 18–19, 21–22, 24, 53, 163, 195, 198
 hypermobile face, 10, 18–19, 195
 identifiable face, 16, 17–18, 41–42, 53, 55, 140–41, 146, 149, 161–62, 173, 193
 facial labor, 21–22
 loss of face, 191–92, 202n.37
 muscles, 1, 10, 28, 187–88, 199n.5, 200n.15
 neutral face (*see* withdrawn face)
 physiological face, 12–13, 17–18, 28, 98, 113–14, 146, 191–92
 pretty face, 81–54
 quotidian face, 3–4, 12, 195
 re-face, 24–25, 142–43, 161–62
 semiotic face, 15, 17–18, 41–42, 53, 55, 69–71, 114–15, 129, 146, 193
 serious face, 50–51, 107
 sexy face, 81
 sociocultural face, 17–18, 28–29, 87, 98, 113–14, 165–66, 191–92
 spectacle, face as, 1–3, 38–39, 140, 149
 straight face, 179, 189–90
 surrogate face, 24, 115–21, 129–13, 132, 135, 166, 169–70, 193–94
 viral face, 166–73, 174
 withdrawn face, 7, 9
faceicity, 128
faciality, 15–16, 69–54, 78–79, 114, 129
 facial machine, 114–15, 129–30
 superfacial, 23, 70–71, 75, 77, 81–82
fan, 118, 142, 150, 172–73, 180–81, 215n.25
Fanon, Frantz, 16, 201–2n.30
fans, 24, 117–18, 126, 128–29, 130–31, 135, 139–40, 141–42, 143–44, 150, 159–60, 174, 176–77
Farris Thompson, Robert, 181, 199n.9, 218n.26
Fast, Susan, 91–92, 137
feeling, 69–77, 95, 102, 118, 122, 128–29, 149, 161, 194–95
feelings, 13, 22–23, 25–26, 28, 30–32, 47–48, 57, 66–67, 87–88, 102–3, 126, 127–28, 130–31, 143–44, 161–62, 165, 191–92, 194–95

femininity, 81, 114–15
 badass femininity, 78–79, 80–81
 compliant femininity, 46–47, 53
 See also White femininity
feminist, 16–17, 33–34, 51, 58–59, 115, 130–32, 135, 205n.46, 208n.39
 feminist killjoy, 16–17, 51, 52–53
 feminist scholarship, 24, 128–29 (*see also* hip hop feminist scholarship)
 feminist theory, 12
Feuillet, Raoul Auguste, 19
figure skating, 44–45
Fleetwood, Nicole, 58–59, 80, 85–86, 201–2n.30
fool, 37, 38, 173
forehead, 83–84
Foucault, Michel, 57–58, 206n.9
frame alignment theory, 177, 217n.18
Franko, Mark, 46, 52–53, 204n.25, 204n.26
freak, 149–51, 215n.21
 enfreakment, 149
 freakery, 24–25, 144–51
 freakish, 136, 139–40, 143–44, 146, 150–51
Frosh, Paul, 5, 127, 212–13n.27
frown
 brooding frown, 23–24, 109
 camp frown, 194
 to frown, 83–84
 menacing frown, 83
 modest frown, 40–41
 provocative frown, 23–24, 80, 81, 83–84, 85–86, 89–90, 92–93, 94–95, 109–10, 137, 193–94
fun, 107–8, 164–65, 173, 177–78, 179–80, 181, 182–84, 189–90
funny, 177–78, 179, 184

gang, 23–24, 86–87, 88–89, 90, 99–100, 101, 109, 209n.6
gangster, 96, 99, 100, 105–6
Gates Jr., Henry Louis, 23–24, 83–84, 92–93, 210n.9, 210n.10
gaze
 colonial gaze, 58–59, 70–71, 77
 evaluative gaze, 66–67
 gendered gaze, 69, 77–78

hegemonic gaze, 23, 69, 75, 77–78, 80, 82, 196
impersonal gaze, 59–60
male gaze, 58–59, 75–76, 207n.10
patriarchal gaze, 71, 74–75
racialized gaze, 58–59
gender, 16, 17, 21, 39–40, 58–59, 69–70, 78–79, 91–92, 114, 140–41, 147–49, 161, 171–72, 193–94
cis-gender, 89
gender transgression, 189–90, 218n.23
genealogy, 22–23, 44, 46–47, 52, 85–86, 193–94
glance, 1–3, 30–32, 42–43, 54, 59, 60, 67, 198
Glytch, 179
Goffman, Ervin, 13–14, 201n.25
Gordy, Berry, 32
grimace, 1, 47, 49, 124f
grimacing, 33, 123
grin, 37–38, 40, 41–42
grinning, 37–38, 107
grotesque, 36–37, 120, 126, 129–30, 133–34, 146, 149, 192

hair, 10, 35, 89–90, 111–12, 133–34, 137–38, 147–48, 159, 174–75, 214n.7
Han Solo, 174–75
happiness, 12–13, 28, 38–39, 41–42, 48–53, 83–84
objects of happiness, 22–23, 49–50, 51
haptic, 69, 77, 82
Hartman, Saidiya, 40, 203n.14
head, 5–7, 10–11, 111–12, 122–23, 127, 166–67
heartache, 115, 123
Heffington, Ryan, 119–21, 126
heterosexual, 82, 90, 91–92, 126, 146, 147–48, 149–50
hip hop
battle strategy, 55
bringing wreck, 78–82
hip hop battles, 1, 10, 21, 55, 59–60, 76, 81–82, 179–85, 191–92, 193–95
hip hop feminism, 74
hip hop feminist scholarship, 23, 70–71, 74–75
Hollywood musicals, 44–45

homophobia, 149–50
homophobic, 150–51, 215n.22, 215n.23
homosocial, 90
hooks, bell, 58–59, 87–88, 92–93
house dance, 54, 55, 75–76, 94–95
Jenesis, 62, 67, 68, 75–76
Mai Lê, 62
howl, 141–42, 151
humor, 25, 107–8, 171–72, 173, 177–79, 180, 181, 182–83, 184, 186–88, 189–90
Hyland, Brooke, 42, 43–44, 48–49
hypermasculine, 109
hypersexualized, 33–34, 74–75

idealized, 3–4, 27–28, 133–35
identity, 10–11, 16–18, 21, 70–71, 91–92, 140–41, 147–49, 159–60, 193
improvisation, 19, 21, 160
Indian classical dance, 7–8, 9, 19
industrial, 34–35, 41–42, 144–45
industry, 35–36, 44, 46–47, 48, 58–59, 92–93, 196
popular music industry, 22–23, 24, 32, 33–34, 38, 53, 86, 87–88, 116, 119, 129–32, 135, 139–40, 157–58, 167–68
infectious, 50–51, 53, 163
insult, 95, 96, 181, 182–83
interaction, 1–2, 13–15, 27–28, 66, 127, 131, 163, 188
intimidation, 23–24, 65, 94–95, 186–87, 192–93
invisibilized, 70–71, 73, 74–75, 154–55

Jackson, Janet, 24–25, 137–38, 141–42, 144–45, 152
Jackson, Michael
addiction, 138, 146–47
Bad, 23–24, 86, 88, 137
"Bad," 86, 88, 89
"Beat It," 85, 86–87
"Billie Jean," 85, 86
"Black and White," 89, 151, 154, 213n.2
Dangerous, 137, 151
"Enjoy Yourself," 35–36
HIStory: Past, Present and Future, Book I 137, 138–39
"I Want You Back," 29, 31f, 35–36

Jackson, Michael (*cont.*)
 Jackson 5 29–35, 203n.7, 203n.11
 Jacksons, The, 35
 Leaving Neverland, 24–25, 138–39, 141–44, 150, 152–53, 157–58, 161–62, 199n.2, 215n.22, 215n.25
 Off the Wall, 38–39, 40–41, 83–84
 Pepsi commercial, 27, 41–42, 138, 202n.2
 "Rock With You," 31*f*, 40–41
 "Scream," 24–25, 137, 139–40, 139*f*, 141–42, 143–45, 151, 152–53, 154, 158–59
 "The Way You Make Me Feel," 86, 90–91
 Thriller, 23–24, 27, 84–86, 150
 "Thriller," 83–84, 85, 92–93, 151, 209n.3, 214n.16
 vitiligo, 138, 146–47, 148–49
 "Wacko Jacko," 142, 149, 214n.9
jaw, 1–2, 40–41, 86–87, 88–89, 90, 97, 124, 141–42, 169–70, 171, 173
jazz, 42–43, 91–92, 93–94
Jenkins, Henry, 168, 176–77, 217n.12, 217n.13
Jimmy Kimmel Live! 25, 167–69, 171–72, 178, 217n.8
 Guillermo Rodriguez, 168–73
Jip the Ruler, 179, 180*f*, 188, 189
Johnson, Imani Kai, 78–79, 81, 96, 99–100
joke, 106, 172–73, 186–87, 188
joy, 30–32, 35–36, 37, 40–41, 53, 113–14, 144, 161, 179, 180
judges, 50–51, 55–56, 59, 64, 66–67, 68, 81–82, 102–3, 164–65, 181–82, 192

Kimmel, Jimmy, 168–73, 177–78, 189–90
King, Eddie, 174–78

LaBeouf, Shia, 120–21
labor, 11, 19–20, 30, 38, 42, 45–47, 104, 114, 119–20, 134–35, 157–58, 160–61, 169–70, 192
 See also facial labor
LaFrance, Marianne, 27–29, 45–47
Lane, William Henry, 37–38
Latin American, 71, 73–74
laugh
 cathartic laugh, 25, 163, 164–65, 173, 193–94
 community of laughter, 24–25, 188, 193–94
 Duchenne laugh, 216n.1
 incongruity theory, 165–66, 171–73
 laugh at, 165, 179
 laugh with, 165, 179
 superiority theory, 165–66, 173, 182–83, 184–85
 tickle, 25, 179, 188
 tickling, 186–90
Levinas, Emmanuel, 14–16, 69–70
lips, 1–2, 7–8, 42–43, 46–47, 86, 87, 88–89, 90, 114–15, 123, 133–34, 147–48
Liu, Chih-Chieh, 172–73, 174
lockdown, 163–65, 196–98
locking, 55, 64, 75, 94–95, 179–80, 181
 Funky Van-go, 180
 lockers, 1
 Professor Lock, 1, 4, 64, 180–81
look
 anxious look, 42–43
 coy look, 194
 defiant look, 23, 77–78, 82, 193–94
 glances, 1–3, 30–32, 42–43, 54, 59, 60, 67, 198
 glancing, 29, 54, 60–61, 152
 impartial look, 66–67
 look back, 52, 55, 77–78, 81, 82, 196
 looked at, 57, 59, 69, 71, 77–78, 81–82, 140–41
 looking, performance of, 23, 55, 65, 77–78
Lukasiak, Chloe, 42, 49
Lutz, Catherine, 14, 114
lyrical dance, 42–43, 50–51, 110, 173

Mad Hatter, 54, 63, 65–67, 68, 71, 72*f*, 75, 179–80, 208n.40
make-up, 11, 44–45, 137–38, 147–48, 214n.13, 214n.17
male-dominated, 74–75, 80, 81
Manning, Harriet, 36–38, 39–40, 93–94, 154
marginalized, 73, 77–79, 81, 155
marketing, 32, 158–59
Marshall, Tyler, 176–77
masculinity, 75, 78–79, 104, 178, 196
 See also Black masculinity; white masculinity

mask, 5, 8–9, 10–11, 13–14, 23–24, 35–36, 37–38, 40, 41–42, 94, 104, 129–30, 140–41, 163
 masked, 3–4
 masking, 25–26, 87–88, 92–93, 116–17, 134–35, 156–57, 188, 196–98
 mask-like, 6–7, 38–39, 110 (*see also* minstrel mask)
 unmasking, 145, 147–48, 149, 150–51
Master Juba. *See* Lane, William Henry
mental health, 130–31, 135
Mighty Zulu Kings, 95
Miller, Abby Lee, 42–44, 47, 48, 49, 50–29, 113, 124–25
 Abby Lee Dance Company (ALDC), 42, 45–47, 50
mimicry, 148–49, 171–72, 177–78
minstrel, 36–42, 85–86, 94
 minstrel mask, 36–37, 39–40
minstrelsy, 22–23, 36–42, 193–94
mirth, 37–38, 52–53, 170–71, 178, 198
misogynistic, 23, 91–92
misogyny, 77, 149–50
mockery, 160–61, 180–84, 187, 194–95
modern dance, 6–7, 9, 59
monstrous, 24–25, 138–40, 143–44, 146, 149, 159–60
Moten, Fred, 24–25, 140, 152–54, 157–58, 159–60
 cut, the, 157–62
 radical breakdown, 24–25, 140, 153–54, 158
Motown, 29, 32, 33–36, 38, 40, 41–42, 92–93, 109, 160–61, 193–94
MTV, 85, 86, 209n.3
mugging, 104, 106, 107–8
 mean mugging, 23–24, 94–100, 101, 106
Mugsy, 101–10
Mulvey, Laura, 58–59, 207n.10
musicality, 66, 79, 96, 97, 182–83
music video, 1–2, 4, 20–21, 41–42, 53, 112, 119, 152–53, 165, 167–68, 171–72, 173, 176–78
mythologies, 94–100, 104, 150–51
mythologized, 23–24, 84–85, 94–95
mythology, 29, 100, 147–48

national, 11, 129, 164–65

neoliberalism, 11, 196
Nesbitt-Stein, Cathy, 48–49
Nesbitt-Stein, Vivi-Anne, 43*f*, 48–49
normative, 14, 16, 69, 70, 81, 91–92, 114–15, 126, 148–50, 155, 156–57, 171–72, 173
norms, 2–3, 10, 17–18, 44–45, 53, 55, 57, 80, 83–84, 122, 126, 129, 146, 158, 193, 196

pain, 121, 122–23, 125–26, 130–31, 154, 161, 194–95, 198
panopticon, 57–58, 77–78, 206n.8
parasocial interaction, 127, 131
parody, 36–37, 166, 167–69, 171–75, 176–78, 189–90
participatory culture, 174, 217n.12, 217n.13
pastiche, 171–72, 174
patriarchal, 17, 70–71, 74–75, 91–92, 116, 129
pedagogy, 29–36, 38, 41–42, 47–48, 51
performance entrapment, 197–98
performative, 21–22, 87–88, 92–93, 134, 147–48, 174, 187–88, 192, 193–94
performativity, 52–53, 80
persona, 23–24, 32, 80–81, 87, 89, 99, 100, 104, 117–18, 119, 182–83, 187–88
Philadelphia, 1, 55–56, 60–61, 96–97, 188
physiognomy, 36–37, 70, 199n.11
plastic surgery. *See* cosmetic surgery
pleasure, 30–32, 35–36, 38–39, 45–46, 65, 79, 83–84, 85–86, 90, 109, 143–44, 149–50, 189, 194
poker-faced, 1, 5–6, 44, 66–67
political, 11, 16–17, 21, 129, 135–36, 148–49, 156–57, 165, 193
politics, 11, 15–16, 33, 39–40, 69–70, 87–88, 94, 99–100, 109, 128–29, 154, 155
popping, 54, 55, 65, 75, 181
 poppers, 1, 65
 Sk8z 62
 Tony Teknik, 54, 65
 waving, 65
popular music industry. *See* industry
popular presentational dance, 9, 17–19, 21, 25–26, 53, 135–36, 161, 191, 194

positivity, 22–23, 25, 33–34, 48, 49–50, 52–53, 163, 164–65, 173, 189–90
postmodern dance, 7, 9, 10, 59–60
pout, 1–2, 52–53, 123
pouting, 42–43, 198
primitivism, 37, 89, 109
primitivist, 23–24, 94
Primus, Pearl, 137, 140, 154, 161
Princess Leia, 174–76, 177–78
privilege, 24, 69, 99–100, 117–18, 134–35
psychological, 6–7, 130–31

Queen Dinita, 181
queer, 16–17, 37–38, 70, 82, 89–90, 126, 147–48, 155–56, 177–78, 193
 queer of color, 149–50
 queer theory, 12

race, 16, 21, 29, 53, 55, 58–59, 69–71, 74, 75, 81–82, 91–92, 129, 143, 144–51, 152–53, 159–60, 193–94, 196
 racial, 9, 14, 16–17, 22–23, 32, 35–36, 39–40, 58–59, 69, 73, 77–78, 83–84, 89, 133–34, 137, 152–53, 155–56, 161, 194–95
 racial self-hatred, 146–47, 148–49
 rage, 83–84, 87–88, 103–4, 109, 110, 138–39, 141–42, 151, 155–56, 161–62, 194–95
reality television, 1–2, 10, 19–20, 21, 27, 53, 110, 112–13
re-choreograph, 20, 23–24, 33, 85–86, 87, 94, 196
recitation, 92–93, 94, 156–57, 161
Redmond, Sean, 133–35
representation, 11, 23–24, 33–34, 37, 39–40, 52, 80, 89, 90–91, 129, 156–57
resistance, 23, 52–53, 69–70, 81, 82, 87–88, 92–93, 117–18, 158
respect, 66, 73–74, 76, 103–4, 181–82
Riot tha Virus, 189
Ross, Diana, 29, 34–35, 203n.7, 203n.11

sadness, 12–13, 110, 113–14, 125–26, 131, 167
safety-valve, 165–66
satire, 171–72, 189–90
savage, 89, 92

Schloss, Joseph, 96, 103–4
schooled, 7–8, 22–23, 32, 41–42, 191. *See also* pedagogy
scream
 potent scream, 24–25, 140, 143–44, 161–62, 193–94
segregation, 35–36, 94
semiotic, 15–16, 69–70, 78–79, 93, 114–15, 187–88, 194–95. *See also* semiotic face
sensations, 3, 10, 13, 127–29, 135, 165
service, 46–47
 service culture, 22–23
 service economy, 46
 service industry, 35–36, 46–47
sexuality, 16, 21, 29, 70–71, 91–92, 131, 137, 147–50, 161, 193–94, 196 (*see also* Black male sexuality)
 sexual desire, 85–86
 sexy, 81, 132
shame, 192
shouting, 113
shriek, 158
Sia
 addiction, 116–17, 119
 anti-fame manifesto, 115–16
 "Big Girls Cry," 4, 24, 111, 112–13, 115, 121, 122–29, 130–31, 133–34, 135, 136
 "Chandelier," 25, 112, 119–20, 165, 166, 167–70, 172–75, 177–78
 "Elastic Heart," 112, 120–21
 1000 Forms of Fear, 111, 115–17, 119–20, 130–31
 voice, Sia's 124–25
signifyin(g), 23–24, 84–85, 92–94
skin, 10, 11, 138, 140–41, 146, 147–49
skit, 105–6, 167–69, 171–73, 176–77
smile
 benign smile, 23–24, 46
 billion-dollar smile, 42–48, 194
 chaste smile, 90–91
 clenched smile, 1–2, 43f, 48–49, 111–12
 fake smile, 28, 45–46, 52–53, 167
 genuine smile, 28, 30–32, 35–36, 45–46, 48
 glossy and tenacious smile, 23, 29, 35–36, 46–47, 53, 85–86, 92–93, 113,

129–30, 137, 140–41, 160, 163, 193–94, 198
polished smile, 30–32, 34–36, 41–42, 45–46, 47, 87, 196
slick smile, 38, 40
smile boycott, 51
sneering smile, 194
winning smile, 27–28, 42–43, 43f, 51, 52–53, 196
snarling, 1–2, 83, 109, 152, 198
sneering, 97, 109
social construction, 24–25, 91–92, 145, 147–48
social dance, 19, 181. *See also* vernacular dance
social media, 11, 20–21, 119, 132–33, 150, 178, 198
spectacle, 1–3, 27–28, 36, 38–39, 44, 46–47, 53, 78–79, 83–84, 140, 149
spectator, 5, 7–8, 10, 24, 36, 40, 55–56, 57, 59–60, 70–71, 87–88, 131, 156–57, 159–60, 174, 191, 195
Star Wars, 25, 174–78
stare, 57, 60, 66–67, 79, 90, 97, 156–57
stare down, the, 1, 61–62, 100, 101
stereotype, 37, 38, 89, 114–15, 126, 130–31, 173
Stras, Laurie, 129–30, 131
streetwise, 23–24, 86, 88, 89–90, 109
striptease, 1–2, 44–45
subjectification, 15, 140. *See also* Black subjectification
subjectivity, 15, 153–54. *See also* Black subjectivity
success, 28, 32, 39–40, 42, 48–50, 53, 85, 109, 134
superficial, 38, 41–42, 52–53, 87
superstar, 20–21, 27–28, 84–85, 150–51, 192
surprise, 12–13, 42–43, 191–92, 197–98
surveillance, 33–34, 57–58, 78–79
survival, 33–34, 87–88, 92–93. *See also* Black survival

tango, 1–2, 47, 82
Tate, Greg, 143, 152–53, 215n.28
Taussig, Michael, 146, 147, 149, 150–51, 159, 170–71, 179

public secret, 145, 146, 147–49, 150–51, 159
tears, 42–43, 49, 111, 113–15, 125–26, 135–36
basal tears, 113–14
psychic tears, 113–14
reflex tears, 113–14
Teddie Films, 174–75, 176–77
teeth, 7–8, 46–48, 53, 81, 83, 86–87, 88–89, 90, 121, 141–42, 144–45, 166–67, 186–88
white teeth, 30, 40–41, 133–34
Temple, Shirley, 47–48, 205n.34
TikTok, 25–26, 189–90, 197–98
tongue, 7–8, 104, 183, 184, 198
trained, 5–6, 27–28, 29, 33, 38, 42, 51, 53, 61, 92, 120, 191–92
training, 7–8, 19, 33, 47–48, 64, 168–69, 175–76, 191–92, 193–94
trash-talking, 96
trauma, 24–25, 116–17, 123, 124–25, 127–28, 130–31, 133, 135, 140, 156–57, 161, 166–67, 173, 177–78, 194–95
trickster, 93, 181, 185
twice-behaved behavior, 156–57

uncivilized, 78–79, 89
unhappiness, 51
universalism, 6–7, 165–66
universalist, 13–15, 28–29
unruly, 85–86, 89, 133–35, 196

vernacular, 10, 21, 93–94, 95, 153, 182–83, 192
vernacular dance, 10, 19, 33, 35, 55, 59, 154, 189–90 (*see also* social dance)
vernacular language, 93
vernacular speech, 88–89, 92–93
violence, 23–24, 69–70, 73, 74–75, 87, 98, 99–100, 102, 109–10
virility, 33–34, 37, 92, 94, 109
viral choreographies, 167–68
visual, 1–2, 8–9, 10, 19–20, 25–26, 30, 32, 57, 58–60, 80, 94, 119–20, 132, 140–41, 159–60, 194–95
Vogel, Joseph, 89, 93–94, 151, 154

waacking, 54, 55, 181

watch, 10, 55–56, 66–67, 105–6
watching, 63, 68, 128–29, 130–31, 171
wealth, 85, 143, 155
weeping, 48, 114–15
 weeping woman, 125–26, 129
weird, 120, 126, 132, 155, 159–60
Weitz, Eric, 165–66, 172, 188
Western, 2–3, 7–8, 10–11, 15–17, 57, 58–59, 154–55, 196–97
 Western concert dance, 9, 59–60
 Western music, 3–4, 160–61
white, 9, 15–16, 19, 33–35, 38, 69, 87–88, 92–94, 146–47
 white audience, 33, 41–42, 53, 157–58, 160–61
 whiteface, 148–49
 white female labor, 47
 white femininity, 44–45, 53, 80, 81
 white mainstream, 32, 35–36, 91–92
 white male, 14, 30–32, 36–37, 143, 146–47, 149–50, 154–55, 193
 white masculinity, 70, 78–79
 white supremacy, 37, 56, 74, 149–50
 white working class, 39–40, 44–45
whiteness, 24, 112–13, 117–18, 133–35, 155, 196
whitening, 32, 148–49
wink, 1–2
winner, 48–49, 55–56, 66, 97
winning, 22–23, 47, 48, 50
wit, 181, 182–84, 192
witnessing, 59–60, 130–31, 153, 163–64, 194–95
wookie, 174–78

York, Lorraine, 117–18, 134–35
YouTube, 25, 119–20, 126, 127, 166, 167–69, 174, 176–78, 189–90, 193–94

Ziegler, Maddie
 blond wig, 111–12, 119–20, 166–67, 169–70, 173
 flesh-colored leotard, 119–20, 166–67
 pale skin, 111–12, 166–67